ANCHEE MIN was born in Shanghai in 1957. At seventeen, she was sent to a labour collective, where a talent scout for Madame Mao's Shanghai Film Studio selected her to work as an actress in propaganda films. Min moved to the United States in 1984. Her first book, the memoir *Red Azalea*, became an international bestseller. She has also published six novels, including the Richard & Judy choice *Empress Orchid, The Last Empress*, and, most recently, *Pearl of China*. Her books have been translated into thirty-two languages. She lives in California.

BY THE SAME AUTHOR

Pearl of China

The Last Empress

Empress Orchid

Wild Ginger

Becoming Madame Mao

Katherine

Red Azalea

The Cooked Seed

A MEMOIR

Anchee Min

B L O O M S B U R Y

First published in Great Britain 2013 This paperback edition published 2014

Copyright © 2013 by Anchee Min

The moral right of the author has been asserted

No part of this book may be used or reproduced in any manner whatsoever without written permission from the Publisher except in the case of hrief quotations embodied in critical articles or reviews

Some of the names, locations and details of the events in this book have been changed to protect the privacy of persons involved

Bloomsbury Publishing Plc 50 Bedford Square London WC1B 3DP

www.bloomsbury.com

Bloomsbury Publishing, London, New Delhi, New York and Sydney

A CIP catalogue record for this book is available from the British Library

ISBN 978 1 4088 3820 4 10 9 8 7 6 5 4 3 2 1

Typeset by Westchester Book Group Printed and bound in Great Britain by CPI Group (UK) Ltd, Croydon CRo 4YY

To Lauryann Thank you for making me write this book.

PART ONE

Control of the State of the Sta

{ CHAPTER 1 }

HE DATE WAS August 31, 1984. It was China's midnight and America's morning. I was about to drop out of the sky and land in Chicago. What made me scared and nervous was that I didn't speak English and had no money. The five hundred dollars I had folded in my wallet was borrowed. But I could not let myself be frightened. I was twenty-seven years old and life had ended for me in China. I was Madame Mao's trash, 四人帮的残渣余孽, which meant that I wasn't worth spit. For eight years, I had worked menial jobs at the Shanghai Film Studio. I was considered a "cooked seed"—no chance to sprout.

Sitting in the airplane crossing the Pacific Ocean, I felt like I was dreaming with my eyes wide open. I tried to imagine the life ahead of me, but my mind went the other way. I saw myself as a child attending kindergarten, where everyone called me Stink. My mother was ill with tuberculosis and never got the chance to wash the blanket I brought home every month.

"It's just a matter of time," Mother said. She was thirty-one years old and she expected herself to die. Watching her labored breathing and thinking about how my grandfather died of tuberculosis at age fifty-five and my grandmother at forty-nine, I didn't have the heart to keep asking my mother to wash my blanket.

I brought the unwashed blanket back to the kindergarten. My teacher rolled her eyes. "And look at that pair of animal claws!" She turned away in disgust. I was embarrassed. I wished that I could tell her that I had tried to do it myself, but the scissor was too rusty to cut. I couldn't get help from my father either. He was rarely home. He spent his days knocking on people's doors asking to borrow money, wearing tattered clothes patched at the knees and elbows. People avoided him the moment they saw him approach.

In the hot and humid summer, pimples began to bloom on my forehead. Infected, they swelled and oozed pus. Flies landed on my head. I tried not to scratch the pimples, but the itch was unbearable. To lessen the chance of passing germs to others, I was restricted from play and had to stay away from the crowd during lessons, especially during story time.

I begged my mother to take me to a doctor. One pimple was now the size of a grape. My mother said that she had no money. She had four children, and I was the only one who was not sick.

"Your father has exhausted every relative," Mother said. "No one will help us anymore." Every month I witnessed my parents struggling against their late debt payments to relatives, friends, and colleagues. We didn't own a towel. For years, the six of us had been sharing one dirty rag. Pinkeye spread to every member of our family. In the end, my mother told me that the zits would not kill me.

We were considered middle-class in Shanghai. I wished that my parents were proletarians like our neighbors, so that we would qualify for free medical care. Unfortunately, both of my parents were teachers, and thus regarded as bourgeois sympathizers. To be reformed was their fate. When the Cultural Revolution erupted in 1965, my mother was sent to a factory. Her job was to pick rubber boots from molds on an assembling line. To get to work, she had to transfer three buses every morning, which took hours. My father's work was farther. He labored in a printing shop.

One day, I was sent home with a notice from my kindergarten. The inspector from the public health bureau was concerned about the spread of my infection. My parents were ordered to "take action," or the government would do it for them. My mother decided not to respond.

A blue tricycle with red stars painted on each side came for me on a Monday afternoon. I was taken to a hospital where a surgeon removed my infected pimples. The surgery left an inch-long scar on the left side of my forehead.

My mother was horrified when she opened the bandages. She protested that she hadn't given consent for the surgery. "For heaven's sake, you have ruined my daughter's appearance!"

Mother was told that a girl's looks carried no meaning in a proletarian society. "You ought to be grateful that the surgery cost you nothing, thanks to the Communist Party and the socialist system!"

When I graduated to elementary school, I was still friendless. My clothes were covered with patches and my shoes were falling apart. Bul-

lies competed at hitting me over the head with umbrellas and abacuses and seemed to enjoy the sound of beads hitting my skull. The more I ducked, the more excitement I generated. I never told my parents about what happened to me at school, because I believed they would only make the situation worse.

"I am going to leave you on the street," my kindergarten teacher threatened. "It's ten P.M.! Your mother is taking advantage of me. I have my own three young children to attend!" I was scared. Finally, my mother showed up. She was so thin she looked like a ghost under the dim streetlight.

On the day my mother got paid, I took my siblings to wait at the number 24 bus stop on Shanxi Road. We had been hungry for days. I licked the rice jar clean with my tongue. I also picked apple cores and sucked on popsicle sticks from public trash bins. The thought of Mother buying bread helped us endure our stomachaches. We cheered the moment our mother stepped off the bus. One time she arrived with bad news—her wallet had been stolen on the bus.

Waiting for my mother in the hospital was another thing I often did. My mother wanted so desperately to qualify for a permission-to-rest slip that she was almost happy when she felt dizzy, for she knew that her condition might earn her the slip. I saw Mother throw away medicine to ensure that her condition would not improve.

My mother was once a beauty. Though she was never interested in her own good looks, she was praised for having a pair of bright doublelid "Indian eyes" and a slender figure. She loved ancient Chinese poetry and singing, although with her poor lungs she could barely hold high notes.

Another strong memory is of waiting for my mother in a pawnshop. It had a huge black door and a high counter. My mother stood on her toes and reached up toward the counter with her bag. The night before, she had mended the clothes and sewed on buttons. She pawned her winter clothes in the summer and her summer clothes in winter. In the end, she ran out of things to pawn. I will never forget the disappointed expression on her face when her items were rejected. Once I saw Mother's eyes light up when a relative bought us children's jackets as gifts for the New Year. I anticipated wearing the new jacket to school the next day. But the clothes disappeared. My mother never told us where the jackets had gone. I knew she had taken them to the pawnshop. She must have convinced herself that she would get the jackets back before the expiration day, but she never had the money.

I remembered the traces of blood on the snow where my mother walked. Her frostbite wounds cracked open and the backs of her feet bled. Her shoes were made of plastic that cut like a knife in winter. She couldn't afford a pair of cotton shoes or socks.

I followed Mother and walked in her bloody footprints. I was amazed that she never complained about the pain. Occasionally, her face would screw up, and she would let out a muted cry.

In the days before my departure for America, I went to a hair salon on Shanxi Road. It was called the Shanghai White Jasmine. I was asked the nature of my "occasion."

"The style must go with the occasion," the hairdresser announced. I told her that I was going abroad to America. The hairdresser looked me up and down in disbelief. I took out my passport and showed her my American visa.

"America!" The hairdresser shouted for the whole room to hear. The salon's workers abandoned their customers and gathered around me.

"You don't go to America looking like a peasant!" one hairdresser said.

"You don't parade the American streets with your moplike straight hair!" others echoed.

I agreed.

After a serious discussion, the salon's hairdressers came up with a style called Esmeralda.

I had no idea what "Esmeralda" meant. They explained that it was Shanghai's hottest style and that it was inspired by a beautiful Gypsy named Esmeralda in a newly imported foreign movie, *The Hunchback of Notre-Dame*.

I rushed to see the movie to make sure that the Esmeralda style

was what I wanted. It was convenient, because the movie theater was located a block from the salon.

I fell in love with Esmeralda. I returned to the salon and requested the style. Seven hours later, the hairdresser announced that my Esmeralda was complete. During the process, I had endured pulling, curling, and blow-drying. The chemicals they used stunk worse than manure. The heated ceramic rollers were heavy on my head. Finally, I was led back to my chair. The moment I saw my reflection in the mirror, I fell out of the chair.

"This is not Esmeralda!" I cried. "It is a basket of seaweed!"

The flight captain's voice came through the speakers. I didn't understand what he was saying. I looked around and saw the passengers on my right and left buckling their seat belts. I copied them.

The plane began to descend. I saw a sca of lights outside the window. The beauty stunned me. "Capitalism rots and socialism thrives" was the phrase passing through my mind. Was this the result of rotting?

The plane rattled as it touched the ground. The passengers cheered when we finally came to a stop. One after another, everyone stood, picked up their belongings, and exited.

"Chicago?" I asked the flight attendant.

"No," she smiled.

"Not Chicago?" I took out my ticket.

"This is Seattle." She signaled me not to block the way. The rest of her words I couldn't understand.

I followed the passengers moving toward a big hall. My growing nervousness began to choke me. The hand that held my passport became damp with sweat

I didn't feel like I was walking on my own legs. The sound inside my head was louder than the sound outside. It was the noise of a tractor with loose screws going over a bumpy road.

I feared getting caught. I was not the person I had claimed to be—a student ready for an American college. But what choice had I had? I wouldn't have been issued a passport if I hadn't lied through my teeth and claimed undying loyalty to the Communist Party. The American

ANCHEE MIN

consulate in Shanghai wouldn't have granted me a visa if I hadn't cheated and sang my self-introduction in English like a song. I had charged forward like a bleeding bull. I had not had the time to get scared until that moment.

My father was scared to death for me. He didn't think that I would make it. No one with common sense, or who had anything to lose, would do what I was doing. But I didn't have anything to lose. I was a caught frog, kicking my last kicks. I jumped the hurdles in front of me.

Off the plane, I went in search of the ladies' room. All the signs in English confused me. I followed a woman into a room with a sign showing a lady in a skirt. I was glad that it was the right place. There was no waiting line. I looked around to make sure that I was where I thought I was. I entered a stall and closed the door. I had never seen such a spacious and clean toilet room. A roll of paper came into view. It was pure white and sort to the touch. I wondered how much it would cost. I would not use it if I had to pay. I sat down and pulled the paper a few inches. I looked around and listened. No alarm went off. I was not sure if I was allowed to use the paper. I dragged out a foot more, and then another foot.

I put the paper under my nose and smelled a lovely faint scent. Perhaps it was free, I decided. Carefully, I wiped my behind with the paper. It didn't scratch my buttocks. What an amazing feeling. I grew up with toilet paper that felt like sandpaper. In fact, it was what I had packed in my suitcase—toilet paper made of raw straw.

People with different colored eyes, hair, and skin confirmed that I was no longer in China. I hoped my seaweed hairstyle didn't offend anybody. I inched forward in the line leading toward the immigration station. I heard the man behind the booth call, "Next!" My heart jumped out of my chest.

I forced myself to step forward. My surroundings started to spin. I was face-to-face with an immigration officer. I wanted to smile and say, "Hello!" but my jaw locked. My mind's eye kept seeing one image—a

group of peasants trying to haul a Buddha statue made of mud across a river. The Buddha statue was breaking apart and dissolving into the water.

Shaking, I held out my right arm and presented my passport.

The officer was a middle-aged white man with a mustache. A big grin crossed his face as he greeted me with what I later came to learn was "Welcome to America!"

My mind went blank. I tried to breathe. Was the man asking me a question or was it a greeting? Did he mean "Where are you from?" or "How are you?"

I had been studying a book called *English 900 Sentences*. According to the book, "How do you do?" would be the first words you would say when you met someone for the first time. Obviously, this was not what the officer had said. How do I respond? Should I say, "I am very well, thank you, and how are you?" or "I am from China"?

What if it was a greeting? Did I hear "America"? I thought I did. "America" meant "United States," didn't it? Did he say, "Why are you in America?"

I could feel the officer's eyes as they bore into me. I decided to give him my prepared response.

Lifting my chin, I forced a smile. I pushed the words out of my chest the best I could: "Thank you very much!"

The officer took my passport and examined it. "An . . . ah Q?" he said. "Ah . . . Q? A . . . Kee? A . . . Q?"

On my passport, my first name was spelled "An-Qi." I had no say in choosing the spelling of my name. The Pinyin spelling system was invented by the Communist government. If the actual name was pronounced "Anchee," the Pinyin would spell it "An-Qi." The Communist official in charge of Chinese language reform believed that a foreigner would pronounce "Chee" when he read "Qi." No Chinese was allowed to spell their name any other way on their passport.

Should I have answered "Yes, I am Ah-Q"? I didn't think so. "Ah-Q" was the name of a famous Chinese idiot. If it was "Ah-B" or "Ah-C," I would have gladly answered yes. But I hadn't come to America to be called an idiot.

The officer spoke again. This time I failed to comprehend anything.

The officer waited for my answer. I heard him say, "Do you understand?" The voice was getting louder. He was losing patience.

The mud Buddha dissolved. The river swallowed it.

The officer looked me up and down with suspicion.

I gathered all my courage and gave another "Thank you very much!"

The officer waved me to move closer. He began to speak rapidly.

Panicking, I shouted, "Thank you very much!"

The man's smile disappeared. He asked no more questions but took away my passport. He pointed behind his back at a room about twenty feet away with a door that had a large glass window.

My world became soundless. My knees gave way.

I was escorted into a brown-colored room. A lady came. She introduced herself as a translator. She began to speak accented Mandarin. "You don't speak any English, but you are here for college. How do you explain that, Iwiss Min?"

I had cheated, I told her. And I was guilty.

"Your papers say you speak fluent English," the translator continued. "I'd guess that you didn't fill out those papers yourself, did you? We need to deport you, Miss Min."

I broke down. "I came to America because I have no future in China. If there hadn't been so many people in the middle of the night at Huangpu River bund, I would have carried out my suicide. I wouldn't be here to bother you."

"I am sorry, Miss Min." The translator looked away.

"I didn't have the fortune to die in China," I cried. "I'll be as good as dead if you deport me. My airplane ticket alone cost fifteen years of my salary. My family is in debt because of me. I am begging you for an opportunity!"

"Miss Min, you wouldn't be able to function in this country." The translator shook her head. "Even if we let you go, you wouldn't be able to survive in an American college. Do you understand? You will become a burden on our society!"

"I'll be nobody's burden. I don't need much to live. I'm an excellent laborer. I'll deport myself if I don't speak English in three months!"

THE COOKED SEED

"Miss Min ..."

"Oh, please, my feet are on American soil! I might not be able to communicate, but I can draw. I'll make people understand me. Look, here are pictures of my paintings. I am going to the School of the Art Institute of Chicago—"

The translator looked at my paintings with a stone face.

"Help me! I'll forever be grateful."

The translator bit her lip. She looked at her watch.

"I am so sorry to bother you." I wept.

The translator stared at me in silence, then abruptly stepped out of the room.

{ CHAPTER 2 }

WAS HANDPICKED BY Madame Mao's talent scouts while hoeing weeds in a cotton field. The year was 1976. I was working in a labor camp near the East China Sea. Half of China's youth had been sent to labor camps in the country. Mao had won the Cultural Revolution. Using the students, calling them the Red Guards, he had successfully eliminated his political opponents. But the youth had started to cause unrest in the cities, so Mao sent them to the countryside. He told us to get "a real education by learning from peasants."

It didn't take long for us to realize that we were in hell. We thought we were growing rice to support Vietnam, but we could barely grow enough to feed ourselves. The salt-saturated land was hostile. We worked eighteen hours a day during planting seasons. There were a hundred thousand youth between seventeen and twenty-five in the camps near the East China Sea. The Communist Party ruled with an iron fist. Harsh punishment, including execution, applied to those who dared disobey the rules. There were no weekends, holidays, sick days, or dating. We lived in army-style barracks without showers or toilets. We worked like slaves. Since childhood we had been taught that we owed our lives to the Communist Party.

Like a package, I was shipped to the Shanghai Film Studio. I was to be trained to play a leading role in Madame Mao's propaganda movies, although I knew nothing about acting. I was chosen only because my looks matched Madame Mao's image of a proletarian heroine. I had a weather-beaten face and a muscled body capable of carrying hundreds of pounds of manure. I froze the moment I heard the sound of a camera rolling, but I tried hard so that I could escape the labor camp.

The nation suffered a double shock in 1976. Chairman Mao died on September 9. When we were still deep in our grief, Madame Mao was overthrown. My status changed in a heartbeat. I was considered "Madame Mao's trash"—guilty by association. My "proletarian beauty" was "evidence of Madame Mao's taste and evil doing."

How could I be disloyal to Mao if I was loyal to Madame Mao? I had never had any say in life. My school textbooks taught me to admire those who died for the cause of Communism. People jumped off buildings, hanged themselves, drank pesticide, drowned in rivers, took sleeping pills, and cut wrists just to prove their loyalty to Mao.

I discovered that killing myself was more complicated than I had thought. I felt undeserving of death, because I was not guilty. It was not my fault that Madame Mao had picked me. She wanted "a piece of a white paper on which to paint any color she liked." All I did was follow orders. I was even taught how to drink water "in the proletarian style" at the Shanghai Film Studio.

"No, you're drinking the water incorrectly, Comrade Min," my instructor yelled. "Your pinkie is up, and that's Miss Bourgeois. You must grab the cup, gulp the water down in one breath, and wipe your mouth with both of your sleeves!"

I had no talent for acting. The camera assistant had to pin the corner of my costume down to hide my trembling. My back was soaked with sweat at the sound of "Action!" I kept picturing myself being shipped back to the labor camp.

I couldn't sleep. I remembered the freezing winter at the labor camp when I woke up to discover that a mother rat had given birth by my feet. I dreaded the taste of the salt water from the man-made pond. I brushed my teeth with water that carried living organisms in the bottom of my mug. My fingernails and toenails were stained brown from chemical fertilizers. Fungus and infections made my skin crack. The infection spread between my toes and caused them to bleed. The skin on my face peeled off along the sweat lines on each side of my nose.

The manure pit was where we did our personal business. I had to squat on a wet wooden board. It took me a week to figure out how to balance like an acrobat while taking a shit. I had to swing both arms behind my back in order to keep mosquitoes from attacking—the kind of mosquitoes with needle-sharp mouths that could shoot through sturdy canvas. If I fell, below me in the pit swarmed millions of maggots.

I didn't fear hardship but the permanence of it. I could endure carrying a hundred pounds of manure balanced across my shoulders from a bamboo pole with two buckets hung by rope. I walked in knee-deep

water across countless rice paddies. I worked day and night shifts. I was proud of the calluses developing between my neck and shoulders. Then an accident injured my spinal cord—a rotten bucket rope broke and I lost my balance and fell into the canal. From then on I was unable to bend my back. I had to kneel in the muddy waters to continue planting rice.

As the guilty one, I was ordered to attend public rallies denouncing Madame Mao. The former first lady's victims marched onstage, giving their accounts of the torture they had endured. Nobody mentioned Mao. His wife was held solely responsible for the millions of deaths during the Cultural Revolution. She was sentenced to death.

I watched the trial on television. Madame Mao delivered her last performance like the heroine in her propaganda opera. Waving both arms in the air, she shouted, "I am Mao's dog! Mao asked me to bite, I bitt

Looking at me with a triumphant smile, one of the old actresses revealed that in her fight against Madame Mao, she had taught me no valuable lessons in acting. "I made sure that our time together was wasted. Min is no innocent newcomer. She was Madame Mao's foot soldier." Her wrinkled face blossomed like an autumn chrysanthemum. "Look at Min's flushed and exhausted face. I am certain that she was plotting tricks. The dark rings around her eyes show that she is fully aware of her role—a bourgeois individualist. Down the drain, finally!"

I had long stopped my correspondence with Yan, my best friend at the labor camp. The last thing I wanted to do was harm her with my negative status. My mother told me that the officials from the film studio had come to my home to announce my downfall. My father believed that my mother had made things worse by claiming my innocence.

My mother was known for being politically backward at her work unit. She not only did not know how to recite Mao's teachings correctly, but she was in denial about anything she didn't wish to happen. For example, she didn't pursue a man who tried to molest me when I was seven years old. I walked home after school one day as a second grader,

and the young man approached me asking for help reading a directory in an apartment building. Because I was too short to reach the directory board to identify the characters, the man lifted me. The man wouldn't let me down after I finished identifying the characters on the board. "There is another character on the second floor's board that I need your help with," he said.

We went up, but there was no board. I asked to be let down. The man refused. He held me and sat down on the staircase. I told him that I wanted to go home. He said that he would only let me go if I would let him see my underwear. I was willing to please an adult, but my underwear was too torn and dirty to be seen. The man forced me. I struggled to get away. The sound of a door slamming at the far end of the hallway allowed me to escape.

I reported what had happened to my mother as soon as I arrived home. My mother said that she didn't want to hear about it, which confused me. When I mentioned his interest in my underwear, my mother screamed, "No! It didn't happen. It can't happen!"

My mother might have been helpless and incapable, but she was a domineering figure in my life. She threatened to disown me after I was honored by my elementary school principal for following his order and denouncing my favorite teacher as an American spy. My mother refused to hang my award certificate on the wall, which read MAO'S GOOD CHILD. Other parents would have been thrilled and honored.

My mother said that the school was turning her children into monsters. She didn't believe that Mao's books should be the only books children read. I wondered if I should report her to the authorities. It was a joke to me that my mother had earned a college degree in elementary education. She told me that she never got a chance to teach a real class because she was unable to discipline her students. Mother was repeatedly transferred from bad schools to worse schools. Eventually, she was dumped into a school crowded with troubled teens and convicts.

Mother was nicknamed "Teacher Idiot" at her work unit. Her last name was Dai, which also can be pronounced as dai—"retarded/idiot." I fought with my mother and tried to get her to act "normal." I didn't care that I was breaking her heart when I told her that she deserved the nickname Teacher Idiot. I didn't stop trying until one day my uncle,

my mother's younger brother, revealed the root of my mother's mental illness.

My uncle said that my mother had suffered a trauma at the age of eight. It took place during a journey in 1938. The family was on a ship sailing from Shandong province to Shanghai, escaping the Japanese. My mother's closest siblings were dying of typhoid. Superstition made people believe the ship would sink if children died on board. My mother watched as her sister and brother were thrown into the ocean while still alive.

I remembered my mother's obsession with water. She would sit for hours on end facing water, be it the Huangpu bund or a pond in People's Park. When there was no water, she would sit facing a picture of water. Resting her chin in her hand, she would stare into the scene. I once stood behind her to see how long she stayed there. I hoped that she would turn around and see me, but she never did. It was I who ran out of patience. My uncle's explanation made sense.

Mother never told me the reason why we had to offer alcumed bread to a homeless old tailor who lived under a staircase next door. The man had a potato-size tumor growing on the back of his head. I begged my mother to let me have a bite of the bread first. She refused. "You don't give people your leftovers and call it kindness."

One day, my mother picked us up from school early. She wore a white cotton mask, and it wasn't cold. I asked why she had to wear a mask. She replied that her tuberculosis had worsened. Doctors had declared her contagious. This was the reason she was given permission to leave work for three months.

"Let's celebrate," my mother said. "Finally I get to see my children in daylight!" $\,$

After we arrived home, Mother cleaned the house with absolute joy. I was so happy to spend time with my mother.

Mother started to wear black clothes. When I asked her the reason, she explained, "I'll be in the right clothes if I don't wake up tomorrow morning." She was smiling, but her words gave me nightmares. I dreamed about my mother lying on her deathbed, asking me to take care of my siblings.

When I asked my mother about men and love for the first time, I was turning seventeen and about to depart for the labor camp. Mother was embarrassed. "Shame on you" were the only words she offered. It is a memory I wish I didn't have. I never asked Mother a question of that nature again. Throughout school, I had been assigned to sit next to a "bad girl" to influence and help her. She was deemed "morally corrupted," which meant that she had had an inappropriate relationship with a man. She was looked down on by everyone. I learned from her lesson and avoided attention from any male. Yet I was curious about how a marriage would take place. My mother told me, "A man who is meant to be your husband will look for you when the time comes."

Unfortunately, the man meant to be my husband never appeared. It wasn't a problem until I turned twenty-seven. If I had discovered anything about myself, it was that I was unable to attract men. I didn't know how to approach them, how to express myself and show my interest. My self-confidence was so shaken that I gave up trying. Yet the need for affection pained me.

I lad no idea that my mother suffered for me. She was confused that no young man had knocked on my door. Many years later, after my mother passed away, my father revealed the extraordinary efforts she had made. She went to the college campuses around Shanghai and loitered around the medical school buildings. When an appealing man appeared, she would approach him with my photo and ask if he would be interested in dating me. My mother was chased off by campus security guards.

I was in tears imagining my mother in such a humiliating position. It was the only way she could think to help me. I imagined her pain and her bravery. It was only then that I realized the depth of her love.

My father hated to be dragged by my mother and her children on any kind of outing. His only passion was astronomy. During the week he labored at the print shop and had no time to work on his own project. Sunday was his only time. He resented doing anything except sitting in front of his little desk working on his star charts. I watched my father stare into the night sky and asked him why he was interested. He replied that it was because the stars wouldn't hurt him.

My mother said that my father had little "guts," or courage, left. The first time he lost his guts was when Japanese soldiers invaded his village in 1937. His family's front yard was turned into a military training ground. The teenage Japanese soldiers were scared of killing at first. They were drilled until they became killing machines. My father witnessed his cousin tied to a post and poked to death with bayonets. He was never the same after that.

The second time my father lost his guts was over a postcard to Russia. My father was twenty-seven years old. He had been in touch with a Russian professor who encouraged him to go to Moscow University to study astronomy. My father wanted to know if he would still be permitted to go, since China was breaking ties with Russia. My father didn't want to be accused of being secretive, so he communicated in an open way that he thought would be safest. He sent a postcard for everyone to see with his question addressed to the professor through the Russian embassy in China.

Forty years later, my father learned that the postcard never reached the Russian embassy. Instead it landed on the desk of the security boss at my father's work unit. My father was labeled a "potential traitor," although he was never notified. He didn't understand why he was never promoted no matter how well he did his job.

To be strong and dependable was what my parents expected of me. No matter how scared I was, I had to wear a brave mask. I was made a caretaker as soon as I could walk. I closed the windows so the neighbors wouldn't complain to my mother about my younger sister's crying. After we four children grew into adults, the six of us shared one room. There was no privacy. Everyone was constantly in each other's way. We shared a toilet with twenty other neighbors. Beating the morning toilet rush was always a challenge. Relationships between neighbors were strained because the toilet room was also used as a kitchen, laundry, and sink. I could be waiting for my neighbor's mother to get off the pot while watching his sister cooking breakfast on the stove, his daughter brushing her teeth by the sink, and another neighbor washing sheets in the tub next to them. When it was my turn to use the toilet, I was always embarrassed. I dreaded the stink. Someone taking a shower meant that nobody could use the space.

{ CHAPTER 3 }

THE SHADOW OF a girl stood in front of my mosquito net. It was dawn and the temperature was freezing. I heard her climb down from her bed, go out to use the washroom, and then return. Her name was Chen Chong. Later, in Hollywood, she would become Joan Chen, a woman who embodied beauty, grace, and glamour. She would be the sex symbol of Asia. But for now, she had just turned fifteen and was only one of my roommates. The day I met her she had come with her grandmother. The girl had an egg-shaped face, ivorysmooth skin, and a pair of large almond-shaped, crystal-clear eyes. They reminded me of a dragonfly. She had a straight nose and a petal-like, full-lipped mouth. She wore a homemade sleeveless white shirt. I noticed her strong shoulders. According to her grandmother, she was a swimmer and a member of a rifle shooting team at her middle school. She had been discovered by the Shanghai Film Studio talent scout. The girl was timid and shy. She hunched her back to conceal her developing chest. Her grandmother had gently pushed her toward us, asking her to introduce herself.

The girl revealed her cute "tiger teeth" as she smiled. Her hair was tied into two buffalo horns. She didn't introduce herself with a slogan-like phrase of our time, such as "I'm here to follow the Communist Party's call, to learn from my comrades, and to give all my heart and soul to serving the people." Instead she spelled her father's name, first and last, followed by her mother's name, then finally her own.

The dorm-mates giggled. "This girl must have been drilled by her grandmother on what to do when lost in the city." When asked how she came to be here, the girl replied that she had been ordered to take acting lessons. She was assigned to play a child Communist in Madame Mao's propaganda film, but the production had been canceled. She had no idea what to do or where to go next. She brought her schoolwork with her because her parents were not pleased that she was missing school.

When asked to explain the meaning of her first name, she replied,

"Chong means to charge forward." I learned that her parents were physicians and that her grandma was the editor in chief of the popular book *The Family Medicine*. The elderly lady asked everyone to help her grand-daughter mature. Since there were only upper bunk beds available, the grandma picked one opposite mine. She tied bamboo sticks around the bed frame to support a mosquito net. When finished, she took out coils of rope. She rounded the bed with the rope to create a kind of barricade. She feared that Chong might fall off the bed at night. "The child has never slept in a bunk bed, and she loves to roll in her sleep."

Chen Chong sucked on sweet-and-sour dried plums. She hurried her grandmother to depart. Afterward, she joined us for the martial arts practice class, and then a rally denouncing Madame Mao.

The Shanghai Film Studio changed hands within a week. A new production was ready to go on location. We heard that the director was searching for a "fresh image" to star in the film. The new face would represent a stark contrast to Madame Mao's taste. It would be the face of classic Chinese beauty with a touch of modernism. The production had already started, and the director had become a drugged fly bouncing aimlessly about in a desperate search for his leading lady.

The director and his men came to our shabby dorm and noticed Chong. They gathered around to analyze the girl's features. The chief cinematographer remarked that the girl's face had the possibility of going both ways—proletarian and traditional classic beauty, depending on camera angle and makeup. "A girl that we can work with," they concluded.

Little Chen Chong was taken away for test shots. After she returned to the dorm, she showed me a stack of black-and-white photos. I asked how she felt about the photos. She shook her head. "They make me look like a child."

The photos were stunningly beautiful. The light, the shadow, and the perspective made her look like a young goddess. There was no doubt in my mind that she was to be a star.

"Sorry to disturb you." Chen Chong whispered as she stood outside my mosquito net. She explained that she had climbed down to go to the washroom and was now having difficulty climbing back. She was afraid that she would get tangled in the ropes. She didn't want to wake everyone by turning on the bare-bulb light. Without the light, she couldn't get back into her bed.

"Are you cold?" I asked, sitting up.

Shivering, the girl nodded.

I opened the curtain of my mosquito net. "Share my bed if you like." Thrilled, she jumped in.

The bed was narrow. I let her sleep against the wall so she didn't have to worry about falling out of bed. I pulled my blankets up to cover her after she was settled. Within minutes, she was sound asleep.

My thoughts went back to the labor camp and Yan. I missed her. In her last letters, she mentioned no misery, hardship, or hopelessness. She was always good at smiling through bruises. Yet I knew she was reaching the limit of her strength. The labor camp was a beast's den. She let me know that she felt better when she suffered alone, I was ashamed for not being able to rescue her. I felt as if I had betrayed her.

The girl's body was heating up. In her sleep, Chen Chong kicked off her thick sweatpants and her head slid off the pillow. She tossed, seeking the comfort of a pillow. I attempted to lift her head so that I could slide my pillow under her. But she grabbed my arm like a drowning person. I tried to pull my arm away, but she wouldn't let go.

With her eyes shut, she pressed her head against my arm as if it were a pillow. I could do nothing but listen to the rhythmic sound of her breathing. What a child, I thought.

The sky began to break. The sound of the city's traffic came through the window My right arm was numb. Chong's weight grew heavy. I attempted to free my arm, but she held on. I pushed her gently. She was an unmoving rock.

The light showed Chong's profile in silhouette. She turned again, revealing her swanlike neck. She wore a tight bra. I wondered how she could breathe—the bra was like foot-binding cloth. In a few months, she would soar to superstardom and become the object of adoration and obsession. Chen Chong would go on to star in American movies. She

would play the empress in Bernardo Bertolucci's *The Last Emperor*, which would win nine Oscars, including Best Picture.

The girl on my arm had velvety-black, beautiful eyelashes. She was blossoming in her sleep. I wondered if she would remember me in the future. We were on two different tracks and headed in opposite directions. It was odd that we should share this moment.

The first sunlight came through the mosquito net. Chong cracked open her eyes and smiled. Her eyelashes fluttered like the wings of a butterfly. It took her a moment to remember where she was. After realizing she had been using my arm as a pillow, she apologized. She followed me into the backyard, where we brushed our teeth. It seemed that she had something to say to me.

I spit out the water and asked, "What is it?"

"Would you like to come to my home with me?" she said timidly.

I hesitated because I didn't know if she was aware of my status.

"I'll treat you with a tomato" She made a hund modon to describe the size of the tomato. "And sugar-sprinkled sticky rice!"

I warned her about my status. She said that she already knew about my disgrace.

I looked at her. "Why are you still inviting me?"

She cracked a naughty smile.

I didn't think that it was a good idea to go with her.

"We can sneak out together," she said in a small voice. "Nobody will notice."

"Why don't you invite someone else? Someone who would be a good influence."

"I like you."

"What if they catch you? You'll get in trouble."

"I'll pretend innocence if they catch me. I'll mock. I don't see why I shouldn't take advantage of everybody's belief that I am too young to know better."

I followed her home. Her grandmother received me warmly. Chen Chong offered me big, sweet tomatoes and sugar-sprinkled sticky rice. I discovered that my young friend loved to laugh, and it was contagious. She made me temporarily forget my troubles. When she told me she was a big reader, I asked about her favorite books. To my surprise, her books

THE COOKED SEED

were not in Chinese. She told me that she had been studying English. I was immensely impressed. She said that she had just finished an American novel entitled *Love Story*. I told her that I had read the Chinese translation.

"I have known people like the lovers in the novel," Chong said. "The couple is my downstairs neighbor. We share the kitchen. The girl was in love with a boy dying of a disease. Her only wish was to carry his child, and she got her wish! But the baby was born sickly and crosseyed. The girl raised the child alone after her lover died. I hear the child screaming and the mother yelling and cursing. I don't know what to make of the love story, you?"

I rode a tricycle loaded with two giant ice-water containers to the studio. It was the summer of 1978. After returning to the dorm, I found that the upper bunk bcd had been cleared—Chong had left Shanghai for Beijing. In just a few months, she became a household name in China and was awarded China's prize for best movie actress.

I stood by the Huangpu River bund. I stared at the water below. On past weekends, I had biked alone to the Dragon Crematorium. Watching the smoke come out of its giant chimney, I felt swallowed by eternal darkness.

One day after I finished cleaning the backstage, I discovered six leaf-wrapped sticky rice cakes in my drawer. People told me that Chen Chong had stopped by with the rice cakes. She had arrived from Beijing for a film shoot near Shanghai. "Chen Chong has grown so arrogant that she didn't bother to say hello to us—her teachers," the old actresses criticized.

I did everything I could to avoid being sent back to the labor camp. With crews that hired me temporarily, I fought to demonstrate my value as a set laborer. As a script girl, I memorized every shot of the film and every line in the script. I drafted the daily call sheet for the assistant producers and assistant directors. For the camera crews, I provided detailed shooting maps that outlined complicated camera angles. For the lighting crew, costume crew, prop crew, sound engineers, and editors, I

offered hand-printed copies of shooting schedules. Out on location, I worked until midnight while everyone elsc slept. Many times I helped save the day for the producers, who would otherwise be over budget. I impressed my bosses and colleagues. Word of mouth spread. Film crews began to "borrow" me. I was cheap, and I could do the work of five people.

The crew heads spoke for me in front of the studio's Party boss. They explained my usefulness and efficiency. Finally, I was hired as a full-time employee of the studio with two conditions. One, the studio reserved the right to "return" me to the labor camp at any time; two, I would remain in my current status as a set laborer for the rest of my working life.

Though I never complained about being overworked, I knew I was sick. For the next five years, I worked the jobs no one else wanted. By the time Deng Xiaoping became China's leader and the country started to transform itself, shadows were found on my lungs and liver. I came down with an intestinal infection while on location. Instead of allowing me to see a doctor, the crew leader threatened to fire me if I dared to leave.

I became skeleton thin and collapsed on the set. After I was released from the hospital's emergency room, I was ordered to depart for Tibet for another job. I was so weak that I couldn't leave my bed. The Party boss came to my home. It was a midsummer day, and the heat had hit 107 degrees. I shivered uncontrollably under thick layers of blankets. The windows were shut because I felt cold.

"You have a stained dossier," the boss reminded me. "You were Madame Mao's trash."

The Party boss was not an unkind man. He had once said good words about me. He also started the process of getting me out of "borrowed worker" status. "You have to produce a doctor's slip confirming illness or go to Tibet. Otherwise, I'll have to fire you."

After examining me, the doctor at the clinic said, "Why do you bother to come? You think I am a magician? What could be prescribed has already been prescribed."

"I'll do anything you say, doctor."

"Prepare to die," he said bluntly, turning away from me. "Diarrhea and severe dehydration at such an advanced stage has no cure. Even the Dowager Empress Tzu Hsi died from it."

THE COOKED SEED

"I have been ordered to work in the mountains of Tibet, doctor. Please help." $\,$

"Be a martyr!"

On the way home, I crashed into a street post and fell off my bicycle. My once-wounded spinal cord was reinjured. I had to stop and take deep breaths while climbing the stairs. I started having blackouts. I knew that I was heading for another collapse. Normally, doctors were reluctant to issue a "proof of illness" slip, but I received one quickly this time. The Party boss dropped me from the Tibet list.

The Communist Party issued a new policy declaring that all middle school diplomas issued during the Cultural Revolution were "invalid." In order to hold a job, every worker was required to take and pass a middle school basic-subject examination. While working fourteen-hour day shifts, I attended night school. I barely made the passing score to graduate. I scored 66 out of 100 on Chinese and 64 on mathematics.

In the winter of 1984, I received a letter with fancy foreign postage stamps. It was from my friend Chen Chong, who had gone to college in America after becoming a star in China. Enclosed with the letter was a balloon with the image of Mickey Mouse. She told me that her new name in English was Joan Chen. I felt grateful that she remembered me. I wished that I had something interesting to report. I couldn't tell her that I had been thinking about ending my life. I was twenty-six years old.

Before I wrote back to Joan Chen, I borrowed a camera. I asked my sister to take a photo of me blowing up the Mickey Mouse balloon. I wanted to show Joan that I enjoyed her gift. As I blew, Mickey's dark colored ears started to grow. Because my blowing was so weak, the ears looked like two hudding breasts. My sisters collapsed laughing to the floor. The photo I sent to Joan Chen appeared that I was having great fun inflating the balloon.

In her next letter, Joan Chen explained that she didn't live the life of a royal princess, nor was she treated the way she had been in China. She had to work as a waitress to support herself and pay her college tuition. When Joan Chen described that this was the case with most Chinese students studying in America, a light came on inside my head.

WANTED TO WRITE to Joan Chen. I hesitated because I felt that I was asking too much. I wanted to tell her that I was finding it difficult to go on living in China and that I was at the end of my rope. Finally, I decided to send her a letter. My question was: "Is there any possibility for a person like me to become a student in America?"

I let Joan Chen know that I was willing to work twenty-four hours a day every day to pay off my debts. It took me many drafts to complete the letter. I knew I could count on my friend for an honest reply. I understood that my chance was slim, because to study abroad one had to first graduate from a Chinese university. I had barely earned a middle school diploma, and I didn't speak English.

Joan Chen wrote back. She told me that she didn't know the answer, but that she was willing to ask around for me. In our next correspondence, she let me know that no college in America was willing to accept a student without proof of English proficiency. The standard test for international students was called TOEFL—Test of English as a Foreign Language. A score of 500 or above was required.

I located schools in Shanghai that offered beginning English classes. I biked and visited every school to see if I could enroll. But I was rejected every place I tried. I learned that there was no such thing as a "beginning level." People accepted in the beginning-level classes were advanced compared to me.

As I waited at a local bus stop one day, I saw a palm-size ad on an electric pole. It was for a beginning-level English class offered by a private tutor. The underlined characters read, YOU DON'T HAVE TO KNOW ABCD TO REGISTER. Although the fee would cost me a month's salary, I decided to try. To locate the address on the ad, I traveled through dark alleys and climbed four stories through pitch-black staircases. My tutor's classroom was in an attic. The space was about four by five feet. The students had to sit on the teacher's bed.

There was no qualification test. As soon as I paid the cash, I was

told to sit down. Six other tired-looking people were crammed around me. We sat with our shoulders touching. The tutor was a toothless old man. He told us that he was brought up by Western missionaries and had worked for an American oil company in Shanghai before the liberation. The old man offered no textbook or practice sheets. He was slow and sleepy in his teaching. After weeks of studying, I was still spelling "Hello," "Good morning," and "I am from Shanghai, China."

I heard about a place called the English Corner at the People's Park. It was a place where interested people practiced their English conversational skills. What excited me was that it was free. On a winter morning, I wrapped two scarves around my neck and biked to the People's Park. There was a crowd, but few participated. Most people observed in silence. There were two men trying to have a conversation in English. I listened hard but couldn't understand anything. After an hour, I gave up.

I began to follow a beginning-level English program on the radio. Because of my job, I missed lessons. Soon I fell behind and was unable to follow. I bought a book titled *English 900 Sentences* I was determined to teach myself. After lesson ten, I was stuck. I was unable to figure out the grammar, especially the proper use of tenses. The more I tried to learn English, the less confidence I had. When I told my father about my correspondence with Joan Chen, he told me I was crazy. "It's a false hope you're building! You'll only end up crushing yourself!"

"I'll continue kicking until my last breath," I replied. Yet the hopelessness began to drown me. It was hard not to give in. I felt weak and sick, but I still forced myself to get up every dawn and sit on a wooden stool in the neighborhood lawn. I tried to memorize English vocabularies from a dictionary. "A-p-p-l-e... apple; a-d-j-e-c-t-i-v-e... adjective; a-b-ā-t-t-d-v-n... abandon"

"Do you have any talent? For example, art?" Joan Chen wrote. "You may try your luck in art school if you do."

"I grew up painting Mao murals for propaganda purposes," I wrote back. "My Chinese calligraphy was average."

Joan Chen put me in touch with a friend of hers who explained to

me the admission process of an American art school. A "portfolio" was what I needed. I wondered what was expected. I had no training at all. I could copy neither the masterpieces of Chinese traditional brush paintings nor the Western masters. The only great Western artist I knew was Michelangelo. It would be impossible for an amateur like me to copy him. I had heard about a new Western art exhibition in Shanghai titled Impressionism and Cubism. I decided to check it out.

At the Shanghai art exhibition, I found myself confused and thrilled at the same time. Confused that Western society had abandoned Michelangelo for childlike paintings, thrilled that so-called modern art would be easy for me to copy. It was the first time I learned the names of Picasso, Monet, Van Gogh, Gauguin, Matisse, and Andy Warhol. I stared at the paintings and was not sure if I liked them. The strokes were clumsy and the subjects unclear and unrecognizable. The only thought that started to excite me was: If Americans preferred childlike paintings like those, I stoud a chance to fool them.

After coming home, I set out canvases, brushes, and colored inks. I painted throughout the night. I found myself having a good time. There was no master's work in front of me. I was guided by my own nature.

I felt like a child who had been given a magical brush. I painted earth, trees, bushes, and water in abstract shapes. I painted my deepest fear in the form of dark and broken strokes mixed with tearlike ink drops. I splashed my emotions on the canvases. My mother said she saw madness and death in my paintings.

Three months later, I received a thick envelope with a catalog and an application. It was from the School of the Art Institute of Chicago. The glossy catalog scared me, for I knew that I wouldn't be able to afford it. I didn't let myself be discouraged, though, because I remembered what Joan Chen had told me: Most Chinese students managed to work to pay their tuition and counted on future earnings to pay off their debts.

I attempted to fill out the application form but got stuck in the first line. I was supposed to fill in my name, but I didn't have an English name. Do I spell "An-Qi" from the Pinyin system? Could Americans recognize that? For advice, I knocked on the door of the wise man in

the neighborhood. He suggested I spell my name as "Angel," for it was an American name. I carefully copied the characters of "Angel" onto the application form, only I didn't realize that I had spelled it as "Angle."

The next line was "sex." I looked up the word *sex* in my English-Chinese dictionary. The word didn't exist. I visited the wise man again for help. He instructed me to circle "female."

The line after "sex" was "field of interest." I was supposed to check one of the following: drawing, painting, sculpting, designing, architecture, music, or filmmaking. I didn't know which to circle. I scanned the remaining pages and sensed that I wouldn't be able to complete the form on my own.

I visited a friend of Joan Chen's after work at ten P.M. I needed help with my application form. The friend was not home, so I waited by her door. After midnight, she appeared. She was a translator and tour guide. She had just gotten off work, returning from Suzhou. I was sorry to bother her. Yawning, she took over my application.

Three months later, I received an acceptance letter from the School of the Art Institute of Chicago. Joan Chen had warned me that acceptance by an American school didn't mean that I could enter the country. It was only the first of many steps. Next I had to obtain a passport from the security authority in Shanghai, and after that I had to apply for a visa at the US Consulate in China. The United States would grant visas only to those who showed promise and potential to contribute to the country.

If I had stopped to think, I never would have developed the guts to try. Everyone said to me, "Where did you get the nerve?" I had to force my mind to focus on jumping through the next hoop and nothing else. In the same letter, the school requested an important document. It said, "In order to issue you an I-20 form, which you will need to apply for a visa to enter America, we must first receive a signed Affidavit of Support."

I had learned from Joan Chen that I must find an individual willing to play the role of my sponsor. I would have to convince this person that I would pay back anything I'd owed. I thought about my mother's sister living in Singapore. The trouble was, I didn't know my aunt very well. During the Cultural Revolution, my father made sure that we

denied her existence to avoid the government's suspicion that we were spies.

My mother refused to write her sister a letter on my behalf. "It is too much to ask," she said firmly. I wrote a letter to my aunt behind my mother's back. It was the most difficult letter I had ever written. I promised that I would not be a burden. Fortunately, my aunt agreed to lend a hand. I could not have been more grateful when I received the signed Affidavit of Support.

I was at the office of the Communist Party boss. I had asked for permission to apply for a passport. The boss was a former veteran and a chain-smoker. He spoke with a northern accent and did not look me in the eye when he talked. He asked me to explain the difference between America and Albania. The question confused me. I was afraid to give the wrong answer. Instead of answering him. I took out the acceptance letter from the School of the Art Institute of Chicago. I pushed the papers toward the boss over the desk and asked him to examine them. He pushed them back.

"What's the difference between America and Albania?" he insisted. I wondered what kind of trick he was playing.

I spoke carefully and humbly. "Please enlighten me, for I am illiterate over international affairs."

"We know that there are proletarians in Albania, yes?" he said.

"Yes."

"Are there proletarians in America, Comrade Min?"

Relieved, I gave a firm answer. "Yes, of course, absolutely, definitely. There are many, many proletarians in America. Hundreds and thousands and perhaps millions of proletarians in America."

"Excellent!" His eyes brightened. "We know what to do now. Are you, Comrade Min, a member of the Youth League of China?"

"Yes."

"Do you intend to promote revolution in America?"

"Of course."

"In the name of the Communist Youth League of China?"

"In the name of the Communist Youth League of China!"

The boss was satisfied. "I shall stamp your application and then forward it to the Department of Security for processing. However, I need you to answer my last question. I want you to complete the lower couplet of a poem I am going to recite." Smiling, as if pleased with himself, he continued. "A spark of flame—"

"Will start a wild fire!" I was thrilled that I had received solid training in reciting Mao's poems and teachings.

I ran from the studio like a criminal who had escaped by accident. I was afraid that the Party boss might change his mind or have another question that I wouldn't be able to answer. I was surprised that he hadn't mentioned that I was Madame Mao's trash. I wondered if he actually checked my dossier. I had heard many people say that the boss was unpredictable. He had once been wounded in the skull. When he was in a dark mood, he would recognize no one. He described himself as a "loyal Communist dog" and was proud of being ruthless. I thanked heaven for putting him in a favorable mood that day.

T WAS DISCOURAGING just to look at the long line wrapped around the block at the United States Consulate in Shanghai. It was an old-style mansion half hidden in a canopy of large trees on the west Huai Hai Boulevard. Armed Chinese soldiers stood on pedestals by the gate watching over the crowd. I was looking for information on how to obtain an American visa. Since our new leader, Deng Xiaoping, had opened China's doors, the people's view of America had changed dramatically. As we watched newsreels showing America's poor protesting on their streets, we were shocked to see that many of them were obese. They dressed better than the rich people in China. For half a century, we had been fed the idea that American people were skeleton thin and wore rags. If a picture was worth a thousand words, the newsreel created a silent revolution in Chinese minds. The newly imported American movies Snow White and The Sound of Music fueled our doubts and wonder. I was beginning to understand that Americans were not the devils we had believed them to be.

More and more university graduates wanted to go to America to see for themselves. The visa office was jammed with applicants. The neighborhood near the consulate entrance became a hot spot for young and interested people. During visa hours, the place was like a refugee camp. Makeshift vendors sold food, water, and aspirin. Old ladies rented out stools, sun hats, sunglasses, fans, and umbrellas. There were wise men and fortune-tellers giving opinions and predictions. The crowd grew bigger in late summer before the start of the school year in America.

The crowd was divided mostly into two groups. Group A was formally rejected visa applicants who wanted to try again. Group B was people like me, about to try their luck for the first time. The update was that the American government had raised the qualification bar on visas. Master's-degree applicants were no longer promised visas. One

had to be a Ph.D. candidate in the area of math and science in order to get a visa.

People said to me, "Going for a bachelor degree in art? Next life!"

I began to cough blood again. My doctor said that it was not tuberculosis, though he couldn't tell what it was. The traditional Chinese doctor told me that my internal breath "chi" was "gravely disturbed." My body had lost its ability to heal. My intestines no longer functioned properly. I suffered from chronic diarrhea. When I saw undigested spinach floating in the toilet bowl, I wept.

I carried *English 900 Sentences* on buses going to and returning from work. Compared to Chinese, English as a language made more sense. For example, the English "I" took one stroke while the Chinese "I" took seven. The Chinese "I," "我", looked like a walking person in an elaborate costume. English seemed to serve as a better tool, while Chinese existed to be admired.

It was obvious that the English "I" was the result of capitalism. Time equaled money. I welcomed the English "I." In China we never stopped talking about "Serving the people with heart and soul," yet people, the majority, were uneducated and illiterate.

To prepare to face an American visa officer, I drafted a "self-introduction." I composed it in Chinese first, then had it translated into English. At the entrance of the US Consulate, the wise men had told me that a "self-introduction" must focus on three points:

- 1 Who are you?
- 2. Why do you want to go to America?
- 3. How will you be able to survive in the US?

"If you fail to impress the consul, you will be given a rejection stamp called code B-14 on your passport. Do not try to lie, because the consuls are trained lie detectors. They can see through you."

When people learned that I did not speak any English, they said, "You must have eaten a lion's gut! How dare you plan to fool the consul?"

There was no way I'd be able to impress the consul, but it would be suicidal if I told the truth: "Hello, I'd like to go to America because I want to escape my misery in China." An American consul in his or her right mind would never issue a visa to a desperate person like me. Would it be better to say, "I'd like to go to America for an education. It might serve to reverse my ill fortune in China"?

Answering the question of how I would survive in the United States would be hard without speaking English. I couldn't afford to be honest and tell the consul that I had memorized the speech.

Why rob myself of my one chance? If the consul were in my shoes, would he not be lying himself? I was not hurting anyone. I had to overcome my guilt. My mother hadn't raised me to be a liar. She would rather die than tell a lie. She would be disappointed and admined that her daughter would choose to lie. She would threaten to disown me. What would happen if I gave up? I would end up living the life my mother led. I felt that this would be worse than getting caught lying.

What if the consul interrupted me? What if he asked a question? I wouldn't be able to understand him and wouldn't know how to respond. I decided that I would recite my self-introduction so fast that it would be difficult for the consul to interrupt me.

I began to drill myself after work. Everyone was irritable around home. My father had collapsed at work due to internal stomach bleeding. He had recently been transferred from the printing shop to a position as an instructor of astronomy at the Shanghai Children's Center. In gratitude to his new Party boss, my father worked long hours and was exhausted. He was rushed to the hospital, where he was diagnosed with stomach cancer. The news sent our family into a panic.

The surgery removed five sixths of my father's stomach. Then he underwent chemotherapy. We took turns caring for him. I studied *English goo Sentences* with a flashlight under his hospital bed. My mother had never been good at caring for her own illnesses, but now she had to learn

to care for her husband. My sisters and brother were in their twenties and worked as laborers in factories where their prospects for the future were dim. I worried that I would have to leave home soon. Traditionally, female children were not supposed to remain at home if there was only one room. Once my brother was married, I would have no place to go.

While my father's discouragement brought me despair, my mother predicted that I would achieve my heart's desire just by believing.

"How?" I yelled. "Don't you think I am too old to be told a fairy tale?"

The government's rule forced me to resign from my current job before I applied for a passport. My father was crushed after learning that I was jobless. He was sure that I had made a critical mistake and ruined my life. I wanted to cry when I looked at my father's ghostly pale face. The chemotherapy had drained the life from him. He was hairless and bone thin. He looked at me with great fear in his eyes.

Never in my life had I been as terrified as I was the day I left for the US Consulate. I shook so hard that I was unable to say to my parents, "Wish me good luck!" My father and mother leaned on each other's shoulders for support. They were in their early fifties and had lost most of their teeth. There was not a hint that my mother had once been a great beauty. Both of them watched me nervously and were unable to say a word.

"May I borrow your clothes?" I asked my mother.

"Why?" She was puzzled.

I wanted to tell her how scared I was.

"Why do you want to borrow an old lady's clothes?" my mother asked. "My white cotton shirt has been washed so many times that it has turned brown. The fabric has frayed around the collar. My skirt is twenty-five years old. It's got stains and moth holes. Are you sure?"

I put my mother's clothes on and immediately felt better.

On the way to the consulate, I kept thinking about what I would do if I was rejected for the visa. I would not be able to get my old job back. The last thing I wanted was to become a burden to my family. The thought of suicide again entered my mind. I found myself unafraid. Life would not be worth living. Death would be an escape.

Before I got on the bus, I felt a sudden weakness. Doubt came over me. Was I being too foolish? Was I mad to push forward knowing that I was not a Ph.D. candidate, knowing that I would be hitting a rock with an egg, knowing that the odds were stacked high against me?

I had no memory of how I got off the bus, walked several blocks, and arrived at the US Consulate. I had no memory of the crowd, the stool-renting lady, the food and water seller, the fan and umbrella seller, the aspirin seller, or the wise men and fortune-tellers. I also had no memory of how I presented my passport to the guards. What I did remember, in fact the only thing I remembered, was the sound of my own thumping heartbeat.

The image of the American consul standing behind the window was rather blurred. He was a man with pale skin and brown hair. He didn't pay attention to the papers I pushed through the bottom of the window slot. He stared at me in silence.

I couldn't breathe. My eyes wouldn't focus. I knew my cue had arrived, but I was unable to deliver the performance. My body was not mine to command. You can do it, Anchee. Jump off the cliff. Now!

The drill kicked in. The flow of English syllables poured out of my mouth like a waterfall. I had no idea where I was in terms of the speech.

The consul continued to stare at me.

My mind spun like a greased wheel. My mouth opened and closed on its own. I was the heroine who ran through the woods toward the enemy carrying a pack of explosives.

I made myself stare back at the consul. I imaged myself locked in hand-to-hand combat with an American soldier. I was ready to be a martyr.

The consul blinked. His expression turned soft and his face human again. He held up a finger as if to ask me a question.

Stop him from interrupting! My tongue rolled faster. I was back in time, acting as a child reciting Mao's quotations onstage. My hands rubbed against the fabric of my mother's skirt. I was running out of air in my lungs.

Then I heard an "Okay!" I wondered if I was hallucinating. Did that okay come from the consul or was it just my imagination? I stopped and

started to panic. The consul spoke again, but I couldn't understand a word he said.

With a pencil in one hand, the consul flipped through the papers that I had submitted. He checked something off on a page, then nodded.

I prepared for the worst.

"I am sorry to have bothered you," I said in Chinese.

To my confusion, the man pulled down his curtain in my face. "Next!" I heard him yell.

Had I been rejected?

I heard my name called in Chinese by a female voice. It was from the next window. I collected myself and moved to the next window. I came face-to-face with a Chinese secretary, who sneered.

"You think you fooled the consul? You are just lucky." She shoveled the papers around.

"May I know what you mean?" I asked.

"What do you mean, 'What do I mcan?'"

"Visa or no visa?"

"Did I just say that you were lucky?"

"Yes, but what does it mean?"

"It means that the American liked you. They like people with crazy determination."

"But that doesn't tell me . . . I mean . . . please . . . visa or no visa?"

"Visa!" She yelled, turning her head away in disgust.

Happiness enveloped me. My feet had never felt lighter as I climbed the stairs at home. My parents opened the door looking as if they had been waiting to console me after the bad news.

My father spread his feet apart as if he was ready to receive a blow. My mother held on to his arm. They didn't have the courage to ask, "Did you get the visa?"

My tears came as I took out my passport. I showed my parents a slip notifying me that I was to pick up my visa in seven days.

My mother collapsed and pulled my father down to the floor with her. "I can't see," my mother said. "I can't see!" "I shall go to America!" I sang.

My mother let out a cry of joy.

My father smiled. A moment later, he was himself again. "You will be caught and deported when you arrive in America! You can't change the fact that you don't speak English."

"No spoiling the moment, Father, I beg you!"

Humming a tune, I ran to the Shanghai Postal and Telegram Center. I sent a two-word telegram to my aunt in Singapore: GOT VISA. If those words had not already cost me a month's salary, I would have added more to express my gratitude. After all, my mother had said, "Your aunt barely knows you."

Mother made me promise to repay the debt I owed my aunt as soon as I became capable. The words "became capable" sounded abstract in that moment, but I was determined to honor my mother's wish.

I wrote a letter to Joan Chen in Los Angeles. I thanked her for helping mo. I told her that I'd be departing for Chicago in a month

My health improved magically. Within a week, I stopped coughing blood. My stomach pain went away. I was able to consume tofu and eggs without getting diarrhea. The bitter Chinese herb soup I had been taking helped too. By the time I received Joan's letter saying, "Congratulations. I'll see you in America," I was fully recovered.

I wrote thirty-three farewell letters to my friends, colleagues, and relatives. I didn't mail them, because there was still a risk that I would get caught and be deported back to China. I told my sister to hold on to my letters until she received word from me in America saying that I had made it.

No one on the film set where I worked knew that I would be leaving the country. Things could go wrong at the last minute. The crew boss might get angry with me and report on me and ruin everything. I had lived long enough to know that I was only an ant everyone could step on. I kept my mouth shut and followed orders. *This will soon be behind me*, I thought triumphantly.

The day I departed for America, my family accompanied me to the Shanghai airport. My father's worry was written all over his face. He

had been imagining my deportation and was so tense that he was unable to hug me or say good-bye. My mother quietly embraced me, as did my sisters and brother. I held a one-way ticket. I tried not to think about how long it would be before I could see my family again. I worried about my mother's health and my father's recovery from cancer.

The sound of the airplane taking off would remain a permanent memory. The noise was deafening, but it was great music to my ears. Before entering the departure building, I waved good-bye to my family for the last time.

I had been waiting almost an hour in the small brown room when the translator again appeared. She wore a solemn expression as she walked briskly toward me. I could now see clearly that she was not Chinese. Her hair was dark, but it was not black. She had deep-set eyes and a large mouth. I could feel my blood freezing in my veins. Whatever the translator conveyed would decide my fate. She carried a stack of documents. Among them must have been my passport and my I-20 papers.

"Miss Min, follow me, please," she said in Chinese, as she opened the door.

I did my best not to collapse. The translator took me back to the officer who had sent me to the questioning room. I watched them exchange words. The translator pulled a page out of the stack of her papers and showed it to the officer. She pointed out something to him on the paper. The officer examined the spot and then nodded. They exchanged more words. The officer bent down and quickly wrote something on the page. They waved at each other as they parted. The translator returned to me.

"Ni tai jin zhanq la!" she said to me in Chinese.

I understood. It meant "You're too nervous!" But what did she mean? She repeated the phrase, and I heard "You're too nervous" again.

I begged her to explain, for I was too disoriented to understand.

"This means we have decided to let you go," she smiled.

"Do you mean I get to go to Chicago? Is that what you just said? Am I understanding you correctly? Do you mean that there will be no deportation for me?"

ANCHEE MIN

She nodded. "No deportation, Miss Min. Congratulations."

I choked with joy. I locked my arms with my hands so that I wouldn't throw myself at the floor to kowtow to the lady.

I asked her what had happened. The translator let me know that she had found a clause in my papers that my school had a plan to place me in an intensive language program at the University of Illinois if upon arrival my English was found to be insufficient. I would be given six months to bring my English up to level and pass an entrance test. If I failed to improve, the school was responsible for reporting me to immigration, which meant my deportation.

Six months! I had only asked for three!

{ CHAPTER 6 }

HAD NEVER MET my cousin, my aunt's son. I was told by my aunt that he would pick me up from the airport in Chicago. I held the paper with his name on it above my head as I exited the terminal. We met but were unable to communicate. I spoke Mandarin and he Cantonese. He was kind enough to allow me to temporarily stay at his student apartment. I promised my aunt that I'd leave as soon as possible.

The foreign-student adviser at the School of the Art Institute of Chicago was upset. I had lied about my "language skills" on the application form. In the "Please describe the level of your English" section, I had marked "Excellent." I confessed that I was guilty, and that I was willing to accept the punishment.

I was sent to the intensive tutorial class held at the University of Illinois Circle Campus. The program cost five hundred dollars. I already felt the weight of my debt and regretted having to borrow more from my aunt. It was painful for me to pay for the university's dormitory. I would have preferred to live on the streets.

I was given a tour of the school and the city of Chicago. I tried to read the street signs and memorize bus numbers and routes. But all I could hear was the soundtrack of a Chinese opera as I bent my head back to admire the Sears Tower.

When asked what type of roommate I'd prefer, I had replied, "Anyone who speaks English, and who doesn't mind my silence."

This was how I met Takisha, my first American triend.

The dorm room was way too luxurious for me. My first thought after entering the room was: I need to look elsewhere for a cheaper place to live.

Chicago's winter was brutal, but the room was heated. It had a window facing a tree. The hallway was freshly painted, and the shared

bathrooms were spacious. That hot water was available twenty-four hours a day was incredible. I felt like a princess, because for the first time in my life I would get to sleep on a mattress. Each roommate had her own desk and closet. I was tormented by the amount I was paying for this. I found myself checking out the garbage Dumpster every time I walked by. I didn't need a mattress. I'd be fine sleeping on concrete.

I heard laughter and a loud knock on the door followed by the sound of a key turning. The door opened and a dark-skinned person entered.

An African freedom fighter, I thought. Takisha looked exactly like the girl I grew up seeing on a Communist propaganda poster calling for the Proletarians of the World to Unite.

Takisha enthralled me. She was a breathing sculpture with chocolate-colored skin and large, fig-shaped eyes. She had a wide nose and pink lips. She had the whitest teeth I had ever seen. Her hair was a ball of frizzy curls in the shape of a tall cake. She was about my height, five foot five.

I realized that Takisha was a cripple. She limped from side to side as she walked. It amazed me that she didn't act like a handicapped person. In China cripples would act timid and scared because they would be subjected to disrespect and vicious bullying. Takisha laughed loudly and freely.

I didn't expect Takisha to treat me like an old friend, which made me feel wonderful and grateful.

"I am Takisha," she said, opening her arms. "I am eighteen, and I am from Alabama."

My English escaped me. All I could do was smile.

"Oh, gosh, is it A.Q., An-Qu, or An-Qui?" Takisha giggled. "Oh, I'm so sorry. Forgive me if I don't pronounce your name correctly."

I tried to figure out what she was saying. I took out my dictionary and said to her, "English. Help."

"Where are you from?" Takisha asked, gesturing with her arms. "East, west, south, or north?"

I opened my $English\ 900\ Sentences\ book.$ "I name are . . . my name is . . . "

"I see, so you don't speak English." Takisha smiled broadly. "It's okay. No problem. Now follow me. Where . . . are . . . you . . . from? Where, watch my mouth, wh . . . ere . . ." She pointed her hand at me. "Don't look at your book. Look at me. Now tell me your home. Home. Do you understand? Home? Papa, mama, milk, dog. Do you understand what I mean?"

"No understand—"

"Hey, listen carefully!" Takisha pointed at herself. "Home Alabama."

I pointed at her. "Your home."

"That's right! My home, Alabama. Now tell me yours. Your home."

"Home? Do you mean h-o-m-e?"

Takisha laughed. "I mean your motherland-"

Yes, I knew the word *motherland*. It was one of the few slogans in English taught in China in 1972 during the visit of the American president Nixon. "I love my motherland" was taught along with "Long live Chairman Mao," "Long live the Communist Party of China," and "Albania is a great socialist country."

"Motherland is China," I said.

"Oh, you talk!"

"China, Papa, Mama, is China."

"You're from China! How wonderful! I want you to tell me all about China."

"Me English poor."

"You'll learn."

Takisha wanted to know how I had enjoyed America so far. I wished that I could have told her that I enjoyed air-conditioned rooms. I loved the flow of warm water from the faucet, I enjoyed sitting on a toilet, and of course the big moving room—the elevator. I loved the American city nights with the streets and buildings all ablaze. I couldn't imagine the cost of electricity, though. Most of all I enjoyed Takisha, the way she accepted me without reservation.

Takisha wanted to know what had brought me to America, and what life was like for me in China. With the help of my dictionary, I composed

and wrote down my answer: "It was like you are hung, your neck bone is breaking, but death doesn't arrive."

"What?" Takisha frowned.

Takisha wrote words for me to look up in my dictionary. This was how I discovered that she was studying to become a doctor. I asked what motivated her to study medicine. She replied that she wanted to find a cure for her mother, who was severely diabetic.

"My mother is in bad shape," Takisha said. "You know what 'bad shape' means? Her doctor wants to cut off her legs. I said no way. I will not let anybody cut off my mother's legs. 'You will keep your legs,' I told my mother. 'I will be your doctor.'"

As I looked for words to express my admiration, I heard a ringing sound and saw that the room had a telephone. Takisha picked up the phone. "Excuse me, it's my mother!"

"My roommate IQ is from China," I heard Takisha say. "Hey, IQ, my mother says hello to you. Hey, wait a minute. Oops, her name is not IQ. It's A.Q. A... An... Qui... Oh, never mind, I'm sorry. How do I pronounce your name again? Ah-Choo? Ah-Chi? Ann? What? Oh, I see, An like Ann. Chee like cheese. Ann-Cheese. That should do it. I got it. Ann-Cheese, without the 's'! Did I get it right this time? What? A-n. Not A-n-n. An-c-hee. Oh, one more try. Okay, Anchee. Is it Anchee? Yes, I got it! Anchee!"

I turned to my *English 900 Sentences* while Takisha continued on the phone. It was hard to concentrate with the noise. I left the room and went to sit on the floor in the hallway. I buried myself in the book for hours on end. What confused me the most about English was its sentence structure, which was completely different from Chinese. For example, "You are not a thief," a policeman might ask. "You didn't steal, did you?"

In English, one would answer, "No, I didn't." But in Chinese, you must answer yes, meaning, "You are correct, I didn't steal." But it would be wrong in English if I said, "Yes, I didn't steal."

I also had great difficulty with *on, in, the, am, was, are,* and *were.* I could never figure out where and when to use them. *Have been, has been,* and *had been* also gave me trouble.

"Good night, Ann Chee," Takisha said, turning the light off on her

side. I covered my lamp with my jacket and the room was instantly dark and quiet. I was tired and wished that I could go to sleep, but I knew I couldn't waste any time.

The next morning, the sound of a door slamming jolted me awake. It was followed by Takisha's loud voice: "Oh, I am soooooo sorry!"

This would be my alarm clock from now on. Takisha had a habit of slamming the door and then saying, "Oh, I am soooooo sorry!"

It was still dark outside after Takisha took her shower. She was drying herself with a towel in front of me. She didn't seem to be concerned about revealing her naked body in front of a stranger.

I left the dorm as soon as Takisha did. The day's task I had set for myself was to go to downtown Chicago. I planned to look for a job waitressing or dishwashing. I would knock on the doors of Chinese restaurants.

The tall buildings in Chicago were fantastic in my eyes. I didn't feel real walking between them. I was reminded how far I had come from home, that my feet were truly on American soil. I remembered the news clip depicting America's poor as I walked past the Chicago city hall, where a small group of people was picketing. It was as if I had stepped into the same TV scene, except it was not black-and-white.

I was surprised by how fancy the post office was. A large American flag hung above its entrance. I wanted to take a picture of myself under that flag and mail it home. My parents were worried about me. My letter to them would take three weeks to arrive in China.

I found a sign that read CHINESE RESTAURANT on Michigan Avenue and let myself in.

A lady greeted me asking, "How many?"

I put on my best smile and replied politely in Chinese, "Do you need a waitress or a dishwasher?"

The lady looked disappointed. She shook her head and waved me away.

I tried another restaurant and received the same response. I kept on. The begging part was the most difficult. I told myself that I must learn to get used to it.

I went as far as my legs could carry me. By the end of the day, I was tired and starving. I had visited every Chinese restaurant in downtown Chicago, but without luck. The one Chinese carry-out-only restaurant owner who had a help-wanted sign in his window said to me, "No English, no job."

On the sidewalk I was blocked by a fat lady who looked like a wrestler. She wore a dirty, grease-covered, brown knee-length coat. Holding a cardboard sign, she approached me. A strong scent of cheap perfume came from her messy orange hair. She spoke to me, but I couldn't understand.

"Sorry me no English," I apologized.

She flashed the sign in front of my face and stuck out her hand. "Spare some change?"

I took out my dictionary and looked up the words on her sign, HUNGRY & HOMELESS.

I said to her, "Yes English, yes job!"

The students in my English class came from all over the world. Since I had trouble pronouncing and memorizing their names, I tried to memorize their faces. It was not easy because black people looked alike, as did the whites and Hispanics. My classmates told me that they had a similar problem—to them Oriental people all looked the same.

A man from Italy with dark wavy hair sat on my right, and a beautiful high-nosed girl on my left was from Greece. With a lot of hand motions and make-believe words, we tried to communicate. Unfortunately, nobody understood anybody.

Our teachers were Americans. One was heavyset with curly blonde hair and the other slender with short dark-brown hair. I made it easier for myself by calling one Light Head and the other Dark Head. I secretly gave names to my classmates. I called the Italian man Michelangelo and the Greek girl Goddess Helena. I called another Middle Eastern—looking man Ali Baba, and a Russian Comrade Lenin.

What fascinated me was not the way the teachers taught, but what they taught. For example, the textbook featured a world that seemed unreal to me. It described an American small town where all the residents could vote and the people decided whether to give permission to a developer to build a shopping mall near the town square. Besides the town's mayor, there were also other elected officials.

Where I came from, everyone was considered "a bolt on the Communist machine." Unless you wanted to be arrested and spend the rest of your life in a prison or labor camp, you wouldn't ever voice your opinion against the authorities. I asked if the world described in the textbook was an accurate reflection of American reality. The teacher, Dark Head, turned to me and said, "Pretty much."

I didn't want to be too hard on my teachers, but I did want my money's worth. I was unsatisfied by the speed of the teaching. The teachers didn't press for results and allowed the class to run at its own pace. They assigned little homework, and only a few students turned in the work that was assigned. The teachers were okay with that, as if they didn't care. I seemed to be the only one who really drilled at the grammar.

Miss Light Head suffered a cold for several days. She carried a box that looked as if it had toilet paper in it. She called it "tissucs." She kept sneezing. It made me want to laugh when I saw her cover her nose with toilet paper.

Each time she would blow her nose she would say two words: "Excuse me." I wondered why. There was nothing to be excused for—you couldn't help it when you sneezed.

In China, in order to ask to be excused, you had to commit a crime, such as wipe your behind with newsprint that had Mao's portrait on it, as my mother had once done accidentally. My mother didn't mean disrespect. She wasn't plotting an anti-Mao event. She was simply out of toilet paper and used the newspaper instead. It was hard to avoid Mao, whose portrait was printed on every page.

I found "excuse me" very useful. It was almost like saying hello. You would say it not only when you sneezed, but also when you entered a building, joined a line, walked past someone, or stepped off a train. I started to practice saying "Excuse me."

Then I couldn't stop saying it. "Excuse me," I said to the man who opened the door for me. "Excuse me," I said to the school janitor. People gave me the friendliest looks when I said "Excuse me." I loved saying "Excuse me."

I didn't mind Miss Light Head's "excuse me," but I did mind that she let the students do the teaching. She seemed exhausted by her sneezing and excuse me's. She sat in front of her desk, and the language cripples took over the class. I didn't pay to listen to the cripples!

Michelangelo loved to express himself in class. He had a thick Italian accent and would take forever to complete one sentence. Although I enjoyed his good looks, I couldn't understand much of what he was saying. What he said didn't sound like English to me.

The Greek Goddess Helena spoke with a thick accent, too. She told the class that she had just celebrated her twentieth birthday. "Happy birthday" was about the only English we understood from her. She threw up her arms and tried to interrupt the Italian. They got into a fight. Eventually they quit speaking English and went with their native tongues.

People started to drift away. Comrade Lenin excused himself to get coffee while Ali Baba took his smoke break. A Frenchman said to a Korean girl who sat in front of him, "I love you! I love you! I love you!" like a parrot. A Hispanic woman wrapped in a bright-colored shawl started a heated conversation with a black man dressed in yellow patterned cloth like an African tribal chief. She told him that the trick to mastering English was to sing it, and she was sure it was something he would do well since he was from Africa.

The black man in the yellow patterned cloth explained that he was not from an African tribe. He had been born in Germany and grew up in France. The woman ignored him and kept going on about singing English until he started to yell at her in French. A Polish man with a thick beard told an Egyptian man who had an even bigger beard, "English is ah . . . aard vark!"

I was appointed to partner with a short Asian man named Suzuki. We were supposed to figure out where the other was from.

"Japan?" I said, and he nodded.

"China?" he said, and I nodded, and that was it. We sat in silence and wasted our time waiting for the others to finish.

During the last week of the class, the teacher came out of her sneezing spell. She smiled warmly for the first time and took control of the class. "We're going to play a game called Pass on the Story," she an-

nounced. She whispered into the ear of a student who repeated the story to the next student.

When it was my turn, I listened with full concentration, but I had a hard time understanding the accent of the Greek Goddess Helena. I did my best to guess. The only word I understood was ox.

I was supposed to pass on the story to Michelangelo. Since I didn't get the full story, I decided to add my own version. I whispered into Michelangelo's ear a story about China's national hero, known as the People's Ox.

"He died pulling his rickety cart toward Communism," I said into his ear.

Michelangelo nodded as if he understood, and then he turned to the student next to him.

After the circle was completed, our teacher announced that her original story was lost.

{ CHAPTER 7 }

WAS EXCITED ABOUT an ad I found in a free newspaper. The description read, "No skill necessary." With the help of my dictionary and Takisha, I came to understand that the job was to be part of an "experimental drug trial."

Takisha said that she wouldn't do it if she were me. "You will be used as a human guinea pig, a human rat—know what I mean? The drug will do damage to your vital organs."

"But it pays a hundred and eighty dollars per week!" I argued.

"Oh, money, Anchee, so you sell yourself! That's absolutely a bad idea!"

Anything that would help me pay my debt is a good idea, I thought.

Taking the subway to the northwest side of Chicago, I located the address I'd found in the newspaper. I didn't call ahead because I didn't want to reveal that I didn't speak English.

I was received by a middle-aged lady. She sat among stacks of papers piled high against her wall. After I filled out her form with my name and address, she read from a piece of paper, which I assumed was about the drug. The lady had a high-pitched child's voice. I nodded at the end of her sentences. I replied "Okay" to her "Okay?"

After she finished, she pulled out a box from an overhead shelf and presented me with a package filled with bottled pills. She told me when to take the pills and provided me with a booklet of forms on which I was to record my daily dosage of the drug.

"We'll be in touch." She smiled. "You'll receive the payment in the mail."

I got up and bowed slightly. "Thank you and good-bye."

"Wait, Miss Min, I need you to sign the contract here."

"No need, no need," I said quickly as I began to collect my stuff.

"I am afraid you have to, Miss Min."

"What is it?"

"It's the conditions and terms."

"I'll sign."

"You must read it first."

"I don't read English. I'll sign. I sign now."

The lady withdrew the paper. She stared at me suspiciously. It was too late when I realized my mistake. Before I could get out the door, the lady jumped from her desk. She grabbed my arm and took away the package of bottles.

"Please," I begged. "I need the money."

The lady pointed at the door. "Leave, now."

Kate was my next-door neighbor at the dorm. Her beauty reminded me of Esmeralda. With her makeup on, she looked like a cover girl out of a fashion magazine. When she spoke to Takisha in the hallway, I listened. Although I could understand very little, I enjoyed their conversation. I got busy with my dictionary as they talked.

Kate had the brightest eyes and a worry-free smile. Her manner was trusting and childlike. She didn't look like she had suffered any hardship in life. Kate was a little taller than Takisha and me. She loved to say to me, "Let's hang out, Anchee."

My dictionary showed me the meaning of *hang* and *out*, but not "hang out." So I asked Kate to explain what it meant. Like Takisha, Kate was not bothered that I was a language cripple. She didn't mind explaining and repeating until I got the meaning.

"Where . . . are . . . you . . . going?" she would say to me, for example. When I failed to understand, she would pick up my dictionary, locate the page, and point out the word for me. She introduced me to other people in the dorm. Now I was fluent in "My name is Anchee, spelled 'An-Qi,' and I am from China."

I noticed that Kate and others never said, "How do you do?"

Instead they greeted each other with "What's up, dude?" I told Kate that I couldn't find "What's up, dude?" in my dictionary, or in *English 900 Sentences*.

She laughed. "It's a silly expression, a fun way of saying the same thing."

Takisha was unhappy about my visiting Kate. She tried to convince me that something was *wrong* with Kate. "She is rich," Takisha said. "Her parents must have a lot of money, or she wouldn't be able to afford a room all to herself." The other evidence of Kate being rich, according to Takisha, was that she owned a TV.

I wanted to explain to Takisha that I hung out with Kate because it gave me a chance to practice English. I knew how boring I was to Kate. It was like trying to have a conversation with a baby. I wouldn't want to spend time with anyone who spoke infant Chinese. I felt guilty about taking advantage of Kate, Takisha voiced hor thoughts and views, but she was not interested in anything I had to say. My baby English didn't help either. In a way, Kate had become my best friend in the dorm.

I asked Kate, "What does 'goof around' mean?" She laughed and told me that it meant to have a good time.

I asked, "What are you supposed to do when you goof around?" Kate laughed again and said, "Nothing!"

I took notes and wrote down the phrases I learned from Kate.

"You are funny, Anchee Min, do you know that?" Kate said.

"What does 'funny' mean?"

The afternoon turned into evening. I sat in Kate's room looking up words in my dictionary while she worked on her homework. I asked Kate what a real American classroom looked like and if she, by any chance, could show me.

"That's easy," Kate said. "Come with me to my business-marketing class tomorrow morning."

I became excited. "Are you sure I wouldn't be intruding? Will I upset your professor since I am not a student?"

"Nobody will notice you," Kate replied. "It's a lecture. It takes place in a hall with hundreds of people."

"Lecture? Will I get caught for not speaking English?" "Well, pretend you do speak English."

I followed Kate to the cafeteria because I was curious about what kind of food she ate. She sat down with a plate of what she called "salad." This was the first salad I'd seen that was not made of potatoes. To a mainland Chinese, *salad* meant Russian food, which was basically potato. Kate told me that Americans didn't have a strict rule about what constituted a salad. "It could be a mix of lettuce with chopped cucumbers, carrots, onions and nuts, leafy greens, and, of course, potatoes. Basically, anything you want."

I couldn't help but laugh when I watched Kate eat. She chewed like a rabbit as she ate the raw leaves. "Are there salads in Chinese food?" Kate asked.

"No," I replied. "In China it's dangerous to eat raw greens. One can get diseases like malaria."

"So you cook everything?"

"Yes, mostly."

"Here, please share my salad." Kate gave me a fork. "This will be your first American experience. I insist."

In order to speed up learning English, I bought a used nine-inch TV set. The only shows I could follow were *Sesame Street* and *Mister Rogers' Neighborhood*. I had never seen anything like them in China. I fell in love with the gentle Mr. Rogers. Every day I would learn new phrases from him; for example, he would say "Good to go" as he finished tying his shoes. TV commercials became my lessons, too. My favorites were McDonald's and 1-800-Empire Carpet. Later I would get sick of them. I found myself improving so much so quickly that I decided to withdraw from the English tutorial class to save money.

An hour hanging out with Kate proved to be the most effective. I felt like I was walking out of the darkness and into the light. I began to understand bits of people's conversations. I also found myself less afraid.

I saw a young man by the elevator. I remembered that he was Kate's friend Steve. When I returned to Kate, I told her, "I saw Steve in the refrigerator."

It took Kate a moment to realize what I meant. "Oh, you mean you saw Steve in the elevator?" The similar ending sounds *-rator* and *-vator* confused me. When Steve came to visit the next time, Kate joked, "Hey, Steve, what were you doing in the refrigerator? My friend Anchee saw you there. Yep, she saw you in the refrigerator. What do you mean, no? Wait, hey, Anchee, is this the guy you saw in the refrigerator?"

I didn't realize the trouble I'd created until I heard a loud banging on the door. I was with Kate in her room. Kate got up and opened her door. It was Takisha, and she was visibly upset. She refused to step in when Kate invited her. Takisha leaned against the door frame and said to me, "What are you doing here, Miss Anchee? Let me remind you that you have your own room and your own roommate."

I smiled and said, "I am hanging out with Kate."

"I can see that," Takisha said.

"I am practicing English," I told Takisha.

"It's time to return to your own room," Takisha responded.

I said good-bye to Kate and followed Takisha back to our room. Locking the door, Takisha motioned for me to sit down on my bed. "We have to talk," she said. She went to sit on her bed facing me.

"Thank you for coming back with me," Takisha began.

"You are welcome."

"May I have your attention?" Takisha asked. "Full attention, understand? I want you to listen."

"Attention, yes. You talk, me listen."

"I am going to share with you a piece of American history, which I don't think you are aware of," Takisha said. "Know what I mean?"

I nodded. "Know what you mean."

Takisha wrote down the word *slave* for me to look up in my dictionary. She waited patiently until I located the word.

"I'd like you to understand that we, the black people of America, used to be slaves."

"My dictionary says slave means proletarians," I responded.

"That's right! Slaves are proletarians!"

"Unite the world's proletarians!" I recited. "It's Mao's slogan."

"Mao who?"

"Mao Zedong, the founding father of the Communist Party of China."

I was shocked that Takisha had no idea who Mao was. I asked if she knew a famous African black who claimed to be the leader of the black slaves of the world, and who came to China in the late 1960s to study guerrilla warfare. Takisha shook her head.

I got busy with my dictionary. It took a long time to find the words I needed. Takisha looked restless. "The black slave leader wanted to meet Mao in person but was refused," I finally told Takisha. "In China, Mao was God. Mao was 'the reddest sun in the universe.' We worshipped Mao. A quarter of the population on earth. See what I mean? Over a billion people! How could anybody, like that African black, schedule a meeting with God?"

"So what happened?"

"Well, the black slave leader took the initiative," I continued. "To demonstrate his affection for Mao, he pinned a Mao button on his bare chest, took a picture of his bleeding chest and sent the picture to China's authorities."

"Did it work?"

"You bet!"

"But it's terrible!" Takisha cried.

"I couldn't pin a Mao button on my bare chest," I said, "although I loved Mao, too! Anyway, the Communist Party officials liked the story so much that they insisted it be told at schools across the nation. That was how I learned about it. The story convinced us that our leader Chairman Mao was popular in the world."

"Did the black guy get to meet Mao in the end?"

"It was said that Mao was so moved that he received the black slave leader inside his home in the Forbidden City."

Takisha had a hard time making me understand that there were differences between African blacks and American blacks.

"You all fight for the same freedom, don't you? In China, we consider all blacks our comrades in arms. We were afraid of whites and

considered them enemies until recently. There were a few exceptions of course. One was the American journalist named Edgar Snow, and the other a Canadian Communist physician, Norman Bethune. Both of them came to China and devoted their lives to our revolution."

I asked Takisha to identify America's friends and foes. "Mao had said that such identification was critical to winning a revolution." I waited for Takisha's response, but she blinked her eyes and gave me a confused look.

"For example, China is friends with North Korea, Albania, and Vietnam," I said. "Russia used to be our friend, but since the Russians betrayed us, we dropped them."

Takisha said that the only famous black leader she knew and admired was Dr. Martin Luther King.

"I know Martin Luther King!" I said.

Takisha became excited. "Tell me, please, how did you know our King?"

"He was in China's school textbooks," I replied.

"Chinese school textbooks? Are you kidding me?"

"Mao wrote an article supporting Dr. Martin Luther King after he was murdered. Mao protested on behalf of the world's proletarians. Mao said that Dr. King's death showed that American society was an evil one."

"It is," Takisha echoed.

"Believe it or not, Takisha, I grew up shouting, 'Down with American imperialism!' but I didn't know where America was located."

"That's weird," Takisha said, looking at me.

"What does weird mean?"

"Well, weird means . . . 'weird.' "Takisha laughed. "Oh, I'm sorry—I was just teasing you. Weird is kind of like strange, okay?"

"Okay. Thank you."

"You are welcome." Takisha smiled. "Anyway . . ."

"What does anyway mean?"

"Oh, shoot, not again."

Daylight faded and the room became dark. I sat upright and listened to Takisha. I waited for her to stop. I wanted to ask Takisha if Dr. King had achieved his dream.

Takisha told me that her ancestors were slaves. I was confused by the tenses of Takisha's sentences.

Did the re sound in they're mean "are" or "were"?

While Takisha paused to catch her breath, I interrupted. "Are you a slave?"

"I am not a slave, but—"

I waited.

"Well, it's too complicated to explain."

"Try, Takisha, would you? I want to learn."

"I can't talk to you," Takisha said. Strangely, her voice sounded tear-filled.

"I am sorry, I mean no offense, Takisha. Talk to me, and educate me."

"You wouldn't understand."

"I shall understand if you talk to me. I'll write the words down. My dictionary is good. I can comprehend you."

"Listen, you'd never understand what it is like to be owned. You were never owned and never will be."

I knew what it was like to be owned. In fact, I didn't know what it was like *not* to be owned. The Communist Party of China and Mao never declared their ownership, yet every person in China knew that one never owned oneself. One was not allowed to do what one liked. Disobeying Mao and the Party meant hell and punishment.

Takisha was too provoked to come out of her own world. Words flowed out of her mouth like water from a broken pipe. I concluded that Takisha might not be a slave, but her family members in Alabama might be. It would explain the anger Takisha had. She couldn't bear that I hung out with a white person like Kate. If being friends with Kate hurt Takisha, I was willing to stop. What I couldn't understand was the fact that Takisha was a medical student at this university.

Takisha told me that she was granted a "tull scholarship" to study to be a doctor. I asked her who offered the scholarship, and she replied, "The government."

I asked who ran the government, whites or blacks.

"People of all colors," was Takisha's reply.

I found myself thinking: I'd love to be a slave so that I could be given a full scholarship to study to become a medical doctor.

In tears Takisha described how her ancestors were sold, beaten, hanged, and burned when they tempted to escape. I wondered what that had to do with Kate.

I interrupted Takisha. I told her that when I was living in China, I was not allowed to see a doctor when sick. I was not allowed to leave the labor camp when my spinal cord was injured. I had no weekends nor holidays. I was not allowed to pursue an education. The price for dating a boy at the labor camp would be humiliation, punishment, and torture.

"Have you heard of the Chinese saying 'Killing a hen to shock the monkeys'? It was the tactic the proletarian government adopted to keep us in place."

I described to Takisha what it was like to witness the revolution. The poor and lower classes took over the government. It was truly the People's Democracy. Within weeks, China's economy shut down completely. Factories, schools, hospitals, and other public service buildings became ghost towns. Even in remote villages, peasants quit farming to join the rebellion.

Being illiterate became glorious. It was exciting to challenge China's five-thousand-year-old tradition. Peasants took over hospital operating tables. They believed that anybody could perform a doctor's job. All one needed was to stock his mind with Mao quotations.

It didn't take long for factions to form. Rallies to consolidate greater power were held in stadiums, which often ended in bloody battles. Every day there were funerals in Shanghai. The city's walls filled up with photos of "new martyrs."

"My parents warned us to stay off the streets because people who had access to large trucks were looting weapons from military compounds. We could hear gunshots in the middle of the night." I told Takisha about the day a group of Red Guards from Beijing came to my house. "They received a tip from our downstairs neighbor saying that we were capitalists and had money. The Red Guards started to loot, but they quit in a few minutes."

"Why?" Takisha asked.

"They discovered that we were so poor that there was nothing to loot. Our downstairs neighbor had always been jealous of us for having

a larger space than theirs. Eventually our neighbor drove us out of our home."

"Are there good things about poor people being in control of their power?" Takisha asked. "Did their life improve?"

"I wouldn't say so. Most people had to get up before dawn to go to the market," I replied. "We had to stand in long lines to buy food. People became irritable and violent after standing in lines for hours in heat or snow only to be told to go home because everything was sold out. I fought with other kids over rotten cabbages and potatoes. Some people simply turned into thieves."

I told Takisha that my parents sent us to my grandparents on my father's side in the summer. The village town was located in Jiangsu province by the Yangtze River. We thought we would escape the Red Guards, but no, they were there, too. When we arrived, a denunciation rally was being held against my grandpa, who lay on his bed suffering from a stroke. The Red Guards couldn't get any response out of the old man. My grandpa was a retired schoolmaster. The Red Guards were mad at my grandma, because she wouldn't cooperate either. She was deaf and mute. She had bound feet and was barely able to walk. She couldn't tell the difference between the new and the old society.

{ CHAPTER 8 }

OOD MORNING, SUNSHINE!" I found these palm-size notes on my door from Kate. It was her way of teaching me English. She made me feel welcomed in this country. "Have a nice day!" "Come over after dinner!"

I enjoyed hanging out with Kate. The more Takisha tried to stop me, the more curious and rebellious I became. What seemed "weird" to me was that both Takisha and Kate shared the same passion for what they called "pop music." They were both crazy about a singer named Michael Jackson.

I was unfamiliar with Michael Jackson's music. I also had no idea about another favorite star named Mick Jagger. The music they played stirred my insides. I no longer looked at the Sears Tower and heard the Chinese gongs. Michael Jackson's electrifying beats pushed the Chinese opera tunes out of me. I imitated Takisha and Kate and let my body rock and sway to the music. I walked along Lake Michigan Avenue to the rhythm of "Beat It."

One day Kate called me to her room and introduced me to her new favorite. His name was Prince.

"Prince? A prince-in-the-castle Prince?" I asked.

Kate smiled, passing me the album. The cover had a photo of a black man in a purple suit that was wrapped with jewelry. This was the first time I had seen a black prince.

"The singer calls himself Prince," Kate explained. "In America you can name yourself anything. Queen, King, Princess, or Prince."

"Does it matter that he has no royal blood?"

"Nope."

I couldn't imagine calling myself Princess, or Queen. If a man named himself after Mao Zedong in China, he would be sent to a mental institution.

Kate's friends that night were people of all different races. They played music and swung their hips from side to side. Their eyes were

half closed as if in ecstasy. Holding a hair curler in her hand as a microphone, Kate kicked off her shoes and sang along to Prince's album.

I don't want to stop
Till I get to the top
Woo—

Kate and her girlfriends fell onto the beds and rolled on the floor, laughing. They told me that Prince's song was about sex.

Handsome young men came up from their floor. They told Kate that they were stopping by to "check out what was going on." They didn't leave. Their enthusiasm encouraged the girls. They spun around and their long hair danced in the air.

A young man looked at me with a beer bottle in his hand. "My name is Don."

I was flattered, but didn't know what to say.

"What's your name?" he asked.

I told him my name, but he frowned. "Ho Chi Minh? Are you from Vietnam?"

"Not Ho Chi Minh," I replied. "Anchee Min. It spells 'A-n-q-i'. It's from Pinyin. Have you heard of Chinese Pinyin system?"

"Nice meeting you, Chi Minh," he responded, and walked away.

I realized that I was too old for this crowd—a twenty-eight-year-old among eighteen-year-olds. Instead of feeling excited and entertained, I felt out of place and lonely.

I was unable to let myself go wild with the crowd. Watching the girls drive the boys crazy and enjoy themselves, I was reminded of my debt, of what limited time I had to save myself.

I didn't intend to offend Takisha when I drew a picture of Ronald Reagan in my sketchbook. "Reagan is a dog!" Takisha yelled. "And I hate him!"

I explained that I picked Reagan not because I worshipped him like I had Mao. It was to test the accuracy of my drawing skills—if I was successful, people would recognize what I drew.

"I have never learned to draw," I told Takisha. "I'm afraid of getting

kicked out of the art school that issued me the I-20. I was looking for something to copy and happened to find a *Time* magazine with Reagan's picture on the cover."

I didn't tell Takisha how shocked I was when I heard her call her president a dog. In China, calling Mao a dog would result in a death sentence. In fact, the moment I heard Takisha, I charged to the door and looked out. I wanted to make sure nobody had heard her.

Closing the door, I asked Takisha to explain her hatred for President Reagan. She didn't have much to say except, "He is a Republican and an evil white man."

I wished that I could have shared Takisha's feelings. But I was allowed to enter the United States when Ronald Reagan was its president. I'd forever be indebted to the kindness of America, kindness that Mr. Reagan represented.

Kate and I walked along the snow-covered campus paths and entered a lecture hall where hundreds of students gathered. I enjoyed the atmosphere tremendously. Although I didn't understand a word of the lecture, I was happy to sit among the crowd. It was a class on marketing techniques. A film clip was played on a big screen. It was a McDonald's hamburger commercial. I found myself humming the McDonald's jingle as I walked out.

Kate said that she would like to be the first to introduce me to Mc-Donald's. I was excited. She said that we would take the subway to down-town Chicago. I asked if I needed to dress up. Kate said that she would help me dress like an American girl. She took me to a local dress store, where everything was too expensive for me. Eventually I paid ten dollars for a clearance item, a zebra-striped black-and-white nylon top. I thought it would make me look wild. For the first time, I was in a mood to be wild.

Kate made up my face. She fixed my hair and applied hair spray. She loaned me her necklace, clip-on earrings, and a bandanna. Everybody in the room cheered when Kate finished. When I looked at myself in the mirror, I was disappointed. Blue shadows and black eyeliner circled my eyes and my skin was caked with foundation. The bright red lipstick reminded me of a prostitute in a Chinese propaganda film.

When I put on my bell-bottom jeans, Kate told me that it was 1985. I didn't get what she meant. Kate explained that bell-bottoms were out of fashion. They were a seventies style. I told Kate that I didn't have another pair of jeans.

We took a subway downtown and got off at Chicago station. I followed Kate into the McDonald's near the Water Tower. Kate ordered me a hamburger, french fries, and a Coke. I fell in love with the taste. I only wished that I could afford it.

Kate was unable to provide answers to my questions about why fried sliced potato was called "french fries" and tomato sauce "catch up."

In the middle of the night, the phone rang. Takisha picked it up and started to scream. I asked, "What happened?" but she wouldn't answer. Takisha stayed on the phone for hours, and she wouldn't stop crying. I turned on the light and found lier curled into a ball on her bed.

Finally she got off the phone. I asked again, "What happened?" She told me that her younger sister had been raped.

"Was it by a white slave owner?" I asked.

"No." She shook her head. "My sister and mother are in bad shape."

The next morning Takisha left without her backpack and textbooks, which were scattered on her desk and bed. She returned two days later looking distracted. She said that she didn't feel like talking.

I remained quiet.

Takisha continued to attend her classes, but she didn't do her homework. In fact, I had never seen Takisha do much homework. Given the subject of Takisha's study, medicine, I assumed that she would have had loads of homework.

A week later Takisha brought a cat she'd found on the street into the room. "I'm adopting it," she announced. She asked me to keep this a secret "because the dorm rules don't allow pets." Takisha fed the cat with milk from the cafeteria. She spent time patiently grooming, cuddling, and talking to the cat. At bedtime she called her mother in Alabama and stayed on the phone for a long time.

Before the semester ended, Takisha announced that she had decided to change her major. She no longer was going to be a doctor. Instead

she would major in nursing. Still, I never saw her do homework. One day she told me that she was ready to give away her adopted kitten. She took the cat downtown and returned with a young black man. Takisha introduced him to me as her boyfriend, and said that he was a photographer. Later, I discovered he wasn't a real photographer when they borrowed my camera. Takisha called to ask me to give instructions to her boyfriend on how to load the film into the camera.

Takisha seemed so happy that she glowed. At lunchtime, the pair took off together. From then on, Takisha no longer returned to the dorm to sleep.

One morning Takisha reappeared. She told me that she was there to say good-bye and collect her stuff. She was going back to Alabama. What surprised me was that she didn't seem a bit upset about not getting her medical degree.

I thanked Takisha for her kindness, smiles, and friendship. I told her that she'd be missed.

A middle-aged white lady approached me as I waited at the bus station. She was bundled in a snow coat and carried a book. It was so cold that she couldn't close her lips in order to make the *M* sound. Instead she said, "... erry Christ-ahss."

I found my lips had the same trouble closing when I tried to say "Merry Christmas" back.

"Would you like a Bible story?" the lady asked.

Before I could say no, she began. I wished that I could tell her that Communism used to be my religion, and Mao my God. His Little Red Quotation Book had been my Bible. I felt bad leaving in the middle of the lady's story. But several buses had come and gone. I was running out of time. I would be late for my class.

When the next bus arrived, I jumped on. To my surprise, the lady followed. Keeping a smile on her face, she sat down next to me. She asked how much I knew about the Christian God. I told her that I was confused between the Virgin, Mary, and Madonna. The lady said she would help me learn. I realized that I was trapped.

"I have a cold," I said. "You don't want to catch cold, do you?"

The lady replied, "I live to honor our Lord."

"I used to live to honor my Lord too," I told the lady. "Do you know the Chinese Jesus Christ? He was a soldier-martyr named Dong Chunrui. He was given an assignment by our Lord to blow up a bridge where the enemy had its firepower. When Dong finally reached the bridge, he couldn't find anywhere to secure his pack of explosives. He utilized his body as a post and completed his mission. That's how he honored our Lord, Mao."

The lady asked if I was afraid of demons.

"Not demons, but dreams," I replied. In my dreams I was never able to secure the explosives. I had been blown into pieces hundreds and thousands of times in my dreams.

I had no place to go during holidays. I had been in America almost four months and wished that I could afford to call home. I longed to hear the voices of my parents and imagined how happy my mother would be. I imagined the lady working at our neighborhood telephone booth when the call came in. I imagined her shouting my mother's name under her window. "A long-distance call for the Min family! Your daughter is calling from overseas! Hurry up!"

I imagined my mother abandoning her chopped vegetables. My mother would run through the narrow hallway, down the wooden staircase, and out onto the lane toward the telephone booth. What a pleasure it would be!

I wrote home, filling both sides of one sheet of paper. I printed my characters as small as I could to save postage. I told my sister to continue to hold on to my farewell letters, because I was not yet certain of my immigration status. I still hadn't made it back to the school that issued me the original I-20 form, although I had been anticipating it since the day I arrived.

I received a letter back from my family. My mother didn't say, "I miss you." She believed that it would weaken me if she showed any emotion. My mind was cast back to the time when my mother abruptly ended her visit to my labor camp. She simply couldn't face the horrid conditions I lived in. She fled despite the fact that she had just arrived.

The journey had taken her eight hours: five hours standing on a crowded bus, then three more walking on rough roads. She feared that if she broke down, my own courage to go on would be affected. I remember how I wished that my mother had stayed overnight. I missed her. Her presence would have comforted me and given me strength.

Kate said she'd love to take me home to spend Christmas with her family. Although I was nervous around strangers, I convinced myself to go. It would give me an opportunity to practice my English listening comprehension. Besides, I had never experienced a real American family in their home. I also simply needed a break from my constant worry about my debt.

Kate's parents' house was located in a Chicago suburb. She had a big family with lovely siblings, parents, and grandparents. It was an eye-opening experience to watch them affectionately greet each other, shower each other with gifts, and eat breakfast together, all laughing and talking together. It was difficult not to miss home.

I put a smile on my face and made myself appear interested. At the same time, I learned a loneliness that had no name. It plagued me. I felt consumed.

Kate's family treated me warmly and kindly. They asked me if I had enjoyed myself, and if I liked the dinner. I responded with equal enthusiasm. "Thank you! It was wonderful," I said. "I enjoyed everything so much."

What was really on my mind was my own family back in China counting on me to save their lives.

Back at school, Kate had news for me. She wanted to introduce me to a group of students from mainland China. "Folks from your hometown!" Kate said excitedly.

It was already too late when I told Kate that I couldn't afford to speak with people from my hometown. I couldn't afford to speak Chinese. I would have stayed with Joan Chen in Los Angeles if I had wanted to be with someone from my hometown. I had asked Joan if she would speak English with me. She said that it'd be awkward. We were so used to speaking to each other, not even in Mandarin but in Shanghai dialect.

But Kate was right that I needed to socialize. Sitting among the students from China, I was able to drop my mask, and it felt good. The

Chinese students shared the same burdens I did. We joked that we were like the roof of a bamboo hut under the weight of snow.

The Chinese students discussed visa expiration and deportation instead of Michael Jackson, Michigan Avenue, and the Chicago Bears. We shared the same homesickness, although we didn't talk about it. Like grasshoppers at the end of autumn, we worried about the freezing winter ahead. One student told me that he hadn't gone back home to China for years. His returning visa was not guaranteed. "An American consul in China can easily reject your reentry," he said. "You can lose everything."

"Practical training period" was what the Chinese students discussed the most. It meant that the graduating student was given one year, the last year, to locate a job in America, which would lead to a green card. The job had to be offered by a reputable American company with a decent salary. The job offer would qualify the Chinese student for an immigration H-1 working visa. The difficulty was that it had to be a job no American citizen would be able to or want to do. A job that might pay a minimum wage but that would require the skill of a Ph.D.

The Chinese students dreamed of earning a green card and the permanent residency in the USA that came with it. The competition was about seven hundred applicants for one position. "You have to beat your rivals by skill and qualification," one Ph.D. student said. "Even if you win, you might still not get the job, if the hiring company doesn't want to go through the immigration process. Unless the company is desperate, they won't pay for an immigration lawyer."

In Mandarin we talked about our "status of beheading."

Stick out your neck or not stick out your neck—your head would get chopped either way. I'd lose if I failed to achieve a green card, and I would also lose if I returned home with accumulated debt. "You might as well commit suicide."

It was the first time I heard the words "going underground" and "illegal alien." The Chinese students called it "the last option." "If the Mexicans have the guts to risk getting shot crossing the borders, why can't we?"

The moment our student visas expired, we would be violating US law. No one wanted to end up going underground. It would mean living like a bat in a cave.

"Can you bear not to see your family forever? Can you stand being a 'permanent missing person' to your family?" "What if your parents became ill and needed you?"

Although the heater in the room was on, no one took off his or her snow jacket. After a while, a male student pointed to a female student and said, "If I were you, I'd sell myself. I'd marry a grandpa or a dying man for a green card. I would consider that seriously."

The female student shot back. "You can do that too. You can marry a man and get the same thing."

Another female student said, "The two of you can marry and give birth to a baby on US soil. *Cee-tee-zen!* The baby would be legal and he could grow up to save your ass."

I learned that every one of them was on some sort of scholarship or grant, plus earning money from teaching-assistant positions and workstudy plans. Although I didn't ask the Chinese students to reveal the sources of their scholarships and grants by the end of the day I understood that it was public information and was available in the university library.

I began my hunt for scholarships and grants. I stayed up all night translating the texts and filling out applications. I also drafted proposals.

My mother wrote to tell me that although my aunt had never mentioned the money I had cost her, it didn't give me the right to take advantage of her. I wrote back to my mother and told her that I understood and that I was doing my best. It maddened me that I was moving at such a slow pace.

I made a great leap forward in English one day. I experienced my first comprehension of a complete sentence. I owed it to Mr. Rogers's TV program. He said, "The best gift you can offer is your honest self."

Upon understanding every word, I broke into tears. What a thrill to feel worthy! It had never occurred to me that my honest self could be a best gift to anyone.

I was in awe of what I was capable of accomplishing. My struggle to translate subsided. The trouble gave itself up. I began to think in English for the first time. My world opened like spring flowers blossoming all at once.

PART TWO

Y TOEFL SCORE didn't reach 500, but after interviewing me over the telephone, Dr. Barbara Guenther from the School of the Art Institute of Chicago decided to admit me. I rewarded myself with two extra hours of sleep.

I felt like Alice in Wonderland at the orientation day. I had never seen so many strange styles of dress, hair, and makeup. People here seemed to compete for attention starting with their hair. One boy dyed his hair in rainbow colors and piled it up like a hamburger. A girl did hers in bright green in the shape of Mount Everest. A tall man wore his like a rooster's crown. He was sitting next to a bearded man whose hair was a giant yellow fan. I was shocked by the multitude of rings worn in cycbrows, cars, under the noses, and on the bellies of girls and boys. I wondered why anyone would want to imitate a cow. In China, a cow's life symbolized misfortune. After working its entire life, a cow was sold or killed for food. Why should such a sad existence fascinate America's youth?

A group of students sitting on my left dressed in black from head to toe. They wore dyed suits, pants, and skirts and knee-high black boots. Their hair was the color of black ink. Their belts, necklaces, armbands, and wristbands were made of beaten silver with spikes. They used purple eye shadow, which made their eyes look bruised. One girl was in such a skintight outfit that her nipples showed. As I took a closer look, I couldn't believe what I saw—she was naked. She had painted her entire body with snake patterns. I must admit that she had done an amazing job. No security guards came to take her away.

I tried hard to understand the president's welcome speech. He said something about how 99 percent of the graduates from this school would not land jobs. He also talked about choices and sacrifices an artist must make. There was still time to change your mind, he told the crowd. But no one stood up or walked away.

I would have stood up and walked away if I could have got any other American college to accept me with my TOEFL score.

I began to look for a way out before I even started to take classes. The immigration law said that I had to stay with the school that issued me the I-20 form to maintain my visa status. With a dictionary in my hand, I visited the school's job-placement office. I stood in front of the wall where employment ads were posted. Unfortunately, most required English. I applied for a modeling job with the school's fashion design department. I was directed to the modeling office, where a little old lady received me. After one glance, she said I had the job.

I was thrilled. The job paid seven dollars per hour, more than my monthly salary in China. I moved all my courses to the evenings so I'd be able to apply for more jobs. Soon my schedule was full. I became an attendant for the student gallery and a helper at the admissions office. I stuffed, sealed, and labeled envelopes while counting and recording visitors who strode through the gallery.

I sought cheaper housing. An ad that read "rent negotiable" got my attention. I composed a script for a telephone call. I practiced reading the script until my tongue obeyed me. I dialed. The person on the other end said that she was also a student. We arranged to meet at the school cafeteria.

Her name was Stella and she was eighteen. She had golden hair, light-brown eyes, and a boyish haircut. She was astonishingly beautiful with a touch of masculinity. She took off her ocean-blue velvet coat and revealed her homemade, matched outfit. Her top was in between a blouse and a dress and she wore it with a pair of jeans splattered with brightly colored paint. The pattern of the fabric reminded me of *One Thousand and One Nights*—Arab themed.

As a sculpture major, Stella worked with metals and found objects. Power saws, hammers, and electric drills were her tools. She described her place as "ideal for artists." I didn't interrupt. Rent would be my only concern. I almost walked away when she said that the total rent was \$1,000. I let her know that I could not afford \$500. "I am from China," I said.

"China? Red China? Communist China? Cool!" Stella said she would give me a good deal. She'd let me pay whatever I liked. "You don't have to pay a penny if you really can't afford it. I'd love to have you as my roommate. All you have to do is share with me your experience

THE COOKED SEED

growing up in China." She told me that she was extremely interested in Communism, socialism, and revolutions.

"One hundred dollars per month is my budget," I said.

"Deal," she said.

I left a note on Kate's door saying good-bye and checked out of the dormitory at University of Illinois Circle Campus. Sharing housing with Stella would save two thirds of my expenses. I was glad and relieved. I moved into Stella's storefront studio unit in Wicker Park. There were no windows and no separate rooms except a tiny makeshift bathroom. There was an old stove by the rear door and an old refrigerator standing next to the stove. There was no kitchen.

The room smelled of animal stink. It was dark inside. The space was cluttered with metal wear, machine parts, auto tires, used fabrics, wood blocks, tools, open paint cans, and wet brushes. On the wall was a large artwork in progress. There were also half-painted canvases and paper drawings. Hanging from the ceiling from a rope was an assembled metal sculpture with a wheel.

As I stared at the sculpture, two ratlike creatures jumped on me from the air.

"Rats!" I screamed.

"They're not rats!" Stella laughed. "They're ferrets, my pets. Sweet and friendly weasels." Stella proudly showed me the home she had built for the ferrets. It was a weblike overhead series of tunnels connecting from ceiling to floor and corner to corner. Stella took me behind her pile of things to a large cage she had built out of wire. She treated the ferrets as if they were her babies. "Touch them," she encouraged.

Carefully I touched the ferrets. They looked too much like the rats that had frightened me at the labor camp in China. I couldn't help but associate them with disease and filth. To demonstrate her affection for the ferrets, Stella let them crawl through her clothes, in through her collar and out from her sleeve. "You'll like them," she said.

I asked where Stella slept. She pointed at a bare mattress on the floor in the middle of the room under the ferret tunnels. She said she had an extra mattress I could use.

I thanked her. I pulled the mattress over and laid it next to Stella's. I put down my things and then visited the bathroom. It was difficult to enter. After I squeezed inside, the door wouldn't close. As I sat on the toilet, I noticed that the sink was full of dirty dishes. A roll of toilet paper hung from the ceiling. Stella explained that it was to prevent the ferrets from tearing up the toilet paper. She warned me not to put food where the ferrets could reach.

In the middle of the night the ferrets came through my blanket. They entered by my feet and came up to my chest. I was horrified. I pulled open my blanket. The two ferrets popped out. They jumped into the tunnel above and disappeared.

Stella laughed and told me that the ferrets didn't bite. "Stop thinking of them as rats," she advised.

After dinner I prepared to share with Stella my former life as a Communist. Stella didn't tell me when I should start. So I waited. Days passed. She was so busy that we barely saw each other. I felt like I was taking advantage of her generosity. One day I decided to bring up the subject. I told her that I was ready whenever she had the time. Stella smiled and said, "That's okay."

Did that mean I owed her, or was she no longer interested? Given a choice, I'd never tell my story. The last thing I wanted to do was to relive my experience. I avoided memories. I preferred that they stayed buried. Yet it was in America, alone, that my memories haunted me. They would come to me in my dreams, or while I sat in a classroom or on a subway train. Anything could trigger them: For example, a snowflake made of foam in the Marshall Field's window display would remind me of the days when the icy earth was too hard to break at the labor camp. A naked mannequin in a clothing store would remind me of the youthful bodies we used to have that were deprived from human contact. A Victoria's Secret underwear ad would remind me of a flower embroidered by my former camp comrade, a long-dead girl who paid her life for love. When I saw an advertisement with milk ringed around a female mouth, I was reminded of a salt ring on the backs of my comrades as we carried buckets of manure. The white-colored ring was formed by sweat after hundreds of rounds.

Stella wasn't interested in my former life. I wanted to know if I

THE COOKED SEED

might ask her a few questions, and she said she would be happy to answer. "What do you think of Mao's teaching that 'American imperialism is a paper tiger'?" I asked.

"Who cares!" was her reply.

I was dumbfounded at first, and then awakened. I marveled that not one out of a billion Chinese would dare say what Stella had just said.

"What's your next question?" Stella asked.

"Well," I read from my notes. "How much money do you offer to your parents each month?"

"Are you kidding me?" Stella laughed.

"How much?"

"Nothing!"

Again I was dumbfounded. "Is that everybody, or just you?"

"Everybody."

"You don't support your parents? When I earn money, it is expected that one third of it will go to the care of my parents."

"This is America! Parents owe their children," Stella said. "Children didn't ask to be born. Besides, my parents don't need my help. They own an airport."

"Own an airport?" I couldn't believe what I heard.

"Do you have another question?" Stella said as if she was in a hurry.

"Well, I'd like to know what your goal is."

"What goal?"

"A goal—for example, my goal is to become an American citizen."

"I don't know. I am working on getting a pilot's license."

I had to look in my dictionary for the word *pilot*. "Do you mean like a driver's license for an airplane instead of a car?"

"Yep!" Stella made a flying motion with her hands.

I felt odd. Kind, warm, and generous as Stella was, we had nothing in common. I shared two classes with Stella. One was Poetry Writing, the other Art and Economics. I wouldn't have signed up for either of these classes if they hadn't been required for the degree. While Stella was the star of both, I could barely follow. I had never heard the word *economics* before, and I was unable to comprehend the concept. Stella told me that economics was the subject that her parents discussed over

dinner while she was growing up. I had never heard of the words *demand* and *supply*. When I asked Stella's advice on how to survive the class, she suggested that I negotiate an exchange with the professor.

"You have something to offer, something we Americans don't know about and would be interested in learning, and that's China," Stella said.

It turned out to be great advice. Instead of turning in a paper on American economics, I presented a paper on "Chinese Communist Economics." With Stella's help, I reported on how socialism worked, and failed to work, in China. I earned a passing grade.

I let Stella know that I needed to be with people who were on my own financial level. She said that she understood. After a semester, we parted on good terms. We remained friends. Once again I sought out the cheapest place to live. I looked in newspapers and searched bulletin boards at local community colleges.

Within a month, I found a group of Chinese students willing to share an apartment near Logan Square. It was a less desirable area farther from downtown Chicago. The five of us moved into a three-bedroom apartment. What made me happy was that my share of the rent was sixty dollars a month.

My temporary job was cleaning construction and event sites. I was not allowed to overwork or help other workers with their jobs. My boss told me that public restrooms and the cafeteria were not for students but for janitors who were union members. "Hard to explain to a foreigner," he said.

My modeling job for fashion illustration classes was limited. The only other job available was to be a nude model for the painting and drawing department.

"Welcome back!" the clerk at the modeling office said. "The figuredrawing professors would love to have you. They never had a young female Asian model before."

I was tempted by the pay. Fourteen dollars per hour! It was double what the fashion department paid. I signed up.

There was nothing wrong with being a nude model, I kept telling myself. Yet I didn't believe myself. The next day my eyes were swollen

after a night of crying. I couldn't stop visualizing removing my clothes in a classroom full of people. I was ashamed and wished that I had other choices. "It's honest money!" I tried to convince myself.

At 8:30 A.M. I checked in with the lady at the modeling office. She offered me a heater. "You will need this," she said. "The classroom is on the third floor."

I burst into tears and my legs refused to move.

"Are you okay?" the lady asked. "Are you sick?"

I shook my head through my tears.

"You must be having your period! Are you? Don't worry if so. Just go home. You don't have to do it, you know. Trust me, this happens all the time. Girls having their period at the last minute. That's why I always schedule a backup model. I can give the backup a call. No trouble at all. Would you like me to call the backup?"

I lost my courage and nodded.

The lady took back the heater. "It's okay, honey. Call me when your period is over, and I'll reschedule you."

I never had the courage to go back.

Dr. Barbara Guenther was a walking impressionistic painting. She taught Essay Writing 101. She was dressed in a fashionable, brightly colored suit with a matching skirt. Part German and part British, she was a tall, slender, middle-aged white lady with brown hair and blue-green eyes. Her lipstick shade always matched the tone of her clothes. She said to us, "You may call me Dr. Guenther, or Barbara Guenther, or Barbara, but never Barb."

I looked up the words Dr. Guenther had written on the board in my dictionary. As she began to explain the "roots" of -cide, she wrote fungicide, pesticide, and suicide. My mind took off instantly. I stared at the blackboard and copied Dr. Guenther's writing, but the words did not register with me. As I spelled suicide, I saw Shanghai's Huangpu River, where I had once contemplated drowning myself. My mind's eye cast further: I saw the electric wires in my home, which I had planned to touch; the sleeping pills I had collected; the gas stove I almost lit but didn't because my neighbor had had an asthma attack that night and

there was a big gap under her door where gas could travel and take her before me.

Suicide remained the very first word I learned from Dr. Guenther.

Virginia Woolf, George Orwell, E. B. White, Lewis Thomas, James Baldwin, Edward Hoagland, Joan Didion, Alice Walker: I had never heard of these names, but I was fascinated. Dr. Guenther introduced them. I remembered Joan Didion the most, because Dr. Guenther said that Didion was her favorite. The book she used as text was entitled *Eight Modern Essayists*.

One of my fellow students complained about Dr. Guenther's strictness. I didn't understand her expectations. How could a teacher behave otherwise? Years later I concluded that the students regarded themselves as mature artists who needed no improvement, especially with their English writing skills.

The only times I ever missed lessons in Dr. Guenther's class were when they conflicted with my job schedule. I had made paying off my debt my priority. My politeness and the fact that I was Dr. Guenther's favorite international student didn't count: She failed me. Dr. Guenther was determined to do her job. The students expected her to do what other professors did and "go easy" with grades. Dr. Guenther made it clear that everyone had to work for their grades in her class. She issued warning letters, made phone calls, and failed students.

Dr. Guenther didn't care about being evaluated negatively by her students. She was passionate about teaching and was loved by her class. She didn't hesitate to show her feelings toward those she considered lazy or spoiled. Open-minded and liberal as she was, she refused to put up with nonsense. "My job is to teach, not to please!" she said.

I never told Dr. Guenther that her failing me was the reason I so wanted to study under her. I respected her sense of responsibility toward her students. I signed up for more of her classes. By then I had received a scholarship grant from an Asia foundation that covered my tuition. Although I still had to earn living expenses, the tremendous pressure was lifted. I could now afford to focus on my studies. I was determined not to disappoint Dr. Guenther, since she was the one who admitted me without a passing TOEFL score. I felt that I owed her that decency.

Reading for me at this point was extremely difficult, if not impossible. Each page of my textbook had around twenty lines and about thirteen words per line. Yet ten out of the thirteen words I did not know. This meant I had to open up my dictionary two hundred times for each page. By the time I advanced to the third page, I was mentally exhausted.

I would cry on bad days. I sprayed ice water on my face, slapped my cheeks, and pinched my thighs in order to stay awake. By accident I found a good strategy. I would read the end of the story first so that I might be able to guess the plot and the words I didn't know. My dictionary was so worn that the corners melted away and pages started to fall out.

Each day I survived in the classroom I regarded as a triumph. I dragged the composition topics into my own territory, against the backdrop of Chinese culture and history, where I could make comparisons and comment intelligently. One of my first successes was a reflection on Edward Hoagland's "City Rat." I described the lives of a different kind of "city rats," the Chinese poor. I wrote slowly with my baby English, but it worked.

I began to repeat my success. When asked to copy the writing style of Virginia Woolf and convey a woman's inner struggle, I wrote about my grandmother. She had had bound feet but still survived the Japanese invasion, China's civil war, and the Communist liberation. To imitate Hemingway's Old Man and the Sea, I told a story about my fellow comrade Little Green at the labor camp. She was driven mad and died because she fell in love with a boy, and the two paid a price for carrying out the affair. To echo George Orwell's "Shooting an Elephant," I described my experience being pressured to denounce my favorite teacher during the Cultural Revolution. For "Portrait of a Family Member," I described how my mother survived under Mao's dictatorship. For a character sketch, I used my father as a subject. I depicted his passion for astronomy and told the story of how he was denounced for teaching about sun spots. Mao was regarded as the brightest sun in the universe and my father was accused of attacking Mao by pointing out his "spots," which might be interpreted as imperfections.

Professor Stalin was a large, tall man of Russian descent. I nicknamed him Stalin because I was unable to pronounce his last name. He had deep-set eyes, a prominent forehead with a grand nose, a mustache, and wavy brown hair piled up in the shape of a bird's nest. Professor Stalin taught Introduction to Filmmaking. I took the class not because I was interested but because I had some experience back in the Shanghai Film Studio. I hoped to glide through Professor Stalin's class.

I took the last seat by the door and avoided eye contact. After the first class, I knew I was in trouble. I couldn't understand 75 percent of what Professor Stalin said. I wanted to transfer to another class but found none that was easier.

I got nervous when Professor Stalin kept staring in my direction. He had a suspicious look in his eyes the moment he saw me. I ducked behind a tall male student pretending to take notes. I was afraid that Professor Stalin was going to call on me.

There was no narration in the films showed in class. The style of filmmaking Professor Stalin taught was called "experimental filmmaking." Professor Stalin pointed out the technique. A cinematographer tied a cord to his camera and swung it in the air as he shot the footage. The purpose was to "break" the viewers' "viewing habits." The concept was "abstract expressionism."

I looked up words in my dictionary as Professor Stalin lectured. My brain was busy translating English to Chinese. I took notes in Chinese writing as fast as I could. The Chinese translations were "quantitatively," "qualitatively," "embodiment," "whereby," "resonance," "tangible," "symphony," "eliminate," "illuminate," "dualistic," "cosmic," "manifest," "transparency," "duplicate," "triplicate" . . .

I was stuck at the word *f-stop*. There was no translation for it in my dictionary. I decided to come back to it later. During the class break, I

visited the ladies' room. When I returned, I found that someone had written on my notebook. "Sex" was next to my "f-stop." The handwriting was childlike.

I looked around. A male student who sat behind me had a smirk on his face. As I crossed out sex he began to laugh, and this distracted Professor Stalin. He turned toward me.

Professor Stalin spoke, but his words failed to register in my ear. He repeated himself while looking directly at me. The class was quiet. I could barely breathe. Professor Stalin repeated himself again. I lowered my head and looked at his feet. I heard him say, "Miss Min, please answer my question. What is the definition of a circle?"

Chinese filled up my head. I knew the definition of a circle. I opened my mouth but lost my English.

A girl who sat next to me tried to help. She whispered to me, "The definition of a circle is—"

Professor Stalin raised his hand. "I am asking Miss Min, please." I shook my head in shame.

Professor Stalin gave a cold laugh. "What did you do in school when you were growing up?"

Would it make sense to Professor Stalin if I told him what I had done in school when I was growing up? I was first drilled to defend my country from Americans who were already in Vietnam. Then I was assigned to a labor camp to grow rice and cotton to support Vietnam. I wished that I could tell Professor Stalin that I might not be able to describe the definition of a circle in English, but I could certainly demonstrate a combat move that would take down an American his size.

The class observed in silence when the professor walked toward me. I could hear the sound of Stalin's breathing above my head. Speaking with controlled anger, he said, "This is not a language school!"

I shut my dictionary and rushed out of the classroom. I didn't blame Professor Stalin. I was guilty of wasting the class's time, and he had every reason to be upset. I had no right to do this to him and the class. It seemed that there was no way I could avoid being a burden. I

ANCHEE MIN

feared that Professor Stalin might report me to the admissions office, and that Dr. Guenther would be punished for admitting me.

A girl followed me out after the class. She had been sitting next to me and had tried to help me answer Stalin's question. She had a petite figure with smooth ivory skin and shoulder-length brown hair. Her eyes were filled with sympathy.

"The school should be embarrassed by the way he treats you!" she said. "I'll go with you if you want to file a complaint. He is such a jerk. Makes me sick!"

Wiping my tears, I asked what jerk meant.

She explained. I opened my dictionary. "How do you spell jerk?"

"Oh, no." She shook her head. "Don't bother to look up the word. You don't want to learn this. By the way, I'm Irene."

This was how I met Irene. We quickly became friends. Irene taught me about the relationship between modern art and experimental filmmaking, which she explained was her passion. I had yet to know the extraordinary filmmaker in her, the talent that in the future would land her highest honors as an artist. Fifteen years later, Irene Smith would exhibit her films at Lincoln Center in New York. I'd be in the audience when she would show her films at the prestigious Egyptian Theater in Los Angeles.

She was barely eighteen when we first met. She painstakingly tried to make me understand that narrative storytelling was not the only way to make films. In addition to Leonardo da Vinci and Michelangelo, Irene introduced me to Sargent, Renoir, Picasso, Dalí, and Matisse. Art was no longer regarded as a tool that pleased, entertained, and belonged to the rich and powerful. Art had become accessible to any human individual as a means of self-expression.

Irene showed me her "work in progress." The film was a stream of composed, decomposed, and recomposed images taken from seemingly unrelated bits of found footage. Although I didn't understand what I saw, I felt her passion. Watching what she was doing forced me to reconsider my old ways of thinking and viewing. New senses opened to me.

It was not that I didn't have a desire to express myself. I was bur-

dened by the pressure to survive. All I dreamed of was to earn citizenship and make a living. Yet it seemed unreachable. It was painful for me to sit among young American art students and pretend to be interested in their discussions about self-expression.

I worked until eight P.M. every Tuesday at the student gallery. There were few visitors after six P.M. Irene would come and sit by me. One day, my friend brought me a book as a gift to help me improve my vocabulary. Its title was *Abnormal Psychology*. Irene told me to keep the book. She said that she had had enough of it. Her family had made her see a "shrink" since she was seven, and she had been in therapy for years. I had no idea what she was talking about.

I opened my dictionary and tried to locate the word *shrink*. Irene told me that I wouldn't find it, because the proper word would be *psychiatrist*. I was confused. My dictionary translated *psychiatrist* as a doctor for the mentally ill. My friend didn't seem mentally ill to me, or was I misjudging?

I asked how much a shrink would cost. Irene wanted to know why I asked. I told her that I felt like a mental patient.

"You are not alone. Look around us. Everybody is pathetic!" Irene said.

I agreed. Looking at the artwork I guarded, which was a freshman exhibition entitled *Self-Portrait*, I was shocked by the way my school-mates expressed themselves. The self-portraits demonstrated nothing but agony, pain, and self-hatred. One artist painted his head into a hairy monster, another a vagina, and next to it was a penis head. In one self-portrait, the head was drowning in water, and the one next to it was a knife-toothed vampire.

Strangely, however, what touched me was not only the work's honesty but also the freedom behind it.

I went to the job-placement office for an interview. The lady asked me if I knew how to type. I said I would be willing to learn.

"You mean you are not good at typing?" the lady asked.

The lady explained that "it doesn't work that way in America."

I visited the Dumpster behind a Payless shoe store and found a throwaway shoe box. I drew a picture of a typewriter keyboard with circles. I took it to the school admissions office and observed the secretary typing. At her lunch break, I asked her to tell me which fingers touch which keys. I practiced typing on my shoebox keyboard whenever possible: on the subway, bus, or as I sat on a curb waiting for a bus.

Two weeks later I returned to the job-placement office. I told the lady that I was ready. She sat me in front of her typewriter and handed me a page of newspaper to copy from.

The lady glanced at her watch and said, "Ready? Go!"

I charged forward. My fingers didn't feel like mine. The English characters in front of me became blurred. Before I could finish a sentence, the lady announced that the test was over. I scored a negative 13.

By the time I got a job painting on fabric, I had worked as a delivery person for the school film center, a checkout person at the equipment booth, an attendant for the gallery, and a mail sorter at the admissions office.

I left early one morning and headed to the northeast side of Chicago for the fabric-painting job. I had to transfer subways twice, from the A train to the B train, then take a bus, and finally walk for forty minutes. It was ten o'clock when I found myself in a pleasant neighborhood in front of a big house. I was surprised to be greeted by an Asian lady. She told me to call her Mrs. Lueng.

"Are you Chinese?" I asked.

The lady said she was Chinese but spoke only Cantonese, which meant we had to communicate in English.

Mrs. Lueng led me to her basement, where rolls of silk were piled high. A large cloth-covered table stood in the middle. Mrs. Lueng told me that she made women's underwear, sleepwear, and gowns. My job was to paint flowers on her merchandise. She gave me a basket filled with tubes of fabric paint.

I thanked Mrs. Lueng for hiring me. Mrs. Lueng kept her face straight and said that she didn't want me to get any wrong ideas.

"I want to be honest with you," she said. "I had a bad experience with a Korean girl before you. I paid her four dollars per hour. She painted too slow, one flower per hour. And she had to take cigarette breaks. I didn't want to pay for cigarette breaks. You don't smoke, do you?"

"Oh, no. I don't smoke."

"Good, I will pay you by the piece, not by the hour. Do you understand? I will pay you three dollars per piece. I hope you will paint a bit faster than the Korean girl."

"I'll try," I said.

"By the way, no coffee, phone, or lunch breaks. You may go to the toilet."

"Of course."

I painted flowers in an impressionistic style. It was not that difficult for me since I used the Chinese brush-painting technique. It allowed me to mix colors in the brush instead of on the canvas. Mrs. Lueng was impressed. Besides roses, she requested lilies, camellias, peonies, wisteria, and bamboo leaves in various compositions. I made my flowers follow the contours of the merchandise.

Standing next to me, Mrs. Lueng said, "The Korean girl painted in the Western style, one stroke at a time, and that was why she was slow. You mix the paints in the brush as you go. How do you do that?"

I told Mrs. Lueng that before dipping my brush in the color jars, my mind already knew the effect the strokes would have on the silk.

By the time I said good-bye, I had earned twenty-four dollars. I was thrilled. Mrs. Lueng asked if I wanted to take work home. She would pay fifty cents for each piece of underwear. Gladly, I accepted her offer and took a stack of fabric with me.

It was midnight by the time I returned to my shared apartment. I stayed up and painted until my eyes refused to stay open, around four in the morning.

Once I knew what Mrs. Lueng liked, I applied my skill with full force. I was so motivated by the income that I skipped drinking water so that I could save toilet time. I was able to produce six pieces per hour, which meant eighteen dollars.

Mrs. Lueng asked me to paint a wedding gown. She later made a 300 percent profit on it. I was happy that I pleased Mrs. Lueng. I earned ninety dollars a day, not counting my travel time, which took three hours. After my train and bus fare, I still profited seventy dollars. On average, I made fourteen dollars per hour.

Unfortunately, my happiness didn't last. A week later, Mrs. Lueng wanted to cut my pay. She said that she had made a mistake. She would no longer pay me by the piece. Instead she wanted to switch to paying me by the hour.

"Four dollars per hour. The same as I paid the Korean girl."

"Do you expect me to paint one flower for each hour?" I was upset.

"No," she replied. "I expect the same productivity. Six pieces or more per hour."

"For four dollars instead of fourteen dollars per hour?"

"That's correct."

"But-"

"Take it or leave it," Mrs. Lueng said coldly.

This was the first time I had witnessed capitalism at work. "You expect me to produce six pieces for four dollars, which comes out to only sixty-six cents per piece. You told me that the Korean girl made one piece per hour. She got paid four dollars, and me only sixty-six cents?"

"You are faster. You still earn four dollars per hour by painting six pieces."

I argued that transportation cost me time and money. It would not be worth it at the end of the day, since I would only have five dollars left.

Mrs. Lueng said that it was not her trouble, and that she had no intention of making my trouble hers.

For the rest of the day I painted six pieces an hour for four dollars an hour. I netted \$8.50 total for that day. I tried not to feel disappointed as I sat on the last subway train returning to Chicago, but I couldn't help myself. I was exhausted and hungry. My hand clenched the eight one-dollar bills and two quarters.

{ CHAPTER 11 }

THE CITY FELT like a big freezer as the snow on the ground turned to ice. Under leafless trees with their crooked branches going in all directions, a naked male student exhibited himself in front of the school entrance. He lay in a swing strung between two tree trunks. I could see the fog of his breath. I wondered how long he had been on the swing. Should I report him to the authorities or call for help? I looked around. It surprised me that the people who walked by paid him no attention.

I went to consult a security guard. "The man will catch cold," I said. The guard let me know that there was nothing to worry about—the maked man was in the midst of a performance. "This happens all the time," he said. What kind of performance? I remembered the acute pain I experienced in China when I stood in icy water planting rice.

Another crowd gathered in the school hallway in front of a portrait of Chicago's mayor Washington. In the painting he was wearing a bra. I had seen the black mayor on TV. I had no idea what he had done to deserve the insult. In my opinion, the portrait was mean-spirited. A TV news crew was interviewing the artist. The naked man outside the entrance must be disappointed, I thought. He had been trying to attract attention, but no one seemed interested.

The head of the student union came in. In excitement he reported that a group of Vietnam veterans was marching outside. They were protesting over a student who had burned a US flag. "The veterans are threatening to shoot the artist and burn down our school! We must unite and fight for our freedom!"

The students held meetings to discuss the "essence of freedom" while the president of the school defended the "constitutional rights of the artist" before the media. The students were disappointed, because nothing happened in the end. The naked man put on his clothes after exhibiting himself without an audience.

I received an invitation to join the Communist Club. I was excited

to meet American Communists for the first time. The gathering took place in the lounge of the school auditorium. The members were a bunch of young people dressed in sloppy clothes with tattoos and long hair. The head of the group spoke in sloganlike sentences. He told me how he grew up worshipping Mao. He and the other members believed that Communism was America's solution. "Countless crimes committed by the American government," I heard him say. "We must destroy the system."

I didn't know what they expected me to say. "Tell us about Red China!" they encouraged. "Tell us your firsthand experience!"

"It didn't work," was all I could say.

The club members didn't believe that I was a real Communist. They doubted that I was from Mao's China. I said that I could prove it. They said that it was time to play a movie made in China about the Cultural Revolution. The title was *The Breakup*.

I opened my mouth and sang along with the movie's soundtrack:

There are green pines all over the hill
There are fat crops to be harvested
It is great to destroy the old system and replace it with a new one
It is great that peasants are becoming the masters of the university

I told the club that the movie was one of Madame Mao's projects. The story featured a Chinese peasant girl who took over the university leadership. She tore apart the system to guarantee the right of every poor person in China to attend the university.

"But it was propaganda!" I said to my American comrades. "It never happened in real life."

Nobody was interested in what I had to say. The club's mind was set on China being the model to replace America's "evil system."

I realized that while I had the right to say what I wanted, others had the same right to ignore me. The school existed to make everyone feel heard and supported. Most of the time one would hear one's own voice. Most of the professors gave favorable critiques. Their job was to encourage "self-expression." Every student was respected as a "mature artist." As long as you paid the tuition, you could be lousy at what you did but still be told, "You are wonderful!"

THE COOKED SEED

To give myself time to earn a living outside of school, I signed up for independent studies. I met with professors once a week for twenty minutes. We discussed semiotics: "the signifier" and "the signified." I did my best to pretend that I was serious about art, but inside I was consumed by frustration and anxiety.

At the art gallery, I guarded a student exhibition in which an American flag was spread on the floor. About three feet above the flag, mounted on the wall, was a notebook-size diary. The viewers had to step on the flag in order to view the diary. The footprints on the flag looked like blotches of mold.

The growing number of footprints on the flag made me feel that I was neglecting my duty. Every time after a viewer left, I took off my jacket and used it to wipe the footprints off the flag. I became tired of doing that. When the next viewer came, I said politely, "Please do not step on the flag."

I quickly learned that it was the artist's intention to have footprints on the flag. My cleaning was ruining the desired effect. The American flag seemed to symbolize evil for the student artist. I reacted the same as I did with the Communist Club. Although I embraced the concept of freedom, I couldn't embrace the artist's self-expression. I was grateful to America. If this country hadn't taken me in, I would not have lived. I loved China, but I couldn't lie and say that I had been anything but a piece of trash there.

I was taught to hate America. As children we were shown films of American soldiers murdering Vietnamese Communists, girls of my own age. When I was in fourth grade, I had denounced my beloved teacher as an American spy. As a teen, I was given a wooden stick to practice fighting the enemy—a dummy made of straw with a US helmet on its head.

I remembered dreaming of being shipped to Vietnam. I was jealous of the boys who were drafted. I envied them even when some of them didn't return. I loved the propaganda movie in which a hero lit an explosive and jumped into a group of American soldiers. As he jumped, grand orchestra music came on and the screen was filled with smoke. Every child in the theater wept and swore revenge. We vowed to follow in the heroes' footsteps to destroy America. I imagined my ashes being returned from Vietnam, wrapped in the red Communist flag made of silk. My memorial stone would show the number of American soldiers I had killed with a single phrase: "She who tore down the American flag."

I didn't know God, but I began to sense his grace in America. Even with some unpleasant experiences, I had been treated with dignity. For example, the painted-fabrics lady, Mrs. Lueng, bothered to negotiate with me. She didn't pinch me or destroy me as if I were a bug. The churchwoman at the bus stop showed me that freedom was given to anyone in this country. She was allowed to act crazy in pursuing her own beliefs. The homeless, alcoholics, and drug users were allowed to roam the streets. The campus Communist club was allowed to exist. The art students were free to burn the American flag and free to paint the mayor with a bra.

I began to write to my parents signing off "With love." It was the beginning of my transformation. Chinese children of my generation said, "I love you, Chairman Mao and the Communist Party of China," but never "I love you, Mama," or "I love you, Papa."

I compared the "men-eat-men capitalism" to Mao's "Serve the people with heart and soul." Mao claimed to have owned no personal property himself, to possess no money, but he purged and robbed millions at will. China's railroad system would grind to a halt anytime Mao's personal train needed to pass. Mao's private plane would fly whenever he wanted and would land anytime and anywhere at a minute's notice. Mao owned China and its citizens.

When my professor in my twentieth-century American art class showed slides of Andy Warhol's *Mao* series, I was surprised. I couldn't understand why Mao portraits were up in American museums and our classroom when a billion Chinese tried to take them down. We finally took the Mao buttons off our jackets, the Mao portraits off our walls, and Mao's quotations out of our conversations. I asked the professor, "Why Mao?"

He shrugged and said, "I don't know."

The professors spent entire courses analyzing the sketches, notebooks, diaries, and journals of famous artists. My classmates also carried sketches, notebooks, diaries, and journals as if they anticipated becoming famous themselves. They sketched in the cafeteria and in the hallways. Each one believed that one day their "stuff" would be discovered, studied, and admired. They dreamed that their names would one day be associated with the history of art.

I wished that I could share my thoughts: for example, how much I envied the homeless. I envied the fact that they spoke English and had the right to work. I couldn't tell people that I craved a meal at McDonald's. If I didn't feel obliged to save my "Chinese face," I would have eaten people's leftover burgers and french fries. I was disappointed one day when a classmate invited me to meet with her parents for lunch. When my friend's father suggested that we eat at McDonald's, I was thrilled. Unfortunately, my friend declined: "I hate McDonald's! I hate junk food!"

I had been in America for almost two years. I was still not where I wanted to be in terms of my immigration status. I had already ruined my sister's and brother's chances to follow in my footsteps. Both of them had applied as students and both were denied US visas. Reason? Because I was here, which revealed an "immigrant tendency." Their passports were stamped "B-14." What could I possibly do to make it up to my siblings?

I tried to concentrate on the lecture. It was a film seminar held from six to nine in the evening. I signed up for the class because I hoped to kill two birds with one stone. Bird one was to practice English listening comprehension. As much as I adored Dr. Guenther, I didn't feel that I was improving fast enough in her class. I couldn't afford to take my time. I needed to earn my degree as soon as possible.

Bird two was to learn a skill that would help me get a foot in a business door. I wanted to learn the mechanics of camera operating.

I sat in the front row of the class facing the instructor, a man in his mid-thirties—a filmmaker from Los Angeles named Albert. He had tanned skin and curly dark-brown hair. Mr. Albert's lecture was not about experimental filmmaking, but about his payment.

Sitting in his chair, Mr. Albert asserted his right to charge the school for the films he showed the class. He explained that he made the

films. They took him years. He said he would play fair. He would charge 50 percent less than what the National Museum of Films charged. "I am only asking to be paid at the rate of \$2.50 per minute," he said. "A real bargain," he pointed out. He reminded me of a carpet seller on TV saying, "It's only \$2.50 per square foot!"

Two hours passed, and Mr. Albert continued on. The students sat in silence. Mr. Albert asked the students for support.

My mind wandered. The image of an old man with a stooped back surfaced in my memory. It was Mr. Cheng, a teacher from my middle school who taught agriculture. He passed by me every Saturday afternoon as I worked on a propaganda wall newspaper for my class. Watching me struggle with drawing, Mr. Cheng offered to give me free art lessons. He wanted to help, he told me, because he saw frostbite on my hands. "You don't quit and I like that," he said.

Mr. Cheng told me to ask my mother for permission and modest supplies. "Two brush pens, one medium, which will cost you seven cents, and a few small ones, for about three cents," he said. "Ten cents will be all your mother has to provide."

I became Mr. Cheng's student for two years. Sitting in the American classroom, I realized that I had taken Mr. Cheng for granted. Perhaps I was wrong to expect Mr. Albert to be as selfless as Mr. Cheng or Dr. Guenther. If I was to become a teacher, I would model myself after Mr. Cheng and Dr. Guenther. I wouldn't hold students responsible for my issues with the school administration.

Mr. Albert forced me to change my perspective on the teacher-student relationship. All of the sudden, a monster called money showed its face in front of me. I realized that my relationship with my American teacher was based on money. The thought repelled me. It chased after me. I couldn't get away from it. I looked at my watch and felt as if Mr. Albert was wasting my time.

The booth was lit, the projection was on, and the film was ready to roll. But without getting proper payment, Mr. Albert was determined not to show his film.

Another hour passed. Mr. Albert sat in his chair. The room was windowless and the air stiff. Mr. Albert suggested that the students con-

duct their own discussion. The students chatted among themselves. They didn't have any trouble with their immigration status. Time and money were not issues for them, but they were life-or-death issues to me. The monster inside me screamed.

The title of the course was 4-D. When it was Jerome's turn to present his project, he requested that we empty the room. I don't know why I peeked through the door, but I was the one who discovered what Jerome was doing to himself. I hadn't detected anything wrong at the beginning of the class. Jerome was a graduate student and a nice guy. My favorite exercise was called Trust. I had to climb onto a crane about two stories high. Below, my classmates were instructed to open their arms and catch me when I jumped. I was instructed to free-fall backwards. I was forced to trust. It felt good to be able to trust.

I couldn't believe my eyes when I saw Jerome hanging from a rope tied to the crane. His feet were in the air, about six feet above the ground. When his face began to turn purple, I realized that this was not art. No one was beside him. I didn't see how he could untie the rope and release himself.

I broke into the room. At the top of my voice, I yelled, "Jerome! I once wished to die too! The night I lay in the rice paddy. But Jerome, you are not in a Communist labor camp. You can turn your life around!"

Jerome jerked his body and kicked his feet. The rope tightened around his neck.

"Get out!" he cried, choking.

I knew I ought to honor his wish, but I couldn't leave him.

"Get . . . out!"

I struggled to find words. "Switch places with you" was what came out of my mouth. I couldn't decide which was the correct word to use, *switch* or *trade*. "I will switch trade places with you!" I yelled. "Switch trade!"

He didn't respond. His body continued its jerky movement.

Did I mispronounce the words? Did "switch trade" fail to make sense to him? How about "trade switch"?

ANCHEE MIN

"I will trade switch you!" I shouted. "Labor camp! Backbreaking! You, in America. You make happy! No good, hanging. Trade switch. You smile. I smile. Make happy together. Trade switch!"

I don't remember how I left the room. I was hysterical. The department chair came and took care of the matter. Many years later, a former classmate told me that Jerome had lived. He never revealed what was on his mind that day. Rumor said that an Asian woman performed Chinese voodoo involving trading sandwiches.

The memory of Jerome's bulging eyes and blue veins stuck with me. I tried hard to understand his pain. I knew that he wasn't faking. But a pain that drove a young American to suicide regardless of his freedom and protected human rights was incomprehensible to me. I didn't have a better phrase to describe how I felt—American youth suffered a different form of deprivation, which might include the lack of suffering itself.

{ CHAPTER 12 }

In the summer of 1986 I sent home a photo of myself. It was an image my family expected—I was successful in America. I wore a red sleeveless top and a matching short skirt. The outfit was Joan Chen's. I had visited her the previous Christmas in Los Angeles. She was kind enough to pay for my airfare and let me stay with her for two weeks. I also wanted to look for any work opportunities and any connections that might lead to work.

Joan Chen had matured into a young woman since leaving China years before. Now twenty-four, she had been trying to make a name for herself in America. Many roles came her way, but few inspired her passion. She craved a substantial acting part, not merely playing a delicate China doll. She was having a hard time avoiding being typecast.

Joan Chen gave me a makeover one evening. She applied what she had learned from her makeup artists. She believed any woman could be transformed into a cover girl. She dressed me with clothes from her closet.

I enjoyed looking in the mirror wearing Joan Chen's red summer outfit. I even looked sexy, I thought. She said I could have the outfit, and I was thrilled. I would have stayed in Los Angeles if my English had not regressed in the short time I visited Joan. As much as I loved my friend and the California weather, I returned to Chicago taking with me her red sleeveless top and matching skirt.

I sat on the shore of Lake Michigan in Chicago dressed in Joan Chen's clothes. I asked a stranger to help take a picture of me. I smiled at the camera leaning toward the shore. Right before the shot, the sound of an engine rumbled from the lake. I turned around and saw a giant sailboat approaching. There were handsome, suntanned men drinking beer on the boat's deck. I asked the kind stranger to please include the men in the background. I put on my biggest smile as the shutter clicked.

In the photo, I looked confident and attractive. The sailboat behind me and the handsome men on it enhanced the effect. I might

have been one of their party. I mailed home the picture, the fake me. The real me was depressed, lonely, and homesick. I craved affection, and I dreamed of love. It had been too long since I had shared intimacy with another human being. I wasn't looking forward to turning thirty. I wished that I had called out to the sailboat, "Hey, I am here! I have been waiting!"

Discount food stores were the only places I shopped. I looked for deals like two dozen eggs for a dollar and a loaf of bread for fifty cents. I made dishes out of rotten vegetables. I never missed the discounted milk and meat that were on or beyond their expiration dates. Sometimes the milk had a funny taste and the meat smelled. I boiled the milk and thoroughly cooked the food. To get rid of the smell, I marinated the meat in dark brown soy sauce and then stir-fried it with ginger and garlic. I was able to live on a thirty-dollar-a-month budget.

Before Christmas, I saw an 80-percent-off sign at Woolworth's in downtown Chicago. I went in and bought seven pairs of orange cotton socks with pumpkin designs for only a dollar. What good luck, I thought. I also bought a set of sweaters and pants with bat designs and the same orange color for only \$1.50. I spent another dollar for a hat and matching mittens. I wondered why everything was orange. I wondered why nobody else was taking advantage of the bargain.

The next day I arrived at school wearing my new outfit. The orange-colored sweater; the pants, hat, and mittens. People smiled at me and said, "Halloween again?" I noticed that it wasn't just one person who said this to me. Almost everyone did.

"What's Halloween?" I asked.

The back-to-back cafeteria sofas shook violently. By now I knew that the place was a favorite for lovers.

Witnessing these activities only made me feel lonelier. What I had missed in my youth had never really hit me until now. I felt sad and sorry for myself. I had never dated boys when I was these girls' age.

I was the flower that had missed its blossoming season, and this

affected the way I thought of myself. I attracted, it seemed, only the crooked melons and rotten peaches. It wasn't that I was holding out for a prince. A few times I was asked out by seemingly nice American men, even professors, only to discover that they were "married but in a terrible relationship." Since drugs and alcohol were not problems in China, I had no idea what "alcoholic" meant until I was approached by one—a Prince Charming on the surface, but who couldn't recognize me the next day.

Other times I received odd comments after the date, such as "You are more American than an American woman," or "Aren't you glad that you don't have bound feet?"

One man said to me, "Would you like to go dutch, or would you like to take care of the entire bill?"

I blinked and believed that the translator inside my head had tricked me.

"Seriously, I wouldn't mind," the man continued. "I can totally understand that you're from Communist China and would prefer to hold... how do you phrase it? You know the Mao quotation? Something about 'half the sky'?"

I dated one Asian man for six months. He was a gentleman who enjoyed taking care of his lady. I waited for him to let me know if we were going somewhere. He finally decided that America didn't suit him. He was returning to Taiwan because he couldn't find a job after earning a master's degree in architecture. His visa had expired. The man didn't know what to say to me. Both of us knew that this would be the last time we would see each other. As a farewell I said to him, "Thanks for stocking beef patties and chocolate ice cream in my refrigerator."

Although I understood that life was not art, I yearned for passion. I was shocked by a tall, blond, handsome student named George who kissed me without warning.

"Happy Valentine's Day!" he sang.

"What's Valentine's Day?" I pushed him away. He said that he was delighted to be the first one to educate me about Valentine's Day. I also adored Justin, who came to sit by me while I tended the gallery. He was a shy boy who had just turned eighteen. After his fourth visit, I decided to tell him my age.

ANCHEE MIN

I will never forget the shock on his face when I told him that I was ten years his senior.

"Wow!" he jumped out of his seat. "That's . . . something!"

Justin never visited again. Although I remained composed, my self-confidence crumbled.

On my way to the subway station there was a video store owned by an old Korean couple. They also owned a dry cleaners next door. I had been renting movies from the husband ever since I purchased a used video player to help me learn English. I had discovered that watching movies was the most effective way to deal with my loneliness while improving my English. I asked the Korean owner if by any chance he carried movies made in mainland China.

The man shook his head. "No, bee don't carry movies from Communist China. However, bee carry something else that might interest you—let bee check." He paused, looked around, and then pulled me to the side. "You student?"

I nodded.

"You live by yourself? You homesick?" he asked. "Bee can help." I told him that I was, yes, alone. Completely alone.

"Bee ha-boo something poor you. I see you, walk by, you, e-bri-day. Come, here." He led me through the racks of his video displays to an enclosed space where there was a curtain by the entrance and a sign that read ADULT ONLY.

I was not sure if I had heard him right. He had said "Free free." I wondered if he meant "Feel free." He eased me in and then pulled the curtain behind.

My cheeks burned. I was shocked by the display of videos of wild images of coupling in every manner and position. I felt terrible and glad at the same time. I left the store and returned to my room. I found that I could think of nothing else. I counted my money, hoping that I could afford to rent an adult video.

The old Korean man welcomed me back with a knowing smile. He pointed his chin toward the adult video section and mouthed a "feel

free." I was embarrassed. The man's grandson was doing his homework by the checkout counter. The old man called for his wife from the dry cleaning. She came and took away the boy. The man led me to the section and closed the curtain.

This must be how a mouse felt after it had fallen into a rice jar. I picked out the film that seemed most romantic. I quickly exited. The old man kept his head down as he took my three dollars. He put the video in a plastic bag and said, "Bring it back before six o'clock tomorrow."

I watched the video with the volume off.

For the first time I discovered masturbation. I was thrilled that I could comfort myself. I closed my eyes and imagined being caressed by a man. It felt good not to beg anyone for affection. My anxiety eased. The craving became bearable.

I visited the video store on my loneliest nights during Thanksgiving and Christmas. I wanted desperately to call China just to hear my family's voices. The Korean man was pleased with the business. I became devoted to one video titled *Sex Education*, which was more artfully done than the others. I first selected it because it was less graphic and it was longer in length. The seductresses in the film left their silk scarves on as they peeled off the rest of their clothes. The sex scenes were less mechanical. The other videos reminded me of plumbers trying to get through a clog.

The Korean man wanted to sell me the *Sex Education* tape at a discounted price. "You good customer," he said. "Bee make you a deal. Twenty-pipe dollars."

"I can't afford twenty-five dollars," I said.

"You'll get your money worth in a long run," the man said. "Look, it has been the only video you rent. You like it, don't you? Why spend more money on renting when you can own the tape? Seven more times, you make your money back. You don't have to visit my store again. I know how embarrassed you are every time. Like I said, you good customer. I no cheating you."

I asked why he was willing to part with the video. He smiled and told me that *Sex Education* was the least popular video in the store. "You're the only one who rents it. I honest with you. Other customers

ANCHEE MIN

think it too slow. No action. Too boring. They want juicy stuff! Lots of action. Okay, how about twenty dollars? My last offer. I lose money. You take it or leave it!"

As I paid the twenty dollars, I thought that I could use the video for the rest of my life.

{ CHAPTER 13 }

ANY STUDENTS FROM mainland China worked in local Chinese restaurants in addition to their campus jobs. It was their way to earn tuition. I begged my roommate, Wen Li, who worked as a waitress at a Chinese restaurant in a Chicago suburb, to keep an eye out for me if there was an opening. I asked Wen Li to bring me a menu from her restaurant. I memorized the thirty-five dishes on the menu in English. I had been rejected by every Chinese restaurant in downtown Chicago and knew that I must impress.

The night a waitress quit, Wen Li called. She told me that her boss was looking for an immediate replacement because the restaurant was in the middle of catering a large corporate party. I put down what I was doing and took a train to the restaurant. I met the owner for an on-the-spot interview. Mrs. Soong was a Taiwanese Chinese lady in her forties. She had short hair and a moon-shaped face. She stood by the entrance of the restaurant and greeted her customers as she interviewed me. I kept hearing her say, "Happy Sex-giving!" or, "Sex for coming!"

I told Mrs. Soong that although I had no previous experience in waitressing, I had memorized her menu. I recited her thirty-five dishes the same way I had once recited Mao's quotations. Mrs. Soong was so impressed that she forgot to say, "Happy Sex-giving!"

I was given three days to try out. I followed Wen Li as an apprentice and was hired after the third day, although Mrs. Soong offered zero salary. I would earn only from tips. Now I was a full-time student and juggling five jobs at the same time. Besides waitressing, I continued fabric painting, although with a different boss. I continued to work as an attendant at the school's film-equipment booth, admission office, and student gallery.

It was a battle to get to the restaurant exactly at 5:15 P.M. My class ended at four P.M. Ten minutes before four P.M., I eased toward the door. When the professor turned his back, I snuck out and ran through downtown Chicago and toward Union Station. I needed to catch the

4:05 train to Libertyville. The train arrived in Libertyville at five P.M., and I ran to the restaurant. Once I arrived, I rushed to the ladies' room to put on my makeup and apron.

Wen Li told me that Mrs. Soong used to be the principal of an elementary school in Taiwan. It was in her nature to give orders and criticize. Mrs. Soong walked around her restaurant with both hands locked behind her back like a general inspecting her troops. She would sense immediately if any of us failed to do her job properly. Before Mrs. Soong became an owner, she had worked as a waitress and a bartender herself.

"Creating return customers is the goal!" she reminded us daily. Mrs. Soong pointed at her watch and said that I was five minutes late. "Did I tell you five fifteen sharp? Don't bother to come if you intend to be late again."

I solved the problem by applying makeup and changing on the train.

"No gasping when you enter my restaurant!" Mrs. Soong said the moment I pushed open the door. "You are scaring away my customers! No moving lips either! No chewing, absolutely! It's not my problem that you haven't eaten all day!"

There were four waitresses working in the restaurant at the same time. Although we worked the same hours, the tips we earned were drastically different. While I made \$25 in tips per night, Sing-Sing, a waitress from Taiwan, could earn \$150; the big-breasted American girl, JoAnn, earned about \$100; and Wen Li between \$50 and \$75. JoAnn believed the problem was my bra. "You need a super-padded bra to show off your assets! Customers like that." JoAnn flaunted her cleavage. "That's how you get return customers."

I discovered that my low earnings had nothing to do with my "assets." Mrs. Soong was pulling the strings. She brought high-tipping costumers to Sing-Sing and JoAnn's tables, while low-tipping folks went to Wen Li and me. One group of regular Filipino costumers never tipped more than two dollars, even for a fifteen-person table. Mrs. Soong always led the same Filipino costumers to my table.

Mrs. Soong was straightforward about what she was doing. "You folks were ill educated by the Communists!" she said to Wen Li and me. "You need to be taught how to properly treat a customer. The American

way. You poor things, capitalism is such a new concept to you, isn't it? Communism has turned you into wooden hens who don't know how to behave in front of Western customers!"

Mrs. Soong explained that the reason she let Sing-Sing earn more was that Sing-Sing had come from her hometown. Mrs. Soong praised the way Sing-Sing charmed her customers. "She speaks fluent English, and she cracks jokes!" Wen Li and I tried our best to impress Mrs. Soong, but she was unmoved. While Sing-Sing took her breaks, we were ordered to clean soy sauce bottles, peel pea pods, and help the busboy clean the floor and set up tables and chairs.

I didn't think Mrs. Soong was being unfair. I believed that I should earn her respect through my performance. The trouble was that earning such low pay was not worth my time and energy. By the time I subtracted the ten-dollar round-trip train fare from the twenty-five dollars of tips, I made only fifteen dollars per night.

I hung on. I learned to smile to customers and became expert at wrapping the stuffed mu-shu pancakes. I began to earn better tips with new customers whom Mrs. Soong hadn't yet sorted as high- or low-tipping people. When I worked the lunch shift during the summer, Mrs. Soong observed me. She would call me a wooden hen if she thought that I talked "too little" to customers. But when I started to chat with customers, she accused me of being a chatterbox. If I walked fast, Mrs. Soong would "whisper" loudly behind me, "Is my house on fire?" When I slowed down, she would hiss, "I didn't hire you to be lazy!"

I didn't mind Mrs. Soong's attitude and bluntness. I never knew exactly the reason why my bosses back in China punished me. With Mrs. Soong, it was up to me to adjust myself and improve. I was happy with my relationship with Mrs. Soong, although I knew that I was being exploited. By American standards, Mrs. Soong owed me minimum wage. Yet who was I to demand such rights? Mrs. Soong was the hand that fed me.

One day a couple of customers left without paying the bill. By the time I ran to the parking lot, they were gone. As a punishment, Mrs. Soong made me pay. It took every penny I earned that day. A week later, while I was busy wrapping pancakes, Wen Li told me that the customer I had just served had left without tipping. It was a nice elderly couple. I

didn't know what to do. I only knew that I was not supposed to chase after customers for a tip.

To my surprise, Mrs. Soong decided to intervene. In her high-collared burgundy-and-pink Chinese dress, she went after the customers. Smiling like a blossoming flower, she asked the elderly couple, "Did you have a good time dining at my restaurant?"

"Absolutely," the couple responded. "The best meal we ever had, as a matter of fact!"

"Then would you please kindly let me know the reason you left no tip so that I can tell my waitress to improve her service?"

"Oh, no, we are terribly sorry!" The couple had forgotten the tip. They apologized and offered it.

One lunchtime, Mrs. Soong took care of a credit card bill. When she noticed that a customer left me a five-dollar tip over a six-dollar dish, she was upset. "The customer could have ordered another dish!" she said. "I hope you didn't try to hit on him, or did you!"

I hanksgiving day, we had almost no costumers. At the end of the day, I had earned negative-ten dollars due to the train fare. I felt sorrier for Mrs. Soong. She stood in front of her restaurant window and stared into the snow. All day long she was silent. Her lips pursed tightly. She must have been thinking of the money she would lose on preparing the meat, vegetables, rice, and soup on top of her rent and the salaries to the chef and his assistants.

My head nodded during art history class in the auditorium. I was so tired that when the slides came on and the professor began his monologue, I began to doze off. I put Chinese Tiger Balm on my eyelids, hoping that the discomfort would help me stay awake. The lecture was on the Mesopotamian region three thousand years ago. My English could barely grasp the basics of what was being said.

I failed the midterm in art history. I went to the teacher's assistant and asked for help. We negotiated a deal. As long as I could spell the name of the artist and remember the date the piece was created and its title, he would give me a passing score. And if I wrote a paragraph on the significance of the piece, I would earn an even higher grade. To

make it easier for me, the assistant exempted the first name of the artist. He would let me pass with "Picasso" instead of "Pablo Picasso."

On the train to Libertyville, I recited each slide's name, date, title, and significance. I wasn't aware that I was becoming sick. I had been ignoring my exhaustion. I told myself that I didn't have time to be sick. Yet my body revolted. I felt weak and was short of breath. A few times I passed out in elevators and once almost threw up in class. "Are you pregnant?" the professor asked.

I tried to keep up with my schoolwork and my various jobs. When I felt truly awful, I rested my head on my arms. *No quitting,* I kept telling myself.

One day I coughed blood. My immediate thought was, I could harm the customers if I have tuberculosis! I phoned Mrs. Soong to explain why I had to quit.

I made a doctor's appointment at a family health center in Chicago. Although I had student health insurance, my copay was 20 percent, which was still a huge amount to me.

Dr. Dutch was the one who received me. He was a gentle-looking white man. He told me that my condition was so grave that I needed to be hospitalized immediately. He told me that he had already contacted Saint Joseph Hospital, and that they were expecting me. He asked if I was with someone who could drive me to the hospital. I told him that I had nobody. "I'll take the subway."

"No," Dr. Dutch insisted. "You could collapse." He glanced at his watch and then asked me to wait. It was five P.M. He said that he would be off work in half an hour and would give me a ride to the hospital.

Two strong male nurses showed up the moment Dr. Dutch dropped me off at the hospital entrance. I was led to an isolation room where a heavyset black lady stood guard at the door. As far as I understood, I was to be tested for possible viruses.

The night in the hospital was long. I learned that it would cost me thirty-three dollars a day to watch TV in the room. I couldn't help but think that I earned only twenty-five dollars a day. The next morning I was put through a white tube. It made me feel like I was living in a science fiction movie.

I was given an IV needle. After a few hours, I felt nauseated. Fearing

medical expenses, I endured the discomfort. I wished that someone would explain to me what was going on.

My nausea worsened the next morning. I could barely think, but I tried my best not to bother the doctors. I began to hallucinate. I heard the phone ring and my aunt on the other end. I knew it was impossible, but I could hear her voice: "Do you know the cost of medical expenses in America?"

I struggled to overcome the nausea, but I felt sicker as the hours went by. I had no memory of passing out, but when I opened my eyes, a group of doctors stood around me. They talked among themselves. I couldn't understand anything. In fact I could barely hear them. They sounded like faraway mosquitoes. When one of them spoke to me, I responded, "I can't hear you."

It didn't occur to me that it might have been the drugs that were knocking the senses out of me.

I was determined not to cause any trouble. In China I was taught to endure pain. The next morning I woke up to face a different group of doctors. I realized that I couldn't hear their voices at all—not even the mosquito sound.

I endured as much as I could and didn't report how I really felt. I passed out in the end. When I woke, I was lying on the floor between the bed and the bathroom. I was no longer connected to the IV needle, as it had snapped out of my vein in my fall. I felt much better. I now knew for sure that it was the drug. I got myself up and moved toward the door. The black lady outside said to me, "Please get back into your room, now!"

After ten days of hospitalization, I was told that the doctors couldn't find anything wrong with me. The blood I had coughed up was not from my lungs. It was from a vessel between my neck and right shoulder. I asked the doctor to write down my trouble, but my Chinese-English dictionary didn't have any translations for medical terms. I asked the doctor to give me a general idea of what was wrong with me. The doctor said that it might be genetic, and that it could happen again when my immune system was down.

The doctors concluded that "depression" was part of my illness. I

looked up the word *depression* in my dictionary, but it didn't make sense. How could I suffer a depression when I didn't feel depressed?

I was instructed to see Dr. Kelly, a psychiatrist who ran an office in the basement of the school. I had neither the desire nor the time to visit her. I had enough trouble on my hands. My roommates suspected that I carried a contagious disease and were kicking me out. I was looking for a new place to live.

After more thought, I decided to see Dr. Kelly. At least I could use her to practice my English. If my English had been good enough to tell the doctors about my reaction to the drugs, I wouldn't have suffered as long or as badly while in the hospital.

Dr. Kelly turned out not to be what I had expected. She was a white woman who spoke in a soft and concerned voice. My problem with her was that she wanted me to do the talking. She gave the shortest answers when I asked her questions about herself.

Why would I want to waste time listening to my own poor English? I tried to steer the conversation back to liei. But Dr. Kelly refused to talk. She asked questions and expected me to give her lengthy answers. I became unhappy. It was a waste of time for both of us. Dr. Kelly kept telling me that I ought to "let go" by speaking. She believed that I'd get rid of my depression if I could just "release" my trouble.

"I don't see how this is working," I said.

She insisted that I needed to talk.

"What do I talk about?"

"Anything," she said. "It's my job to listen. You can discuss anything with me, for example, your deepest fear. It would be confidential."

"What does confidential mean?"

"It means that your secret will rest safe with me."

Why would she want to know my fears and secrets? She couldn't and wouldn't be able to help me even if she wanted to. She said it was her job. Did she mean that her service was part of my tuition?

I told Dr. Kelly that I didn't feel like troubling her with my fears and secrets. She said, "That's what I am here for."

"You mean it?"

"Of course."

"Okay, here it is: I fear the coming of my visa expiration date, and I fear not being able to pay off my debt."

She listened, took notes, and looked at me intently.

I waited for her response, but she remained quiet.

Disappointed, I shut up.

She suggested that I keep talking.

"I have let myself go," I said. "I have done the 'releasing.' I don't feel any less troubled. Talking doesn't help me."

Dr. Kelly insisted that we continue. We made another appointment. We met every Tuesday from noon to 12:45 P.M. It was economical to use my lunch break. Since Dr. Kelly would charge as a doctor, I imagined the bill would be high. And this bothered me a great deal.

Dr. Kelly phoned me. She said that it was rude to stop showing up without calling to cancel first. I just wanted to avoid her. Would I like to see her again? Of course not. Why? Because I hated the sound of my own voice in her little office. I could have painted a dozen roses on ladies' underwear and made three dollars.

Dr. Kelly reminded me that it was part of my medical treatment. "Your health is my priority," she insisted. I promised that I'd go and see her again. She wanted to focus on the root of my depression. She wanted to discuss my loneliness. Should I tell her that I had been using my *Sex Education* videotape? That I dreamed of making love with a real man? That I wept when I was pleasing myself? Should I let her know that the *Sex Education* videotape was a better psychiatrist?

I came up with a one-stone, two-bird plan. I told Dr. Kelly that if I continued to see her, she had to promise to correct my English. I'd get treated while improving my English. Dr. Kelly smiled, and I took it as a promise. When I showed up, I answered all her questions. But she didn't correct my English. She didn't fix even one English grammar er ror. Through the entire session I had to listen to my own voice until I caught a mistake on my own.

"You didn't fix me," I complained. "So I can't come again."

I kept dreaming of my mother dressed in black clothes. It had been three years since I had left China. My homesickness chewed at my heart. I had saved enough money for airfare, but the fear of applying for a new visa stopped me. I was afraid that I wouldn't be able to reenter America.

Through letters I learned that my mother had survived a stroke. My father was still recovering from his stomach cancer. So many times I thought of taking the chance to return home. I had heard stories of students who took that risk and were never granted a visa back to America.

In my memory, my mother always wore a cotton blouse she had dyed blue herself. In my sleep, I could feel her hand touching my forehead. I was a little girl once again having nightmares of her dying. Mother was oddly cheerful in my dreams. In Dr. Kelly's words, it was her "disguise that served to hide her deepest fears."

I remembered my mother taught me how to hand-wash the sheets. When the last bit of soap was gone and she couldn't afford to buy more, she used alkaline cleansers. We cleaned everything with alkaline and even used it to wash our hair. Once I soaked my head in it for too long and damaged my scalp.

The day I heard the music of "Silent Night" outside the Marshall Field's store in Chicago during Christmas, I wept. It was my mother's song. I remembered Mother sang the tune when she felt that her tuberculosis was bringing her closer to an end. She never told me that it was a Western song, a Christmas song, and that she was a Christian.

I fell in love with "Silent Night" as a child because it was different from songs composed of Mao quotations. I hummed it with Mother even though I had no idea what it was about. In retrospect, Mother was wise not to reveal her Christian identity. I would have reported her if she had shared her faith with me. I had been conditioned to place my loyalty toward Mao before my mother.

"Silent Night" helped my mother get through hard times. We hummed the tune together during hunger, during steaming-hot summers when we lay soaked in our own sweat and were unable to sleep, and during frozen winters when we shivered under thin blankets.

It was in America, in Chicago, at Union Station, while I waited for the next train to go to work, that I heard "Silent Night" filling the air. This time I understood, for the first time, the lyrics! And they made

ANCHEE MIN

great sense to me. My eyes filled with tears because I was unable to share my joy with my mother. I wondered how she was doing. I wished that I could afford to call her. I wanted to tell her that I had made progress in English, so much that I understood her song.

{ CHAPTER 14 }

HE RENT WAS the first thing that caught my eye. "\$80 a month heat included," the ad read. I had been paying \$150. My schoolmates paid three times as much. After I finished translating the ad, I understood why the rent was so cheap. The location was undesirable; it was in a rough area on the south side of Chicago near Twenty-sixth Avenue and Wallace Street.

I phoned the number. A male voice answered. He said his name was Peng Xu. I detected his accent and asked if he was from China. He said he was from Beijing. I was glad. Peng Xu told me that he got his graduate degree in philosophy in China and was pursuing a Ph.D. in political science. I was impressed. I told him that it was too bad that we couldn't be roommates since we were a man and a woman.

Peng Xu said there was no reason to behave as if we were still in China, a modern yet still feudalistic society. "In America a man and a woman in college share an apartment with separate rooms all the time. There are two bedrooms here. We would share only the living room, kitchen, and bathroom."

I hesitated. I liked the price but was uncertain if it was the right thing to do—living with a male stranger. On the other hand, he sounded nice and was a few years older than me. His background wouldn't be that different than mine. The fact that he was a Ph.D. candidate meant that he must be a highly educated man.

"By Chinese standards this is a mansion," Peng Xu continued over the phone "This apartment could have housed three families in China. You have complete privacy in your own bedroom."

We set up an appointment to meet at the apartment. Peng Xu greeted me. He was in his early thirties. The apartment was half below street level, a basement unit. I was not bothered because the place was clean and the surroundings seemed safe. My room was more spacious than I had expected. I was pleased that it had a window.

Peng Xu told me that he was his parents' youngest son and the

only one who made it to college. He was proud that he had brought honor to his family. His father had been a high-ranking Communist Party official who was tortured to death during the Cultural Revolution. Peng Xu was close to his mother, who was ill with terminal cancer.

I put down a deposit and was happy about the money I was going to save. The next day I moved in. The moment I put my things in my room, I discovered that my room didn't have a door. The bedroom door had been removed from its hinges. Peng Xu explained that the Italian landlord who lived upstairs had removed all bedroom doors. It was to ensure that renters didn't play the role of a "second landlord." "The landlord only wanted to rent to a couple," Peng Xu said. "I hope you don't mind that I told him that we were a couple."

"But we are not!" I said.

"It's just formality, no big deal," Peng Xu said.

Standing between the living room and the bedroom, I felt uncomfortable.

Peng Xu suggested that I hang a blanket as a curtain.

After hanging the blanket, I still didn't feel right. "I can't do this," I said. "I can't pretend that we are a couple."

"I only said it to fool the landlord," Peng Xu said. "We survived the Cultural Revolution. What else can't we survive? Besides, I have already told the landlord that you're my wife."

My instincts told me not to go ahead, but my mind convinced me that I had no choice—living below my means was a necessity.

I hung an extra blanket over my door frame. I thought to myself that I would settle for now and move as soon as I could find someplace better.

Peng Xu made a person-to-person call to his mother in Beijing every Friday night. When the international operator connected the line and asked his mother, "Is this Mrs. Xu?" she would respond, as her son had instructed, "No, Mrs. Xu is not here."

Peng Xu said this was how he avoided paying the expensive international long distance telephone fees and still find out if his mother was alive. Peng Xu was happy when he heard it more than once: "No, Mrs.

Xu is not here." His mother repeated the phrase until the operator disconnected them.

I avoided being close to Peng Xu because his clothes were unwashed and he rarely bathed. To help pay his bills, he worked as a laborer at a railway construction site on weekends. Trying to save money, he rarely visited the coin laundry. His overgrown hair stuck out from his head. Luckily he didn't need to shave. He was naturally beardless and smooth-skinned. He had a pair of sheep eyes, a flat nose, and a crooked mouth that pulled toward the right when he talked. He insisted that drinking beer was not a waste of time while doing laundry was.

Peng Xu ate while working on his research papers. He didn't care that he scattered bread crumbs on the floor, attracting ants and cockroaches. He used an old–fashioned ink pen and wrote English in a Chinese calligraphic style. He labored on his research papers until he fell asleep. His socks were covered with ink stains.

There was no furniture in the apartment. Peng Xu picked up a few chairs from the trash dump in the back lane. "America, the land of treasure," Peng Xu would sing as he collected mattresses, blankets, clothes, lamps, and cookware from Dumpsters.

Peng Xu was upset on New Year's Eve. It would be 1987. His mother hadn't answered the operator. "She didn't sound right the last time I spoke to her," Peng Xu told me. "Her illness must have worsened! She could even be dead!" He shook the phone set and punched the wall holding the receiver. "I could have comforted her. I should have had the operator connect us! To hell with phone bills!"

Peng Xu called China direct to friends and relatives and asked about his mother. "My mother is waiting to hear from me on her deathbed," he yelled as he dialed. "Her last wish must be fulfilled even if it means that I have to rob!"

I wouldn't have minded helping with the phone bill it I could make my own ends meet. I wanted desperately to call home myself. Besides her lung condition, my mother suffered from diabetes, stroke, and heart disease, and my father had developed a skin condition as a result of his chemotherapy.

Peng Xu kicked the TV set. He said that it was the only way to keep it working. The images were blurred and the figures distorted. Peng Xu

had found the TV set in the same trash Dumpster out back. He kept the volume high as if he needed to drown out everything else. Sometimes Peng Xu fell asleep and left the TV on all night.

The noise kept me awake. I found myself lying in bed waiting for Peng Xu to turn the TV off so that I could sleep. At three A.M., I'd decided I'd had enough. I'd walk into the living room and find Peng Xu sound asleep with the TV still on.

The phone bill came and it was \$450. Peng Xu insisted that I share 50 percent of the payment.

"You called China, not me," I protested.

Although his demand angered me, I paid. In the meantime, I announced that I would be moving out. I let him know that he still owed me twenty dollars that he'd borrowed for his share of the rent.

Peng Xu lit a cigarette and inhaled deeply. "As I said, I told the landlord that you were my wife when I signed the lease. How would I explain your departure?"

"It's not my business that you lied to the landlord," I said.

"My mother is dead," Peng Xu spoke, staring at the television screen. "I'll never call China again."

"She died? When?" I asked.

"Last night."

Although this was expected, I was still stunned. I imagined the sadness he was going through.

"I am so sorry, Peng Xu. I feel terrible about your loss—"

He interrupted. "I wouldn't do what you are doing to me if I knew your mother was dead."

If I had the money, I thought.

"You are not moving out." Peng Xu pinched the cigarette butt between the cracks of a broken floor tile. "I can't afford this place alone."

I was jolted from deep sleep. Peng Xu was on top of me.

Holding tight to my blanket, I asked, "What are you doing?" He didn't answer but wrapped his arms around me.

"I dreamed of my mother." He was crying. "She asked for me! She kept asking for me!"

THE COOKED SEED

The room was as cold as an icebox. The wall was black. The more I tried to push him away, the tighter he held on to me. He sobbed like a helpless child. I let his arms stay around my shoulders.

I told myself that I was moving out in a week, that I would no longer have to put up with him. I would be nice to him for one last time. There would be no more fighting. No more arguing over phone bills, or his leaving the television on all night. I'd soon be able to sleep. He had lost his mother. He didn't get to say good-bye to her. "This is not Mrs. Xu" were her last words to him.

His hands began to move over me. He tried to kiss me.

"No, please, Peng Xu."

He refused and forced his way. He grabbed my breasts and said, "Shush! Nobody will know."

I pushed him. "Please stop!"

He apologized but continued what he was doing.

I tried to reach the light, but he pinned my arms down. The weight of him was crushing me.

"I need you." He buried his face in my chest. "I beg you."

"Please get off me!"

"My mother sent me baby clothes she made herself," he said in a strange voice. "She was an accomplished knitter. She quoted Confucius to me: 'On all counts of bad piety, not to provide offspring counts as number one.' . . . I'd love to give her a grandchild, but you and your type won't even look at a man like me. No woman desires a man who is poor—not in a capitalistic society—no matter how rich I am intellectually."

I began to scream.

He covered my mouth with his hand.

I struggled.

His hand pressed harder into my face.

"Don't make me hurt you." He held my ear between his teeth. "Be a nice girl."

My tears came as I realized that I was unable to fight him.

"You can get me pregnant!" I begged, "I am not protected."

He kept going. "Don't wake up the landlord. Please, pretend that we are lovers. Pretend, for once."

My mind's eye saw glittering water under sunshine. It was the Shanghai Huangpu River, where I had once envisioned drowning myself.

He cried out on top of me. He removed himself and then exited the room. I heard him turn on the TV.

I missed my period. I made a call to the Planned Parenthood hotline and asked for the cost of an abortion.

"Five hundred dollars," was the answer. I only had three hundred. I ran into Stella in the school hallway. She asked how I was doing. I tried to sound pleasant, but Stella detected something. "Are you sure you're okay?"

"I have to run to work," I said. I was afraid that I might break down and cry.

"Let me know if you need any help," Stella said. "I bought a car. It'o a junk, but it runs great."

I walked across State Street toward the Wallace bus stop. I was tempted by the McDonald's ad for a ninety-nine-cent burger at the corner of Jackson Street, but passed it by. I prayed that I was not pregnant. I prayed hard.

The bus was late. The wind felt like needles on my skin and my toes were becoming numb. I covered my head with a scarf. Soon the moisture from my breath made my eyelashes stick together.

I decided that I would save the bus fare by walking back to the apartment. I walked as fast as I could. It was impossible to escape the thought that I might be pregnant. The snow-covered street became quiet once I was beyond downtown. By the time I reached Chinatown, the streetlights were on.

I saw an old lady walking ahead of me. She slowed down and appeared to be having difficulty. Before my eyes, she dropped her wallet.

I picked up the wallet and called out to her. "Madam, you dropped your wallet!" She was an elderly, gentle-looking black lady. She thanked me for the wallet.

"You don't know what can happen to me if I lose this," she said, opening her wallet. She showed me cash worth a few hundred dollars and identification cards. The lady pulled out a piece of paper with printed pink dots. She told me that it was her lottery ticket, and she had just won \$50,000.

The old lady said that she would like to share some of her profit with me as a gesture of gratitude.

"I don't think I deserve your money," I told her.

"It's a gift!" She insisted. "It wouldn't be much, two thousand dollars."

"I can't, but thank you."

 $\rm ``Iinsist."$ The lady grabbed my hand and smiled warmly. "I can tell that you could use the money."

Of course. I thought about the cost of an abortion. Two thousand dollars would not only cover the cost of the abortion but also help me escape Peng Xu.

As if reading my mind, the old lady said, "Sweetheart, I want you to have it. God bless you. You deserve it."

The lady explained that in order to cash the lottery ticket, there was a procedure. "It's standard." She said that she was waiting for her two nieces to pick her up and drive her to the money exchange. "Do you know the money exchange on South Halsted and Thirty-first Street, across the street from the public library?"

I said that I wasn't sure.

"Follow me, honey," she said.

A burgundy car pulled over. The old lady introduced me to her nieces, Clara and Mimi, both well-dressed black ladies in their thirties. Clara was the driver, and she invited me to sit in the passenger seat. They thanked me for my good deed and told me that I must take the token from their aunt.

"Let's go to the money exchange," Clara said.

We parked across the street from the money exchange. Mimi took the lottery ticket from her aunt. "I'll be right back." She waved and smiled at me.

I watched her enter the money exchange. I felt uneasy that I was in a stranger's car. I turned to look at the old lady and Clara, who chatted

warmly. Clara asked the aunt if she had been following her doctor's instructions to take her arthritis medication. "You are not going to enjoy the money if you can't walk."

I saw Mimi making her way back across the street. She got into the car. "The money exchange needs serial numbers in order to cash the lottery ticket." She turned to me. "Can we borrow some of your money so we can get the serial numbers? Don't be afraid, this is how the lottery system works. Trust me. Where is your bank? It's just a technical thing we need to take care of before getting you the two thousand dollars. You need to go to your bank and withdraw cash. The money you take from the bank will have serial numbers printed on it. The number is invisible to the human eye, but it is there. In order to get one hundred dollars, you must take out one hundred dollars first."

I was confused. I didn't have \$2,000 in the bank. "Thank you, but it is too much trouble," I said. "Good-bye."

"No trouble at all, honey" the three of them said

"What's the name of your bank?" Clara asked.

"Citibank."

"Oh, it's right around the corner," Mimi said.

"Let's go." Clara started the car.

"Never mind, truly," I said.

"Don't you leave without my gift." The old lady put her hand on my shoulder. "It will take just a minute."

Clara and Mimi followed me into the Citibank. We moved to the front counter. I asked to withdraw all the money I had in the account.

"The total is \$300.61," a bright-eyed young clerk said. "Would you like to leave the sixty-one cents so that your account remains open?"

"Sure."

"Three hundred dollars, that's all you have?" Clara appeared disappointed. "Do you have another account?"

"No," I replied.

"It's a dollar-for-dollar match," Mimi reminded me. "With the three hundred dollars you can only get six hundred. For two thousand dollars, you need at least one thousand."

I gave Clara my three hundred dollars and told her that it was all I had.

THE COOKED SEED

Walking out of Citibank, we headed to the money exchange again. This time Mimi returned saying that the money was ready. However, to get it we had to go to a money exchange at the other side of the town. "The traffic is awful at this time," Clara said. "How about we let you off and meet you two hours from now at the public library to deliver your money?"

Before I could respond, the three of them shut the door. "Bye! See you at five." They waved and the car pulled off.

Suddenly I felt a kick in the gut. "Three hundred dollars is all you have?" The sound of Clara's disappointed voice stuck in my mind. Was I a fool?

I arrived at the public library at five p.m., but the ladies never showed up.

For three hours I waited, standing on the ice. My mother's words came to mind: "Flies land only on cracked eggs."

{ CHAPTER 15 }

WAS DISCUSTED AT the sight of Peng Xu. The pregnancy-test kit had revealed that I was pregnant. I was ashamed of myself.

I entered the apartment and took off my ice-covered boots. Peng Xu was in the kitchen making his dinner. I went into my room and began to pack. Two suitcases were all I had. I didn't know when and where I would be moving. I simply had to do something in order not to break down. Packing made me feel that I was doing something toward an escape.

I planned to get up early in the morning. I'd visit the city community college and check its housing bulletin board. I had to find a place that would fit my budget.

"We need to talk." Peng Xu's voice came from the kitchen. I heard him turn off the television.

I closed my suitcase and said, "There is nothing to talk about. I have already told you that I'm moving."

"You signed a one-year lease."

"No, I didn't. Your signature was the only signature on the land-lord's lease agreement."

"But you verbally agreed to live with me."

"Not after what you did to me."

"I am in trouble, you see. I need your help."

"Find another roommate or move."

"You gave me too short of a notice."

"It was twenty-five days in advance."

"That is not enough."

I knew it was useless to argue. I was thinking about spending the night on the floor of the film-editing room at the school. The trash bags would keep me warm.

"You are not walking out on me!" Peng Xu banged the wok on the stove. He then came into my room. We were face-to-face.

"This is America," I said, staring into his eyes.

THE COOKED SEED

"You know what Communists used to do to those who betrayed the Party? Shoot them."

I picked up my school bag and moved toward the door. "I am leaving," I said.

"But I am not done talking!" He came to stand between the door and me.

"Let me through, please."

."The landlord upstairs is listening." He pushed me to the side and then slammed the door shut. "You don't care about our reputation as Chinese. I do. Let's go inside the bathroom and talk. Please at least make an effort to work things out."

"Why the bathroom?" I asked.

"So the landlord won't hear us."

I let him know that I was no longer interested in speaking with him. "I am through with this."

"It won't be long, I promisc."

I stood, unmoving.

"Come on. I'll let you go after we talk."

I took off my school bag, thinking, *This will be the last time I'll let him bother me.*

He pointed to the bathroom like a traffic police officer.

I entered the room and switched on the light. He followed me. He immediately switched off the light and shut the door behind him.

"What are you doing?" I sensed danger.

In pitch dark he pushed me against the wall.

I couldn't see, but I heard the sound of his heavy breathing.

"Please, turn the light back on—"

Before I could say another word, I felt his hands on my throat.

"No!" I cried out.

His hands were a pair of steel claws. He pressed and squeezed.

My neck felt like it was breaking.

We wrestled, but I was not his equal. My strength began to weaken as my airway was cut off.

I realized that I might die tonight, here, in this bathroom, in a foreign land. My thoughts went to my mother.

He must have thought that I was dead when he tossed me off.

I didn't know how long I remained unconscious. When I woke, I heard the sound of the television. I was lying on the concrete floor in the bathroom. The killer was in the living room.

Run was the first thought that entered my mind. I thought about the back door, which we rarely used. I started across the floor. A shooting pain from my neck stopped me. I looked at the dead bolt and imagined turning the knob. Behind this door was an exterior door at the end of a short hallway. I had to get through both.

I kept an eye on Peng Xu as I continued crawling. I reached the bottom of the door. As I rose, grabbed the door, and was about to open it, Peng Xu heard the noise. He came toward me with a Coke in his hand. He seemed surprised.

Peng Xu was behind me when I opened the exterior door at the end of the short hallway. He yelled, "Give it up, bitch!"

With all my might I pushed him off. I ran into the snow-covered street in my socks.

Peng Xu followed.

I cried, "Help!" But there was no one, no cars, no bus. The snow was about a foot high. The houses had no lights on.

I kept making turns into the alleys and dark streets. I tried to lose him, but he was getting closer. I headed toward the Wallace bus stop, where I knew there was a phone booth next to a Chinese takeout café.

After making one last turn, I was inside the phone booth, and I watched him run past.

Who to call for help? My mind raced. "Stella!" Her phone number was the only one I could remember.

"You don't sound okay," Stella said as she picked up the phone.

I told her that there had been an emergency. I asked if she would come and pick me up at the corner of Wallace and Twenty-sixth Street by the bus stop.

"I'm on my way," Stella said.

I waited by the pay phone booth, trembling and freezing. The snowflakes came down like white feathers. In my icy socks, I couldn't feel my toes.

THE COOKED SEED

An hour later Stella's car pulled up. She opened the passenger door to let me in. "What's going on?"

I broke down sobbing.

She discovered the bruise on my neck. "Oh, my God! You have been strangled! Who the hell...your roommate?"

I nodded.

"Did you call 911?" Stella asked. "No? Why not? Would you like me to call 911 for you?"

I shook my head.

I let Stella know that I wanted no trouble.

"Anchee Min, for God's sake, that son of a bitch just strangled you!"

"I know."

"He could have murdered you! What is wrong with you acting like it's your fault? I am driving you to the police station!"

The streetlights were dim and the roads barely visible in the snow. Stella drove down the middle of the street. She didn't know where the nearest police station was. She wanted to stop and make a call.

I was having a hard time thinking of what I would say to an American police officer, or a group of police officers, about what had happened to me. Would they believe me? Would they think that I had asked for it? I couldn't say that I hadn't invited the trouble. Nobody had forced me to move in with Peng Xu. The police could say that I was a grown woman and should be held accountable for my own actions. I knew that my bedroom had no door, but I still chose to stay. I had put myself in a vulnerable situation for cheaper rent.

Stella told me that if I made a police report, Peng Xu would be arrested and deported back to China. The thought burdened me. Peng Xu's future would be destroyed and his entire family devastated. It would dishonor his dead mother. Her soul would never rest in peace. If I was 1 percent at fault, I was at fault.

"I don't want to go to the police," I said to Stella.

"Why not?" Stella turned to stare at me. "This man has committed a crime!"

"I survived," I said. "Would you let me spend the night at your place?"

I asked Dr. Kelly if she knew of a low-cost abortion clinic. She gave me the number for the Rape Hotline.

"What's your budget?" a woman on the other end asked.

"One hundred and fifty dollars is all I have," I replied.

She told me to hold on. A few minutes later, she returned and told me that she had booked me an appointment at a nonprofit clinic.

At the clinic I was asked to first confirm that it was a rape case. I was asked the name of the rapist. I was afraid to give the information in fear that Peng Xu would distort the truth. He would say that I had seduced him. I told the doctor that I would like to leave.

"You don't have to give us the name if you don't want to," the woman at the clinic's front desk said. She also told me that I needed to wait for two months before the surgery.

"Why?" I asked, frustrated.

"It can't be done when the fetus is too small."

For the next two months, I tried to shut my mind off while I dealt with the pregnancy symptoms. When I felt nauseated, it was hard not to feel the life I carried. I was unable to sleep at night. I recited the alphabet and let the tears wash my face. I looked for a new place to live, went to classes, and tried my best to act as if everything was fine. I didn't tell Stella that I was pregnant.

It was Monday—a clear day—when I went for the abortion. On Michigan Avenue, nicely dressed people were taking their lunch breaks outside under the bright sun. I told myself to be glad that today would be the end of my agony. Two months of torture, I desperately wanted to believe that the abortion would help me move on, but I was not sure if I would be able to. I tried not to cry.

My family sent me letters from China asking how I was doing. I wrote back saying, "I am doing great. School is great. America is great."

The clinic was quiet. The nurse took my urine sample and blood test to confirm the pregnancy. The clinic policy was read to me,

THE COOKED SEED

and I was asked, "Is there anyone we can contact in case of emergency?"

I answered, "No."

"Are you with someone?"

"No."

"Your husband? Boyfriend? A family member? A friend?"

"No."

"Miss Min, I understand that you want privacy, but someone has to drive you home after the surgery. You will bleed. Some women bleed quite a lot. There is risk involved. Do you understand?"

I nodded but said nothing.

In the changing room, I put on a paper gown. I was led into a small room, told to lie down, and was left alone facing pictures on the wall of a woman's uterus, with a baby growing inside. I turned away and burst into tears.

The doctor and his assistant came in. Putting on his rubber gloves, the doctor said, "Are you ready?"

"Yes," I replied.

He saw my tears and paused. "Are you okay?"

"I am okay," I said.

The doctor and his assistant quietly exchanged words. The assistant left the room and returned with a middle-aged woman. She introduced herself as a counselor. "I am here to support you." She sat down next to me.

A blue paper blanket was put over my lower body and the surgery began.

I clenched my teeth as the pain came.

The counselor spoke to me softly and told me to relax.

I couldn't relay with her holding my hand. I needed to deal with this by myself. I didn't want to be rude and tell her to go away.

The doctor and his assistant were working their way into my body. I felt the pull inside. The pain was overwhelming.

The counselor wouldn't let go of my hand. She mumbled something about sharing my pain.

By the time the surgery was over, I was about to pass out. I was in so much pain that I forgot to thank the doctor.

I was wheeled to the recovery room, where a sturdy-looking nurse received me. She spoke with a Hispanic accent. She asked me if I wanted a "chicken ball."

I told her I didn't want any chicken ball. She said, "Everybody has chicken ball after the surgery. It will make you feel better. Think about it, please, take your time."

Would I have time? I had to be at work at the student gallery by four o'clock. Missing work might give my boss a reason to fire me. I worried that I wouldn't have enough time to walk to the gallery.

"I'd like some chicken ball, please," I said.

The "chicken ball" turned out to be "chicken broth."

It was my first time tasting chicken broth. Like the nurse said, it made me feel instantly better. From then on, I associated chicken broth with the abortion.

In the middle of my walk through downtown Chicago, I started to bleed heavily. By the time I reached State and Adam streets, blood was dribbling down my legs despite the diaper the hospital had given me. I leaned against a newspaper stand and then sat down on the curb.

I felt dizzy and feared that I might pass out. The school was only a block away. I could see the two stone lions in front of the museum.

I made it to the school and changed before going to the gallery. The diaper was true to its Super Pamper name—the blood must have weighed over two pounds, yet the Pamper had not fallen apart.

The gallery boss was glad that I was on time. "There is a list of things I need to talk to you about before tonight's opening," she said. "By the way, would you be able to stay a little longer to help with the cleanup afterward?"

My head was spinning. The boss now had two heads and four hands.

"Sure," I managed to say.

PART THREE

{ CHAPTER 16 }

The summer of 1987, I returned to China for the first time in three years. I had anticipated the trip for so long that I almost couldn't believe that I was finally going. I wished that there had been a way to secure a return visa before my departure, but it was impossible. I had to first exit America and then apply for a reentry visa. There was always the possibility that I could be denied. I assumed that the visa officer would understand that, after three years, I needed to see my family. Refusing my reentry visa would mean denying me the opportunity of completing my degree. I would argue: Why bother issuing me a visa in the first place?

What gave me the courage was that now I spoke English, I would fight like an American. I'd let the consul know that I knew my rights.

My motion sickness didn't seem to bother me on the long flight. When the plane touched down, my emotion spilled over into tears. The moment I saw my parents standing among the crowd at the Shanghai airport, I ran toward them. Age had taken its toll on both of them, especially my mother. She had lost all her teeth and looked frail. My father told me that she had begun to show signs of dementia. I was yet to know how rapidly the disease would progress. It pained me to see her in such a state. She needed my father's help just to stay upright.

I hugged my parents in the American style. My affection took my mother by surprise, and her dentures fell from her mouth.

I was sad to see that my father had become bald, due to chemotherapy. He had once been so handsome that people often mistook him for my brother.

At home I reunited with my siblings. Our family still lived on the same crowded lane in the same place—one room with an enclosed porch. The building had deteriorated so much that the floor had begun to sink. The wooden staircase slanted toward the right side. The dark hallway was piled with dusty bamboo baskets and old window frames wrapped in plastic sheets. I told my father that I would help remove the

junk to make room for walking. My father shook his head and whispered that the neighbors might claim the space for their own storage.

Our family conversation at dinner was warm. None of us anticipated that it would turn unpleasant. It began with me talking about America. About how advanced and wonderful the country was, and what it was like to be treated with dignity, respect, and kindness. I described how much I enjoyed my life as an international student, and what China should learn from America.

I regretted my words in retrospect. I wasn't aware of how Americanized I had become. I was bragging about my full belly in front of people who were starving. I was neither sensitive nor careful about what I was saying. I didn't pay attention to their open wounds, the fact that two of my siblings had been rejected for US visas and now my younger sister was too afraid to even apply.

I had thought that the best gift I could offer my family was to share my honest thoughts. I said that the greatest thing I had discovered in America was who I was. My journey hadn't been a smooth one, especially on the job-hunting front, but the key was that I was no longer afraid. I wouldn't let my life be defined by anything, not even a green card. I had confidence that I could make it elsewhere if I failed in America. I'd go where I would be appreciated, and that included China. Part of my purpose in returning home was to explore my options.

My family was quiet as they listened. I could see confusion, uneasiness, and disapproval on their faces. I went on, certain that they would understand and support me. I told them that I was inspired by a newspaper clipping Father had sent me. It was the story of rural China, a village principal, and the only teacher, who was dying of cancer. He summoned his daughter to take over his teaching position. The fourteen-year-old daughter sacrificed her middle school education in order to help her father.

"I'd like to help promote public education in China!" I said. I told my family that I could see myself as a teacher. I would make use of my degree in visual art. I would also introduce American pop music: It would be good to hear Chinese people say "I love you." Love would be a great new theme to explore. One could learn a great deal about democracy and individualism through pop music and art.

I waited for my family's response, but none came.

Finally my father broke the silence.

"Anchee, have you forgotten that you once denounced your teacher as an American spy?" My father was unable to hide the disappointment in his voice. "What makes you believe that you wouldn't be denounced as an American spy and suffer the same fate?"

I rebuffed, "Father, it is people like you, who live in fear, that have kept China backward!"

"You talk like you didn't grow up in China," my sister said.

"Is there something wrong?" my father looked at me suspiciously. "Are you okay? Why are you speaking about promoting public education in China, instead of America? Are you afraid that you are not able to make it in America? You don't have the luxury to speak like this, my daughter, let me remind you. Our family has a long way to go in terms of paying off our debt and meeting our basic needs."

I was supposed to rescue the family. How could I have forgotten that? So far I had done nothing but harm—ruining everybody else's chances of obtaining American visas.

My mother said she had trouble understanding what we were talking about.

My siblings did their best not to voice their disapproval.

As I continued to explain myself, my elder sister and younger brother removed themselves from the dinner table and began to clean the dishes.

I raised my voice as I quoted Mr. Rogers: "The best gift you can offer to anybody is your honest self."

It was at this point my younger sister burst into tears. "Who are you trying to fool?" she said to me. "Since when have you lost touch with reality? Help promote public education in China? How can you forget that all of us have been waiting for you to help us to escape misery? We received rejections one after another from the US Consulate. You were the only one who succeeded. The only one who jumped over the dragon's gate! You escaped! You took the spot! And you don't bother to look back or to check how low we fell, how hard we hit the ground, and if we were bleeding inside or dying.

"You were blessed with luck, strength, and smarts. You owe this

family. What have you done for us? Other people who have gone to America have rescued their family members. The Wong brother from the next lane who went to America helped his sister get there too. The elder son of the Wei family in the next street helped to immigrate his entire family to America.

"You're my only hope. I had to go to the labor camp because you got picked by Madame Mao. I had to take your place. I work as a laborer at the electric-switch factory for a few dollars a day. I am twenty-eight years old. I have been waiting for your rescue. I trusted that you would do what you are supposed to do as an elder sister. But you told me that you couldn't help me unless I produced a TOEFL score of five hundred. I do not speak English, and I am not allowed to take time from work to take lessons. You do not mean to help me. You are watching me drown and refusing to offer your hand.

"What have you done in the past three years? You studied art! You enjoyed being treated with respect and kindness. You do not care if we suffer in China. You do not care that I do not have a life here, and that my hair is turning white as I wait for your call. You are nothing but a hypocrite! I hate you! I hate you!"

Although filled with guilt, I didn't feel that I deserved the accusation. I could not accept my younger sister calling me a selfish, cruel, and heartless bloodsucker.

I shot back, "I have tried my best in America! You don't know what I have gone through!"

I turned to my father and proposed that I give up my visa so that my sister would have a chance to go to America to try on her own.

My father rejected my proposal. He said, "I would consider it if your returning would guarantee your sister or brother a visa to America. But it would not. You might end up sacrificing your own opportunity for nothing. Our family might end up losing both the hen and the egg."

I wanted to run away from my family. I located my best friend from the labor camp, Yan, the former commander. I went to her old house only to discover that the entire neighborhood had been turned into a construc-

THE COOKED SEED

tion zone. I left messages with a mutual friend asking for her. A few days later I received Yan's letter. She instructed me to quit looking for her.

"I don't want to show my face to anyone," she wrote. "I don't want to see anyone. I appreciate your thoughts. I know you will remember me, and that is enough to comfort me." As for her life, she said that she had developed chronic headaches, which crippled her ability to study for college. After the Cultural Revolution, she became a teacher at the labor camp's elementary school. In 1986 the labor camp was closed. "A businessman from Taiwan bought the land. He turned it into a chicken farm—a supplier of Shanghai's Kentucky Fried Chicken."

Yan revealed that she was now making a living as a fruit vendor. She also sold home-cooked baby food. Occasionally, she exported handembroidered clothes to foreign countries. She ended her letter by saying, "I would like you to remember me the way I was, not the way I am."

In my remini letter, I begged for a chance to see her again. I mailed the letter enclosed with a check for four hundred dollars. Yan returned the check uncashed and left me with no word.

I went to the US Consulate in Shanghai to apply for my reentry visa. The crowd reminded me of how fortunate I had been. Inside, the visa officer asked me what I would do after graduation. I said that I didn't know, but I was in Shanghai seeking a future job position. The officer granted me the visa without further questioning.

Two weeks later, I bade good-bye to my family.

Upon returning to Chicago, I responded to a listing for a tiny storage room on 4311 South Halstead Street next to a parking lot. Its only window was a foot-square glass pane that couldn't be opened. There wasn't enough space for a twin-size bed, so I slept on a little two-foot-wide sofa that took up half the room. Although there was no kitchen counter or stove, the landlord had installed a makeshift shower, a minisink, and a toilet. The rent was \$150 a month including heat and utilities. It was the cheapest place I could find in Chicago.

I was thrilled with the privacy. For the first time in my life, I might have a place that I wouldn't have to share, a place of my own. I had to beg the landlord to rent it to me because he was concerned about my safety. He had intended to rent the space to a single man who would use it only for sleeping. I convinced the landlord that I was no weakling. I told him that I had been riding the subway at night for years. I showed him my "scissor hand"—how I would hold each key on my key ring between my clenched fingers and punch if attacked.

The landlord warned me not to be frightened of the man next door who wore orange clothes. He was a retarded man named Nick whom the landlord looked after.

"Nick is harmless," the landlord promised.

It took me a while to get used to Nick's strange habits. Besides the orange hat and clothing, he talked loudly at night, perhaps to himself. I wasn't prepared to deal with his stink, either. I hadn't noticed until I moved in that the dividing wall between Nick and me was not fully closed. The two feet from the ceiling between Nick's toilet room and my room was open. I had assumed that it was sealed with glass.

When I complained, the landlord said, "This is why the rent is cheap. It is a storage space."

Lying awake at night, I asked myself the question, "Who are you, Anchee Min?" If I ever had a chance to learn what it meant to "stay positive," it was now. I did not yet know the American I was becoming, but I was sure that I was no longer the same An-Qi from China. I, who was defeated, was refusing to accept the defeat. I was broken yet standing determinedly erect. I could be crushed, but I would not be conquered. And that, I concluded, was who I truly was. Who I would be.

{ CHAPTER 17 }

ENEW PRACTICALLY NOTHING about her, but from the first I was desperate for her friendship. Beneath our differences, I sensed that we had something in common. Margaret was her name. She caught my eye because she stood out from the crowd. She was a graduate student, an interior designer who owned her own business. She was shy and her face blushed as she spoke. When I asked her why she was taking the class, she said that she was "searching to explore and to rediscover."

Unlike me, she didn't seem self-conscious about being older. Most people in the class were half her age; being older was something that I was burdened by. I felt inadequate and embarrassed among all the young students. I knew too much and yet nothing at all.

In her late thirties, Margaret was a beautiful woman who had Elizabeth Taylor's eyes, a lovely figure, and a gentle voice. She was goodnatured and easygoing. She laughed like a child and made those around her feel comfortable and invited.

Looking back, I was amazed that I approached her so boldly. The class where we met and became friends was American Design Since 1945. She would usually arrive late, having come directly from work. Still dressed in her elegant work clothes, she would apologize for disturbing the class and slip into the seat I had saved for her. It was a convenient way to show my enthusiasm. By the time she had driven through downtown Chicago, parked her Volvo, entered the building, and reached our classroom, the slide show had already begun and all the good seats were taken.

Although I didn't want to bother her, the professor's vocabulary was beyond me. I spent most of my time looking up words in my dictionary. I asked Margaret for help when I missed the professor's comment on a slide.

"Margaret, what does 'eerie foreboding' mean?" Margaret turned and whispered into my ear. But I still couldn't spell it. I opened my dictionary and was unable to locate *eerie*. The struggle exhausted me.

I failed the midterm exam, while Margaret received an A. She was sympathetic. She asked why I would take a course that was beyond my reach. "Aren't you here like the rest of the kids to express yourself?"

I told Margaret that I wished that I was here to express myself. I was miserable because my days in America were numbered. "I am fighting for my survival."

She looked at me for a long moment, then turned her head back to the professor. From that moment on, without my asking, she would write down the words that she felt I would have trouble spelling into my notebook. I was able to focus on looking up the words in my dictionary and follow the class. Occasionally Margaret would also lean over my shoulder and explain the meaning of a difficult phrase the professor had just spoken.

I improved quickly. To negotiate with the professor for a paccing grade, I produced a paper with illustrations entitled "Chinese Communist Design Since 1949," for which I received an A minus. Margaret was happy for me.

One day we left school together after class. It was dark outside and I accompanied Margaret to where she parked her car in an underground parking lot. She was grateful and asked if I'd like a ride home. She looked alarmed when I told her my address. "South side at that number? You know how rough the area is?"

"The rent is very cheap." I smiled.

Margaret shook her head as she started the car. I suggested that she drop me off at the Halstead bus stop. "Seven blocks down."

"Why seven blocks down?" she said. "How about at the nearest downtown stop?"

I told her the stop seven blocks away would save me a quarter from the bus fare. "A dollar twenty-five is my budget," I said. "I can save five dollars per month."

When Margaret wanted company, she took me to her job at a client's home on the north side of Chicago. During the ride Margaret would put an Aretha Franklin tape into the cassette player and begin to sing along. Over the years of our friendship, she would be my guide not only to the best American pop music, but also to art, architecture, design, and fashion. In my eyes she was everything I wanted to be. In her company, I felt grateful and privileged.

Margaret never made me feel inadequate or small. If I made a mistake, she let me find out on my own. She earned my respect and trust for what she chose not to do. She understood my sensitivity and awkwardness as a new immigrant. Most Americans I encountered treated me with kindness and respect, but they generally didn't have any interest in me either. Fried rice and fortune cookies were about as much as an average American knew, or was willing to know, about China. I had never met anyone like Margaret. She was sincerely interested in China. She loved Chinese culture, art, philosophy, and architecture. Her favorite book was Pearl S. Buck's *The Good Earth*. Since childhood, she fancied that her former life was as a Chinese peasant.

Our friendship blossomed. One day I invited Margaret in after she dropped mc off. I was glad that Nick hadn't produced his stink that day. In her Armani suit, Margaret entered my little storage room. I heard her draw her breath. "Oh, you make me feel so guilty!"

I admired the fact that Margaret had no trouble speaking her mind. As a Jewish American, she believed that I was wrong to judge Jerome, the young man who had attempted to hang himself in class.

"Are you not flawed?" Margaret questioned me. "You call Jerome's act selfish and foolish, but what do you know about him as an individual and his situation? Do you have any idea of his background? What kind of childhood he might have had? Were his parents abusive? Does he have mental problems that he fights to control? Shouldn't you try to wear his shoes and walk his path before you criticize?"

I loved Margaret for these questions. Through her, I learned my own narrowness and smallness. One thing she said that stuck with me was, "You think you were deprived because you suffered under the Communist dictatorship, but you had your parents and their love. The real deprivation is being betrayed by your own parents. It'd destroy the core of a child if he was abandoned and abused by people he trusted the most. Can you imagine being raped by your mother's boyfriend at a

young age, being blamed for it, and beaten by your mother? Can you imagine the devastation, hurt, and confusion?"

Margaret humbled me. She put seeds in my head and they sprouted inside me. Margaret was my enlightenment. I wanted to know more about her and learn from her. I concluded that until I met Margaret, I had been wasting money and time at the school.

Originally from Cleveland, Ohio, Margaret had been adopted by a middle-class American family as an infant. She didn't know her birth mother—who, as she found out later, was deaf and blind. Margaret would not have children for fear of passing on her damaged genes. When she met me, she had been married, divorced, engaged, and disengaged three times. She was an extremely attractive woman. She described herself as part of the "baby boomer generation."

I asked what it meant when Margaret talked about "Woodstock." I wanted to learn about the period, especially the "sex, drugs, and revolution." Years later Margaret would recall that period as my "age of innocence." She adored who I was then. "Bright-eyed and not yet corrupted."

Through Margaret, I glimpsed an intimacy that I hadn't experienced for a long time. I became more attentive to Margaret than ever and did everything I could to spend time with her. My loneliness had finally found a balm. I pursued Margaret as if she were my lover. I was fascinated by the way she attracted men, and I wanted to learn from her about that, and everything else.

I visited Margaret's office. It was a small interior design firm. Margaret was surprised to see me. She was more surprised when I asked if I could help. "I'll work for free. Just for the experience." My real thinking was: This could be an opportunity—I had to start somewhere.

"If you like," was Margaret's response.

For the first week, I helped clean the office. I learned to use the coffeemaker. I ran errands in the downtown area. The second week, I became exhausted because I had to carry on with my other jobs and

schoolwork. The third week, Margaret began to feel bad and tried to get me to leave. Hoping to learn on the job, impress Margaret, and possibly get hired, I signed up for an interior-architecture course at the school. The professor threw me out because I was unable to follow.

"I need a trained draftsman," Margaret said finally. "You are wasting your time here, Anchee."

I begged her to let me stay. "I am good at improving myself."

She shook her head and sighed. "I know you are after the H-1 visa. I'd help you if I could. The truth is that my firm is barely surviving. I have consulted an attorney. He told me that the H-1 visa requires a salary, and I don't have the budget!"

I said good-bye to Margaret and promised that I would not bother her again. Margaret pleaded with me not to be upset. "It's been hard for me to get clients," she said.

I felt indebted to her. I would have done the same if I had been her. She had never promised me anything in the first place.

Deepening my distress, I was let go as a waitress at my Chinese restaurant. The owner had decided to comply with immigration law, which forbade the hiring of noncitizen workers.

I begged my boss at the school's new student gallery for extra work hours. The gallery was located in the middle of the abandoned industrial area on Huron Street. "Neo-abstract Expressionism" had been the theme of most of the exhibitions. There were few visitors. I noticed that the artists had begun to incorporate paintings with installations. The works included a broken tire nailed with a worn shoe, or a bloody bedsheet draped over a pile of trash. The artists devoted themselves to their projects with absolute dedication. I watched them labor tirelessly to install, deinstall, and reinstall.

Opening nights were what the artists lived for. People came for the party, the food and drinks. The rest of the time during the exhibitions, I was the only soul in the well-lit but empty space. A few times I switched off lights to save electricity.

Graduation approached and I was still without a job prospect. I

ANCHEE MIN

tried and failed repeatedly. In a handful of interviews I got—for example, for an art-teacher position in a district nicknamed Little Saigon—the employer wouldn't consider paying an immigration lawyer fees to change my status to H-1 visa. I learned that my bachelor of fine arts degree counted for little in the job market. To maintain my legal status and gain time, I applied for the master's of fine arts degree and became a graduate student. Although I was temporarily sheltered immigrationwise, I lived like an ant crawling on a hottening wok. Not a day went by that I did not envision the ultimate disgrace: returning to China emptyhanded.

{ CHAPTER 18 }

A NEW FACE APPEARED at the gallery one fine morning during the spring of 1988, ten minutes before the end of my shift. The visitor was a Chinese man in his late twenties. He was slender, of medium height, and had the classically handsome look of a Southern Chinese. He had a pair of bright single-lid eyes, and his skin was so fine and smooth that it gave him a touch of femininity. His silky black hair was combed toward the back of his head. Smiling like a rose, he introduced himself.

"My name is Qigu Jiang. It is nice to meet you. I arrived from Shanghai two days ago. I am here to take over the next shift."

He didn't carry the usual fresh-off the boat immigrant look, nor did he appear disoriented by his new surroundings. Instantly I lound myself wondering where his confidence and ease came from. His face beamed as he surveyed the exhibition. He wore a Western black silk suit and a long gray coat. Around his neck hung a bright-red scarf made of wool. I was impressed. Later I'd learn that he had picked up his ward-robe from the local thrift store.

I asked the meaning of his name in written Chinese. He was pleased to explain. "Qigu, as 'unique valley."

"This is not a working-class name," I said, already sensing his family background.

"You have excellent sense." He smiled. "No, it's not a working-class name." He said the Jiang family had been the wealthiest in Zhejiang province until the 1949 revolution, when Communists took over China. The family was evicted from the home that had been built by his great-grandfather during the late Qing dynasty. Mao personally claimed the old Jiang mansion. The government also confiscated the Jiang family land, temples, and collections of art; these included valuable ancient scrolls of Chinese calligraphy. "It's just another boring story," he said. "How about you? How's life in America? Do you miss China?"

I told him that I missed everything Chinese, especially reading.

"That's strange," he responded. "Most would say that they miss Chinese food."

"I have been avoiding speaking the mother tongue for years."

"Why?" he looked at me intently. "How can you?"

"It is the only way to learn English. Survival depends on my ability to communicate."

He smiled and said that my English sounded excellent.

"You are not bad yourself," I complimented him. "Where did you learn to speak English?"

He told me that he had learned English at the Shanghai Teacher's College, where he had earned his bachelor's degree. He passed the TOEFL test with a score of 540. I asked why he came to America.

"Because there is no freedom of expression in China," was his reply. "You think you can find it here?"

"Yes."

I thought the newcomer would soon find out otherwise. I didn't mean to be rude or blunt, but I couldn't help myself. "Without a green card, there is no freedom in America."

"That's not what I have heard," he responded.

"Unless you have money," I said. "Have you?"

"Two thousand dollars is all I possess," he said. "But I don't worry." "Where do you live?" I asked.

He told me that he was temporarily staying with an old college friend. "A few blocks south of Chinatown." He had a work-study scholarship.

"You're going to experience difficulty with people pronouncing your name." I smiled.

"What kind of difficulty?"

"Well, when Americans see a 'Qi,' they pronounce it as ki instead of chi."

He said that he had already experienced difficulties in almost everything, beginning with finding the bus stop. He couldn't read the signs at the supermarket, either. He made me laugh because he kept pronouncing *supermarket* as "shoe-per-market." He told me that he was already tired of correcting people who mispronounced his name.

"When I tell them I am Qigu, like Chico, they tell me that I have a Mexican name. I figure I should give myself an American name."

In days to come I'd hear people call him David Jiang, John Jiang, Sy Jiang, and Cy Jiang in addition to Chico Jiang. He told me that he picked different names just to "try them out." So far, none struck the right cord. He decided to live with all the different names to see if one would stick.

I found myself laughing with him. His lightheartedness lifted my spirit. I was impressed that he was able to meet a difficult situation with humor.

When Qigu told me that Chinese ink painting was his soul passion, I warned him that I could not be fooled. "I practiced Chinese ink painting myself for ten years," I said. "And I got nowhere."

He asked for an opportunity to demonstrate his talent. "I've never failed to charm people with my abilities. All I need is to be discovered and recognized."

I told him that I had never met anyone who was so "full of booloony." I had to explain to him what "boo-loony" meant. He didn't mind and insisted that he was blessed with a gift. I offered him a brush, ink, and water. The exhibition in the gallery was being taken down—there was plenty of wall space. "Show me," I said.

He took the brush and dipped it into the ink. With his eyes closed, in a single motion and with one stroke, he created a Michelangelo figure with hair-thin lines.

The image took my breath away.

The next time, Qigu came with his entire portfolio. He arrived a little before we switched shifts. He made a show of his elegant black case, which was made in China. I was stunned by the poetry in his work. Besides human figures, he painted my favorite subjects—bamboo, creeks, flowers, leaves, geese, hills, and clouds.

We began to chat in Shanghai dialect. Since I felt as if I had been living inside a pressure cooker, I asked him about his seeming tranquility.

It was then he revealed that he was a practitioner of Taoism and Zen.

"I know Taoism and Zen," I said, "and all the rest of the Chinese stuff. But don't you worry about survival in America? Money, security, and a green card? It is the first concern of every newcomer."

"Of course," he replied. "I just won't let it chew me up. It's the mind that kills the living."

"Easier said than done," I responded. "I used to, and still do, envy the American homeless. I consider them rich because they are blessed with citizenship. They have the right to work, and they already speak English."

I also told Qigu that I admired the Chinese students who majored in math and engineering. "They live lives of security and peace," I said. "They know they will get a job offer after graduation. They don't chase the green card, the green card chases them."

"Well, seemingly purposeful men but without a purpose," Qigu said. "So many people with well-paying jobs lead miserable lives. They seek money so much that they are ruled by money, That is self-imposed slavery, in my view."

Qigu was convinced that unless I could free myself from my mental cage, opportunities would pass me by. "There are options and solutions in dealing with the visa issue," he said. "For example, one can hop from one community college to another and pay the low tuition in exchange for a student visa. You can be a lifetime 'foreign student' without violating US immigration law."

Talking with Qigu relaxed me. To thank him, I invited him out for the five-dollar shrimp wonton soup in Chinatown. I insisted on paying, because I felt that I had been in America three years and was in a better financial situation. Five dollars would mean Qigu's monthly salary in China. It didn't occur to me that I was sending Qigu a message that I would regret.

Years later Qigu would tell me that he thought I was hitting on him. I not only set up the date, but also paid for the dinner. During the meal, I told Qigu that I had a hard time picturing myself, as an old woman, posing as a foreign student. "What an awful life would that be!"

Qigu laughed. "To me life is about making time to enjoy the sun-

shine, to smell the flowers, to have friends and tasty food—as Americans would say, 'a good time'!"

It didn't take me long to discover that there were people who would pay to listen to Qigu. Margaret was one of them. She became Qigu's instant disciple. She began to take Chinese brush-painting lessons from him. According to the Zen and Taoism philosophies Qigu preached, penniless people were better off than the wealthy. "They lead richer spiritual lives," Qigu insisted. He firmly believed that people needed to free themselves of monetary concerns before they would be able to achieve nobility and find life's purpose.

"Such human beings get a lot more out of living," Qigu concluded. "They can truly feel, absorb, and harvest what life offers."

Qigu made Margaret feel that going broke could be a purifying experience. "To let go of everything is the only way to gain everything."

Qigu and I often ran into each other at the South Halstead bus stop. In the mornings we took the same route through Chinatown and the downtown loop. In afternoons or evenings, when we returned from the school or work, we took the same bus. He would get off on Thirty-fifth Street and I on Forty-third Street. Besides saying hello, we shared our views, discoveries, and opinions about America, our classes, art, professors, and schoolmates.

It was odd to me that Qigu had no intention of applying for a job in a Chinese restaurant. Instead he spent time learning about American art and artists. One day he invited me to visit his friends, who were former artists who had given up their passion in exchange for well-paying jobs in corporate America.

I was surprised to see that these people were deeply unhappy. They called their H-1 visa status "meaningless." With Qigu they discussed their boredom, homesickness, and their inability to feel truly at home in America.

As if to compensate for their deprivations, they got together with Qigu on American holidays. They listened to classical music on their new, high-quality sound systems, and they cooked Chinese food. We made Shanghai-style wonton with meat and spinach. Being with Qigu and his friends made me feel less lonely, although the dread of my visa expiring was never far from my mind.

The day before the Chinese New Year, Qigu and I rode the Halstead bus together on our way home from school. We joked about having to spend the Chinese New Year's Eve alone. He told me about China's new comedian stars. "Unfortunately, I don't have a TV set," he said. "The new broadcasting system by Central China Television is said to reach every corner in the world, including America!"

"I have a nine-inch TV set," I offered eagerly.

It was too late when I realized that I had sounded too inviting. We stopped talking. The bus kept rolling. "Twenty-third Halstead," the conductor announced. "Twenty-sixth Halstead." "Twenty-ninth Halstead." We sat in awkward silence. Everything was too obvious. A single man and a single woman—a convenient pair. I felt too old and too aware. There was nothing spontaneous or unexpected. Wasn't love supposed to involve passion, not just naked needs? I felt that I was spoiling the relationship before it had a chance to begin.

The bus approached Thirty-fifth Street. Qigu rose as if in slow motion, as if hesitating and waiting. I debated whether or not to invite him. I concluded that I shouldn't be the one to ask. I saw him sit back down and then stand again. He pulled the please-stop cord and the bus slowed down and angled toward the curb. At Thirty-fifth Street, Qigu moved toward the exit, nodding and smiling at me.

I felt strangely encouraged. Maybe it was just my imagination that he was moving so slowly. I felt an odd connection. A ripe moment. I found myself speaking: "If you like, you're welcome to join mc to watch TV."

I convinced myself that it was nothing but a gesture between friends. But I already knew. I was fooling nobody but myself. I knew exactly what I was doing. In retrospect, I couldn't say I didn't ask for it.

If a good beginning equals half the success, according to the Chinese saying, a bad beginning equals half the failure. The truth was that I had no confidence. The foundation of my being had rotted, although

the building appeared to be standing. I feared that I would face the snow-covered parking lot and Nick's stink forever. The difference between now and when I served as a laborer in China was that my age had almost doubled. Even though I dreamed that my prince would come one day, the reality had sunk in. The possibility that a prince might ever show up had faded.

Looking back, I must have given up, already, at the age of thirty. I must have already admitted and accepted my defeat. I had committed myself to a loser's position.

I was being murdered by my own fear that I was missing my "last bus." If I had kept my mouth shut that day on the bus and let Qigu get off at Thirty-fifth Street, I would have avoided a sad story. If Qigu had the means to love me, I should have had the patience to let him reveal himself. But I could not wait to end the misery of being alone.

"I have a nine-inch TV set" were the words that did the poisoning.

We watched three hours of TV broadcast from mainland China and talked during commercial breaks. Leaning against the narrow sofa bed together, side by side, we exchanged our childhood memories of growing up in Shanghai during the Cultural Revolution. Later, Qigu would tell me his first impressions of my place. He focused on the ugly cracks on the ceramic floor. "I am sure you had cleaned the floor," he said, "but it looked dirty. It kind of made me wonder about your standards, just kidding."

I found it difficult to see his opinion as humorous. I explained that I had cleaned my floor every day because I wore socks in the room. The floor was easy to clean because the space was tiny, less than four by five feet. I folt disappointed that I had left that impression. After all, it was our first date.

Our parting that first time was friendly. We both were awkward, too aware of what we were doing. We were no longer ordinary friends, and yet we were not ready to kiss good-bye as lovers.

We gave each other a hug, an imitation American hug—bear style, chests apart. Qigu pecked my lower cheek, half an inch from my lips. He bounced away, his face turning bright red.

A week later, Qigu invited me to the Moon Palace Restaurant in Chinatown. He came with gifts, a rose-colored silk scarf and a Paul Klee art book. I was flattered, although I felt bad about what he had spent, especially on the dinner. He was relaxed and enjoyed himself.

From then on, he paid me regular visits. We watched the Chinese news on TV together. One day, Qigu stayed past midnight. We had sex. It was unceremonial. Naked needs took us. Neither of us ever mentioned our "first time together" again. It was as if we were guilty of our act, as if we were using each other. We let it continue because it felt good, physically if not mentally.

It became inconvenient that I didn't have a stove. It was easy to say yes to him when he invited me to his place, where we could cook together. By now Qigu had moved from his friend's place. He lived alone on the top floor of a house on Parnell Street near Thirty-second Street in the neighborhood of Bridgeport. I was surprised that with only a few hundred dollars to his name. Qigu was not afraid to rent a two-bedroom apartment with a drawing room, a living room, and a kitchen. I asked him how he could possibly afford such a place. He replied that he planned to rent out one bedroom.

"What if nobody takes it?" I asked.

"The boat will straighten itself," he smiled. Once again he pointed out that I had become a slave to my constant worry.

We cooked Chinese cup noodles mixed with fresh green vegetables. It had been a long time since I had eaten at a table with another person, and it felt wonderful. After dinner, Qigu worked on his paintings. When he invited friends over, the discussion turned to literature, art, and poetry. Classical music played and sometimes we all danced. Margaret continued to come for her brush-painting lessons. Qigu captivated people. Taoism and Zen philosophy became organic flowers that branched out and blossomed as he interpreted them.

"Why don't you take the extra bedroom?" Qigu asked me one day. "Your lease is ending, and I need a roommate. It's a good deal."

It was true. For the same amount of money, \$150, I would gain a larger bedroom with a living room, a kitchen, and a bathroom. But the invitation upset me. I felt that Qigu was taking advantage of our relationship. He didn't want to visit me and leave my place in the middle of

the night to walk back to his place in the bitter cold. It seemed more for his own convenience.

I let Qigu know that his offer made me feel cheap.

"Please don't misunderstand me!" Qigu said. "I didn't mean to offend you." He defended himself by saying that he was conducting himself in a Chinese manner. "It's unfair that you expect me to behave in the American way."

I asked what he meant by "the American way."

"The American way means saying 'I love you,' with a fifty percent divorce rate." Qigu explained that behind his proposal was his desire for me to be his girlfriend.

I told him that I needed time to think about it. I was unsure about what might happen if I moved in with him. Sadly, the only determining factor of how I lived at that moment was money. I never dared forget my duty to my family. My father told me in his letters that after another failed attempt to obtain an American visa, my brother had gone to Japan, where he worked as a dishwasher to support his study in college. I knew that my father had bitter feelings toward Japan. He would never forget the murder he witnessed in his own backyard. My father dreamed that one day I would pave the way for my brother in America. My father reported that my younger sister had been trying to leave China for Australia because she had lost hope that I would ever help get her to America. This news made me feel terrible.

Moving in with Qigu would save me time as well as money, because his place was closer to school. I could not deny the fact that I sought comfort as well. In the short time we had known each another, I had come to depend on Qigu for his ability to put me at ease.

What finally got me to move in with Qigu was an art fair we participated in at the Bloomingdale's mall in downtown Chicago. I didn't believe we stood a chance to sell any paintings. I told Qigu that it would be a waste of the sixty-five-dollar booth fee. But Qigu was confident. He insisted that I bring my paintings.

A Chinese master would consider the artwork I produced awful. But Qigu believed that I was good enough to fool the Americans. Jokingly, he called me a "Matisse reborn."

I watched as Qigu played a trick on his customers. First he laid out

his paintings and priced them for \$150 each. He then placed my paintings next to his and priced them at \$5 to \$10 each. I was so uncomfortable that I hid behind the booth and watched the shoppers strolling by. Qigu had to drag me back into the booth to give a "live demonstration of Chinese brush painting."

As I worked on the paintings, Qigu called out to the people passing, "Chinese art! Traditional Chinese art!"

A little old lady stood in front of me and watched as I painted. She asked Qigu why the prices were so different. She said, "I don't see that much of a difference between the five-dollar paintings and the hundred-and-fifty-dollar paintings except the price."

Qigu explained that he had painted the ones marked \$150.

"Why?" the old lady demanded.

"Because I am a master," Qigu said. "I have trained for twenty years in traditional brush painting. You see, the five-dollar and ten-dollar ones have been painted by an amateur." He pointed at me "This beautiful lady who is an art student. Right here, madam, look this way. Promising, isn't she? You think that she can paint, don't you? But she is really an amateur and can only command five dollars a piece."

The woman did not like what Qigu said. "To be honest," she remarked, "I actually like the amateur's paintings better than the so-called master's. The amateur's work reminds me of Henry Matisse, the great master, and my personal favorite!" The woman reached for her purse. "In fact, I am going to purchase all of her paintings for ten dollars each! I just finished remodeling my bathrooms, and these images of beautiful herbs in bright colors will be perfect!"

Qigu beamed with joy. "What a sharp eye you have, madam! What a wise investment! I agree with you wholeheartedly! This art student, by the way, her name is Anchee Min, and she is truly a gem in the rough."

The woman nodded. "I know what I'm doing!"

Winking at me, Qigu went on. "Madam, I have no doubt that this amateur artist will one day become famous. Do remember her name, Anchee Min. It is spelled A-n-c-h-e-e M-i-n. What you have purchased here at my booth for ten dollars each will one day be worth hundreds

THE COOKED SEED

and perhaps thousands of dollars! Your bathroom walls will be lovely indeed!"

A warm feeling caught me as I watched Qigu entertain the little lady. He thanked her as he wrapped each painting in newsprint. By the end of the day, we had sold most of our brush paintings, except those priced for \$150. We made nearly \$300 after the booth fee. With child-like elation and excitement, Qigu asked if I'd do it again with him. I nodded. We celebrated our success by going to Chinatown for shrimp wonton soup.

{ CHAPTER 19 }

The school had decided to respect the students' wishes to do away with tradition. To me the ceremony looked more like the protest I had seen in front of Chicago's city hall. Some graduates wore their everyday jeans and sneakers. Others were more creative. I dared not send my photos home to China. My folks might have thought I was making a joke.

I wished that I could have been in a cap and gown. I wished to make my family proud. But I was not given a choice.

"That's not true, Miss Min," the school adviser said. "You do have a choice. You have the right to dress in anything you like. You can rent a cap and gown anywhere."

Imagine being the only one dressed in the traditional manner. I would look silly and out of place. It would seem like I was making a "statement," and I would offend my fellow students. Besides, it wouldn't look real in a photo. Folks back in China would point out, "That's a fake graduation! Look, people in the background didn't wear the same gown and cap!"

I wore the costume I had made myself. It was a white satin gown with Chinese calligraphy painted in black ink. The winglike sleeves were made for dancing and showing off the calligraphy. It was not made for walking or standing still. I looked silly, but not out of place.

My diploma didn't make me feel accomplished. Neither did it comfort me that I had been accepted for a graduate program, which would extend my visa for two more years. I recalled the president's speech on orientation day four years earlier. I was now one of the 99 percent of graduates who could not find a job in the field of my degree. If I had spoken better English and been able to transfer to another college, I never would have stayed.

When the new semester started I looked for professors who were "flexible," who would give me the credit while leaving me alone. The

school offered little help on the job-seeking front. My classmates were dreamers. And the professors made sure to keep them in the dreaming state. Everyone was encouraged to live a poetic life, to point at a horse and say that it was a dragon. In Qigu's view, the school was a "nurturing and necessary environment" because "common sense kills art."

Once after I showed my homework, a documentary video featuring my friend Joan Chen, I was criticized as being "ridiculous" and "commercial." It wasn't until I learned to speak the "same language" that I was accepted and respected as a "serious artist."

I learned to fake it. I joined the crowd and cheered when the American master John Cage visited our school. Mr. Cage was known for his famous stage performance—sitting frozen in front of a piano for twenty minutes. He was held in the highest regard for having performed a masterpiece without producing a note.

In my film history class, the professor made us sit through a three-hour movic with a single scene—a woman in her kitchen peeling potatoes. It was a "conceptual statement," but it put me to sleep. I dreamt that I became homeless. I woke up thinking: My schoolmates could get food stamps and shelter from the American government. I would be deported back to China.

From the very beginning, Qigu knew not to take the schoolwork seriously. He approached galleries. He submitted his work to national and international competitions. He was always positive, calm, and pleasant even after repeated rejections. Professors and classmates adored him. With the touch of an Eastern sage, Qigu spoke thoughtfully and elegantly. Compared to Qigu, I sounded like an imbecile. Sign, signifier, and signified were terms I used during critiques. To compensate for my critical shortcomings, I attempted to dress the part. I made holes in my jeans and wore them with my knees exposed. I ink-dripped half of my clothes, claiming to be inspired by Jackson Pollock.

By now I was comfortable with the extravagant works of the "action artists." Nothing surprised me anymore. I snuck out of the classroom when a professor's praise got to be too much. There were some brilliant pieces, I must admit, but most work was plain garbage, mine included. "Anything goes" meant one could spit and pee on the canvas and call it art.

Qigu and I searched trash bins and Dumpsters looking for throw-away furniture. We hunted Bridgeport's backstreets and alleys. We picked up stained mattresses and broken furniture. Coming home, we cleaned what we found. Qigu was handy when it came to fixing furniture with nails and glue. By the time winter arrived, we had filled our nest with found objects. Besides mattresses, we had bed frames, sheets, pots, cookware, buckets, stools, chairs, tables, lamps, and bookshelves.

One day an artist friend of Qigu's arrived from California. We picked him up at the airport. I sat in the passenger seat, with Qigu behind me in the back while the friend drove. It was a small car, so I pulled my seat up to make space for Qigu. To fit, I raised my knees against the dashboard. Qigu and his friend chatted as we entered downtown.

At the intersection of Columbus Drive and Jackson Avenue, Qigu's friend rushed to catch the tail of a yellow traffic light. But he changed his mind at the last second and slammed on the brakes as the red light came on. The car behind us emashed into our rear. The impact knocked Qigu unconscious instantly. None of us knew that we ought to wear seat belts. I was blessed by the way I sat—my knees against the dashboard, forcing my neck to press against the back of the seat, bracing me. I got out of the car, ran to the phone booth, and dialed 911.

Qigu survived, although the doctors were unsure of the extent of the damage. Friends, professors, and schoolmates surrounded Qigu in the hospital room. He wore a foam neck brace when I visited. I didn't expect to be treated as Qigu's wife, but I was. The nurses and doctors took me aside and filled me in with information on his condition. One physical therapist even called me Mrs. Jiang. I thought I'd play the role until Qigu recovered.

Qigu became more dependent on me after he left the hospital. The compensation from the insurance company barely covered the medical costs. The driver who hit us was himself living off a government disability pension. He had no assets or income and had already been sued by his fellow passengers. Since Qigu had no broken bones, the neck pain he complained of was ignored and his claim disregarded.

We moved on. At Chicago's annual Blues Festival, Qigu and I did portraits. As I kept an eye out for the police, Qigu drew. His neck became so stiff and hurt so much that he could no longer turn his head. When he gave me the stacks of one-dollar bills to count, I broke into tears. I felt like a Chinese village wife who made a fortune at the market selling her yams. The day we made the most, we were caught by a police officer. Every dollar we earned was confiscated. In addition, we were fined for working without a permit.

To save on our heating bills, Qigu and I sealed our apartment windows with sheets of plastic. Going further, we used more plastic to create a cocoonlike interior space in the corner of the living room right next to the heater. We ran the heater ten minutes a day. Five minutes in the morning when we woke, and five minutes at night before we settled in bed. I found myself worrying less about deportation and a green card. Qigu convinced me that there was no reason to be so frightened.

I was beginning to adore Qigu, although I felt confused from time to time and questioned my own judgment.

Qigu was not interested in discussing our relationship. He said that he liked to keep it "poetic." He criticized the shallow culture of America.

"We are from China and carry different values and principles," Qigu said. I interpreted his words as a personal commitment. Qigu led me to believe that he was the opposite of America's shallowness.

Sometimes I woke up in the middle of the night tormented with doubt. I wondered if I was digging my own grave. I was not the liberal-minded woman Qigu believed me to be. I had the commonest thoughts of a conventional Chinese woman. I desired a family, for instance. I was dying to know if I meant anything to Qigu—if he loved me enough to propose marriage in the future. My biggest trouble was that I didn't find our relationship "poetic."

My insecurity about money bothered Qigu. He asked me to quit bugging him, because he would never be interested in becoming a waiter. "Tips will never get you rich," he said. He was looking into other ways of finding success.

Qigu talked to a Chinatown real estate broker named Kim Lau, a friendly fellow originally from Hong Kong. Upon returning, Qigu couldn't stop talking about the term "down payment." I thought he had gone crazy.

I had saved \$9,000 from working multiple jobs over the years. Qigu had about \$2,000. "Kim Lau said that we could put our money together

and make a down payment for a fixer-upper investment property!" Qigu said excitedly. He pulled up his sleeves and flexed his skinny muscles. "I made an appointment with Mr. Kim Lau so that you can listen to what he has to say."

Kim Lau's real estate sign was the biggest in Chinatown. His new office was on Halstead and Thirty-first Street. Mrs. Lau was the receptionist and secretary. Mr. Lau had a lovely smile that disarmed. His hair was neatly trimmed, and he wore a gray suit with a tie. His small eyes darted excitedly behind his glasses as he spoke. After Qigu described our situation and asked for his thoughts, he said, "I'm glad you decided to come to me."

Signaling his wife to pass him a calculator, Mr. Lau performed a finger dance.

Qigu and I watched with fascination I thought, Mr. Lau docon't look like a crook, but he could be.

I remembered the time I had fallen for a scam and lost \$300. I was determined not to trust blindly again.

Mr. Lau said that we could make the down payment with the cash we had: However, the difficulty was getting a loan.

"You will be considered 'high risk' by any bank because you don't have regular jobs," Mr. Lau said. "You probably won't even be qualified for the ten-percent high-interest loan. The bank will simply reject your application."

"Do you mean there is nothing you can do?" Qigu asked.

Mr. Lau smiled as he put away the calculator. "There are always ways." He told us that he was thinking of a private lender, a Taiwanese woman named Mrs. Mei. "What American banks don't know is that Chinese honor their debts, in most cases. Mrs. Mei will charge higher than an American bank, thirteen percent interest, but you will have the loan!"

Smiling, Mr. Lau inquired about our backgrounds. He wanted to know what kind of relationship Qigu and I had. "Boyfriend-girlfriend, going steady, engaged?"

Qigu told him we were living together.

"That sounds like a steady relationship," Mr. Lau said. "Mrs. Mei would not loan her money otherwise, I am sure. You have to be a couple. Would you like me to convince Mrs. Mei on the loan?"

Qigu and I could hardly believe that we were actually "house hunting" in America. Mr. Lau showed us his listings. It felt thrilling and scary at the same time.

A few days later, Mr. Lau showed us a half-vacant apartment property located on South Union street. It had five units, three in the front and two in the back. "The price reflects its condition," Mr. Lau said. "It is selling as a fixer-upper, fifty-six thousand dollars, which is reasonable. The owner is eager."

Qigu and I walked out of Mr. Kim's office with our heads buzzing. We figured that if we would fix up the building and rent out all the units, we not only would be able to cover Mrs. Mei's mortgage payments, but we could also live in one of the units free.

"It would be like serving in a labor camp once again," I said. "The difference is that we would be working for ourselves."

"It'd be an American dream come true!" Qigu agreed.

The next day, Mr. Lau arrived with good news. Mrs. Mei had agreed to give us the high-interest mortgage. We went to Mr. Lau's office to complete the real estate transaction process. It felt surreal. We met with Mrs. Mei, a well-dressed and smart-looking lady with permed hair, and went to the title company together. Mr. Lau guided us step by step. We signed paper after paper. We waived inspections and insurance coverage because we had no money left. We figured that since we already knew that the building was in need of repair, it would be wise to save so that we could pay for the materials and tools.

I realized that this was no small matter. What bothered me was that my relationship with Qigu had no name. Qigu said that it was a joint investment. We were in business together. He promised that if we separated in the future for any reason, he would take back only his initial \$2,000. "We would split the profit fifty-fifty, if there is any."

Qigu gave me a pat on the shoulder and said, "Stop worrying, Anchee. We are Chinese, and the American way doesn't suit us. Material things should never be a deciding element in our relationship."

I felt that I had no reason not to trust Qigu. After all, he was the man I had been sleeping with. I wanted to believe that we were building a home together. I convinced myself that Qigu was set in his Chinese ways and was too shy to say "I love you." I preferred to think that he demonstrated his love with his actions. We were \$50,000 in debt together! There could be no tighter bond.

Yet the uncertainty lingered like a ghost. At the end of the day, my self-confidence fell apart. I started to question myself. Why couldn't I look Qigu in the eye and say, "Do you love me?" I tried it once, with feeling, and Qigu told me that I sounded ridiculous. "It's better that you don't say it," he said.

The word *love* sounded ironic, superficial, and mocking to the mainland Chinese, I agreed.

"You know how I feel about you," Qigu said, "and I know how you feel about me. Isn't that enough?"

Yet I wished that I had the courage to ask him to clarify what he meant. I didn't ask, because I was afraid to kill the "poetry." Both Qigu and I came from a place where we had our memories buried. I loved the song "The Way We Were." When memories became too painful to remember, the best way to deal with them was to simply forget they ever existed.

One day after dinner I asked Qigu to share with me his memory of first love. I had never heard the story before. They met each other at college in China. She was nineteen, and he twenty-two. She was from Sichuan province, the daughter of a peasant family. The couple had to break off their relationship because he wanted to leave the country for America. He told her that he didn't want to hurt her. Yet the relationship went on. Love held on until the moment he obtained an American visa. She took the news badly. She tried to congratulate him, but she broke down instead.

In the shadows of the lamplight, Qigu spoke softly. It was as if he was telling someone else's story. The pauses between the syllables gave away his emotion. The pain was in his controlled voice. He insisted that he didn't suffer, for he had long warned himself that there would be a price to pay for going to America.

There was a definitive moment in their doomed love affair. It happened two weeks after their separation, when the girl showed up in his apartment. She told him that she was engaged to be married and was going back to her province. She asked to be with him for one last time, to say good-bye. That night she offered him her gift—they slept together for the first time. She believed that the act would allow them both to find closure. "She then said something I will never forget," Qigu recalled. "She said 'I wish that I had never loved you.'"

"What about you?" I asked. "Did you regret loving her?"

"Zen and Taoism have teachings that speak to this," Qigu said. "There is a way to bear the burden. Let life happen to you. Let it Don't try to resist it. You would win by doing nothing as an individual. Only when doing nothing, you are doing everything. To do nothing is wisdom. It is the best way to cope with tragedy. Only by doing nothing can you survive."

"So you just let her happen to you?" I asked.

"Yes. She insisted."

"But what did you mean by doing nothing? My question is, Did you love her?"

"I don't know, to tell the truth. I had been afraid to love. I had to train my mind."

Qigu reached toward the lamp and turned the light away from him. "I am not the only one who sacrificed," he continued in a calm voice. "So many I knew either gave up their relationships or stayed single for their entire four years in college. All to pursue the dream of coming to America."

Would I have done the same if I had been that girl? I wondered.

"It is less difficult when such sacrifice is expected and shared," Qigu concluded. "As in war, there will be casualties. You can't take it personally."

"But it is personal."

"That's the irony of life."

"The situation was similar at the labor camp." I sighed. "In order to get back to the city, many sacrificed their relationships. People were afraid to fall in love because parting was unbearable."

"Tragedy, precisely." Qigu's voice trailed off in the dark. "Yet life goes on. It always does."

Had he succeeded in moving on? Had he forgotten the girl? I didn't need to hear the answers. I could tell that he was still stuck with his memories. So was I. I wished that I could fool myself. We were like twice-dyed T-shirts. New bleach was not helping to wash off the old patterns. The deeply ingrained images kept resurfacing.

Qigu said that in his book of values, love was hope, and dreams were fortune itself.

I asked him to elaborate.

He said, "A fifty-percent divorce rate in America means half the population is disappointed with their love lives. People go on regardless, eating, drinking, sleeping, farting, et cetera. Let life be, I say! That's why artists are the happiest bunch. Artists choose not to deal with life's ABCs. Artists refuse to behave according to society's XYZ rules. An artist lives within his own realm of imagination. Art is the best religion. It is opium without side effects."

I felt myself falling off Qigu's wagon. I wanted my life to be a love story. I wanted to be able to say "I love you" to Qigu and have him say the same words back.

The doubt was there. The doubt couldn't be chased away. The doubt continued to trouble me. It made me feel dishonest. I shouldn't be gliding on a watermelon skin. It would be better if I put a stop to it myself. I needed to deal with my cowardliness. The proper thing to do was to celebrate the truth, however ugly and hurtful. Truth would lead to real beauty. It would be the best gift to both myself and to Qigu.

"Art is about ambiguity," Qigu said.

But I could see no beauty in the ambiguity of our relationship.

Yet I continued my watermelon-skin ride, shamelessly and irresponsibly. The truth was I didn't have the guts to face the truth. I didn't

THE COOKED SEED

have the confidence that I would be able to survive living in America on my own. I let myself be penetrated by fear.

It had been five years, and a green card remained a dream. I no longer saw the light at the end of my tunnel. I had been willing to crawl on all fours. I had done what my parents told me never to do. I now lived with a man who was not my husband and I was in debt beyond my parents' wildest imagination.

Qigu had been decent compared to other suitors. I seemed to attract men with problems: social outcasts, alcoholics, married men. A few acres plus a farming cow, husband, and children makes a happy woman, went a Chinese folk song I loved. I prayed that Qigu would find me worthy. Besides being his bedmate, I tried to prove that I could also be a breadwinner and a homemaker.

I didn't excite Qigu, even when I walked out of the shower naked, I wished that I knew what I was doing wrong. My mother had taught me, "If you are nice to your man, he will be nice to you." I couldn't help but think sometimes that it was because Qigu still hadn't gotten over his loss. He loved the girl he left behind; in time I would find out that there was more than one girl. We lived like an old couple. Qigu would discuss whatever was on his mind as he sat on the toilet while I cleaned my purse and counted the coins on the floor.

"I choose giving birth to art" came Qigu's reply when I asked if he would ever consider having children.

How did I not only choose not to hear him, but also to take it as a joke?

"You'll make a good father," I remembered saying to him. "You'll change your mind in time."

When Mr. Lau congratulated us on the closing of the property, I started to panic. All I could think about was that we would not be able to make the mortgage payment. It would take only one tenant to miss his rent. We had no money in reserve. To save expenses, Qigu and I lived on cup

noodles, which cost a dollar for seven packs. Qigu believed that good things would happen if only I relaxed. He pointed out that we had just bought a used Chevrolet for the bargain price of sixty-five dollars. Well, it was not a real purchase. A Christian friend whom Qigu met at a church donated the car to help us in the name of his Lord. But I couldn't get my mind off the mortgage debt and property tax and utility bills.

The day after we bought the property, we discovered that two fat homeless men had been living in the vacant units. There were shopping carts stolen from grocery stores parked in the yard. We found the men drunk in a room filled with leftover pizzas, empty liquor bottles, soda cans, and cigarette butts littering the floor. The homeless men complained about water not being available to them. The toilet was filled with waste. Because the building had not been properly heated during the winter, the water pipes had burst.

We gave the homeless men three days to remove themselves from our property. We explained that we needed to fix the house. The homeless men said, "Sure, sure."

The condition of the front three units was worse than it had first appeared. The basement unit was occupied by a retired couple, Bruno and Helen, who were drunk all the time. Helen told Qigu that she and Bruno got their alcoholic blood from their Irish ancestors. "Bruno has to drink a dozen beers a day mixed with liquor, or he can't function."

Bruno shot back and said that it was because he had to deal with a bitch like Helen. "She's an alcoholic since birth."

The unit smelled. Bruno and Helen never walked their dog, whose name was Washa. Washa was mean, wild, and aggressive. He would attack anyone and ran laps in the weed-covered lot next to our building. On our first encounter, Washa bit through my pants and left teeth marks on my thigh.

With liquor on her breath, Helen told us that she and Bruno had been living here since the day they were married. They had an unmarried daughter, who was twenty-five years old and pregnant, living with them. The father of the child was a Mexican truck driver whom they disapproved of as a son-in-law. We didn't know that this was a warning that we would be in charge of paying for window replacements. The son-in-law would shoot bullets through the windows.

An old Italian woman named Maria and her brother John, both in their late sixties, occupied the unit above Bruno and Helen. We stood in their clean kitchen but couldn't understand a word they said. It wasn't until Maria got down on the floor and began to imitate a bug crawling that we understood they were complaining about cockroaches.

Qigu and I didn't know what to do besides offer to buy the cockroach poison. Maria shook her head violently. With the help of her brother, she got on a chair and reached toward the cupboard. She pulled out a plastic bag full of cockroach poison. John showed us that he wanted to open his windows, but was unable to because the window frames had rotted. Qigu said we'd fix their problems as soon as possible.

On the third floor lived two Mexican men, Alfonso and José, who spoke only a few words of English. They told us that a rent increase was not fair because they didn't have families living with them, and that they used the unit only for sleeping after work.

Qigu and I told them that they were welcome to move if they thought our rent was unreasonable. We pointed out that even with the increase, our rent was still the cheapest on the block. Alfonso said he already knew that, and it was why they would not move. Alfonso told us that the building's electric system was shot. "It makes popping sounds," he said.

After the homeless men were gone, we began to move the trash they left behind out of the back building. As we cleared the closets and drawers, we discovered a stack of photo albums featuring generations of a white family. It was someone's entire life story. There were over twenty albums meticulously framed, marked, and dated. I couldn't understand why anyone would leave the albums behind when they moved.

Qigu and I took the albums and set them up as a display on boxes next to the trash cans. We hoped that the neighbors would see them and contact whoever had lived here. Days passed, and no one came to claim the albums. The city's garbage truck came and went, leaving the boxes untouched. I felt awful when it started to rain. I couldn't stand the idea that the albums would be ruined. Qigu and I put them back into the boxes and carried them inside. We took the boxes out again after the rain. It took us a while to realize that no one was interested in picking them up. It bothered me that we had to be the ones to make the decision to throw away these precious memories.

Qigu and I sat down on the floor and went through the albums one by one as if they were our own. I heard Qigu sigh as he flipped the pages. "Looks like the family was originally from Poland. Here is the great-grandpa and -grandma. They must have been the first-generation immigrants, just like us."

"The way they dressed got better as the family grew." I pointed out. "I can almost imagine how they built their lives in America."

"Too bad a museum wouldn't take the albums," Qigu said. "It is real American history."

Qigu and I notified our landlord on Parnell Street that we would move out the next month. The landlord asked us if we knew any other Chinese students who would rent the apartment. The landlord said that we had been excellent tenants, and he would miss us.

Qigu and I returned to our property after dinner. We had been discussing the cost of hiring a licensed electrician. We decided that we would have no choice but to spend the money. I said to Qigu, "Fire would be a serious hazard if we tried to fix the electrical problems ourselves..."

I couldn't believe what I saw as the word *fire* rolled off my tongue—our property was on fire. Like in a disaster movie, our roof was in flames. The smoke was coming out of the back building where the two homeless men once lived.

Bruno ran out of his unit in his pajamas. Helen waved her arms and was shouting after her husband. I heard the sound of the fire truck coming from a distance. It can't be our property! I yelled at Qigu. We just bought it and without any insurance!

Qigu and I rechecked the house number and were shocked to realize that it was indeed ours.

We told the police officers that we were the new owners, and that there had been two homeless men living there without our permission. The police officer said that they had found no individuals in the building. There were no witnesses who could prove who had started the fire.

"What about the shopping carts left in the yard by the homeless men?" I asked.

THE COOKED SEED

"Sorry, ma'am, the carts would not be considered valid evidence." The police officer told us that he regretted that there was nothing he could do to help.

Weeks later, one of the homeless men returned to visit Bruno. He and Bruno drank sitting side by side in the yard. They laughed together and tossed the empty beer cans into the shopping cart. Later, after a fight with her husband, Helen told me that the homeless man had admitted to Bruno that he had been the one who had set the fire.

{ CHAPTER 20 }

IGU AND I worked on repairing the fire-damaged apartment for the entire year. We slept in the attic. We had no money to buy power tools and we couldn't afford to hire help. We had to learn to do everything ourselves. To keep our legal status, we continued our schooling. We took independent-study courses to buy time.

Local lumberyards and hardware stores became our real-life class-rooms. We learned everything about fixing an old house. We gutted the section of our roof where the fire had burnt through. Taking out walls and clearing the debris was much easier than dragging the eight-by-four, three-quarter-inch-thick sheets of plywood. The irony was that the labor camp in China had prepared me for this. I did the heavy carrying because Qigu hadn't recovered from the neck injury he'd received in the car accident. The foam neck brace he wore turned gray with dirt.

I was afraid of falling when it came time to place the plywood over the roof frame. I told myself that Qigu couldn't do it alone. It was a windy day. My knees kept shaking. I could see the narrow alley three stories below. I pictured myself falling and my body hitting the concrete. The roof pitch was steep. Qigu needed me to hold, slide, and push the sheets into place and hammer the nails.

Qigu suggested that I tie a cord around my waist for protection. I did, but the problem was the weight. I didn't have enough strength to lift the large sheets. We experimented with several ways and failed. Finally, Qigu phoned a school friend who was a carpenter. The friend came to help. With two men working together on the roof, and I as their assistant, we were able to get the roof on before the first snowfall.

By December we finished stripping the burnt interior—the walls, windows, bathrooms, and the kitchen. I wore a mask, a shower cap, and gloves. My clothes were filthy. We joked about our nostrils being black, like two chimneys, even though we wore masks. Qigu's hair was caked with dust.

One day, something got into my eyes. It hurt like hell and for days

my tears wouldn't stop running. My right eye was bloodred and swollen. Rubbing made it worse. I carried on half blind.

At Chicago's Maxwell Street flea market, we shopped for second-hand tools. We were able to find a used power saw and an electric drill. Afterward, Qigu and I headed to the lumberyard and loaded our car with building materials. There, at a small stand, we had Polish hot dogs for lunch. Qigu enjoyed grilled onions. He loved to say to the vendor, "Extra onions, please." We had never tasted anything so delicious.

As I watched Qigu take a big bite of his Polish hot dog, I found myself falling into the joy that spread across his face.

I loved the feeling of us working together as a team. When it came time to tackle the plumbing, we became partners in the delicate work of soldering. As Qigu prepared the inside of the fitting with a round wire brush, I used steel wool to clean the outside of the pipe.

"Be careful with the sharp edges," Qigu would say.

I waited for Qigu to measure and cut the pipe, then put the fittings together. After Qigu applied flux soldering paste, I would light the propane torch and pass it to him.

Meanwhile I quickly inserted an inch of solder into the joint. Qigu held the tip of the flame against the middle of the fitting. We would wait until the soldering paste began to sizzle.

We watched as the capillary action sucked the liquid solder into the joint. The moment Qigu said, "Now!" I wiped away the excess with a rag.

The moments when Qigu heated up the fittings with the propane torch, when we waited for the solder to sizzle, when the liquid solder sealed the copper joints, I felt my heart was at home.

I adored the way Qigu gazed intently at the flame. I found his concentration attractive and even seductive. Bundled in thick winter coats, we moved like two polar bears in a forest of copper pipes. The room's frigid air made Qigu's nose turn red. I remember thinking, *I can kiss him just now.* He might never be rich, but we would be wealthy in love. I began to see Qigu as my ideal peasant farmer who plowed his land tirelessly, and I wanted to be his wife.

The sixty-five-dollar Chevrolet had been serving us well, although the front and taillights no longer worked. Every time I drove, I had to place flashlights inside the light housings, and every time I returned home I took them out. One day I forgot to turn off the flashlights after parking and the batteries died. I received a ticket from the police. Before saving enough money to pay off the first fine, another ticket arrived. A neighbor reported to the city that we had been filling our trash cans with construction debris. We hadn't known that this was illegal. I was depressed over the lost money. Qigu tried to cheer me up with the Chinese horseman story—the man's horse ran off and he was distraught from the loss; but as he was moaning into the wind, the horse returned with a finely made new pack.

A period of rain was forecast just after the lumberyard truck dropped off a huge stack of eight-by-four drywall sheets in front of our yard. For three days, Qigu and I carried the drywall to the second floor. We were exhausted and fruotrated by our inertectiveness. My spine, injured at the labor camp, began to hurt. Qigu had to endure the pain from his injured neck. By the end of the day we could barely move. Yet we could not afford to quit because heavy rain was on its way.

We were so thankful when two strangers, two white men, passed by and offered to help. For a total of ninety dollars they promised to carry the rest of the drywall up the stairs. To show our gratitude, we offered each man a twenty-dollar tip as they finished. The next morning we were shocked to discover that our basement window had been broken into, and that all of our equipment was gone.

The exterior siding would have to be put up in the middle of winter. The snow on the ground was three feet deep. I could hear Christmas music from the neighbors' house. As Qigu and I began the job, we each were on an aluminum ladder. The wind was strong. Because the space between the buildings was extremely narrow, the ladders leaned against the wall at almost 90 degrees. As Qigu and I carried the lengths of siding between us up the wall, my ladder kept sliding to the side. Qigu and I had to adjust our positions, like acrobatic actors, in order to keep the balance.

I clenched my teeth as I held on. Qigu had me hold the board as he

hammered the nails on his side, and then I would hammer the nails on my side. We worked without stopping. As the evening deepened, the wind grew stronger. It was difficult for me to remove a two-and-a-half-inch nail from my pocket, hold it between my lips, and climb up while juggling to stabilize the ladder. Once I secured my position, I pressed the board with one hand while reaching behind to grab my hammer.

I could feel the ladder under me begin to slide. It went fast. Before I could make a sound, the ladder fell, taking me with it. It was like a slow-motion film. I was falling from three stories while trying to let go of the board for fear that it would pull Qigu down with me.

I hit the ground. Fortunately, the three-foot-high snow cushioned my fall. For a moment I couldn't move.

"Are you okay?" I heard Qigu's cry. "Anchee, answer me! Please, are you alive?"

I knew I was not dead, because I could still hear the neighbors' Christmas music, yet I was unable to speak. Qigu came down from his ladder and held me in his arms.

Strangely, I felt happy.

"How dare you smile!" Qigu yelled in Chinese. His facial expression twisted. "You scared the shit out of me!"

I returned to China to visit my family in the summer of 1989. Students had already begun to gather in Tiananmen Square by the thousands. They were calling for democracy and there was electricity in the air. I met with a former middle schoolmate, who was now one of the student leaders. He tried to convince me to join his organized hunger strike in Beijing. Sitting across from him, I found myself thinking that he had always been an opportunist. I was offended by his cunning. His interest in seeking international media attention at any cost repelled me.

"Democracy has a price!" he kept saying to me. "To wake up the masses, there must be bloodshed. We'll not back down until we get what we want."

What he wanted was power. I knew that with certainty because he had once been the leader of the Red Guards in my middle school. When he talked about blood and death, he did not mean his own.

As history played out, the movement was crushed. There was indeed blood and death. What bothered me the most was not the government firing on its own people, but the student leaders who fled to the West on preissued American and European visas: the fact that they left their fellow students to the slaughter.

My mother saw me but didn't believe what her eyes told her. She had been leaning on the same window frame for years dreaming of my homecoming. I yelled at the top of my lungs, "Mama!"

Frozen in disbelief, my mother failed to respond. Another figure appeared behind her. It was my father. The old man lit up and waved. I heard him shout to my mother, "You are not dreaming! Anchee is here!" Instantly my mother dropped out of sight. She had collapsed to the floor in happiness.

It was not easy to explain to my parents the reason I had returned to China. After failing at every job application I'd tried in America, I realized that the only way I'd over find u job was to create one myself.

I had been watching the popular American TV series *Dynasty* when an idea came to me. If I could create a TV series featuring Chinese students' lives in America, I knew it would have an audience in China. I could write the stories and convince my friend Joan Chen to play the lead. Maybe I could find an American company interested in advertising in China to sponsor the show. I could contact one of my former film bosses in China to coproduce the stories and have the shows broadcast in China—this way, I'd create a job for myself.

I met a young black man at the school named Eric, who worked for a small Chicago film production company. Eric liked my idea so much that he arranged a meeting for me with his boss to pitch the idea.

Mr. R, the head of the production company, was excited about my idea. He told me that a notable corporation was one of his clients. He said that he would present the idea of sponsorship to them while I worked up a detailed proposal describing the show. Several meetings later, the corporation sent its representative, Miss K, to meet with me. I suggested that Mr. R and Miss K come to China with me to investigate the possibility, and they were thrilled.

I contacted Mr. Chong, whom I had once worked for. He was now the boss of the Beijing Film Corporation. I arranged multiple phone

meetings between Mr. Chong, Eric, Mr. R, and Miss K. I translated what Mr. Chong said. "China would love to earn US dollars by supplying equipment and labor." Miss K wanted to know that China would air the show. "Mr. Chong doesn't think it will be a problem as long as the show is not anti–Communist Party."

A trip to China to meet with Mr. Chong in person was scheduled. The day before our departure, Eric came to me looking devastated.

"They canceled my ticket. They said there was no need for me to go. I've been double-crossed. I need your help."

This was the first time I witnessed betrayal in an American setting. I went to Mr. R and told him that I would not have met him if it hadn't been for Eric's introduction. "I will not lead you to China if Eric is not on board. There will be no meeting with Mr. Chong, either."

Mr. R had no choice but to let Eric join the trip to China.

To welcome the American guests, Mr. Chong threw a lavish banquet. Like a local king, he ushered our party through a tour of his property. Beijing Film Corporation was larger than Hollywood's Universal Studios, although bare land was all he had. I didn't know what to say when Mr. Chong asked me how big Mr. R's film company was. It would be like comparing a horse to a mosquito. I only said that the US film companies operated differently. The success of a film didn't depend on the size of its production office.

I believed that it was a waste of money when Mr. R and Miss K insisted on signing a contract with Mr. Chong through an American law office based in Beijing. I advised that American law wouldn't bind the Chinese government—it was part of the risk of doing business in China.

Refusing to listen to me, Mr. R paid a foolish amount to the law office, and then he was happy, and felt secure about the deal.

A month after we returned to the US, Mr. Chong was removed from his position by the Central Communist Party because he had sided with the students at Tiananmen Square. Mr. Chong had personally ordered a documentary crew to film the event when the tanks rolled in. Mr. Chong might have been a historical hero if he hadn't miscalculated.

The last thing Mr. Chong did was to tell me that the contract was still valid. He asked me to tell Mr. R and Miss K to wire the first production funds promised in the contract. With this, Mr. Chong shot himself in the foot. I smelled his rotten character. He knew he wouldn't be able to guarantee the production or the broadcast, yet he still wanted the American dollars. He didn't care what might happen to the American investors or me.

I was not as foolish as Mr. Chong thought I was. I told Mr. R and Miss K that the deal was off due to China's political situation and Mr. Chong's downfall. By then, they had already been informed. The image of a Chinese man standing in front of a line of military tanks was on TV all over the world.

"But we have the contract with Mr. Chong," Mr. R argued. "It was notarized by our law office in Beijing!"

A couple years later I cowrote a new twenty-five-episode TV series for China based on the same idea. This time I was betrayed by my own people. I looked for partners to coproduce my show because I was tied up in writing a book and completing the scripts of the twenty-five episodes. Two former students from China, Mr. S and Mr. Z, approached me. They had been running a small Chinese-language television station in Chicago. They begged for a chance to work with me. I was impressed by their enthusiasm. I convinced Joan Chen to lend her name to the project and I composed a letter introducing Mr. S and Mr. Z to the Minister of China's Cultural and Art Bureau. When Joan Chen asked if I trusted these young men, I gave a positive answer.

It never occurred to me that I would be double-crossed the same way Eric was. The moment China's Central Television Corporation picked up the show and became its solo sponsor, which guaranteed over a billion viewers, I found myself excluded from the project. My partners, the two students whom I named executive producers, had "fired" me.

Most of the creative members of the crew went with the money, understandably, except my loyal friend Joan Chen. She did exactly what

THE COOKED SEED

I had done for Eric—she stood up for me and withdrew her name from the show. She witnessed how I was stabbed in the back and lost her faith in the project. She no longer felt safe working with them. "They were your friends," she said to me.

{ CHAPTER 21 }

TOT A DAY passed that I didn't think about my younger sister's tear-washed face, my mother pretending that she hadn't witnessed our fight, and my father pleading, "Anchee, it is my wish that you go back to America. You might be poor there, but you will be safe. America will have no Cultural Revolution. You'll never worry about waking up one morning to find yourself denounced."

I couldn't make my father understand that without a green card there would be no safety in America. The door kept shutting in my face in terms of jobs, even with my master's degree. I began to see that some Chinese students who couldn't get jobs chose to pursue Ph.D. degrees. Why not try the same route? My master's degree might lool people into believing I was qualified. I submitted my application to the University of Chicago in Chinese history and women's studies.

Qigu said, "It's crazy to focus your entire life on securing your immigration status. Your life is passing you by. You're robbing yourself of all that is wonderful—sunshine, spring, flowers, and birds. You forget the real reason we exist on this planet." Once again he listed examples of people who were green card holders, American citizens who lived unfulfilled and miserable lives.

"If you continue to slave yourself, what is the purpose of coming to America?" Qigu continued. "It's a downward spiral, a black hole. It will not end even after you achieve citizenship. Such discontent is like greed. You will want to upgrade your house to match your new status. Then you'll realize that you must drive an equally fancy car. You will then need to update your wardrobe in order to match your car; along the way your hair, accessories, shoes, socks, and skin color will come up for review. Finally, you'll convince yourself that your partner is a mismatch . . ."

Qigu won the Tokyo Tri-annual International Art Exhibition competition. As a result, he was accepted for a group show at a Chicago gallery. He believed that only when one was free in body and spirit would one's mind be open to positive energy and opportunities. "This is exactly what is happening to me."

Qigu was happy doing what he loved. I admired his mental strength and his sense of calm confidence. This, in fact, was what I most valued in him. His perspective was a balm that I had come to depend on. I needed him to tell me that I would be okay.

Although I loved painting, I never imagined that I could be an artist. Under Qigu's influence, a Chinese-American gallery owner took a chance on me. He offered to exhibit my paintings, but none sold.

I was not looking forward to my thirty-fourth birthday. I felt stuck and in a rut, without much to look forward to. Only Qigu didn't think I was a loser. And I was not sure if he was a winner.

I longed for a family and children. Qigu didn't know how desperate I was to settle down. I had secretly gone to the library looking for information on how late was too late for a woman to have children. What I learned scared me. When a woman turned thirty-five, there was a 2 percent chance that her fetus would be retarded or wouldn't survive the pregnancy. The percentage of such risk increased drastically as the woman aged. If I wanted a healthy baby, assuming I was still capable, I had less than a year.

It had become obvious that Qigu had no interest in proposing to me. In my cowardly way, I had asked him about love, and he gave his usual answer that "we were Chinese." I took this as a sign that he loved me in a profound way, the Chinese way. I carefully asked him about his future in terms of a family. He asked me if I understood the word fatalism.

When I replied no, he explained that he would never make enough money to provide for a family. "How can I feed my children when I can barely feed myself?" he said. "It would be irresponsible—to you, society, and the child."

Qigu took me to a dinner at the house of his favorite professor, Don. The old man sensed my anxiety during our conversation. He said, "Trust me, I have been teaching art for nearly thirty years. Qigu turns his feelings into inspired works of art. His paintings are poetic encounters with life: a small miracle, a separation over a misfortune,

the sharing of a contented moment. Qigu's gift is his ability to feel deeply."

But feeling deeply doesn't get us a green card, I thought.

"He is such a gentle soul, and he loves you." The wine had turned the man's face bright pink. "Shield Qigu from the ordinary duties of life. Spare him from such torture. Qigu was born to paint. A genius. He honors God with his art. It's our fortune that Qigu shares his gift with us. I pray that God will give him the strength to endure life's cruelty."

I continued to live with Qigu in the attic as we worked to fix the rest of the units. I had trouble getting used to the attic doorway, which was only five feet high. I kept bruising my forehead. I let Qigu know that I was trying to feel free and safe, but I didn't. I had trouble playing the role of his girlfriend, although we got along well as friends and schoolmates. Sometimes I felt embarrassed to be associated with him.

I felt a lose of face and resemed Qigu when our tenants Maria and her brother didn't get their window fixed. They deserved a decent window; they were the only family who was never late on the rent. I would have done the job myself if I could have. If we could have afforded to hire someone, I would have. Instead I kept pushing Qigu. I fought with him and he kept putting me off. I couldn't tell him how much it really bothered me, and I felt ashamed because Qigu's inaction reflected badly on me. If it hadn't been for the mortgage, I would have asked Maria to hold on to her rent until we fixed her window.

Another thing that bothered me involved our downstairs tenants, two students from India. Qigu had great conversations with them about their motherland, but he did not provide quality service as a landlord. The students came to the attic one morning complaining that they had caught cold due to insufficient heat. They reported that the heat had been cut off in the middle of the night.

I confronted Qigu, who admitted that it was his doing. He was trying to save on the heating bill. He meant to turn the heat back on in the morning but overslept and forgot. In an attempt to calm the students he said, "We survived in China and you in India, where heat and airconditioning don't exist."

THE COOKED SEED

"But this is not China or India," the students protested. "This is America!"

The students insisted that their lease clearly stated that the rent included heat. "We have to stay up late to do our homework and prepare for exams. We'd offer to pay an extra twenty dollars to help keep the heat on."

I was embarrassed beyond words. I could see that the Indian students had lost respect for us as Chinese. I felt not only disappointed but hurt.

"You talk like a model Communist!" Qigu said after the students went back downstairs. "Before demanding others to be perfect, first examine yourself. Are you perfect? Since nobody is perfect, let's relax. You are neither behind nor ahead of anyone else in human virtue. Why do you have to be so self-righteous all the time? Maybe it is your former training Maybe being dramatic is your nature."

I could no longer ignore the sad fact that Qigu and I were not in love. We had been sleeping in the bed we made—the mortgage contract was under both of our names. I felt that I had little choice but to stick with Qigu. Hopefully for my good behavior he would reward me with a marriage proposal. In the meantime I found it difficult to put up with him. He saw himself as a guru while I saw him as a beggar.

My comment didn't offend Qigu a bit. His response was, "Confucius was a beggar before he was a sage—so was Buddha."

It was during a dinner with friends that I turned mad. Qigu had initiated the dinner. Since I knew we couldn't afford it, I didn't want to go. But he insisted. "Let's have a good time. I'll take care of everything."

When the menus were passed around, I became nervous over the pricy dishes. Qigu kept encouraging everyone, "Pick whatever you like the best! How about baked oysters with ginger? It's absolutely delicious!"

I kicked Qigu under the table, but he ignored me. I leaned over his shoulder and pointed at the price of the oyster dish, \$14.99.

"No problem!" Qigu continued.

Intoxicated by the rice wine, the guests were inspired by Qigu's

brilliant commentary on Taoism and Zen philosophy. The dishes kept coming one after another until the table was full. Everyone but me was enjoying himself and having a great time. The discussion focused on the current international art trend.

It was getting late. The conversation quieted down. Pointing his chopsticks at the various plates, Qigu gave eloquent critiques of the dishes. I, on the other hand, could only think of the bill.

It came. One hundred and forty dollars. Our budget for two months of food.

I glanced at Qigu.

He smiled and pretended that he didn't see the bill.

The discussion continued on ancient philosophers. Laozi and Zhuangzi and his butterfly.

Qigu didn't look at the bill. He let it sit on the tray.

The friends kept on. There were jokes and laughter.

The restaurant was empty of customers, but Qigu continued to talk. He was animated.

What's the game? I wondered. It's supposed to be his treat.

The waiter flipped the light switch, hinting for us to wrap up.

Qigu sipped more wine and laughed loudly at his own jokes.

He pretended not to notice the waiter's impatience.

The waiter came to the table. He stood next to Qigu with a long face.

"Is there anything else I can help you with?" the waiter asked, visibly upset.

Qigu did not move. "A couple more minutes, okay?" he said to the waiter, smiling.

Finally, one of the guests took out his credit card.

"No, please!" Qigu cried, throwing up his hands. "I said it was my treat, didn't I? Please, let me pay."

But it was too late. The waiter took the friend's credit card.

Qigu shook his head and made an expression of disappointment. "You shouldn't have!" he said to the friend.

After we returned to our apartment, I told Qigu that I felt ashamed as his girlfriend. "You are pathetic, stingy, and low!"

"Why such rage?" Qigu kicked off his shoes and went to turn on the TV.

"It might not be a big deal to you, but it is to me. You are my man." "Here you go again, being dramatic," Qigu said. "Didn't you see how well my friends were entertained? You are wrong to think that I didn't contribute. I offered laugher, the best medicine. I enhanced everybody's longevity. I am the best gift money can't buy."

I sat in front of the Ph.D. program committee at the University of Chicago. I was given a chance to convince the committee. It was an interview and an evaluation. They didn't think I understood what I was getting myself into. "We need to know what you want to do with a Ph.D. degree. Your goal, Miss Min."

I couldn't tell the truth. I couldn't say that my goal was to earn American citizenship. I told them that I had a great thesis in mind. The title would be, "The Psychological Impact of Madame Mao's Brain-Washing Propaganda over 1.5 Billion Chinese people."

"Indeed, that would be an excellent topic," the head of the committee responded. "China is on its way to becoming a major player in the world's economy and a rival to America. We are interested in China. However, Miss Min, that is not the issue we're concerned with here."

"I can sing Madame Mao's operas from beginning to end, every one of them," I said eagerly. "I can recite the lyrics and the melodies! Test me if you wish."

"This is not a Broadway audition, Miss Min," the woman smiled. "We need to know how you plan to survive the academic program. Before you get to work on your thesis, you have to complete the basic academic requirements. You must be fluent in a foreign language, Greek, for example . . ."

I was barely fluent in English.

The woman read my mind. "That's our point. Your background seems to be studio art. What would be the purpose of pursuing a Ph.D.? Do you see yourself as a professor, researcher, or an artist?"

Qigu had no sympathy for my rejection. "You presented yourself as a headless fly," he commented. "It might be a good thing that they turned

you down. A Ph.D. does not suit you. You are an original. Your talent is inborn. Unfortunately, you refuse to see it my way."

I looked at him and blinked. "What kind of talent are you talking about? Fixing toilets? Tiling a floor? Mixing concrete, or carrying drywall?"

Qigu spoke as if he knew me better than I knew myself. I disbelieved him, and yet I desperately relied on his encouragement. I was dying to hold on to the belief that I had potential, that I'd be good at something, that I could make my life a success.

"My friends call me Eagle Eye for a reason," Qigu said as he opened the door and headed toward the basement. He had built a makeshift table and installed carpeting that he'd found in the Dumpster. The space had been turned into his painting studio. Pulling sketches out of a pile, he tried to convince me that he was serious about my talent.

"I have been trying to copy your wild energy, but without luck. I wish I could untrain mysolf. Everything Is too set for me. For example, see here..." He pointed to a large drawing. "I can no longer think outside of the box, so to speak. When I draw a figure, the head must be on the neck, the shoulders must be connected to arms, and hips to legs... I mean, my training has disabled me. It has killed my imagination."

Qigu showed me another pile of his sketches. "I did these with my eyes closed. I wanted to break old habits. But still, look, I paint the human figure with a realist's precision! Look at you—poetry comes with you. You hear the music, and your eye sees beauty. There is no fighting yourself, no struggle . . ."

I was touched, strangely, when Qigu told me that he was frustrated that I'd let getting a green card dictate my life. "You are doing yourself injustice," he said. "You are burying your talent."

This man, I thought, with all his heart, believed that I was born to be extraordinary, but he had never said that he loved me. He was never shy about cracking sex jokes with his friends, but he had to turn off lights when getting into bed. There was no pretension in his voice. He wanted me to know the truth about myself.

I looked at Qigu. His face and his funny haircut—my work, to save money. His bangs covered half of his forehead. There was a spot of paint under his chin.

THE COOKED SEED

"I'd hate to see you give up," he said quietly.

"I have finished reading my English teacher's book," I said.

"Which one?" he asked.

"The one who told me that I was a lousy writer but had excellent material."

"The one who has published three novels?"

"Yes."

"What do you think of him?"

"He is a fine writer, but his material is pale. I didn't understand what he meant by calling me a 'lousy writer with excellent material' until I read his book."

Qigu beamed. "Wow! This is the best thing I have heard you say. Do you think you can make a better writer given your material?"

"I can try. It doesn't hurt. In fact, I have been thinking about where to start." $\,$

"The picce about your labor camp experience is something," Qigu said.

"You mean my paper for English 101?"

"A piece of art, in my judgment."

I stood by the shore of Lake Michigan and inhaled a mouthful of cold air. The water made me think of the Yangtze River. I missed China. I continued to have dreams about my mother getting sicker. I wished that I could visit her. Instead Qigu and I frequented lumberyards and plumbing stores. The repair job had turned into a nightmare. Qigu and I were not good at working together as a team. I liked to get things done as soon as possible, while Qigu preferred to take his time. It drove me crazy when we installed a tub without a level. Qigu didn't want to spend the money buying a level. He wanted to wait until we could find a second-hand level at the flea market. I worried that we wouldn't be able to get the tub in properly.

Qigu said, "My eyes can measure with precision. That's the benefit of being an artist."

We connected the plumbing fixtures around the tub, closed the drywall, taped, spackled, sanded, and painted.

After the tenants moved in, the bathtub began to leak. When the calls came reporting the trouble, I discovered that it was due to the unleveled bathtub. Qigu tried to use sealers and caulking to stop the problem, but the leak continued. We had to cut open the walls, relevel the tub, and redo the plumbing.

The mortgage and property tax worried me when the tenants fell behind in their rent. It felt strange to be called "owners" when we were really servants and laborers. We were the ones who smelled like sewage while our tenants smelled clean and fresh.

Our lives were harder than our tenants'. We lived in the attic, slept on the floor, and peed in a bucket. We couldn't afford to buy gifts during Christmas. We watched our tenants Bruno and Helen, sitting on their sofa and watching TV, or outside under the sun drinking beer and smoking cigarettes. They entertained their friends and never seemed to worry about anything. When Helen got drunk, she called us "Chinamen" and juld us to "go home."

Qigu took a day off once a week. He insisted that it was necessary to "keep his sanity." During his time off, he visited the Chicago Public Library. He brought back art books by successful artists. He studied them. His latest favorites were a modern Italian painter named Francesco Clemente and the American artist Jean-Michel Basquiat.

Qigu said it would do me good to look at the works by Clemente and Basquiat, because he believed that I spoke a similar language.

In retrospect, Qigu did me a big favor. He led me to an important self-discovery. I fell in love with Clemente and Basquiat. Qigu was right that I understood their language. I was inspired. Memories became so alive that my past flooded my mind. I could hear voices and remember the long-lost feelings even as I worked on fixing a toilet or dug up a broken section of the sewage line. I realized that I could be "the book." I wanted to write.

I developed the feelings of a budding athlete, with a green card as a gold medal. I dared not dream that I would ever be successful as a writer. But if I did manage to publish something, I would have a better chance of being awarded a green card, for there was an immigration law that recruited "international talents."

After working myself to exhaustion, I sat in the attic and studied

Charlotte Brontë's Jane Eyre in its original English. I read it three times. First I looked up every word that I didn't know in my dictionary. I marked the translation next to the words. Second I read it with the eye of a reader, and then finally with the eye of a writer. It was not unusual for me to understand the individual words but still not get the sentence. I went back and forth trying to figure out the meaning. I would try different approaches and think of the equivalent in Chinese. Often I was forced to abandon the sentence for the moment; then I would return after a few paragraphs or pages. On a good day I would get to crack the nut. I found good sleep a key to unlocking a hard phrase. I lived for those moments, and it thrilled me more than anything. It made me feel that I might actually be smart.

I tried to compose, but got stuck. What I produced didn't match my imagination. My writing didn't sound awful, but it didn't sound bright either. The elements I had expected were not there: the grace, the emotion, the poetry, not to mention the style. In order to beat my disappointment and stay positive, I told myself to consider it a blessing that I was able to recognize my shortcomings. It took talent to notice that I lacked talent. I stood on American soil, and there was no reason not to try harder. If nothing came of it, my English would improve. It would help me land a job as an office receptionist. I would get to answer the phone and take messages in English.

{ CHAPTER 22 }

LL MY LIFE I had been a soldier whose job was to kill pain. I was proud of being strong. It became my second nature to pull the plug as soon as I sensed an undercurrent stirring inside me. I locked up memories and allowed no place in my heart for feelings, because I believed that I could not afford to be weak. I told myself that I didn't have a legitimate reason to complain about anything. I had survived China and was now living in America, a place people risk their lives to come to.

And yet as I struggled to write, I discovered that my soul had a mind of its own. It wandered to the wrong neighborhoods as I followed a memory I was trying to capture. There, as the hidden pain came to the surface, I was disarmed. When I felt as if I had been shot, I ordered my soldier self to take over. In darkness, silent and wounded, I watched myself flat on the ground enduring the internal bleeding.

Writing made me feel vulnerable. The soldier inside me surrendered. I didn't know what to do.

I continued to write for the sake of improving my English and to see if my memories would become a story. The process was difficult and unpleasant. I composed my writing first in Chinese, then translated into English. This helped me catch the memories and also to exercise the translator in my head. My English did seem to improve, and this was important if my goal was to get a job as an office secretary. Finding the story was harder. I was borrowing from some of my old writing that I'd done for Dr. Guenther, and I had new stories and lots of not-quite stories. Finally, I brought my mess of pages to a new independent study with Dr. Guenther and asked her for help. The tutorial went by in a flash and Dr. Guenther had to kick me out. I begged her for more time and she sympathetically arranged for me to meet with her colleague Mrs. Watson. Both of them asked me lots of questions about my characters.

And they wanted to know what would happen next, and this encouraged me.

Before I knew what was happening, I couldn't escape my memories. I might be listening to a professor lecturing on contemporary American art while seeing myself carrying a hundred-pound load of manure to the rice paddy. I would be on a Chicago rapid-transit train hearing the pounding of Chinese drums along with shouted Cultural Revolution slogans. Memories flooded my mind and dominated my waking hours and even my dreams. I began to write like a mad person. There became no day or night. Qigu moved downstairs to get away. He slept in the hallway, which we closed for an extra room. It was extremely cold, but at least he was undisturbed.

I had never tasted the bitterness of guilt, regret, and remorse until then. I was haunted by those whom I had left behind, those who were part of my life, and those who were dead or as good as dead. I thought that I had long buried them, but writing brought them back. They were with me every day. We began to have conversations. Among them were my labor camp comrades Little Green and Yan. Little Green died when she was eighteen. I was the one who discovered her drowned body. No one was held responsible for her death. Nothing about her was spoken or written.

Yan was alive and was living in China, but she was as good as dead. On my last trip to China she had finally agreed to meet me. We sat sipping tea in a park across from one another. She did not want to remember the past, but it was eating her up. She seemed ghostlike, the most real thing about her was the gloves she wore to hide the scars on her hands from working in the fields. She had been a Communist boss at the labor camp. She used to be my heroine, my role model, my best friend and love. I couldn't face the fact that I had failed to rescue her. I felt that I had betrayed her and let her down. I had escaped to America to a good life while she faded and was forgotten.

As Yan and I drank our tea, an opera club that had come into the park sang the famous lines of an ancient poem:

When young we hadn't the taste of sadness We climbed the city wall to get inspirations

ANCHEE MIN

For the sake of composing a new poem
We described sadness as if we understood such feelings

Now that we are old and gray
We have tasted every bitterness and sadness
Once again we climbed the city wall and arrived at the top
Instead of composing poems we smile and say, "What a great
autumn day!"

My heart began to burn with the desire to tell the stories of Little Green and Yan. I began to write down what I remembered of them. I wrote on buses, on subways, in between classes, during work breaks, in the middle of the night. My pockets were filled with paper notes. The backs of my hands and my forearms were covered with ink characters in Chinese. "Nice tattoo," my schoolmates commented.

It made me feel noble and my existence justified when I wrote I embraced myself for committing to the task. I felt fortunate that I lived to do this. I forgot my goal. I no longer cared if I ever became an office secretary. Mentally, I had to write to survive. Through writing I wanted to help Little Green and Yan achieve immortality. Through writing I wanted to purge my own ghosts and ensure that I didn't become a ghost myself.

I lost myself in chasing the images. When the ink touched the surface of the paper, I felt alive. I began to notice changes in my thoughts, feelings, and perspective. I was writing what I would never have dared if I had still been living in China. I wrote about how we risked our lives to love.

When I finished my manuscript, I sat on the attic floor and looked out the window. I was struck by the beauty of the white night. Growing up in Shanghai, I had never experienced a grand snowfall. I let the pure silence of the whiteness seep into my soul. As I turned to look at the stack of papers sitting on my desk, a thought came to me: No publisher or literary agent would accept a handwritten manuscript. I didn't dare to think about buying a typewriter. Qigu and I could barely afford to eat after the mortgage and property tax.

One Sunday morning at the flea market on Maxwell Street, we happened upon an old-fashioned typewriter on sale for six dollars. Qigu and I bargained the owner down to five. Thrilled, I carried the typewriter home as if it was my newborn.

I sat down and began typing. Nothing appeared on the paper. The ribbon was dried-up. There was no place that sold old-fashioned ribbons. Qigu and I searched all over Chicago's junk stores. Finally we discovered a pair of ribbons.

With the new ribbons, I tried to type again. This time I was stuck with a different problem. Every time I typed an *N*, *P* would come up at the same time. Now I had to buy a bottle of Wite-Out to get rid of the *P*'s.

I mailed out my manuscript to a dozen publishers and agents but received no response. I ran out of money for copying and mailing. After I spent my last dollar, I returned to work as a plumber.

One afternoon I received a postcard from a literary agent whose two lines of handwriting I was unable to read. With the help of the local librarian, I deciphered what was written on the postcard. The first line told me that the agency did not accept authors that were unpublished. The second line suggested that I try to get a shorter version of my work published in a magazine first.

I was grateful for the postcard. Qigu and I visited a local bookstore, searching for advertisements for writing contests. We located the ads in the backs of magazines such as *Writer's Digest*. The problem was that there was an entry fee. It was too expensive for me. Twenty-five dollars to enter a short-story contest was more than I could afford.

I kept looking and discovered a contest that charged a cheaper entry fee. The magazine was called the *Mississippi Valley Review*. It was its "20th Anniversary National Writing Contest." It would cost me only five dollars. Another magazine I discovered later was even better; it required no entry fee at all. The magazine was called *Granta*.

I mailed my story "Wild Chrysanthemums" to the *Mississippi Valley Review* and another story, "Red Fire Farm," to *Granta*. In three months, I received news that the *Mississippi Valley Review* would publish my piece as a reward for winning the contest. After six months, *Granta* informed me that it would publish "Red Fire Farm."

With these publication credits, I contacted publishers and agencies again. No one responded. After a year and a half, I figured that it was not meant to be. Respecting reality had always been my virtue. I was disappointed, but I was American enough not to take it as a personal disgrace.

Mr. Lin Po was Qigu's old friend. He was a sophisticated man and was regarded as a great critic of art and literature among the Chinese. When he heard from Qigu that I had been trying to write, he said, "Who do you think you are, Mao Zedong's daughter? What makes you think you deserve to tell the story of your life, when your life is as plain as millions of Chinese? Why do you think you might succeed while every other writer from mainland China has failed to break into the mainstream American market? For heaven's sake, they are veteran writers who are well published in China."

I didn't bother to argue with Mr. Lin Po. He meant well. I knew I didn't have the luxury to sit around and write. Qigu and I were behind in our mortgage payments. Qigu said that the Chicago Art Fair was coming up. It would be an opportunity to earn a few dollars if we got lucky.

We set up a booth selling Chinese brush paintings again inside the downtown Bloomingdale's. Although there was traffic, few paid attention. Qigu told me that I was a lousy salesperson because I couldn't help but point out the flaws in my paintings to people who were interested. By the time the fair closed, we barely made back the booth fee.

A week later, the phone rang. I was in the middle of fixing a leaky toilet. A lady's voice on the other end asked for "Ahjeih." I was not sure if she meant me.

"Who are you?" I asked, It was too late to correct myself. I meant to say, "Who is this please?"

The lady didn't mind and introduced herself as Sandra Dijkstra.

Between the distraction of regretting my bad phone manners and juggling my plumbing tools, my mind missed the translation. I didn't understand what the lady was saying.

"Who is this, please?" I kept repeating. I knew my pronunciation

was good. The trouble was that it made people think I was fluent in English. They would start to talk fast, like this lady now, and I had to guess what she was trying to say.

"Sandy Dijkstra, Sandy, from the Sandra Dijkstra Literary Agency \dots "

"Par-... pardon me? Your name?"

"My name is Sandy."

"Sandy what?"

"Sandy, from the Sandra Dijkstra Literary Agency."

Agency? What kind of agency? I was glad that I caught the key word. She sounded like an authority figure. Could she be from a government agency? Might she be an immigration officer calling to inquire about my visa status? A police detective? Had I been followed? Did this mean that my time in America was up? My thoughts got ahead of me: Was I to be deported?

A thought in my head buzzed so loudly that I could no longer hear the lady.

"Hold on." I put down the receiver and went looking for Qigu.

With my heart racing, I ran up and down the staircase. But I couldn't locate Qigu. I knew he was fixing a broken electric switch somewhere. He must be downstairs in the basement. I needed his rescue, needed him to tell me what to say to the lady on the phone. I must not give a wrong answer. I was afraid of getting myself in trouble with immigration, and the lady on the phone might try to trap me. I'd be fooled and then arrested. I must think quickly about why I had not renewed my visa.

"H-... hello, this is Anchee Min," I said.

Again I missed what the lady was saying.

My fear was paralyzing me.

There was a silence. *Is the lady waiting for me to answer her question?* I collected my English. "How did you know my phone number?"

"Well, do you remember about a year and a half ago you submitted..."

"My English is not good."

"Excuse me?"

"Would you please speak slowly? My English is no good."

The lady slowed down. "About a year and half ago, you submitted your manuscript titled *Red Azalea* to our agency . . ."

Of course I remembered.

"Do you remember the Sandra Dijkstra Literary Agency, my agency?"

"I submitted my manuscript to twelve places."

"Anyway . . . I am Sandy, a literary agent. I am interested in meeting you." $\,$

With effort she helped me understand that she was on her way to New York, stopping by in Chicago for a night. She would be available for a breakfast meeting at eight in the morning at her hotel.

"I'll come," I said.

"Fabulous!"

"Your name again?" I wanted to make sure.

"Sandra Dijkstra."

"How do you spell it? One syllable at a time, please."

She did.

I started to feel that I might be hallucinating. I didn't trust what was happening. How would I know that the person on the line was who she claimed to be?

"So, good-bye for now, and I'll see you tomorrow, Ahjeih? Or Annjeih?"

"It's Anchee."

"Excellent, Anchee."

"Did you say you read my manuscript?" I asked before hanging up the phone.

"Well, I have just started, but my reader did."

"Your reader?"

"I hire readers to work for me at the agency \dots " She was talking fast again and I lost her.

I tried not to interrupt. I began to guess. She said something about the person she hired. Something about the individual whom she assigned to read my manuscript and who finished it and gave a report. But it was not a great report. Something about the reader who "didn't fall in love" with my manuscript. Finally something about an evaluation that crossed her desk months later.

THE COOKED SEED

"I was intrigued," I heard her say. "So I decided to give the manuscript a shot \ldots "

"Qigu! Qigu!" I screamed as I hung up the phone. I ran all over the building, but he was still nowhere to be found.

I phoned my friend Joan Chen in California. "Do you know Sandra Dijkstra?"

"Of course I do," Joan Chen replied calmly. "She is Amy Tan's agent. Remember, you once asked for the agency's address? The one in Del Mar, California?"

Now I remembered sending my manuscript to Amy Tan's agent. I remembered "Del Mar" because the manuscript was at first returned to me as "undeliverable," for I had given the wrong address. I wrote one "Del Mar" instead of two. The correct address was "Camino Del Mar, Del Mar, California."

"Anyway, Sandy Dijkstra called and arranged to meet me tomor row morning!" I told Joan Chen about the phone call. "Please advise me, Joan. What do I wear? Do I dress up? Do I tie my hair back or let it down? What if Sandy Dijkstra finds out that I am a country bumpkin? Think this: My manuscript has gone through years of revisions. But in person she will find out that my English is a wreck. She will be disappointed. I am afraid..."

"Just be yourself," Joan advised. "I don't think she'll care that your English is not perfect."

"But what do I say to her?"

"Let her do the talking." Joan Chen convinced me that there was no need to be nervous. "The quality of your manuscript is the only thing Sandy will be concerned about. She wouldn't waste her time meeting you if she didn't think you were worth it. Trust me, she knows what to do. It's her business."

Qigu returned. He shared my excitement. The only thing I worried about now was our car. The Chevrolet had been unreliable. There was no way to know if it would start tomorrow. The temperature had dropped below zero again.

I took a hot shower and washed my hair. I tried to ensure that the stink of the sewage wouldn't follow me to Sandy Dijkstra's hotel. I took out my Chinese cotton coat and ironed it. I also cleaned my worn boots the best I could.

By dawn I was up. Qigu was still in his dreamland. I was relieved to find that the snow had stopped. Luckily, after much huffing and puffing, the car engine came up. I left the engine running and cleared the snow from around the car. I retaped the car's broken window with cardboard.

At six A.M., I pulled into the street and headed toward downtown Chicago.

Like a spring breeze, Sandra Dijkstra walked into the hotel's restaurant. She was a handsome lady in her forties with a youthful look, bright eyes, and an affectionale suille. Her short damp hair told me that she had come from a morning shower, or perhaps from swimming. Her face lit up as she greeted me with a "Good morning, Anh-chje!"

I didn't know she was pronouncing my name the French way. She looked at me with beautiful crystal-clear eyes. The waiter led us to a corner table. Sandy said, "How nice it is to finally meet you. Correct me, please, is it *Anh-chje?*"

I told her I enjoyed the accent, though I had no idea what kind of accent it was.

She told me that she had a Ph.D. in French literature. "I got up at dawn this morning and reread your manuscript. Fantastic work, I must say. I would like to try your luck in New York. What do you say?"

I told her that I didn't know what else to say but thank you.

She took out a piece of paper and told me that it was an author-agent contract.

I forgot how I drove back home. Upon returning, I excitedly described to Qigu my meeting with Sandy. "I don't expect anything to come of this, though," I concluded.

"We must get back to fixing the plumbing," Qigu agreed. "The tenants are threatening to move out."

It took me a while to calm down, to stop dreaming of Sandy calling. It was good that I never really believed that anything would happen.

Life quickly went back to normal. The weather warmed up and Qigu and I were forced to fight a new battle—termites. They were discovered in our building and the city had issued a fine. We had to hire a professional pest-control company, which meant more debt. In the meantime, we had been doing the mortar ourselves. I carried buckets of cement up the stairs from dawn to dark. I passed the bucket to Qigu, who stood on a ladder three stories high.

Qigu was unhappy because I wouldn't let him work on his art without getting the property fixed first. "We are in this together," I said to him. "And I am a woman doing a man's job."

"I didn't come to America to be a slave," Qigu protested.

Sandra Dijkstra phoned again. This time I recognized her voice.

"How are you, Anchee Min? What are you doing?"

I was not sure if I should tell Sandy that this was the second time Qigu and I had had to work on the building's plumbing. The new joints leaked because the solder paste we had used was too old. Qigu and I were mad at each other because we should have spent the \$1.29 to buy new solder paste. We were ruled by the desire to save every penny and were in the middle of taking apart the entire plumbing system and resoldering it.

"Are you sitting down, Anchee?" Sandy continued.

"Would you like me to sit down?" I wondered why she would ask. What difference would it make, sitting down or standing up? I was only talking to her on the phone. Should I let her know that Qigu was waiting? That he was holding the propane torch? That I just pulled an inch of solder wire out of its spool and was getting ready to feed it to the pipe joint? "I can sit down if you want me to, though I have to sit on the floor, because there is no chair here."

"Never mind," Sandy said. "Listen, I am in the middle of auctioning *Red Azalea*. Five publishers have joined the bidding. I have narrowed it down to the final two—both are great houses. My question to you is

ANCHEE MIN

which publisher would you like me to go with—Random House or Knopf?"

How could I possibly have any idea? "Will you \dots Sandy, will you kindly decide for me?"

"Sure. And there is an author's advance," Sandy said.

"What does 'an advance' mean?"

She started to explain what an advance was.

I asked Qigu for a pen and piece of paper. The cold had made my fingers stiff. I could barely hold the pen. I was not sure I caught the amount Sandy mentioned. I wondered if she meant five thousand dollars or seven thousand. I had a feeling that I was translating the number wrong. It couldn't be this much money. "Is it one zero or two zeros after the number seventy-five?" I asked.

"Three zeros, honey."

{ CHAPTER 23 }

Y MIND KEPT playing a particular scene from my childhood. My mother was on her back on the floor. Mrs. Bao, our downstairs neighbor, was on top of her. Mrs. Bao was holding a pair of scissors and stabbing my mother. I stood next to them, frozen and terrified. I was five years old. I remembered struggling to breathe.

My feet were beside my mother's head, but I was unable to move. My body felt like a tree stump. My younger sister was near my mother's feet. She was pulling on Mrs. Bao's legs, trying to help Mother. Although I desperately wanted to help, I could do nothing.

Mother was losing her strength. She tried to push Mrs. Bao off, but Mrs. Bao was too strong. Then I heard my mother's cry.

Mrs. Bao's scissors slashed across my mother's face. Blood seeped between her eyes and nose.

There were people outside. Someone banged on the door.

Mrs. Bao got off Mother and ran downstairs.

With blood crawling like earthworms down her face, my mother rose.

Seeing that she was alive, I was able to breathe again.

I heard Mrs. Bao open the downstairs door. She shouted to a gathering crowd.

I went downstairs and saw Mrs. Bao telling her story. She was waving both of her fists above her head. To my surprise, I saw blood oozing from her wrists.

"An anti-Mao incident has just taken place!" Mrs. Bao cried at the top of her lungs, "A bourgeois intellectual denied a proletarian worker a toilet!" She told the crowd that my mother had cut her wrists.

"Justice!" the crowd yelled. "Blood debt must be paid with blood!" $\,$

My mother rushed downstairs. Although she had cleaned her face, blood still seeped from the wound. She was unable to convince the crowd that Mrs. Bao had lied.

Three generations of the Bao family lived downstairs without a bathroom. A wooden chamber pot was all they had. Every day Mrs. Bao waited for the sanitation truck to come and empty the chamber pot. The revolution erupted and the sanitation truck stopped coming. The Bao family had taken to dumping their waste at the end of the lane under a tree. The neighbors complained of the stink. My mother felt bad that the tree was dying.

Against my father's wishes, my mother invited the Bao family to share our toilet. We had no idea what we were getting ourselves into.

Our toilet started to back up, for it was not designed to swallow the contents of a chamber pot filled with the waste of eleven people all at once.

My father had to manually break up the turds. He used a pump to push and flush the waste. It got worse. The sewage pipe was clogged. Every time we flushed the toilet, it would flood. The feces spilled over the toilet and covered our floor.

The Bao family demanded possession of our toilet. One taste of the comfort and they were driven to believe they were entitled. "You have two toilets and we have none, and revolution is about fairness." They told my mother that times had changed. The proletarians ruled.

My mother refused. The Bao family decided to teach my mother a lesson. They came up with their chamber pot and emptied it over our beds and sheets.

There were no police, no courts. Under the control of the "proletarian dictatorship," Shanghai was chaos. Mao's teenage Red Guards began looting the city. My mother couldn't get any help. She and my father had to wash the soiled blankets and clean the neighbors' feces every evening when they returned from work. Soon we had to sleep with our clothes on because we no longer had any dry sheets, blankets, or bed mats. Eventually we were driven out and relocated, to a place with no toilet of our own.

I was witnessing my life change before my eyes. I could hardly believe that I was signing a book contract from one of America's leading publishing houses. The sad days were over. I would never forget the time when my family shared one towel, and when we were bullied by the neighbor over use of the toilet.

With the money I earned, I wrote to tell my mother that my first wish was to get her a toilet. She had dreamt one day that she might have her own toilet. I was thrilled to make this dream come true. Also, with the advance I would be able to pay off my debts, and more important, I went to see an immigration lawyer, who told me that, with the proof of a book contract, I stood a good chance of qualifying for a green card.

Qigu came home with unexpected news—the US government had just decided to grant political asylum to all Chinese students in America who participated in the 1989 democratic movement in Beijing or abroad. We would all be granted a green card, and in five years American citizenship.

Sitting on his rocking chair bought from a Chicago flea market for four dollars, Qigu recited an ancient Chinese poem:

The worry seems no end
When it comes to searching for your heart's desire
Even by wearing out your shoes made of iron
Yet without one's slightest effort
Fate strikes
Opportunity lands on your lap

Overnight we were legal immigrants. We walked out of darkness to breathe in the sun. Although I was not religious, I prayed for God to bless America. To repay with a well for a drop of water during drought was a Chinese virtue. I wanted so much to be deserving of the kindness.

I felt uneasy over my good fortune. We had done nothing to actually help the students in China. I had taken part in the protest and shouted slogans calling for democracy, but I didn't risk my life like those at Tiananmen Square.

My father let me know that I had just lifted a crushing weight off his chest. He was so happy that he hummed the newly learned tune of "Yankee Doodle Dandy" over the phone. I told my mother that the money for her private toilet was in the mail.

A year later, my father sent me a photo of my mother sitting on her new toilet. "Your mother wants you to know that it was her happiest moment," he wrote.

My mother dressed in her best clothes for the photo. She had her hair done. She beamed like a child having her picture taken in front of Disneyland.

Once again Qigu asserted his trust-in-fate theory. "If it is meant to be yours, it will be yours without you fighting for it. That is the essence of Zen and Taoism."

Watching him slip into his sage mode, I tried not to show irritation. I believed in the early-bird-gets-the-worm theory. I was not a Christian, but I liked what the Dible said, "God helps those who help themselves." Fate and luck play a role in one's life, I agreed, but expecting rice to rain from the sky was crazy. What about one's obligation toward the less fortunate?

When the author's advance payment arrived in the mail, I paid off our mortgage. There were still many repairs to be completed on the building, but we now owned the property free and clear. Without the pressure of monthly mortgage payments, everything became manageable. We were able to provide our tenants with major repairs and improvements. I expected Qigu to work on finishing the apartment while I revised the manuscript *Red Azalea*.

Perhaps it was the lifting of the stress, perhaps it was that we could now afford to eat our favorite Polish hot dogs three times a week, or perhaps that ticking of my biological clock was growing louder—whatever the reason, for the first time in my life, I asked myself, "What do you really want, Anchee?"

A child! The thought was so clear, overwhelming, and powerful. The next day I found myself in the library reading self-help books on pregnancy. I wished that I knew how to tell Qigu that I could not wait any longer. I was turning thirty-five. I wanted to have a child of my own.

But I didn't know how to properly speak to Qigu about this. We had been together for six years. The right time to mention wanting a child would be after his proposal. But there had been no proposal. Not even a hint of it. What could I do but wait? I had been my best self. Qigu was a nice guy. My mother believed that a decent man like Qigu would propose to a woman of my quality. What went wrong? I wondered.

I finally decided to ask Qigu, for the last time, what he thought about us having a family.

Qigu sighed and sang the old song: "How can I support a family when I can barely feed myself?"

Telling me the truth was a sign of a good character, I convinced myself. Qigu was only trying to be responsible. Qigu loved to recite Confucius—"Men are born weak"—but I thought that awareness was the sign of a strong man.

The dilemma was: How long should I continue to wait?

The concern seemed to be mine and mine only. I realized that I was at a disadvantage after spending so many years being what Qigu praised as a "liberal-minded" woman.

On New Year's Eve of 1991, I approached Qigu with a Chinese book *The Science of a Female Body*. Feeling sorry for me, Qigu attempted to calm me with his usual tactics. But they failed to work this time. Qigu kept excusing himself as a "weak man."

"You accomplished jumping over the dragon gate to America!" I challenged. "One cannot afford to be strong in China, but we can in America. We are green card holders. We can afford to be strong, and be whoever we want to be! It is the privilege of being an American!"

Qigu shook his head. I realized that he would not propose marriage, now or perhaps ever.

On the surface, I was my normal pleasant self, but underneath I was a raging storm. The crisis was reaching a critical point. I knew that I would regret it for the rest of my life if I robbed myself of the chance to be a mother. I decided that I could endure not getting a marriage proposal, but that I could not go on without trying to have a child.

Qigu was beyond devastated when I broke the news to him that I was pregnant. He claimed that he was the victim of my conspiracy. What he thought had been a romantic evening was a trap. He was willing to accompany me to an abortion clinic.

I refused. "I will not go to the abortion clinic."

Qigu was upset and called me irresponsible and sneaky. "How can you bring a life into the world unplanned?"

I had long been planning. I felt responsible for conceiving before turning thirty-five. "I did this to avoid the increased risk of birth defects that occur after a mother turns thirty-five. Thirty-five is where the line is!"

Qigu let me know that he didn't want to be forced into fatherhood. He felt that I was manipulating him. "It is a mistake!"

I felt bad about dragging Qigu into fatherhood, but I had no choice—he wouldn't get off the pot, and I couldn't date other men. We had been a couple in reality. Although Qigu never said that he loved me, he never said that he didn't love me, either. According to Qigu we were practicing love the Chinese way, although deep inside I had doubts.

I was selfish in wanting this child. But I also thought living with a man for six years was a solid foundation for a family. Usually, I felt secure about our love for each other. What was more romantic than fighting to achieve the American dream? Qigu was a man of great potential. He was a work in progress and a piece of art.

In retrospect, I would see that Qigu and I didn't share the same values, which most immediately included an interest in creating a family. We needed each other because neither of us could afford to take time off to meet people and to date, to break up, to make up, to pick and choose a truly compatible life partner.

I rarely had the time to stay in touch with my girlfriends. All they knew was that I had been living with Qigu. My pride kept me from admitting that I was in a mess, even that I was unhappy about not being proposed to. The way I dealt with it was to be an ostrich and bury my head in the sand, all the while praying for things to go right.

I feared that Qigu might leave me if I pressed him too hard on marriage. I was convinced that no man would want me. My beauty had

THE COOKED SEED

faded and I was at a loss about what else I could do. I felt my only option was to squeeze my dream and make do with what I had.

Being pregnant was the first thing I ever did for myself. It was my act of rebellion against the world, and I found it exhilarating. Falling deeply in love with the baby growing inside of me, I couldn't say that I was not worried or frightened. I was, but I also had never felt so empowered, so charged with energy and strength. If I wasn't experiencing romance with Qigu, I was with my baby. Each day became a song, each day a blessing.

Although Qigu and I no longer had the mortgage to worry about, we had vacancies. Our neighbors protested when we rented one of the units to two black students from the Illinois Institute of Technology. We ignored the threats. We saw no reason not to rent to the black students.

As a result, our car windows were smashed. More threats were posted on our door.

We didn't report the incidents to the police because we felt that the entire neighborhood was against us. We feared, however, the police might not come to our aid if something should happen.

Qigu and I discussed the hostility with our black tenants. We told them that we didn't feel comfortable as Chinese living in the area either. Once, Qigu was pelted with stones on the street, not just by whites but by blacks as well. Another time, a group of teenage gang members from the projects on the other side of Thirty-fifth Street attacked us. We let the tenants know that we feared for their safety. They were welcome to stay, but we couldn't guarantee their safety.

The black students finally decided to cancel their lease and move out. We telt terrible, but what could we do?

After I mailed the manuscript off to my editor in New York, I joined Qigu on the job. I was aware of the risk of a miscarriage. My thinking was: Chinese peasant women continued to work in the rice paddies, carry manure, and feed the animals while pregnant. I saw myself doing

the same. I was careful climbing ladders. I wore a mask when applying drywall joint compound. I continued to paint the walls and clean up debris. I made sure not to overload the buckets of cement when I carried them to the third floor.

Morning sickness was dramatic for me. I didn't mind. I considered it a sign of the fetus's vitality. I kept eating and kept throwing up. I grew used to my face hanging over the toilet bowl. For weeks, I couldn't get my stomach to take food. My energy dropped and I wanted to rest, but I continued working. It was important to help Qigu as much as I could before my belly got too big.

In the meantime, I had a secret. I had prayed that my child would be a boy. I was not discriminating against females. As a Chinese female, I simply understood that I belonged to a discriminated-against class. My whole life had been proof of this. I had hit hurdles that men never had to face. Those hurdles were both physical and mental. Chinese culture was deeply prejudiced against famales, even under Communism when women were supposed to hold up half the sky. I did not want my child to be born with any disadvantage if I could help it. Being male meant respect and opportunity. Though to a lesser degree, I saw that this was true in America as well.

I visited dusty Chinese herb stores and purchased ingredients to help boost my body's chemistry. The fragrant contents of the little bottles promised to create an "environment" that would "welcome" a male. I followed the herbalist's instructions on washing my behind each night with a special formula of herb water. If there had been a Buddhist temple in the area, I would have gone to pray.

When Qigu voiced his resentment and sang his I-am-a-starving-artist song, I told him that the baby would be my responsibility alone.

"We are not married anyway," I said. "I will register the child as being born to a single mother."

{ CHAPTER 24 }

IGU SAID, "LET'S get married. I don't want the baby to follow your bad example."

I found myself trying to survive the moment. We were putting away the tools after the day's work. Realizing that I was hurt, Qigu explained that he had meant humor.

What I felt was that Qigu saw no reason to hide his true feelings. It was nevertheless a marriage proposal. An official one. The one that I had been waiting for for six years. I tried not to break down in front of Qigu. I never imagined that the marriage proposal I would receive would be like this. I wished Qigu had not proposed. I wished that he might have made an effort to fake a proposal.

For the first time I couldn't bear to look at him—the father of my child, the father who felt cheated and trapped. Qigu had the right to a lifestyle he desired, which did not include a child. I was too afraid to leave. I was disgusted with myself for driving both of us into this.

I don't want the baby to follow your bad example. The words kept stabbing me in the gut.

I loaded construction debris into garbage bags and struggled to hold back my tears. I had lost my dream—to feel like a princess for once. Something precious in me died. Ever since I had read *Jane Eyre* and learned the meaning of love, I had wanted love. I dreamed of love as a Chinese peasant might. I had fancied myself as a peasant-wife planting rice with an infant tied to my back. I had imagined myself walking the edge of a field carrying lunch to my husband. Buckets of cool water, at both ends of a bamboo pole that sat across my shoulders, would sway and slosh as I drew near. My husband would greet me with a sweet smile. He would take a break from his plowing. I would hand him a towel to wipe the sweat from his face. I would sit down on the edge of our land and breast-feed my baby.

"Really, I meant humor," Qigu said again. "You are overreacting as usual."

I had nothing to say.

Qigu shrugged, "Well, I can't stop you if you want to take me the wrong way. Let me know when you are ready. We can go to the city hall and register for a marriage license."

I would have refused. His words felt like insult. But the pregnancy changed my perspective. All I cared about was the baby inside me. I owed this child a set of parents.

"I am ready," I said to Qigu.

We made an appointment with the city to be married in front of a judge on February 6, 1991.

We couldn't afford a wedding, but I still longed to celebrate. Wasn't it, after all, the biggest moment in my life? Shouldn't I share the news, or call someone and announce, "Hi, I am getting married tomorrow!" I wanted a blessing. I thought about calling my ramily in China, Joan Chen, and Margaret.

I dropped the idea because truth hit—I would be sharing false happiness. Qigu wasn't marrying me because he was in love with me, although he tried to convince me and himself otherwise. Qigu's "bad example" had been seared into my mind: It contained all of his reluctance, resentment, and regret. I felt sad. Qigu didn't look forward to marrying me. He was only doing me a favor. He was defeated.

Instead of preparing a celebration party, or giving my wedding dress a final inspection, Qigu and I worked on the apartments. We drove to the hardware store and purchased plumbing supplies. We ate Polish hot dogs. After returning home, Qigu went down to the basement to work on his paintings. "Good night," he said.

I reheated leftover food and ate dinner alone. I washed the dishes. Afterward, I sat in the kitchen. I was overwhelmed by sadness.

Qigu hadn't revealed anything to his parents about my pregnancy, although they knew that I had been living with him. Qigu told me that his parents were "stiff-minded" folks, former Communists. "All they did with their lives was blindly follow the Party," he said. "My mother was never offered Party membership in the end, which crushed her. My father was a veteran Party member, but he lived a crappy life. He was distrusted,

punished, and sent to a reform camp. His bourgeois family background was a stain he could never escape from." Qigu and his younger brother grew up on the streets of Shanghai while their parents were denounced. His mother was tormented by jealous coworkers and suffered a mental breakdown, from which she never completely recovered.

The last time Qigu had heard from his mother was on a cassette tape. She mailed it across the ocean, which must have cost half a month's salary. The tape was ninety minutes long and advised Qigu on what to do and what not to do, with an emphasis on safety and food poisoning.

Qigu asked me to press the fast-forward button. I felt sorry for his mother. I wished that I could write her to tell her that her son was safe.

I imagined that my future in-laws would be excited to learn that they were going to have a grandchild. When I visited China two years before, Qigu's father sat me down and shared the history of his family. After Mao died and the Cultural Revolution ended, his "stain" had miraculously been transformed into proof of his prestige. "My ancestors, the Jiangs, were first silkworm farmers and then silk merchants from Zhejiang province in southern China. By the turn of the century, they became the founding fathers of China's textile and banking industry." The old man recalled his youth as a romantic idealist who joined the Communist Party to change the world for the poor. Although he was dedicated to his work, he never rose far in rank. "Qigu didn't grow up with a silver spoon in his mouth. We lived in one small room located in Shanghai's Xuhui district. It was too crowded for five people from three different generations."

As we spoke, Qigu's mother cooked rice by the staircase. The scene filled my heart with warmth because I identified with their poverty. I took comfort in the thought that Qigu came from a humble home. I assumed that lie would understand suffering—a quality I'd look for in the man I would marry.

Qigu did not have fond memories of his childhood. Fear had been his constant companion. He was beaten by street gangs while his parents were away serving at a series of reform camps. Qigu resented that his father's family had "donated" its fortune to the government in order to prove its loyalty to the Communist Party. "I could have been a rich man today," Qigu once said to his father.

"It was a forced donation," the father argued. "You wouldn't have escaped punishment and gone on to live the life you now enjoy if I had failed to comply with orders! You definitely would not have been given a passport to America!"

Qigu and I arrived at the Chicago city hall. It was crowded with people. A lady received us and gave us forms to fill out. She then directed us to a window that read RECORDING, where we filed our forms.

Qigu grinned at the signs above and said, "At this window you file a marriage application, and at the next window you file a divorce application."

"Please don't rain on my parade," I said.

"Sorry," Qigu responded. "I just think humans are foolish creatures."

We were led to an empty waiting room and told that a court judge would call us. After a long wait, Qigu and I wondered if we should knock on the door where there was a sign that read COURTROOM. As we were about to knock, the door opened. A large, dark-skinned man appeared. He seemed to be in the middle of changing his costume.

"Stay outside, please!" he said loudly. "I'm not ready yet." He then closed the door in our faces.

We went back and sat down on a bench in the corner. Other couples slowly filled the room. They walked through the doorway holding hands or smiling at each other. The men were in pressed suits and the women in pretty and ceremonial dresses.

All of a sudden I felt awkward. I wished that I had dressed up like the other brides in the room. Qigu and I wore clothes bought from thrift stores. He was in a casual navy-blue jacket, while I was in a mixed-color blouse matched with India-style pants and matching-colored shoes.

Qigu detected my discomfort and leaned over. "It's all a circus show anyway," he whispered in my ear. "Fifty percent of these marriages will end in divorce."

I looked at him. "Will we be the fifty percent divorced, or the fifty percent who stay married?"

THE COOKED SEED

Qigu gave a sage's smile and said, "Of course the latter."

The door to the courtroom finally opened. To our surprise, a happy couple came out followed by the smiling judge in his black gown. The bride wore a white dress and had white gardenias in her hair.

The happy couple kissed passionately. Their arms were wrapped around each other as they exited the room. I was moved by their affection and my uneasiness deepened.

"How come we haven't been called?" Qigu said. "The rules say, 'First come first serve.'"

I looked around. "Maybe we should check with the clerk again."

A female clerk came into the room and yelled, "Q Young and Amen!" Nobody responded.

"Q Young and Amen!" the clerk repeated.

The couples in the room all looked at each other.

"Last call, Mr. Q Young and Miss Amen!"

"That must be us!" I cried to Qigu. "Americans can't pronounce *Qigu*. They can't sound *Qi* as 'chi.' They pronounce it as 'Q.' They pronounce *Jiang* as 'young.'" But this was the first time anyone had turned *Anchee Min* into "Amen."

Qigu and I stood in front of the judge. The man looked straight at us with his big, penetrating eyes. I grew nervous, because he remained silent, as if he was taking his time to examine us. I noticed that he was looking at our clothing. I regretted that I had been following Qigu's sense of fashion. I believed that Qigu knew how to dress *cool*.

Finally the judge spoke. "Have you a ring?" His voice was like a church bell.

I wasn't sure If I had heard him right. I was relieved when the judge turned to Qigu. He stared at him, waiting.

"Ex-... excuse me?" Qigu leaned forward.

"A ring!" the judge said.

Qigu's face turned red. He cleared his throat and then replied, "No, sir. No ring."

"A souvenir of any kind?" The judge asked.

"No, sir. We ... uh ... No souvenir," Qigu said.

"Not even a flower for your bride?" This time the judge's voice was harsh. His tone showed disapproval.

"I...uh...we...uh...sorry about that." Qigu tried to put on a sage-style smile, but didn't make it.

The judge turned toward me. He went silent, but his message came through loud and clear.

I struggled to hold back my tears.

The judge's expression softened. He stopped asking questions.

I could feel the judge's eyes on me. It was at that moment I realized that I was after all an ordinary woman. My heart desired a wedding ring. It had been praying for a ring. If not a ring, a souvenir or a flower. Qigu had prepared none of it. What kind of fool was I? Qigu had given no thought to this occasion. This ceremony was meaningless to him.

I wiped my tears and turned to Qigu.

He looked like a hostage waiting to be released.

The judge began to speak words of blessing. But my brain had difficulty performing the translation. The judge said something about marriage not being child's play. It should be held sacred as a commitment between two people. A vow under God. He said something about faith, the faithful, and the faithless.

Qigu was embarrassed, and I was ashamed.

Abruptly the judge left us. I would forever remember the frown on his face.

I walked ahead of Qigu as we exited the building. My tears were uncontrollable. Outside, the sun was bright. It was lunch hour, and people were going into and out of cafés and the McDonald's on the corner. We passed the Loop under the elevated subway rails. A clattering train passed over our heads.

I didn't know why I was walking so fast, as if I was running away. At the bus stop, Qigu caught up with me. He pulled me toward him, and I collapsed into his arms. I told Qigu that I felt awful, and that I missed my family.

Qigu told me that I had every reason to be upset. "We are in Amer-

ica, a country and culture that values superficial appearances. Once you compare yourself with these people, you're bound to feel sorry for yourself. My question is: Have these people achieved lasting harmonious marriages? Will they have the same happy faces thirty years from now? Did the rings, the souvenirs, and the flowers stop half of the marriages in this country from failing? No!"

I had never seen Qigu so dignified.

"I might be poor in a material sense, but I am wealthy in my spirituality," he continued. "What I am offering you is what money can't buy."

Qigu tried to convince me that it was his intent to "sing against the American tune." "That doesn't mean I take our marriage lightly. Quite the opposite!" He said that he would prove to me and to the judge that without the ring, the souvenir, and the flowers, our marriage would not only last but also flourish and prosper.

I am married. I am a married woman, I woke up thinking. This was supposed to be my honeymoon! I looked around. I was still on the same mattress that we had found in a Dumpster. Our side table was a wooden box, and a stained carpet covered the floor. Qigu was still asleep across from me on the other side of the bed. We had come straight home yesterday from the city hall. We ate again leftovers for dinner, and went straight to bed. Nobody in the whole world knew that we were newlyweds.

"You only get married once!" I heard my heart say.

I wanted to honor this moment. I wanted to congratulate myself. I needed a photo to send my family in China. A photo of my wedding day.

I took out my camera and went downstairs into the yard. I set up the camera on a tripod and tested the auto-timer button. It was about eight o'clock in the morning. Although the sun was rising, the air was freezing and the ground icy. I was apprehensive about waking Qigu, but I needed him to pose, to smile at the camera.

With the neighbors' garage as my picture's background, I ran back and forth adjusting the tripod to the right height. Once again I checked the camera's auto timer and lens focus. When all was set, I went back upstairs. I woke up Qigu. I told him that I wanted him to join me for a wedding photo.

Qigu did not want to leave his warm bed. I promised him that it would only take a minute. "Do it for me, please," I begged. "Just one shot and I'll let you go back to bed. Please, it is important to me."

I helped Qigu into his sweater and pants. He got himself into a big winter coat.

In front of the camera, Qigu looked miserable. He pulled up his hood and tightened his coat. He was in his slippers. I told him that I needed to readjust the camera angle to avoid his slippers.

"I am cold!" Qigu cried. "I am going back inside!"

"We are almost done! Ready? Set? Here I come! Say 'cheese'!" I released the auto-timer button and rushed to stand next to Qigu.

I offered the camera a big happy smile. I held the smile until I heard a clicking sound.

Qigu ran toward the door,

"Wait!" I cried. "One more shot just in case!"

The photo didn't turn out the way I wanted because Qigu looked unhappy.

I had wanted to send the photo to my family in China, but Qigu's expression made me abandon the idea. There was too much misery on his face. People would question. I knew my parents would. They would wonder where his expression came from.

I ended up sending a letter instead. I described how happy I was about the marriage. I didn't mention that there were no rings, no souvenirs, and no flowers. I didn't mention the judge. I faked a happy ending by telling everyone the news of my pregnancy. "The wedding photo didn't turn out," I wrote. "The negative was defective."

I received my parents' blessing. They were thrilled about my pregnancy. "Your mother has started knitting a baby sweater," my father wrote.

A friend who worked at a Chicago health clinic offered a free ultrasound exam as a gift when I was about four months pregnant. Asked if I would like to know the sex of the baby, I said, "Sure." I was certain that I would be told that I carried a male. When the fetus appeared to be a female, I said, "Look again!"

Upon returning home, I devoured books on pregnancy. I clung to one author who said in a footnote that there were cases in which ultrasounds had failed to accurately predict the sex of the baby.

By the end of summer 1991, I finished revising my manuscript and sent it to my publisher. I was seven months pregnant. I continued to work with Qigu on the building, because the city inspector kept issuing violations. The reinspection deadline for the front staircase was approaching, and there was still much work to do. I had meant to finish the job long ago, but Qigu kept coming up with excuses. What worried me was that we had already removed the rotted boards, so there were gaping holes that were tricky to navigate. If tenants forgot to be careful, they might fall from the second floor.

I told Qigu that the longer we waited, the less I would be physically able to help.

Qigu started to sleep late after we got married, usually not rising until lunchtime. I kept reminding him about the upcoming city inspection, and he kept ignoring me.

I decided to do the job myself. It was after the lumberyard truck dropped off the eight-foot-long replacement boards in front of our building. I dragged the heavy boards from the curb to the staircase one by one. With my big belly, I was soon out of breath. I apologized to the baby inside: "It's something Mommy has to do."

It took two hours for me to stack the boards next to the stairway. I was sweating heavily. I pulled up my hood to avoid getting a chill.

Measuring and cutting the boards was easier. I then started to nail them down. The noise of hammering drew Bruno out of his apartment. He watched me with a beer in his hand.

"You don't want to lose the baby!" Bruno said to me.

"Thank you, Bruno!"

"Where is your husband?" Bruno asked.

I gave no reply. What could I say? "Sleeping"?

I continued to hammer down the three-inch nails. By now my palm hurt and my arm was sore.

Helen came yelling. "For Christ's sake, you're going to have a miscarriage!"

I felt a stir inside my belly. I prayed that my baby was undisturbed.

In the middle of my hammering I heard Qigu's voice. He came out in his slippers and pajamas. He was waving his arms above his head. Bruno and Helen were standing behind him.

"Why do you do this to me?" Qigu shouted. "You are putting on a show! You want everyone to think that I am a bad husband!"

By now I no longer bothered to argue with Qigu. He always had his reasons for doing things or not doing things. Failing the city's reinspection meant more fines. The trouble would not go away. The citations would keep coming and the charges would double.

The tenants' safety was a tremendous hability. It was a risk we couldn't afford to take. Since we had no insurance, we could lose everything. The new staircase had to be finished before the baby was born.

A half hour later, Qigu picked up a hammer and started to work beside me, cursing the whole time.

{ CHAPTER 25 }

I remember hearing, "Congratulations, it's a girl!" Happiness and sadness overwhelmed me at the same time. I was happy that my baby would not belong to the Communist Party of China but only and gloriously to herself. And I was sad—I regret to say now—I was sad that she was not a boy. Being female meant a tougher life.

I remember feeling cold. Then I couldn't breathe. An oxygen mask was put on my face. I remember people rushing around and shouting. Then I went unconscious. Qigu later told me that he was terrified by the amount of blood pouring out of me. Nobody knew that my cervix had torn. My doctor was still trying to get to the hospital.

"They kept wiping you with gauze," Qigu said later. "It was a blood-soaked mop. They rolled up your bed with your head down, trying to slow the bleeding. I was asked to say good-bye to you before they rolled you into the emergency room. It felt like I was saying good-bye to you for good."

Three days later, I woke up in the intensive care unit. To my shock and confusion, a priest was sitting by my bed. It felt like I was in a movie scene. The priest wore a black robe with a white collar. He was speaking gently to me, holding his Bible. I heard him say "Lord's hand," "guidance," and "eternal light." I thought I must be hallucinating.

"God's peace that passes all understanding is guarding your heart and mind in Christ Jesus," the priest's voice continued.

It dawned on me that I must be dying.

"Be free of anxiety," the voice prayed. "You journey here is almost over, and you're leaving for your final glorious destination \dots "

"No!" I screamed. "No die! No God! Please! No die \dots Go away, I am not \dots not ready \dots Me no die! Help! Me haven't see my baby! My child! Let me see my child!"

I must have passed out, because I have no memory of the priest leaving the room.

Someone kept waking me up. Someone told me that it was time to measure my blood count. I was disturbed every hour. I begged to be left alone so that I could get some sleep.

"Sorry," the nurse said. "We have to check on you. We have to test your blood. You are still in critical condition, Miss Min."

"What do you mean by 'critical condition'?"

"You could die."

A nurse told me that Qigu had called but was not allowed to visit. I was in an isolation unit and could easily catch pneumonia.

It had been four days since giving birth. I was tied up with plastic tubes from head to toe. My hands and feet were bruised and swollen from needles. I was still on blood transfusion. Things had been perfect at the beginning. First my in-laws, Qigu's parents, arrived from China. They moved into our newly fixed back unit while Qigu and I continued to live in the attic. I was happy that my in-laws were there to help. When the time came, my mother-in-law tracked the timing of my contractions. I was dancing, holding my belly. It was a delightful moment, and I welcomed the pain.

When I walked into the delivery room, the hospital staff said that I looked so strong that I could deliver ten babies. My doctor hadn't shown up. He had predicted the date of my delivery a ways off. "Three more weeks to wait," he had said, but the baby arrived right on time, according to the calculations of a pregnancy chart.

I remembered a male nurse who was in a great hurry. I felt his roughness when he broke my water bag. He kept telling me to push. "Push, or your baby will suffocate in the birth canal. Do you understand? Push harder! Push!"

Qigu stood nervously next to the male nurse and watched the monitor. He saw the indication of the level of the contractions was down. When he saw the contraction levels fall and pointed this out, the male nurse responded, "Who knows more about delivering, you or I?"

My doctor arrived after I was rolled into the emergency room. "Your cervix is like a rubber band," he later explained to me. "It gets brittle as the body ages."

"I pushed as told," I said.

The doctor let me know that I was too old.

THE COOKED SEED

I woke up to the sound of an animal-like howling. It was coming from next door. I asked a nurse what it was.

"The old gentleman is dying. He is in great pain." The nurse explained that she had just given him morphine, and he would soon be calmer.

The next morning everything was quiet. I asked the nurse what had happened to the gentleman. She told me that he had passed away. I asked if I could go home.

"Not yet," the nurse said. "The doctor says you are still unstable." My blood count was too low. I asked the nurse if I could sit up. She smiled but shook her head. I had been tube fed for days.

The nurse promised to let me see a picture of my baby if I would agree to stay in bed and not move. A few minutes later, she returned with a Polaroid photo. This was the first time I met my daughter. On the edge of the photo the nurse had written, BABY MIN.

Feelings of gratitude filled my heart. I thanked God for letting me survive to enjoy this moment.

Both Qigu and I liked the idea of having a Chinese name for our newborn. We found the name of a famous Chinese beauty, Luoyan. It was said that one look at Luoyan and the Moon Goddess would feel outshined, flowers would close themselves, the fish would sink, and birds would drop from the sky. One of the submeanings of *Luoyan* was "wild goose." I liked this because wild geese flew south every winter. I wanted my American child to keep the Chinese traditional values. To make sure that the name did not sound too odd to Americans, we consulted a musician friend, who converted *Luoyan* into *Lauryann*.

I returned home with Lauryann She was a fairy-faced, sevenpound, healthy baby. We placed her in a straw basket lined with soft pink cotton blankets. Her grandparents received her with absolute delight and affection. I wrote to my parents in China after we arrived home. "Qigu, Lauryann, and I have completed a happy family." Qigu disappeared into his basement studio while the rest of the family got busy caring for the newborn. Still recovering from the surgery that repaired my cervix, for weeks I had to crawl around the house on all fours. The baby's chaotic sleeping schedule drove my father-in-law's blood pressure up and aggravated my mother-in-law's heart condition. Concerned for my in-laws' health, I tried to manage the baby care. To my great disappointment, I had no milk. My body had been so shocked by the trauma that my milk stopped after a few drops. So ended my dream of breast-feeding Lauryann.

Lauryann was fed milk formula. The minute she woke, my in-laws began to work on getting food into her mouth. The task exhausted them. Only when Lauryann was asleep could my in-laws get a break. Soon their daily objective was just to put Lauryann back to sleep. After sleeping all day, Lauryann became wide awake at night.

I found Qigu in his basement, his hideout art studio. He refused to deal with the city and fix the violutions in the building. I complained to my in-laws, but they were offended.

"It's not that Qigu is lazy," my mother-in-law said to me. "We have been taking care of your baby. It should count as Qigu's contribution."

I didn't want to argue with my mother-in-law, but I disagreed with her. Qigu's behaviors and habits were being tolerated by his parents. They had always felt guilty about Qigu's childhood, about their absence and how rough he'd had it on his own. They told Qigu that they were here to make up for his loss by taking care of his child.

Art had become Qigu's sanctuary. It was where he happily lost himself, removing himself from reality. But in my mind, to use the American expression, shit was about to hit the fan. Tenants would move out if we left their windows unfixed for another winter. If we ignored the termites, they would chew the house down. Fuses kept popping when-tenants used a hair dryer and a coffeemaker at the same time. If we continued to postpone hiring an electrician to update the lines, fire could break out. The sewage line had backed up several times already, and tenants had started to withhold their rents.

Tension between Qigu and I started to build. I was most upset when he slept till lunchtime. On top of taking care of Lauryann, I had begun the second round of revisions on my manuscript. My stomach devel-

THE COOKED SEED

oped ulcers. I was still recovering from my torn cervix. Qigu had stopped working because we no longer carried a mortgage.

"Why can't you get a job too, Sleeping Beauty?" I said to Qigu. "Why can't you leave the house in the morning like my neighbor's husband and do what a man is supposed to do?"

Qigu started to avoid me. He said that I had become "unreasonable, irrational, and irritable." I popped like a lit Chinese firecracker. I didn't know how to deal with the situation with a baby in our lives. I felt helpless and powerless as I watched my marriage begin to fall apart in front of my eyes.

I hated to fight, but I found myself in constant battles with Qigu.

"You are roasting yourself in a pressure cooker," Qigu told me. "It is a self-imposed tragedy. A soap opera at the expense and sacrifice of our family. You are insane!"

I told Qigu that his "embracing a tranquil lifestyle" was backfiring. His lack of motivation to work and provide bothered me.

"You are no longer the girl I met six years ago," Qigu responded. "You used to be capable of simple happiness. You've been bitten by the material bug. It's sad that money has become your priority."

When Lauryann was a year and a half old, I took her to the Bridgeport neighborhood park for her first swing. It was a lovely spring day. The sun was bright and the trees were budding with new leaves. The park was nearly empty. A group of teenage boys was sitting on the fence chatting among themselves. Lauryann was laughing on the swing. She had rarely been out since birth. She was chubby and didn't like to move. Her favorite thing to do was to sit with her father on the couch and watch TV. She refused to play outside.

Her grandma told me that Lauryann was not fat enough. "It's a sign of ill health," she warned me. After my in-laws applied the "Peking Duck feeding style," Lauryann gained weight. Her belly was so big that she earned the nickname Buddha. It was impossible to zip her clothes in the front. All the buttons had popped. What concerned me

was Lauryann's cough. She had a cold that she seemed incapable of getting rid of. Every photo I took of her, there was snot dripping from her nose.

Lauryann's laugher made my heart sing. As I pushed the swing, I thought she would soon learn to say "I love you, Mama," and "I love you, Papa," instead of "I love you, Chairman Mao." I was proud of myself for being able to provide her a safe place.

I loved the part of American culture in which children were adored and celebrated. Lauryann was fortunate. I would not let her forget where her mother had come from, and what life could have been for her. It made me smile to imagine that my daughter would get sick of me saying, "When I was in China…" I would insist that she serve America when she grew up. She had been given so much, and much ought to be expected from her.

"Are you Chinese?" I heard a tender voice calling behind me.

It was a white boy about ten years old. "Are you Chinese?" he repeated.

"Yes, I am." I returned his smile.

"They"—the boy pointed at three white teenage boys sitting on the fence—"they asked me to ask you if they can fuck you."

I was stunned. I looked at the boy and said, "Did I hear you say the f-word?"

"Yes, you did. Fuck, fuck you!"

I stood, speechless.

The boy ran toward the teenage boys. The group received him and patted him on his back.

I wished that I could erase that memory. There must have been a reason these children did what they did. They must have been influenced or taught hatred. They hated Chinese because they didn't know Chinese. I remembered how I was taught to hate Americans as a child. The time when my mind was locked in a permanent sunless winter. I believed that Americans were the source of evil. It was because I didn't know Americans.

Suddenly I was fearful of the environment Lauryann would grow up in. I would not be able to sew her into my pocket in order to protect her.

THE COOKED SEED

I removed Lauryann from the swing and started to walk home. It was during that walk I realized my "calling." Instantly I knew what I would do for the rest of my life. I wanted to introduce China and its people to Americans. My soon-to-be-published books might serve as grout between bricks. I would help defrost the ice in the hearts of Americans.

{ CHAPTER 26 }

INTIMACY TOOK PLACE less and less between Qigu and me. When it did, it was difficult. My body was dead to his and his to mine. We felt frustrated, defeated, and angry. Our hearts knew that the marriage had reached a breaking point, yet we refused to acknowledge that we no longer traveled the same path. We tried to act as if everything was normal. We fooled ourselves into believing that we could sail through life if we could just hold on to the pretending.

At first we slept in separate rooms. We didn't say that we had no desire to be near each other. We said that it was the baby. The baby had taken over our lives. Everything else deserved to be ignored. We were living the saying, "When the shoes don't ht, only the person who walks in them knows the pain."

Yet we could no longer fool Qigu's parents. They had been breathing the toxic air under the same roof. More and more I threw up the word *divorce* in our fights. Qigu thought that I was crazy to think about relocating because of what had happened at the Bridgeport Park. Lauryann was born here, he said; it would be her life and her fight, and I ought not try to live her life for her.

It was hard to keep our voices down. My mother-in-law told me that her heart had been skipping beats, and once it came to a long, frightening stop. My father-in-law's blood sugar shot up. Both said that they worried about the baby, who seemed to have grown too quiet. When the in-laws saw that they could not stop us from fighting, they said that it was time for them to return to China.

My mother-in-law's parting words to me were, "Don't try to change my son. Trust me, I tried. I understand what you are going through. As a woman and mother, I am on your side. But I am Qigu's mother. I have no choice but to take his side. All I can say to you is that it is not in Qigu's nature to change. He is who he is. Doesn't he have the right to stay true to himself?"

My father-in-law had given himself an American name, Old Frank.

His parting words were, "The bond between you and Qigu is a commitment. You live in a foreign country, and you depend on each other to survive. For the sake of Lauryann, please think twice about mentioning the word *divorce* again. My son has not done anything wrong. He follows his passion, and he works hard as an artist. You married him knowing that he was an artist, didn't you? He has never cheated or lied to you. He has been his honest self since day one. You shared difficult times together in the past. Why can't you share the good times now that you have green cards and a roof over your heads?"

I admitted that it was the money that was splitting us. I felt that we needed to start saving money in order to send Lauryann to a good school, a school where nobody would say to her, "Are you Chinese? Fuck you."

"Money corrupts the soul," Old Frank continued. "Money leads to greed. You were the girl who didn't care about Qigu being penniless when you met him. You were good, pure, and virtuous. What changed you?"

"Being a mother changed me!" I replied. I could bear to live in this neighborhood with Qigu, but not with Lauryann on board. I had followed Qigu's dream long enough. I didn't mind that during winter, Qigu scraped the frost from inside the car window while I drove; I didn't mind taping cardboard over the car's side windows; I put up with neighbors who smashed our car because it was a wreck that made the neighborhood look bad. Did I have good memories of living here? Yes. Did I want my daughter to grow up here? No!

The impact of the fuck-you incident affected me. I no longer took Lauryann to swing in the park. I no longer felt safe. Qigu didn't want to hear any of my reasoning. He did not want to move. I had been thinking about moving to California. It would be closer to China. More important, the fine weather would encourage Lauryann to get off the couch and play under the sun.

I told Qigu that I had investigated the quality of the public schools in the Bridgeport area. The south side of Chicago looked bad from elementary through high school. The academic scores of our district were shockingly low. I could not imagine enrolling Lauryann there.

"Lauryann is only a baby!" Qigu said. "The boat will straighten itself when it hits a bridge."

I realized that I could never convince Qigu to agree to move. When

he emphasized that we didn't have the money for it, I knew the real meaning behind his words. "I came to America to pursue my dream of becoming an artist," he insisted. "I don't want to be what you want me to be. My time has already been robbed over and over. How can I be a great artist if I am not given time to work on my paintings?"

"Your paintings are not selling," I replied. "And we need money to survive."

"That's not true!" Qigu shot back. "We have enough to survive. We are not begging on the streets. We own the house. We get by shopping at the dollar store. It's you who wants more! You want to live in a better area, with a better neighborhood park, a better car, a better school for Lauryann. But look around us, our tenants are Americans. They are fine with living the way they do; why can't we be? Honestly, you have been corrupted, your soul sucked in by capitalistic greed!"

The essence of a good life, according to Qigu, was to go with the flow. "The eatch is that one must let life happen, at its own pace, its own rhythm, and run its own course. All you need to do is be receptive. One must not rob oneself of the opportunity to experience life's magic."

I might not have been knowledgeable about ancient Chinese philosophy, but I did know one thing—I wouldn't have landed on American soil if I had practiced "doing nothing." Life's magic would not take place if the fuck-you boys remained uneducated. I didn't want to miss the boat in helping Lauryann to become the kind of human being she deserved to be.

I told Qigu, "The hell with do-nothing and your nothingness."

As our relationship deteriorated, everything became a bother. For example, I could no longer stand Qigu's habit of putting off the dishwashing till the next day.

"It's not that I refuse to clean the dishes," Qigu tried to justify. "I just don't want to do it right after dinner. I don't want to ruin the enjoyment, the aftertaste of a good meal, a moment of relaxation. I'll clean the dishes in the morning."

"You invite cockroaches and rats!" I yelled. "It is disgusting!"

As time went on, Qigu lost his charm in front of me completely. I was bothered by his messy hair, his made-in-China cheap slippers, his stooped posture, his pajamas topped by a down vest. He was no longer

the handsome man I used to know. He looked pathetic wearing the sweatpants his mother hand-knitted, which didn't have a zipper in the front, leaving his crotch open.

I thought, *I must move on before Lauryann is permanently pickled in her father's jar.* I suffered great anxiety when Lauryann sucked her thumb staring at the TV. She was sitting beside her father, who hadn't dressed or washed since morning. What pained me was that Lauryann was having fun. I could visualize her "relaxing" her future away.

Qigu said, "The baby needs to de-stress from her crazy mother."

It upset me that Qigu didn't care what kind of school Lauryann would attend. "What's the issue?" he asked. "Isn't it an American school? There are millions of people on this planet who dream of attending an American school!"

Lauryann began to side with her father before she could talk. She hung on to Qigu's arm like a spider when I tried to drag her to play outside in the sun. She continued to glue her eyes on the TV set, and screamed and kicked when I tried to remove her. She had discovered that her father would come to her rescue, so she erupted in dramatic tantrums. In the end, she always got her way with Qigu present.

"I can't bear Lauryann sitting around all day," I protested.

"What's wrong with sitting around?" Qigu said. "Spending time in meditation and self-reflection is part of a good life, be it in front of a TV set or on your knees in a temple. It is the spirit of Taoism. Our daughter is blessed by the wealth of the Chinese culture. She will inherit from me a priceless fortune—that is to say, if you'd stop corrupting her with the American culture of stress."

After I put Lauryann to sleep, I went to look out the attic window. Outside, the tree had turned bright yellow and the wind was blowing the leaves off the branches. I thought about how for thousands of years autumn had been the favorite subject of Chinese artists. To them, autumn meant inevitability and destitution. Autumn was the embodiment of aging, lost beauty, the absence of life giving. Symbolically, autumn

taught people that you can't stop the leaves from falling. Autumn predicted the impending brutality and death of winter.

Mourning was what Chinese artists did best. Famous Chinese paintings, poems, and novels featured either escapism or living in acceptance of fate. Mental indifference was grace, and sacrifice a virtue.

I learned to appreciate the true culture of China as an adult during the time of opening after the Cultural Revolution. Long-suppressed books suddenly became available, and I devoured them. My favorites included the Tang dynasty verse "Song of Forever Regret," collections of Song dynasty poems by the female poet Li Qingzhao, the classic Qing dynasty novel *Dream of the Red Chamber*, and the most popular Chinese opera, *The Butterfly Lovers*.

I remember weeping when I read the "Song of Forever Regret." My heart went out to Beauty Yang. The artist had composed the verse as a eulogy from the viewpoint of Emperor Tang, who had ordered his lover's hanging. The emperor was given a choice between Deuuty Yang or his generals who threatened an uprising. The emperor chose to sacrifice Beauty Yang. In the beautiful, melancholy verse, he expressed his great sorrow and regret.

I had shed more tears for the housewife poet Li Qingzhao, who wrote poems in self-imposed confinement. I had admired the novel *Dream of the Red Chamber* and its female protagonist Lin Daiyu, who was good at nothing but poem composing. I shared her dream of marrying the love of her life, Jia Baoyu. I regarded their grandmother as a monster who destroyed the couple's love. The Chinese Yue opera *The Butterfly Lovers* taught me that there was no better way to live than to die for true love. Chinese were trained to appreciate tragedy. I was steeped in tragedy. I identified with tragic characters.

It was only after being exposed to American culture and society that I realized that there was not much to it to glorify tragedy. I was able to see for the first time that indulging in tragic thinking was a Chinese way of life, but not a healthy one.

Qigu was right about my being "corrupted" by American popular culture, although I replaced the word *corrupted* with *inspired*. Never before had any Chinese classics lost their appeal to me. They were my old clothes, which I had changed and Qigu had not. He was still in love

with the old culture. It soothed him, comforted him, and fitted him. We grew to disagree over the fact that Chinese had been living in mental and physical cages as a race, culture, and civilization.

Never before had I realized that the Chinese thinking instilled and promoted the notion that life could not be changed. Looking back, it was impossible for any individual to change his or her life in China before the 1980s. It was not only a collective self-expression, but also a need, an emotional necessity, to dwell on the literature of misery, exile, imprisonment, and despair.

"Your life is how you set it up to be," was what I learned in America. "Settling is temporary, while change is permanent," had become my new adopted mantra. This perspective had not crystallized until now. It brought back the memory of when Qigu and I first discovered the abandoned collection of photo albums of the possibly Polish immigrant family. It never occurred to me that perhaps it was meant to be tossed in the trash. To part with the albums could have been a conscious decision made by the albums' owner. To let go of things associated with the past was part of an action for the family to move on. To be an immigrant was to leave behind part of you and take with you only the essentials.

Scarlett O'Hara in Margaret Mitchell's novel *Gone with the Wind* had become my new heroine. I read the book to learn English. I found myself captured not by the love story between Scarlett, Ashley, and Rhett Butler, but by how Scarlett survived as a female. I reread the passages in which Scarlett had to fight alone. She sacrificed. She did what was necessary to keep her mill running. She was the provider for her family and a woman of incredible resilience. She did not sit around and cry about her circumstances and minfortune, as a Chinese character in her shoes might have done. Scarlett did not compose poems, or jump into a well to end her misery. Instead she fought. She married men whom she did not truly love and who were below her in intelligence and appearance. When she needed to, she picked up a gun and shot the Yankee who broke into her house and threatened her life. She climbed onto the horse and rode from town to town to sell her products. At her lowest point, Scarlett did not pray for nothingness. She fought on by telling herself, "Tomorrow is another day!"

Scarlett showed me the way to fight for my life. I owed Lauryann that much and more.

Qigu told me that he wouldn't consider a divorce unless I gave him Lauryann. He knew that I would rather die than be separated from Lauryann. I knew Qigu didn't mean that he would take care of Lauryann on his own. I asked him how he would raise the baby without a job or help. "I'll send her to my parents," Qigu replied. "She'll be raised in China, where everything is cheaper."

I couldn't imagine Lauryann being raised in China, although I didn't doubt that her grandparents loved her. My in-laws had not asked for the job. They ought not take on Qigu's responsibility. I imagined the grandparents spoiling Lauryann. Discipline was already a strange concept to her. If she went to China, she would be raised the same way Qigu had been raised. She would be brainwashed by the do-nothing-isto-do-everything culture. She would learn her "place in life as a female." Instead of becoming a fighter, she would uccept Injustice as her fate.

"Lauryann must grow up in America," I said firmly.

I placed my cheek gently against Lauryann's forehead. She was sleeping soundly. My heart was filled with tenderness. If I walked out of the marriage, Lauryann would be the one who would be hurt the most. Her sky would be overcast with shadows. Yet I couldn't afford not to walk out. Staying with Qigu and living in Bridgeport would not be in the best interest of Lauryann. Single motherhood and lack of financial means weighed on me, but I would not let it claim me.

Qigu and I agreed that for the sake of Lauryann, we would try to make the marriage work one last time. We negotiated. I asked him to bring home an annual income of no less than \$15,000. I figured that he should be able to earn this amount by working minimum-wage jobs. He could be a waiter, a cab driver, a pizza-delivery man, or a handyman. There was no shame or disgrace in making an honest living. I said, "I must see my man making an effort to provide."

Qigu promised to try, but there was no action. He avoided me. One

day I ran into him in the basement. He looked nervous, as if he was hiding something. I found out that he was only trying to put away an antique instrument he had been playing. "I'll work on my paintings," he said in a pleading tone.

I felt a sudden rush of self-disgust, followed by a profound sadness. I saw how I was preventing Qigu from pursuing his dream. I had made him feel guilty about doing what he loved to do. Now he was forced to steal moments from me, to hide himself. I was a monster. I was responsible for killing the artist in him.

I knew what he wanted from life. He wanted to live the life of a sage. He wanted a cabin high in the mountain hills, a waterfall spilling into the valley below. He wanted to paint pines, cliffs, and clouds. He desired a life doing little else but composing poems, making paintings, and enjoying the company of his friends.

I had once teased him. "How will you get water and food up to the mountain? What about a shower and plumbing? How will you deal with an emergency or medical needs? What about your daughter's education?"

I left the basement and walked upstairs.

Qigu followed me.

I stopped and turned around. I was face-to-face with him. "I want a divorce," I said.

"It's all in your head," Qigu said. "You are crazy."

"You won't contribute to this marriage."

"There are different ways to contribute," Qigu argued. "Why can't a woman be the bread-earner? You were a Communist, a product of women's liberation. Why can't you consider changing places? I wouldn't mind being a stay-at-home dad."

"I mind!" I yelled.

I was a woman who took it as my duty to compromise and sacrifice, but I couldn't help but feel that I was simply being taken advantage of. I stopped arguing because I knew that at the end of the day Qigu would win. I was sick of a fight that would change nothing.

"It's not that I don't work," Qigu said. "It's not my fault that my paintings are not selling like doughnuts."

"You must bring home fifteen thousand dollars a year," I said.

"You are turning into a money worshiper!" Qigu yelled. "Karl Marx

was so right about capitalism being a monster with its every hair dripping blood! Talk about contributing—I supported you when you wrote your book, didn't I? I believed in you when nobody else did, didn't I? I am entitled to your advance as well!"

I could only say that I was sleeping in the bed I had made. Qigu had never promised to change in the first place. It was I who had chosen to imagine the man that he might become. He just wasn't that man.

"It's not the end of the world," Margaret said to me. She understood. She was a divorced woman herself. I asked if I could stay with her for a couple of weeks before I found a place to live. "Can Lauryann and I sleep on your floor?"

Margaret welcomed us into her condo. She told me that she was in the process of adopting an orphan from China, a little girl Lauryann's age. "I'll get to learn what it's like to be a mom with Lauryann first," she said. I asked Margaret her future daughter's name.

"Fooh-Fann was her Chinese name," she said.

"'Lucky Flower'?" I asked.

"Yes. Lauryann and Fooh-Fann will become sisters." Margaret was excited. "I'd love you to teach Fooh-Fann Chinese."

I told Margaret that it would be my pleasure. But right now I wanted to complete the divorce before Lauryann became too aware of what was going on. Qigu was refusing to sign the divorce papers. He said he would over the phone, but he wouldn't do it once I met with him. Lauryann was confused. "She is accustomed to Qigu's ways," I told Margaret. "I can't say that Qigu doesn't have Lauryann's best interests in mind—he just has a different vision. He will convince her to be proud of being homeless. I can imagine him saying to her, 'Look, Buddha used to be homeless—so did Jesus Christ.'"

Margaret said she knew a good lawyer named Linda whose office was located in downtown Chicago on LaSalle Street.

I shook my head. "I don't have the budget for an expensive lawyer."

Margaret convinced me to make an appointment with Linda for a one-time free consultation.

It turned out that Linda was a godsend. She was an honest and capable lawyer who charged reasonable fees. She said that the child support would be a tough issue in my case. "It is the only concern of the judge. If Qigu refuses to work out an agreement with you on that, the divorce can drag on."

I doubted that Qigu would agree to pay child support. He wouldn't split the house fifty-fifty with me, although his original investment was less than 5 percent. All I wanted was Lauryann, I told Linda. I'd let everything else go.

Linda was efficient. She got things moving for me and set the court date. I faced Qigu at the same Chicago city hall where we had been married. I remembered the day clearly, and I remembered the judge.

As Linda had predicted, the divorce-court judge focused on the child-support issue. When Qigu said, "I'll do my best," the judge was dissatisfied.

"We are talking a monthly payment here, sir," he said to Qigu.

"I am an artist without a salary," Qigu responded. "It is impossible for me to commit to a monthly payment."

The judge did not grant the divorce.

The second time I was alone in front of the judge. Qigu refused to show up. Linda spoke on my behalf. She let the judge know that I was willing to waive the child support.

The judge took off his glasses and stared at me. "I want you to understand that you are filing for shared custody," he said, "which means you are entitled to child support."

Linda translated the judge's words to me. I responded that I understood my rights. Still, I wanted to waive child support. It was the only way to get Qigu off my back. I wanted to get the divorce over with as soon as possible. Qigu would find a way to avoid paying child support regardless of whether or not he was required to by law.

The judgment arrived. I was given physical custody of Lauryann. I was immensely relieved to gain control of Lauryann's life. She needed

structure and order. In the past few weeks I had received repeated calls from Lauryann's nursery school teacher. She notified me that my daughter had been late every day that Qigu had her. Instead of arriving at 8:30, Qigu brought her in at lunchtime. As a result, Lauryann missed morning lessons.

Qigu thought that the teacher was overreacting. I simply saw it as Qigu robbing Lauryann of learning time.

"Why are you so serious?" Qigu protested. "It's only nursery school."
"It is about foundation building," I said. "Good habits help build sound character. Lauryann needs discipline."

Qigu didn't go to sleep until after midnight. Lauryann stayed up with him. She was turning into an owl by the power of her father's example. She was active and spirited at night and couldn't get out of bed when the sun rose. Her teacher reported that during the day she was sleepy. "Lauryann has trouble concentrating," she said. All the discipline work I did with Lauryann was reversed the moment she went back to Qigu.

It became clear to me that as long as Qigu remained a presence in Lauryann's life, I would be wasting my time trying to teach Lauryann anything. Lauryann was already a pleasure seeker, and she was not shy about letting me know that she preferred her father. Lauryann fought with me when I attempted to give her a simple lesson. Instead of learning to count from one to ten, Lauryann sucked her thumb and ignored me. Qigu cheered at her behavior. He found it amusing and entertaining.

I had started to dream of moving with Lauryann to California. The challenge was that the law was not in my favor. The law required that, unless I had written permission from Qigu, we must remain within fifty miles of each other. The law served to protect the child's right to be close to both parents.

I knew Qigu would never give me his permission to take Lauryann and move to California. I feared that my custody rights would be revoked if I dared to defy the law. Nonetheless, I was desperate to free Lauryann of her father's influence and began to move forward.

I didn't realize that in America my action would be described as "kid-napping."

If I had never consciously tried to use anyone in my life, I did it now. I targeted my former mother-in-law, Lauryann's grandma. I felt indecent, but not guilty.

I phoned China. I put Lauryann on. She was yet to speak in complete sentences, but she knew who was on the other end. "Nai Nai!"—grandma—"Nai Nai!" she cried joyfully.

I took over the phone and said, "Would you like me to bring Lauryann to see you this summer?"

"I can't wait!" came Grandma's delighted response.

"Listen, United Airlines is offering a promotional fare from Chicago to Los Angeles and then to Shanghai," I said. "I'm thinking about taking advantage of that." The truth was that I didn't have to take a flight through Los Angeles; United Airlines had direct flights from Chicago to Shanghai. My intention was to purchase a Chicago—Los Angeles—Shanghai round-trip ticket, so that we could remain in California for good after we returned from China

"There is an issue, though," I said to Grandma. "And I must have your advice."

"What issue? We already know that you and Qigu are divorced."

"I am not allowed to travel with Lauryann without Qigu's permission."

"What does that have to do with your bringing Lauryann to see me?"

"Well, American law requires me to stay within fifty miles of where Qigu lives. He will not let me take Lauryann out of Chicago."

"Nonsense!" The old woman said. "You tell him that I want to see my granddaughter! I'll give him big trouble if he refuses to give you permission!"

I went to Qigu with his mother's request. I showed him the ticket I purchased, a round trip Chicago—Loc Angeles—Shanghai ticket. I presented my precomposed permission slip, which stated, "I, Qigu Jiung, hereby give permission to my ex-wife, Anchee Min, to take our daughter Lauryann Jiang to California and China."

I kept my fingers crossed and prayed that Qigu would be his usual sage self, which meant that he wouldn't pay attention to the missing return date.

He signed.

{ CHAPTER 27 }

A s I was getting ready to head to California, Margaret told me that she had been thinking about relocating too. "Los Angeles could be my next address," she said.

I couldn't have been more pleased with Margaret's idea. As single mothers we could be great help to each other. We could share the rent and each keep an eye on the other's child. It would enable us to work full-time. "We have been best friends since college," I said. "It would be ideal!"

As Margaret completed the adopting process and was on her way to pick up her daughter in China, I packed. I avoided going back to Bridgeport, because it hurt to look back. Witnessing my stomach pain, Margaret suggested that I see a divorce counselor. I told her that psychoanalysis didn't work for Chinese. The only thing it did was make me more conscious of my misfortune. I came to America with one suitcase filled with toilet paper. Ten years later, I had three suitcases—two filled with Lauryann's stuff. What changed was my way of thinking. I was blessed with a tomorrow-is-another-day attitude.

I loved the Southern California sunshine. The blazing red and pink bougainvilleas I saw everywhere lifted my spirit and brought me hope. Being able to play outside improved Lauryann's health and her cough was finally gone.

We settled in a town called Torrance and shared a modest threebedroom house with Margaret and her adopted daughter Fooh-Fann. The girls shared a room while Margaret and I each had our own bedroom. I made mine an office as well. I was pleased with the private space and quiet I desperately craved.

After the success of *Red Azalea*, I gained the confidence to try a novel and wrote *Katherine*, the story of a Chinese girl and her American teacher. *Wild Ginger* followed, and then I started to take the first steps

toward my first big historical novel, *Becoming Madame Mao*. All these stories were set during the Cultural Revolution, and writing them forced me back into the period that still lived just under my skin. I wrote for endless hours. Once I got the story going, there was no stopping me. My characters left me with no peace until I got their voices on paper. I was living to catch the spirits.

Outside, the small yard and green lawn was heavenly. I planted roses on the edges along the fence. My hands had missed the touch of the soil. I was tempted to dig a manure pit and make my own compost. I wanted to introduce Lauryann to nature, to the pleasure of working with the earth. I bought poppy and wildflower seeds and planted them with Lauryann. I was bathed in happiness as I sat under a tree watching Lauryann, who dragged the hose trying to water the lawn. The little girl stood under the clear blue sky in bright-pink top and skirt—a picture of beauty and a blessing.

I observed Lauryann to see how she was adjusting to our relocation. I was sure deep down she missed her father, and I felt terrible that I had torn her away. Her young mind must have been stained by memories of our broken family and the horrible and endless fights I had with Qigu. Lauryann's only knowledge of what it meant to be a family was disharmony and tears. What would it do to her? Would she grow up bitter? Distrustful? In fear of closeness and relationships? How could I possibly explain to Lauryann that she was better off without Qigu? That the pain was a ticket to a brighter future? That her life was finally hers to claim and create without disturbance? That my divorce had made me a wiser woman and a better mother? That I was thrilled that I could now teach her my core values about heaven rewarding the hardworking without being put down and ridiculed as "refusing to learn the joy of life"? That she was the center of her own universe and mine while in the meantime life was not all about her? That she must learn to give back to America and to mankind?

For the next three years, the four of us were a family. Margaret was a devoted mother to Fooh-Fann, a sun-kissed, apple-cheeked little girl with big eyes. She had an intensity about her, a quality Lauryann didn't have being American-born, and a quality I associated with Chinese who had lived through poverty.

The girls became best friends. I followed Margaret's choice for Fooh-Fann and enrolled Lauryann in the same private school, a Montessori kindergarten. I changed my mind after six months because the tuition was too expensive. I pulled Lauryann out and enrolled her in a nearby public school. When Lauryann complained, I simply told her that we had no choice but to live below our means.

Margaret and I got along great at first, but in time we began to drive each other crazy. Our cultural differences and personalities clashed. In one instance, I refused to share the cost of her hiring a housekeeper. "I can clean my own toilet and mop my own floor!" I said. "I don't want Lauryann to miss the opportunity of learning to make her own bed and organize her own closet."

Margaret ended up paying for a housekeeper to come half the month while I was my own maid for the other half. Also, I told Margaret that I wouldn't split the utility bill if she didn't stop running the laundry machine with only six pairs of socks and one pair of underwear. And I had trouble with Margaret telling me to postpone depositing her check for half of the mortgage payment.

"If you're so short on money, why can't Fooh-Fann go to the same free public school Lauryann does? You can save the tuition and make your ends meet! Why wouldn't you? What's wrong with the public school? The teachers are great and Lauryann is not disrespected in any way. She's having fun!"

I was confused when Margaret warned me that I was hindering Lauryann's future by letting her attend a public school. I felt more and more challenged by issues rising at home each day. Comparing herself to her friend, Lauryann cried about not having what Fooh-Fann had. Lauryann envied Fooh-Fann's soccer, violin, swimming, jazz, and horseback-riding lessons. Margaret said she was emptying her retirement account to fund these activities.

I couldn't afford to provide Lauryann with such luxuries. I bought a used Michael Jackson videotape and tried to learn how to moonwalk together with Lauryann, and she ended up becoming good at learning things from videotapes. Many years later, she would learn to play piano from YouTube. When Lauryann was a child, making the best of what we had was a struggle for both of us.

Lauryann broke down and sobbed when I refused to give her the same birthday party Fooh-Fann had. She expected a pretty dress, gifts, games, and to give goody bags to friends, but she got none of that. It bothered me to see my daughter acting as if she was deprived. I was unable to talk her out of her misery. My values were under attack, but there was no enemy in sight that I could see or fight. I felt helpless and unfit as a mother. Fooh-Fann told me one day that Lauryann had secretly revealed to her that she considered herself a Cinderella and that I was her evil stepmother. The next day Lauryann asked me if I was her real mother. When I said yes, she asked if I would give her up for adoption.

I clipped a photo from the *New York Times* and showed it to Lauryann. The photo featured a little Chinese orphan girl tied to a stool with a chamber pot beneath her. The image led Lauryann to ask Fooh-Fann if that was the way she had lived in China.

To an American, the photo was evidence of child abuse. But to Chinese eyes, it was only how things were done in China. When one caretaker had to be responsible for over forty children in poverty-stricken provinces, it was the only way to keep the floor clean, and the children were trained to shout, "I am done pottying!" when done. Then the caretaker would come and release the child.

To Margaret, I had committed a crime by sharing the image with Fooh-Fann. With tears streaming down her face, she cried, "It's heartless of you to show her the picture! Don't you think my daughter suffered enough in China? Why do you have to keep reminding her what I try so hard to help her forget?"

I was moved by Margaret's love for Fooh-Fann, although I refused to admit any wrongdoing on my part.

Margaret also felt left out when I spoke Chinese to Fooh-Fann. I protested, "Margaret, you were the one who asked me to teach Fooh-Fann Chinese in the first place!"

Fooh-Fann was a strong-willed child who thrived on challenges. She was determined to impress me. She didn't mind that I was tough. She enjoyed earning my praise. She sensed that beneath my iron mask, I adored her, and I did.

Fooh-Fann loved to say, "Watch me, Anchee Min!" Margaret felt that I had crossed the boundary as a friend. She began to accuse me of stealing Fooh-Fann's affection. Margaret couldn't hide her bitterness when Fooh-Fann spoke to me in Chinese. Realizing the injustice I had done to Margaret, I quit speaking Chinese to Fooh-Fann. A week later, Margaret enrolled Fooh-Fann in a local Chinese language school, but Fooh-Fann never learned to speak Chinese.

It was difficult to take Lauryann to my bedroom and shut the door when Fooh-Fann was having her violin lesson in the living room. Every time Fooh-Fann invited her friends over, Lauryann would weep with envy.

"I have no friends, Mommy," Lauryann cried. "Nobody likes me."

I stared at my daughter's little tearful face; her spirit was breaking. She feared being rejected by Fooh-Fann.

The environment had turned toxic. I realized that I was the one responsible. I was punishing Lauryann for wetting her shoes while walking her along the beach.

I decided to teach Lauryann to stand up for herself. "You must learn to earn respect from people," I said to her.

"But how, Mommy? What do I do?"

"Show your best self." I told Lauryann that I used to earn respect by winning contests reciting Mao poems and quotations. "You just have to be standing by and snatch it when opportunity knocks on your door."

Lady Natasha was Fooh-Fann's violin teacher from Russia. She protested to Margaret, "I was paid to teach one child, not two!" What Lady Natasha meant was that Lauryann had peeked during Fooh-Fann's violin lessons.

I ordered Lauryann to lock herself in my bedroom the next time Lady Natasha came. I made Lauryann promise not to open the door and peek.

The violin lessons continued. Although Lauryann was not opening the door nor peeking, she was listening behind the door. By now she was used to not having what Fooh-Fann had, such as lessons in sports and music.

During Fooh-Fann's toilet break, Lauryann tiptoed out of the bedroom. Sticking her head out from behind a corner of the hallway wall,

THE COOKED SEED

she said to Lady Natasha, "Hello, I am Lauryann. I am Fooh-Fann's friend and I live here."

Lady Natasha paid no attention.

Lauryann was determined to show her best self. "Are you from Russia, Miss Natasha?" she asked.

Lady Natasha's answer was a grunt.

"Do you know a Russian song called 'Moscow Evening'?"
"Uhm."

Lauryann opened her mouth and sang in Russian:

The snow makes a white night
The great city sleeps in quiet
Let me hold your hand, my love
Let us stride in the beautiful Moscow evening

To Lauryann's surprise, the song brought tears to Lady Natasha's eyes. She turned around and grabbed Lauryann by the shoulders. "Oh, goodness, how beautiful! Where did you learn this? Who taught you to sing the song in Russian?"

"You...you don't like it?" Lauryann didn't expect the instant affection.

"I love the song!" Lady Natasha cried. "I grew up with the song. Everybody in Russia knows the song! It makes me homesick! So much, oh, excuse my tears. I have to blow my nose. I'm just wondering, how a little Chinese girl like you learned to sing my song?"

"My grandpa in China taught me. He said China used to be great friends with Russia."

"Indeed! Indeed!" Lady Natasha said. "I am so impressed. What's your name?" $\,$

"Lauryann."

"That's right, Lauryann. I'd love to teach you violin!"

"But my mother doesn't have money."

"I see. How about I invite you to sing at my concert opening?"

"You mean Fooh-Fann's concert?"

"Yes, my dear."

"I'd love to, but you have to talk to my mother first."

Lady Natasha asked my permission to let Lauryann sing "Moscow Evening" at the opening of her concert. She promised no charge. I was happy for the opportunity. Lauryann became a sensation. She brought down the house. Lady Natasha was thrilled.

Later that night, as I was saying good night to Lauryann, she whispered in my ear that she'd had a wonderful time singing at the concert. I meant to congratulate my daughter, but found myself thinking of Fooh-Fann. It dawned on me that Lauryann's glory had been at the expense of Fooh-Fann. I felt horrible. Margaret had invested every ounce of her energy and money into nurturing Fooh-Fann so that she could have a moment to shine, and I had ruined it, although unintentionally.

Although I love Margaret to this day, I also understood that we were both protective mothers who, when the matters concerned our children, were not capable of compromising. Margaret and I both felt that it was time for us to go our separate ways.

The parting days were tough on Lauryann and Fooh-Fann. They had become as close as sisters and best friends. It was as if they had sensed the day coming. There were no tears—just simple good-byes.

It took the moving truck less than twenty minutes to load all my stuff. I let Margaret know that she had been a great friend and a teacher. She would remain my biggest influence. Being a Jewish American, Margaret taught Lauryann and me about Jewish history, traditions, and family values, which we would have never otherwise experienced. We loved her Thanksgiving dinners and Hanukkah parties.

We were shocked when we received the news that Fooh-Fann died in an accident in 2010. She was a few days away from her eighteenth birthday and her graduation from a Chicago high school. She was hit by a van driven by an eighty-six-year-old man in southern Illinois. Fooh-Fann was on a bike trip with her best friends. Gifted in math, Fooh-Fann was kind, compassionate, and loved by her schoolmates, teachers, and friends. Lauryann was devastated.

English poet Alfred, Lord Tennyson, once said, "It is better to have loved and lost than never to have loved at all." I don't know if I still believe that after witnessing Margaret's suffering.

I will never forget the day Margaret met Fooh-Fann for the first time. I was her translator. We stayed in a hotel in the city of Nanchang in China's Jiangxi province. Margaret had been anxious as she anticipated Fooh-Fann's arrival. She had barely slept. The orphanage was running late that day, and the children had failed to show up at the appointed time. Margaret was concerned that something had gone wrong. She wanted to go out to the remote town and check things out for herself. I reminded her that she was on the soil of Communist China, and that she had better stay where she was. I suggested that she spray on her mosquito repellant and get ready for a long night.

Fooh-Fann had been the joy of Margaret's life. The mother and daughter were close and loved each other. Every time Fooh-Fann picked up the phone when I called, I would remind her that it was a Chinese daughter's duty to take care of her mother in her old age. "Don't you become too American as to forget the Chinese piety."

"I know, I know, Anchee Min."

Perhaps it was too much for Margaret to bear to stay in touch. Lauryann and I never heard from Margaret again after Fooh-Fann's funeral. I missed Fooh-Fann. I also often wondered how Margaret was doing.

From time to time, Lauryann continued to visit Fooh-Fann's Facebook page, where she wrote to her friend's spirit. Lauryann discovered that she was not alone—Fooh-Fann's other friends also left messages. It comforted me to learn that Margaret finally was able to move on—a mutual friend informed me that Margaret recently got married and moved away from Chicago. I wish her peace and love.

Six months after I moved to California, Qigu visited. To my surprise, he announced that he was getting married. "I thought I ought to let you know," he said.

I tried not to show surprise. After a moment, I asked, "Who is she?" "The girl of my dreams. My very first love. I was only a teen when I met her. I lost her to my best friend, who married her. I recently found out that they were divorced. I couldn't possibly pass up the opportunity, since I never really got over her. I proposed as soon as I could, and she said yes."

Should I say that it was strange that I felt hurt? The fact that Qigu was capable of passion confirmed that he had never been in love with me. It took six years and my pregnancy for him to propose. I remembered clearly how reluctant he was. I recalled the morning when I dragged him out of his bed so that I could take a photo of our "wedding day."

"Will you have a ring this time?" I asked.

He smiled. "I already booked a trip to take her on a honeymoon to the Grand Canyon."

"What an improvement!" I tried to be sarcastic.

I carried Lauryann outside so that she could wave good-bye to her father. I watched Qigu climb into his rented car and drive away. Lauryann saw my tears and asked to be let down. She ran into the house and returned with a tissue box.

PART FOUR

发展存取 25年 域 1985年 1985年

{ CHAPTER 28 }

HEN THE PUBLISHERS first rejected Becoming Madame Mao, my income dropped to zero. I understood that most authors in America supported themselves by working other jobs. Since I was not able to get any other job, I decided to do what I had done before. I bought a run-down four-unit apartment property and set my mind to fix it. I took out a loan and put in every dollar I had saved as a down payment.

Lauryann helped me even though she was only six years old. In the beginning, it proved to be a challenge, because she had been raised as an "American princess."

"I don't like my tomatoes touching my potato," she would say. She was scared of flies as if they were assassins. "The sun hurts my eyes!" She would cry as we drove. She hated vegetables and drank soda instead of water.

"I helped my mother as a child," I said. "At the age of five, I was responsible for picking up my three siblings from different nursery schools and kindergarten. I was in charge of buying food for my family at the age of six. As an eight-year-old, I carried a forty-pound bag of rice. I took my brother to a hospital when I was nine. I remember the doctor asking, 'Where is your parent?' I stepped up and said, 'I am the parent.'"

I had been driving around the neighborhood in the evenings with Lauryann beside me. I tried to locate the nearest park with a public restroom in case we had to live in the car. "It's always wise to prepare for the worst," I said.

Lauryann had to adjust to a new school every time we moved. I didn't ask her if it was okay. I knew it was not okay with her. It hurt me to see Lauryann lose friends and the teachers she loved. But we had to live below our means and go where the rent was cheaper. Lauryann was forced to adapt. She learned to engage quickly with her new teachers and schoolmates. She tried her best to keep the friendships. As the years went by she would visit her old friends, especially her teachers. I

drove her to those visits before she got her own driver's license. Lauryann shared with her teachers aspects of her life that she didn't think I would understand. She didn't trust that my advice would actually work for her.

For a period of time, Lauryann slept in a closet. Years later, she told me that when she was scared of the darkness, she imagined herself as a friend of Harry Potter. She also said the reason she quit complaining was because she was sick of me pulling "the labor-camp stunt."

"You are not deprived," I would say to her. "What do you mean that you don't have dance lessons? You can learn dancing from the videotapes I bought you. You can learn singing from playing the cassettes. Don't you dare say I never take you to the movies. Didn't I play you the *Little Mermaid* I recorded from the TV children's channel? So what if it had commercials? You're just too lazy to press the fast-forward button to skip the commercials."

Lauryann and I finally figured out Michael Jackson's moves from a videotape. Although we couldn't quite make the moonwalk steps, I kept saying, "We saved another fourteen dollars by giving ourselves this lesson!"

The air was filled with the smell of fumes. The property I had been trying to fix was in a working-class neighborhood. Stolen shopping carts were scattered on the streets and behind the buildings. The tenants drank beer in their cars, especially in summer and winter, leaving the car idling and the air-conditioning or heat running. They threw their cigarette butts everywhere. Part of Lauryann's job was to pick up cigarette butts, beer cans, and liquor bottles. Tenants also stripped off the smoke detectors and fire extinguishers we had installed. The carport wall was caved in—the work of a drunk driver.

Income-wise the tenants were poor, but they had expensive habits. They gave lavish birthday parties and went on family vacations to Disneyland while short on rent. Stuffed animals filled their kids' rooms from floor to ceiling. The kids' birthday gifts included TV sets and video games, which made Lauryann envious.

On Lauryann's birthday, I took her to Home Depot. My gift to her was Home Depot's free lesson on how to use an electric power saw, and how to install ceramic tiles. I also bought her two books, *Plumbing 1-2-3* and *The Complete Fix-It-Yourself Manual*.

Lauryann did not want to wear the child-size orange Home Depot apron on which a clerk wrote, HI, I AM LAURYANN.

Lauryann let me know that she wanted what other kids had at their birthday parties. She preferred to dress up like a princess and receive "normal gifts."

My answer was, "You are not going to make me slap my face making it swell so that I'll look well fed!"

Lauryann helped me clean clogged sewage lines, spray and scrub mold, lift sheets of drywall, and carry bags of concrete. She came to call her time with me "jail time."

Every hour, she would request, "Mom, I've got to pee!" She knew I would have no choice but to release her. She took a long time inside the bathroom. When she stepped out and faced my disapproving look, she would say flatly, "Sorry, I was pooping."

"Compared to millions of children in China, you are living a fantasy life!" I said to Lauryann. "You get to shower in hot water, and you get to pee sitting on a toilet. You get to go to school. For a dollar, we get to purchase packs of noodles—hunger is a strange concept to you!" I found myself strangely speaking in the tone of Communist teaching. "There is pleasure in serving the people! There is honor and satisfaction! How can you not feel it?"

Lauryann turned her head and made exaggerated yawns.

Originally, I hoped it would be a great experience for Lauryann to witness the lives of America's working class. It would help me fix what was lacking in Lauryann—the understanding of how rough life could be—and help her develop a sense of gratitude. I thought that after she witnessed what poor children didn't have, she would appreciate what she had.

My plan backfired when Lauryann witnessed the opposite.

I asked Lauryann to mix cement while I tiled the floor in one unit. During the summer, we worked from morning until midnight. Lauryann

was given my old paint-stained clothes to wear. She was with me on the construction site seven days a week.

Lauryann started her battle against me first by telling me that I looked nothing like a "regular American mom." "People have reasons when they ask you, 'Are you a landscaper?' or, 'Do you work at the Home Depot?'" Then Lauryann complained about the fact that I had her walk in the rain. "American moms never let their kids walk in the rain," she said. "They drive their kids to where they ought to be. I have no raincoat, or an umbrella, and you expect me to walk in the rain. You don't care that I could get wet and get sick."

I pulled out a trash bag and cut one hole on the bottom and two holes in the sides to turn it into a makeshift raincoat. I made one for myself too. "Here, your raincoat. It works great!"

"Mom, people are going to laugh!"

"Why should you bother with people's opinions? Why should you he affected by neuple's tooligh and masty comments? Walk your own path, daughter. Cheer up. It's a nice day."

"But the TV weatherman said it's a bad day."

"I have a real problem with the American TV weatherman," I snapped. "Rainy days are the best days. A Chinese weatherman would congratulate the farmers. He would say that the rain is good for agriculture. The crops need a deep soak. It's a gift from heaven. I love rainy days. At the labor camp we got no breaks except when it rained. I am not talking about average rain. Average rain didn't count. It had to be pouring so hard that the rice shoots we just planted floated back up . . . I prayed for the rain to never stop . . ."

Lauryann rolled her eyes.

Lauryann and I worked as a team. While I unloaded construction material from the car, Lauryann carried tools into the unit. To avoid inconveniencing the tenants, we worked around their time schedules, which meant we often had to skip lunch and dinner. It was also because we couldn't afford to let the mixed concrete harden or the water-pipe holes stay exposed.

On the way home, Lauryann would fall asleep soon after climbing in the car. I felt bad working her like this. How I would have loved to see her playing with other kids on bikes and scooters. I had to stop this train of thought from going further.

The tenants would say to Lauryann, "Oh honey, you poor thing. Your mother ought to take you to Disneyland. Listen, a kid's job is to have fun."

I would have encouraged Lauryann to have fun if she didn't have to struggle to get decent grades. Lauryann had demonstrated slowness in certain areas, such as mathematics. She could barely do second-grade math as a fourth grader. For example, she was unable to figure out the answer to 0.39 times 10,000. It was the Fourth of July and we were having dinner at a friend's house. The friend had just gotten his real estate agent license. He needed to mail out ten thousand letters at thirty-nine cents each to introduce himself to the community. Nobody meant to embarrass Lauryann. The man addressed the question to her because it was an easy question and he wanted to give her a chance to participate in the conversation. It surprised everyone when Lauryann took a long time and counted with her fingers. Finally she shook her head and broke down in tears.

I told Lauryann that it was not her problem that she didn't have the smart genes. "I didn't give it to you. It's Mommy's fault." I told her that I was proud of her effort. "Thanks for being brave." Her best effort was good enough for me. She relaxed and trusted that I meant what I said.

After the math incident, I received well-meaning advice from my friends. They all noticed Lauryann's "slowness" and were concerned. They encouraged me to enroll Lauryann in an art school, since she was good at dancing.

I didn't want to enroll Lauryann in an alternative school without putting up a fight. "I don't see why you can't follow in my steps," I said to Lauryann. "I taught myself English."

I loved American public school teachers. Every one of them offered my daughter a chance. Lauryann crawled her way to the top. I made "How can I make it right?" Lauryann's motto. She was getting used to falling to the bottom before climbing out of the "grade pit."

"If you can fix broken toilets, reconnect pipes, become a floor master and a locksmith, you can make anything work," I encouraged her.

A tenant named Ruth asked Lauryann, "What would you like to be when you grow up?"

"A plumber," Lauryann replied. "Mom thinks that is a good idea. Right, Mom?"

I gave her a look of approval.

"You've got to be kidding me!" Ruth shook her head. "Grow up to be a plumber? Is this your American dream? Come on, Mrs. Min, I don't know what to say! I mean, I am in disbelief! How could you do this to your daughter? She's so pretty. She can be a model, an actress, or the next Miss America."

"Well, there is no limit to what she can dream," I said. "I just don't want her to set herself up for a crash"

"What do you think her best option would be?"

"Joining the army can be a good option if I haven't saved enough for her college by the time she turns eighteen," I replied.

Ruth gave an exaggerated jaw-dropping expression. "You might as well kill her! What the hell are you thinking?"

"Well, the army provides free college tuition. I have learned about the benefits of serving in a US military hospital. A guaranteed job. Of course, Lauryann has to go through nursing school first. Nobody can rob what you put inside your brain. The army pay is decent and you'd be covered by VA medical care for the rest of your life."

"But your daughter can come back in a body bag!"

"Well, I look at it this way: Auto accidents kill on average fifty thousand a year in this country, while the total number of American soldiers killed in the recent war is only in the thousands."

"You sound crazy to me, Mrs. Min," Ruth said.

"Well, my daughter could also become the one who figures out a cure for AIDS."

Lauryann asked Ruth's daughter Candy what her dream was.

"I want to be a fashion model," Candy said, chewing gum and ad-

THE COOKED SEED

miring herself in a mirror. "Or a movie actress. Maybe a veterinarian, 'cause I love animals."

"I am so proud of Candy," Ruth said.

Driving home, I said to Lauryann, "Did you notice that there are no books in all four units? I have never seen any of the children do homework and she talked about becoming a veterinarian."

"Mom, you are not supposed to talk like this behind people's backs," Lauryann said. "People can do anything they like in America. It's none of your business!"

"These parents don't love their children," I continued. "I mean, not enough."

"How do you know?"

"They don't prepare their children."

"Well, the parents might not have the time to prepare their children."

"You think I have time? I make time! I will park on your back if you bring home a low grade without a good reason! I make you do homework in the car, in the stores, at the construction site, that's how you get A's. Maybe the Americans need a Communist system, so the mothers can have labor-camp experiences . . ."

"Watch your mouth, Mom!"

I struggled to find time to work on my manuscript. I wrote through the night until I came down with the flu. It was hard to drag myself out of bed with a pounding headache. I knew I couldn't afford to be sick. The mortgage company, the IRS, and the property tax had to be paid, regardless of the fact that I was unable to get the tenants to pay their rent.

I shut myself in the tenants' bathroom to throw up. The construction tool I was using started to feel heavy. I knew I was about to pass out. I feared accidents because I had no medical insurance.

When Lauryann saw my face turn pale and my shirt drenched in sweat, she brought me water. At the end of the day, I was unable to drive home. I had to sit in the car to catch my breath.

Still, I felt blessed that I had the right to work. In the meantime, I

couldn't help but think that if Lauryann hadn't had me as a mother, she would have been having a good time at a summer camp. She could be traveling the world or attending dance classes or playing piano. She could have her friends sleep over and watch movies. Instead she was stuck with my troubles.

It often happened that I received two A.M. calls from tenants complaining about sewage backups. The police also phoned about a domestic violence incident in one of my units. I had to leave home immediately to fix the problem. Returning from the property at dawn, I tiptoed into Lauryann's room. White paint stains were still in her hair and her chin was scratched, but my daughter was sound asleep. My love for her recharged my strength.

I felt overwhelmed by guilt. Was I denying my little girl the American childhood she was entitled to? I had denied her water and food the previous day because we were in the middle of caulking a bathroom. What option did I have? I had out the coalant tubes open, and the caulking had to be used immediately or wasted.

On Thanksgiving and Christmas evenings, I played Lauryann movies that I had bought in China dubbed in Chinese. I considered this an education. Because I could not afford to pay for Lauryann to attend a Chinese language school, she would learn by watching the films. In the meantime, I sent her moral messages through the movies.

The White Haired Girl, filmed in China in the 1960s, was one of my favorites. The Girl Who Sells Flowers was another favorite, a North Korean movie produced in the 1970s.

Lauryann enjoyed the movies but had trouble believing the stories. "Why is every landlord portrayed as heartless, cruel, and evil?" she questioned. In *The White Haired Girl*, the landlord raped the peasant's daughter because the peasant was late on his rent. The daughter escaped into the mountains and lived like an animal. Malnutrition turned her hair snow white. Later, she was saved by the Communists and returned for revenge. The landlord was executed at the end of the movie.

The North Korean flower seller sang the most beautiful yet the saddest songs. She belonged to a family of tenants who were unable to make the rent and suffered at the hands of the landlord. The tenants were forced to sell their children in order to come up with the rent. "This is Communist propaganda, Mom!" Lauryann protested. "Look at you, the real-life landlord! Your tenants walk all over you!"

Lauryann and I were on ladders. We had been repairing a ceiling damaged from a bathtub leak on the second floor. We had taken down the old, soaked ceiling drywall and were trying to replace it with a new sheet. We were having difficulty lifting the drywall sheet into place. The weight was crushing us, and my strength was failing. I asked Lauryann to hold up the drywall by using her head as a stabilizer. Standing on the ladder, she tried to push the drywall sheet toward the ceiling.

I grabbed my drill and climbed back onto the ladder. Driving in the screws, I started to fasten the drywall onto the ceiling joists. My arms were shaking. Lauryann was losing her strength. "Almost there!" I cried. "Push the drywall up, Lauryann! Harder! Push all the way!" She was in tears as I drove the last screws in.

I examined Lauryann afterward. The protective adult-size glasses had fallen from her little face. Neither Home Depot, Ace, nor Orchard Hardware carried child-size protective glasses.

"Can I take the glasses off now?" Lauryann asked.

"Not yet," I replied. "We have more to do and dust can get in your eyes."

After we finished taping the drywall joints and spreading the compound over the tape, our legs and arms were so sore that it hurt to move. I took off my daughter's shower cap, bent down, and kissed her little dust-coated face.

While we waited for the drywall compound to dry before painting the ceiling, I took Lauryann with me to shop for plumbing material. We got to know the salespeople at hardware stores. They were the best teachers. From them, I learned the tricks of the trade. For example, some plumbers would use a trick to avoid being called back. They would use both plumber's tape and glue on valves, and it would hide a lousy job—for a while. In time the leak would return, but by then the warranty date would have passed.

We never knew the kind of problems we would run into. A new toilet we installed wouldn't stop dripping water. Every few hours I would find a spoonful of water under the tank. Lauryann and I exchanged the toilet for a new one and reinstalled it. But there was another problem. Water seepage and moisture under the toilet. I was frustrated and knew that I couldn't afford to ignore it. The slow dripping would lead to mold and over time attract termites. We took the toilet apart for the third time. I figured that the toilet tank had to be defective. We returned to Home Depot for another replacement.

Lauryann sat in the car and was doing her homework while I waited in line to talk to clerks at customer service. Hours passed and I was tired by the time I picked up the new toilet. We drove back to the unit. Lauryann had to put down her homework and help me lift the toilet and set it in place. She sat next to me on the floor finishing her homework as I caulked and sealed the bottom of the toilet.

Holding a large wrench in her right hund and a medium wrench in her left, Lauryann helped me replace a shower valve. The severe corrosion made the fixture hard to turn. My right arm was in pain trying to get the rusted cartridge to move. We struggled for hours, but the rusted parts wouldn't budge. I had to be careful not to apply too much force. It could cause the pipe inside the wall to bend, crack, and leak. The angle where I stood was awkward. I stood inside the tub, my elbow against the wall, and I was not able to use a larger wrench. My clothes were soaked with sweat. Lauryann told me that she was worried about her math test the next day.

"Do you think I am having fun?" I said in frustration.

Tears filled Lauryann's eyes.

"This is not a good time to play princess," I said. "Go to the car and get me the WD-40."

As Lauryann left, I felt my heart ache. I regretted taking out my frustration on her. When she returned, I apologized. "I was mad at the rusty valve and not you."

Lauryann handed me tools like a nurse to a surgeon. I was under the sink replacing a broken faucet. Lauryann unplugged electric cords, cleaned the work site, and removed the clay deposits from the blade used to cut the tiles. When I set the tiles, Lauryann mixed the concrete in a bucket. I gave her a cooking utensil to make the job easier. We worked in complete harmony. I laid the tiles and she passed me the supplies.

"Mom, here, the corner piece."

"Mom, watch out! There is a nail sticking out behind your left foot!"

"Mom, should I open another bag of concrete, or do you think this is enough?" $\,$

Jameeka, a heavyset pregnant lady who lived across the street, watched us work. She was keeping an eye on her three children playing in the street.

"Nice job!" Jameeka commented. "Is this unit for rent?"

"Are you interested?" I asked. "I guarantee the lowest price on the block."

Sipping a Coke, Jameeka said the price was never her concern.

"What do you mean?" I asked. "I thought price was everybody's main concern."

"I can pay for any apartment I want."

"You have a good job that pays well?"

"Kidding me? I can't work with all these kids."

"How do you get money then? From the father of your children?"

"Nope. My boyfriend don't pay no child support."

"I am a single mother too," I said. "My ex-husband don't pay child support either."

"The government is responsible for the children's welfare. I can go hungry, but my kids can't, right?"

I learned that Jameeka collected \$800 from the government for each of her children. Her total income was \$3,200 a month. Jameeka offered to show me her apartment. "I love my place," she said, glowing. "You should take a look at my bathroom tiling. It'll give you some good ideas on picking more attractive tiles."

"That'll be nice!" I said.

The visit turned out to be a tipping point for Lauryann. As much as I had prepared my daughter, nothing was more powerful than a real-life demonstration. For her, the shock was subversive.

We followed Jameeka across the street into a showroom-quality three-bedroom apartment. I was surprised that it had white carpet, a fireplace, and designer furniture. The kitchen counter was made of marble.

"May I ask how much rent you pay for this fancy place?"

"Twenty-five hundred," Jameeka replied. "Beauty has its price, I know."

"Well . . . I guess it pays to have a lot of children in America."

"Don't you get misled," she said. "Children can be real headaches."

"What kind of headaches?"

"Like . . . you know . . . trying to keep your daughter off the drugs."

"You mean your daughter?"

"Yep."

"But she's only . . . how old?"

"Fourteen. She keeps asking me for money. She says she needs the cash to pay off debts. Debts my ass!"

"Does she have dehts?"

"She's been threatened by the gang. She could be murdered if she doesn't cough up the money. I have to help her. That's why I'm broke. My gut tells me that she uses the money for drugs."

I observed Lauryann. Her expression started to change as she followed Jameeka. Lauryann was making a comparison inside her head. Jameeka's children had everything she wished to have. They each had a bedroom with designer beds and matching sheets. Their closets were full of lovely dresses and fashionable shoes. They had their own TV sets, video games, toy cars, bikes, and skateboards.

Back in the car, I tried to discuss the idea of "milking the system" with Lauryann.

"Mom, don't start." Lauryann's voice was confrontational. "I don't feel like having a discussion. Not right now."

Since Lauryann's birth, I had been preaching the philosophy that the only way to achieve the American dream was by hard work. Unfortunately, Lauryann had seen with her own eyes the opposite.

"I must know what is on your mind," I said.

"You wouldn't like it, Mom."

"I must know."

"It's not the end of the world being poor-okay?"

"It's supposed to be the end. And it is. The impression you have gotten here is . . . is . . . wrong. This is a peculiar and a particular case. Not all poor people live this way. I mean, not in a normal situation . . . You can't tell from one spot that it is a leopard."

"Mom, don't try to fix . . . me or anybody else! I mean it!"

"I am afraid that you're getting the wrong impression."

"I don't think so."

"You are not seeing the whole truth, Lauryann."

"You know what I see, Mom? I see the freedom Jameeka's kids have. The true freedom! The freedom you came to America for. The freedom I don't have. I see that Jameeka's kids have a normal childhood. They don't have to carry thirty-pound concrete bags day in and day out. They don't have to clean other people's toilets and sewage, and end up getting a stink in their hair that even a bottle of shampoo can't get rid of. Jameeka's kids wear clean clothes, have weekends and friends, and are happy." Lauryann broke down. "I don't think what I am asking is too much. I really don't!"

A strange phrase slowly entered my mind. It was a description by Marguerite Duras from her novel *The Lover.* "Cry out, to crack the ice in which the whole scene was fatally freezing. My mother turned her head . . ."

My mind was coping. It was responding in an awareness, strangely knowing its options, including my own confusion and the lack of strategies. Never before had I been so clear about the state of my mind. There was something unfamiliar, something exquisitely American taking place. I asked myself: Has Lauryann become a part of you that you can't listen to? Have you been ignoring her feelings? What have the mixed cultural messages done to her? Is she haunted by my past? Am I making her into a maid because I myself wasn't raised to believe that I was a princess? After all, the saying goes, "You are who you believe you are." Is my damaged self-worth affecting Lauryann's sense of self-worth? Am I passing her my virtue or my disease? Hard work to achieve the American dream—at what cost?

In the days to come, when I was myself again and so was Lauryann,

we had a discussion. I described the homeless families I used to see growing up in China. The beggar kids' exposed wounds covered by flies and chewed by maggots. I said, "Although America's poor carry cell phones, and some live the lifestyle of Jameeka, their deprivation lies in the fact that they don't know their options. You don't know what you don't know. Just like before I came to America. I had thought that I had no choice, but I did. I made bad decisions and did myself great disfavors. People like Jameeka are not in dissimilar situations. There is a difference in being poor and being ignorant. When children are not cultivating a sense of honor, they grow up shameless. And that is true deprivation."

Lauryann tried her best to comprehend. It wasn't until years later when I took her to see the movie *Precious*, produced by Oprah Winfrey and Tyler Perry, that Lauryann was able to understand that to be deprived from understanding was true misfortune, the policy I meant to explain to her all along Lauryann realized how fortunate she was that she had learned the difference.

The ballet lessons were eight dollars an hour. They were not private but group lessons.

The day of her lesson, Lauryann finished her schoolwork as soon as she could. With glowing anticipation, she put on her shoes. She combed her hair and braided it into a bun. She kept looking at me, amazed that she was actually going to a ballet lesson instead of the construction site.

"Thanks, Mom," she said. "I love you."

"Have fun." I smiled.

"I will!" She stretched out her arms, making dance motions while humming the theme of *Swan Lake*.

Lauryann treasured every minute that she was out of her paint-stained work clothes and memorized the dance moves a few classes later. She was first asked to demonstrate the moves to other children and then was made the lead dancer of her group. By the time the school showcased its annual performance of *Swan Lake*, Lauryann was given the lead spot for the group and danced the Black Swan. Handpicked by her teacher, Lauryann competed at Disneyland's American Dance Com-

THE COOKED SEED

petition and American Dance Championships. She won gold medals as a solo dancer in both the competitive and folk categories.

Watching my daughter performing onstage and receiving awards thrilled me. It helped me forget my troubles. I smiled when I recalled how Lauryann practiced her moves in a church parking lot wearing sneakers. "You don't have to worry about the lack of space," I said. "Also, the downstairs neighbors won't complain about the noise you make."

{ CHAPTER 29 }

SAT IN MY car crying because I had not been able to collect rent for several months. One after another, my tenants had stopped paying. By now they knew nothing would happen to them. They ignored my warning letters. They refused to move. I begged and promised to waive their unpaid rent.

Ruth said, "I don't want to be the only one paying rent!"

It was as if the tenants had discovered a flaw in my defenses and ambushed me.

One tenant said, "I can report this filthy building to the state's health organization, you know. And they will come and shut down the building."

I knew she wanted me to stop pressuring her for the rent.

"I deserve a rent reduction for the inconvenience," another tenant demanded. "The roach bomb you bought us didn't work. We had to do it again ourselves. As a result, my son had to miss his football game."

The pest exterminator told me that he had applied two treatments.

"But my tenants said there were still cockroaches," I said.

"You've got pigs living here!" The exterminator pointed at the dog food, cat food, hamster food, and fish food scattered all over the unit. "It's roach heaven!"

I was angry because I provided the tenants with the best service—something I could not afford—only to learn that most of the repairs and remodeling were destroyed in a few months. The unit became unrecognizable, with toilets pulled out of place, sinks cracked, pipes clogged, a dishwasher drainage hose punctured, holes in the closet doors, graffiti on the bedroom walls, cabinet hinges broken, and flooding in the basement.

When I asked the tenants what happened, every one of them gave the same reply: "I don't know who did it. Not me."

My tenants were experts at dealing with eviction notices. At that game, I was no match.

I could no longer sleep because I was behind on the mortgage pay-

ment. The bank had served me with a "final notice" and threatened to foreclose on my property. My stomach burned so badly that the pain-killers were no longer effective.

I never expected that the moment I chased the wolf out of my front gate, a tiger would come in my back door. After I paid an eviction law-yer \$6,000 and finally got rid of the worst tenant and the unit cleaned and ready, a well-dressed young couple, Brandi and Marc, responded to my for-rent advertisement. They came to the open house and told me that they "loved" the unit. They wanted to rent it as soon as possible. Brandi told me that she was college educated and worked as a leasing manager for an inner-city apartment complex. Her fiancé, Marc, was a department store stocking manager. The couple had a young son. Brandi mentioned that she majored in business communications in college. She said, "I would have pursued a career as a lawyer if I hadn't had my son."

We talked about America being the best place in the world for providing opportunities to its minorities.

"It took three generations to achieve where I am." Brandi beamed.

The only thing that sounded unusual to me was what Brandi said when I asked for a reference.

"I can get you the best reference, because that's what I do in my office."

I noticed that the son was hyperactive. He first played with the stove knobs, then went to press the buttons on the dishwasher. His parents didn't try to stop him. The father even tossed a basketball to the boy over the center island in the kitchen. Then they began to play by throwing the ball beneath the hanging ceiling light.

I became nervous when the son pulled on the floor-length vinyl blinds that covered the sliding glass door. Several of the slats snapped loose and fell and almost hit the boy on the head. I was aware of liability lawsuits in America. After the couple left, I wrote an e-mail to Brandi and Marc with my concerns. I told them that I liked them and wanted to rent to them, but we must come up with a solution regarding "child safety." I told them that I was willing to replace the vertical blinds with cotton curtains.

Brandi e-mailed me back and said, "If you don't wish to rent to us, would you please send an e-mail telling us in writing that we are denied?"

I showed Brandi's e-mail to Lauryann, who was at the time eleven years old. "Am I not comprehending English correctly here?"

Lauryann said that she smelled "something fishy." "Mom, don't answer that e-mail!"

"Decency, Lauryann!" I replied. "Wouldn't you appreciate a response if you were the applicant? Besides, I don't see why I'd get myself in trouble for my concerns about a child's safety."

"Fine, do it your way."

"Lauryann, be nice and kind to people, always. You hear me?"

"Yes, Mom."

I sent an e-mail to Brandi. "As a landlord, I am concerned about the liability. I am willing to sign the lease as soon as the child-safety issue is resolved." I let Brandi know that I would understand and wouldn't mind if she felt that she could not wait and would like to move on.

What came next shocked me: Instead of an e-mail from Brandi, I received a letter from the Department of Fair Housing. It was a "Notice of Filing of Discrimination Complaint."

"My family and I were denied rental of a two-bedroom condominium," Brandi wrote on the complaint form. "There were approximately twenty units in the complex. We believe we were denied rental based on our familial status (minor child). This is a violation of Government Code, Section 12955, Subdivisions (a) and (c). Our belief is based on the following: The owner indicated in an e-mail that though she was impressed with our application, she was concerned about liability issues with having a small child in the unit and rented the unit to someone else."

I did not own a twenty-unit complex! The unit was still vacant! If I had known that Brandi was an expert on "government violation codes," I would have handled the issue with caution. I would have treated her the same way I would have my former Communist Party boss. I would have stayed on the safe side and would not have responded to her e-mails.

The officer's name was Sonya. She was in charge of my case representing the Department of Fair Housing. Sonya asked me to pay Brandi \$2,000 as "a gesture of agreeing to the conciliation process." Ms. Sonya did not want to hear my side of the story. "Please send the check to Brandi through my office," she instructed.

I felt wronged so I didn't send the check.

I began to receive phone calls from Ms. Sonya. She made me feel as if I was a criminal when she said, "Will you cooperate, Ms. Min?"

I asked Lauryann if she had learned from school anything about the workings of the American government that could guide me. Lauryann did not have an answer.

Ms. Sonya's repeated phone calls terrified me. "I am asking you to cooperate, Ms. Min. It does not make any difference whether or not you are guilty. I will mark you as refusing to cooperate, Ms. Min. I will move you to a different category, and it will cost you more than two thousand dollars!"

I became nervous every time the phone rang. When I got on the line with Ms. Sonya, the "translator" inside my head would freeze. I told Ms. Sonya that I couldn't handle the phone conversations. I needed to look up words in my dictionary to make sure that I didn't say the wrong thing. I requested to communicate through writing.

But Ms. Sonya continued to call. She seemed to enjoy the effect she had on me.

Sonya: Are you there?

Min: . . .

Sonya: Ms. Min, are you there?

Min: Yes.

Sonya: Like I said, it will cost you a lot more if you refuse to cooperate!

Min: But I didn't do anything wrong.

Sonya: Did you write that e-mail?

Min: Well, my nine-foot vertical blind was not safe for the young child...

Sonya: Answer my question. Did you write that e-mail?

Min: I didn't write to discriminate. The e-mail explains itself . . .

ANCHEE MIN

Sonya: PLEASE! Would you just answer the question: DID YOU WRITE THAT E-MAIL?

Min: Yes, I did.

Sonya: So you discriminated!

Min: But that's not true!

Sonya: Oh, yes, that's true! I read your e-mail. To me you sounded discriminatory!

Min: But I . . . can't do this over the phone.

Sonya: Why?

Min: I am afraid . . .

Sonya: What are you afraid of?

Min: Mis . . . misunderstanding you. I am sorry. English is not my first language.

Sonya: Your English sounds fine to me!

Min: I prefer writing.

Sonya: What language do you speak!

Min: Chinese.

Ms. Sonya told me that she could get someone on the phone who could speak Chinese. On second thought, I declined. I sensed that whomever Ms. Sonya sent would be from the same agency and would share the same attitude. I pleaded with Ms. Sonya to put her words in a letter and mail it to me. She agreed, but with a condition.

Sonya: Once you receive my letter, you will cooperate and pay the two thousand dollars, right?

Min: I would have to study your letter first.

Sonya: Well, I need to know when you will get back to me and cooperate.

Min: May I have ten days?

Sonya: No.

Min: A week?

Sonya: No, I'll give you two days. I will mail my letter today, which is Monday. You will get it by Wednesday. I'll expect you to call me to settle on Friday, or I will send you other papers to fill out. You will be in a different category. You

THE COOKED SEED

will be responsible for the consequences! Like I said, it'll cost you A LOT MORE.

I wrote a check for \$2,000 to Brandi and sent it to Ms. Sonya. I thought I had swallowed the bullying and had ended the nightmare, but I was wrong. Ms. Sonya decided that I needed more torture.

A few days later, I received another notice from Ms. Sonya. She demanded that I attend a "landlord school." "You need to learn how to be a proper landlord," she said. Again, Ms. Sonya threatened to put me in a "different category" if I refused to comply with her order.

For the next week, I rose early and drove two hours to landlord school, located in a different county. It was there that I first learned about "the protected class." Folks who attended the class were small-time landlords like me. My group was made of a retired garbageman, a former grocery store owner, a handyman, a retired teacher, and a former fireman.

The class reminded me of the "thought-reform sections" that I attended in China during the Cultural Revolution. Our instructor was a middle-aged black woman. She advised us to "cooperate" with the Department of Fair Housing. When I explained my case and asked what I should do, the black woman told me a story. "I want to tell you about a landlord in a similar situation," she said. "He was concerned for a child's safety due to his backyard pool. The prospective renter was a single mother with two small children. The landlord refused to rent to the woman because he feared the liability. He was fined two thousand dollars at first for discrimination, but he decided not to cooperate. He kept taking the case to a higher court. Guess what happened in the end? He was fined fifty thousand dollars."

"Did he pay?" Everybody in the class asked.

"Of course!" The woman smiled. "The tenants had the right to put a lien on the property if the landlord failed to pay."

"Are you saying that landlords can't win?"

"Unless you are Donald Trump." The instructor laughed.

One of the attendees argued that the fifty-thousand-dollar case must be an out-of-the-ordinary incident. "Law is square," he said. "Justice is blind."

The instructor gave him a you-haven't-heard-anything-yet expression. "Here, please help pass out this material. I want everyone to read it carefully. It's a cover story published in the *Apartment Owners Association News* under the headline 'Landlord Paid Over \$1 Million in Discriminatory Complaint."

She went on to explain, "It was the largest settlement ever obtained by the Justice Department in an individual housing-discrimination case. The tenant requested a wheelchair elevator installed inside his unit after he was injured in an auto accident. The landlord refused. When the tenant protested, the landlord told him to move. The one-million-dollar fine on the landlord showed that our law *is* square and our justice *is* blind."

The city inspector came five times within a year. Each time, I had to pay the city \$150 for the inspection fee. Each time, the inspector gave me a new violation list. There were thirty nine items to be corrected. The inspector took her job seriously. Nothing escaped her trained eye. If the wall paint was chipped or was less than spotlessly clean, she would mark it as a violation. She ordered me to spend over \$1,000 to repaint the entire unit. She looked for mold in the bathroom. If she saw a dark spot, she would mark that as another violation. It was no use for me to explain that the mold smell was due to poor ventilation—the tenants were too lazy to open the windows after showering. I was fined for "lack of proper lighting" for Ruth's stage-set-like dark bedroom, with its layers of canvas curtains pinned with giant fake spiders and sprayed with thick paint in the image of a monstrous web.

I obeyed the orders and lost every dollar I earned from the rentals. In time, the inspector grew sympathetic to me. It was after she repeatedly witnessed how the fire extinguishers and smoke detectors she ordered me to replace were stolen the next day. She had a record of the new stove hood I had replaced that was destroyed a few days later. Although she praised me as a "model landlord" and wished that she could be more helpful, she issued me a fine for mattresses the tenants threw out on the street. She also ordered me to repave the driveway and reroof the carport.

I hired a licensed contractor. After taking my deposit, the contrac-

tor stopped showing up. When I canceled the contract, he put a lien on my property accusing me of breach of contract. He demanded \$150,000 to remove the lien.

My mother was gravely ill in China, but I had to postpone my visit in order to deal with this issue. My doctor said that I was "one step away from stomach cancer." As if she had matured overnight, Lauryann came to my rescue. She could no longer stand the way I was being bullied. She had witnessed my sleepless nights, my tears, and my need for her. She realized that she could protect me as I had once protected my mother in China. Lauryann helped me write a letter to the Fair Housing Department, the City Inspection Department, and the Department of California License Board. I was in tears as I watched Lauryann edit my letters.

A Chinese saying goes, "The flowers that you spent all of your time trying to grow failed to blossom, while the willow you had no intention to cultivate provides you with shade."

I never expected that my books would take off to become international bestsellers. As a result, my publisher offered me a generous two-book contract.

The money brought freedom. I hired a real estate property management company to take care of my apartment troubles. This relief improved my health. I cannot say that the experience with my rentals did not shake my faith in people. I lost my innocence, and I did not like the transformation. I didn't enjoy learning how to profile prospective tenants without getting caught.

With Lauryann's help, I challenged the lien. I contacted the State License Board. At first, I didn't have much faith in the investigator because of my previous experience with Sonya. I went along with the investigation. It surprised me that after a year, a conclusion was reached by the State License Board. The contractor was ordered to remove his lien. I won the case but did not recover most of the money I had already paid the contractor. This experience restored my faith in America's justice system. I was grateful to the California State License Board.

Lauryann didn't come out of the experience as bitter as I did. I had

so feared that she would lose her generosity and trust in people. I didn't know why she wasn't more affected. Nothing helped speed up a child's maturity more than witnessing her mother's failures and struggles in crisis. Lauryann was forced to live my reality. I hadn't meant to involve her—a young girl at her tender age—though in my heart I had no regrets. I felt that it was the best thing that could have happened to her. She learned to respect reality. American children are the best-cared-for children in the world. Most of them are sheltered from everything bad and cruel. The future to most of them was rose colored. I told Lauryann that I didn't want her to grow up a houseplant. I would rather have the shit hit her fan now, so that she would have the time to develop coping skills.

I felt a great sense of achievement when I heard her say, "Mom, there will always be bad apples. You just have to recognize them."

Lauryann didn't really get to choose her foreign language at school. She was offered a choice between French, Japanese, and Spanish. I made her pick Spanish because I wanted her to help me communicate with the tenants. I wanted her to be prepared to serve the majority of the immigrant population in the future. This was part of a larger conversation. I told her that I had nothing against pleasure seeking as long as pleasure seeking was not the goal of her life. Spanish would be useful.

"Qigu and I have agreed to disagree on this point," I said. I felt a bit guilty imposing, but I had always been straightforward about my values and opinions. Lauryann had been mine to not only love and cherish, but also to influence and mold. To the Chinese, "It is the carving that turns a piece of raw wood into fine art."

Lauryann was no longer a houseplant. In the years to come, life would turn her into a storm petrel, the tube-nosed seabird that enjoys taking flight, soaring into the sky, and diving into the wildest ocean waves. I felt blessed to witness my daughter growing into a confident young woman, fully in possession of her mind and body and unafraid of what lay before her.

PART FIVE

Pried him. I answer, "From the Yellow Pages." But people don't believe me. They say, "What a great sense of humor you have, Anchee Min!" I wasn't being funny. I was telling the truth.

In 1999 I moved to a neighborhood where Lauryann could attend a better public school. At the time she was a first grader, soon to start second grade, and I was forty-two years old. I had come to accept the reality that no man found me attractive enough to approach me. In the five years since my divorce, I had thought a lot about the failure of my marriage and believed I understood my role in it. I had asked myself questions and read self-help books. I believed that I could now make better choices and be a better partner, though it seemed that there was no longer going to be a chance to prove this.

I told myself that it was not a disgrace to be in my situation. It would only be a disgrace if I didn't make an effort to dig myself out of it. So I kept trying, but without luck. I continued to dread the Thanksgiving and Christmas holidays, because I wanted to cook for more than just Lauryann and myself.

It wasn't that I didn't meet men. I met colorful characters: authors, journalists, publishers, and college academics, but I was seen by these men as the writer Anchee Min, not a single woman lonely for affection. I presented myself as "interesting" and "fascinating." People became animated when they spoke to *Anchee Min*.

I didn't feel secure revealing my true self. Often, when I did, it came out wrong because language was still a hurdle. For example, one woman who was escorting me on a book tour had a Ph.D. in human sexuality. While driving, she discussed the subject with great passion. Afterward, she asked my opinion on women's sexual liberation.

I told her that I didn't know what to say, because for seven years my experience with sex had been with a videotape instead of a man.

"It's not that I don't want sex," I said flatly, "but an opportunity has not presented itself."

The Ph.D. became visibly disturbed as if I had invaded her personal space. For the rest of the trip, she remained silent. I didn't understand what I had said to offend her. I should have known better. People paid me to be inspiring, to stand on a pedestal. I wasn't supposed to disappoint them by showing that I was just a flawed and weak human being.

Later, I realized she hadn't meant to ask about my sex life.

What I learned from my failed marriage to Qigu was that I didn't want to live like a frog at the bottom of a well. I knew that the sky was not the size of the well's opening. I craved sunlight, spring, and rain.

If someone had told me twenty years ago that I would become a bestselling author in America and around the world, I would never have believed it. All I knew then was that I could barely understand my own utility bills. Why should I rob myself of the chance of finding love? Why should I bury myself at the age of forty two? But how would I find a suitable man who would love me and whom I would love back? How could I let the world know that I existed and was interested and available?

It was then that I thought of the Yellow Pages, the phone book. If the Yellow Pages had helped me locate an electrician, a plumber, a refrigerator, a stove, and a garbage disposal, why not a man through a dating service? I must not be the only one in this world who was lonely and desperate for companionship. Was there another soul out there who shared the same frustration and hope? Another human being who had much to offer, just like me?

The thought of advertising myself depressed me. Despite all my changes, I was still a Chinese woman at my core. I stood in front of a mirror and gave myself an appraisal. What I saw matched a Chinatown herb doctor's observation of me. He wrote: "The patient's skin color looks like preserved vegetable; her pulse is weak. She has leaky Chi (internal breath)."

It took me three weeks to work up the courage to call the dating service that I found in the Yellow Pages. I composed a script starting with, "Hello, my name is Angie, and I am calling to get information for a girlfriend of mine." When asked my girlfriend's name, my tongue got stuck. I was not prepared to be asked my girlfriend's phone number either.

The person on the other end was kind and patient. She said that she understood it wasn't easy. "I'm Robin, and I'm here for you whenever you're ready," she said. Eventually she made me comfortable enough to admit that there was no girlfriend. "It's me who is interested. And yes, I'd like an appointment."

Robin was a charming middle-aged lady with a broad smile and great energy. She received me at the dating office. It was half past five in the afternoon, and her staff members were closing for the day.

Robin opened the door and gave me a hug. "I'm so excited that you made it!"

"Why?" I was suspicious of her enthusiasm.

"Because you are a super-attractive woman! I want your business. I'm sure you'll find what you're looking for with us. We need women like you."

"Well, thank you, but I know the truth about myself."

"No, you don't," Robin said. "You'll be surprised how much you don't know about yourself, and how much you can achieve with what you've got."

"I am looking for an average man."

"Average men are what we've got!" Robin pulled down the blinds to block the setting sun. "Our clients are as average as they can be."

"What kind of people are they?"

"Well, they are schoolteachers, mechanics, engineers, government workers, and accountants. Is that average enough for you? Many of these are decent men with jobs that allow limited social time. We have men who are divorcés and others who are struggling as single parents. You know what that's like."

"Yes, I do."

Robin smiled. "Haven't you heard that 'love is lovelier the second time around'? Well, Frank Sinatra sang that song, and he was a genius."

To show good faith, Robin offered me a discount. After I signed up, she revealed her "exciting list" of clients. But I was disappointed. The list was not as promising as what she had described it to be. The men who appeared interesting and good-looking were either "unavailable" or were in a "time away" with another member. The ones left were unattractive, to say the least.

"Have you selected anyone?" Robin asked when I finished looking through the files. When she saw my expression, she said, "Oh, I'm sorry. Don't feel bad. It's only your first day. There will be other opportunities."

I suggested to Robin that I bring my own photos. The photos the dating agency shot of me were worse than the one on my driver's license. Robin gave me a firm no.

"It is our agency's policy not to allow clients to bring their own photos. People do anything to make themselves appear attractive. In the past, we had folks who brought glamorous shots touched up with an airbrush. It looked nothing like the actual person. And it backfired"

"But I look absolutely unattractive in your photo," I said. "I wouldn't want to date me if I were a man."

"Our business is based on reputation and word of mouth," Robin insisted. "We must present people as they are."

A few days later, the dating agency called and reported that two men had left me "invitations." With excitement, I went in. I sat down with the inviters' profiles. To my greatest disappointment, these were men in their seventies, one with obviously false front teeth. I told Robin that I wanted to cancel my membership.

I thought I must have had less market value than I'd imagined. If I had ever had self-esteem issues before, they were about to be revived. I had written in my application that I preferred men "between forty and fifty years in age," but grandpas had approached me anyway. I found myself reeling from the shock.

Robin said that she would let me quit if I promised to try for one more week. I agreed. The next day Robin called saying that she had a "super match" for me. I told her that it would be a waste of time if the super match was a seventy-year-old.

THE COOKED SEED

Robin said, "He is not seventy. That's for sure. But he does not exactly match the age you described in your application. Are you willing to be a little flexible? I assume you are?"

"How old is he?"

"Fifty-two."

"What is his name? What does he do for a living?"

"Why don't you come in, and we can talk?" Before I answered, she hung up.

I didn't bother until a week later when Lauryann went on a twoday school trip and I was alone. I figured that my strained eyes needed a rest from writing anyway. It wouldn't hurt to check out the "super match."

Robin was taking a coffee break with the receptionist outside her office building when I pulled into the parking lot. She waved at me and cried joyfully, "Anchee Min, today is your lucky day!"

His name was Lloyd Lofthouse, a former US Marine, a Vietnam vet, and an English teacher. "Lloyd has been calling to make sure we passed you his invitation," Robin said almost breathlessly. "We told him that we already had, but he said he hasn't heard from you. He called in and checked with us three times today already. He wanted to see if you left him any message. Unfortunately, I had to tell him that you had not responded. I told him that it's in your hands, and there's nothing more we could do. Anyway, Lloyd is six foot four. A handsome guy. He's been teaching English for twenty-five years. What I meant by a 'super match' is that he is extremely interested in you! Wait—I forgot to tell you that he's a writer, too. I can see you two discussing the art of writing together!"

"No writer, no artist, please. I said I wanted an average man."

"Well, Lloyd is an average man who happens to love writing. He admires and appreciates what you do."

I thought of all the profiles I had checked. No one had appealed to me. I must have crossed Lloyd off already.

"Is this Lloyd Lofthouse a new member?" I asked.

"No, Lloyd has been with us for two years. He hasn't been lucky in finding anyone to his liking. His membership is expiring, and he has already notified us that he will not renew. To tell you the truth, he came

in today to sign off the membership. God bless him—he has discovered you!"

"I think I already passed him."

"Do me a favor, Anchee, go and check out Lloyd Lofthouse one last time. Maybe you missed him. It happens. You never know, the love song you heard on the radio on your way here might have put you in a better mood. The song might have influenced your brain chemistry. Maybe you had a good sleep last night. I can see that you are cheerful today."

I shook my head. "Thank you for being sweet, Robin, but-"

"Trust me, human beings are strange creatures," Robin continued. "Lloyd deserves a chance. He is a serious member, and I like him personally. He paid for two years, over six thousand dollars. A lot of money for a man like him. He means business. He wants to find love. He has called and called regarding you. The man is making his best effort. Would you give him credit for that—for trying 30 hard!"

"I'll think about it," I said. "But I have to go now. I'll take it slow. Like you said, it's only my first chance."

"But it's *his* last chance! Lloyd is leaving the service. I wish there was more I could do for him. Since you are already here, it wouldn't hurt to take a final look."

I located Lloyd Lofthouse in the members photo book. I had been right—I had passed him. He was a plain-looking man with bottle-thick glasses and a grin on his face. He was obviously awkward posing for the camera. His expression reminded me of a Halloween pumpkin. Many years later, after I became his wife, I learned that Lloyd was "photophobic." He would tense up in front of a camera. It was the one thing he would never do well. Unless he was unaware of the camera, in every family photo he posed for, the Halloween-pumpkin grin was there. The more Lauryann and I tried to get him to relax, the stiffer he would become. It was so hopeless that he would run the moment he saw a camera aimed in his direction.

Lloyd must have believed that his hairstyle was attractive. Heavily

gelled, his hair was pasted flat over his skull and appeared so thin that he looked as if he was balding. He was dressed in a dark-blue three-piece suit with a rainbow-striped tie. He reminded me of a car salesman.

I turned over the page and read his personal information. To my surprise, he had divorced twice! He must be a "habitual walker," a term I had come across in a relationship advice book. For the question "Is it okay if your partner smokes?" he wrote a capital-letter "NO!!!" A man of strong will and opinion, this Lloyd must be. I also sensed that he could be extreme in his views.

Lloyd's self-introduction was straightforward and clear. He certainly wrote well. He described himself as both an introvert and an extrovert. For "introvert," he explained that he was a "lover of books" and "enjoyed quiet time by himself." For "extrovert," he mentioned that he enjoyed the company of friends. If his friends had one word to describe him, it was loyal. For his "passion," he wrote, "A commitment to a healthy lifestyle." For "hobby," he wrote "hiking" and "movies."

What he was looking for in a woman sounded peculiar. While other men put down "reasonably good-looking, a lady who enjoys companionship, romantic evenings, and candlelight dinners," Lloyd wrote, "A woman who is health conscious and who would welcome (or at least accept) vegetarianism, and who is, or has been, working toward keeping herself in good physical shape."

When asked the preference of a personality type, where other men wrote "kind and caring" or "easygoing and fun-loving," Lloyd wrote, "A strong sense of family and personal responsibility." I wondered why he had underlined "personal responsibility." What had happened to him that moved him to underline that phrase?

Although I wasn't attracted to Lloyd's appearance, his personal statement intrigued me. I was impressed by this unyielding character. It was obvious that Lloyd Lofthouse was a man who knew exactly what he wanted, and that he wasn't shy about making that known.

I thought, *Too bad he has that awful Halloween-pumpkin grin.* As I was leaving, Robin asked me if I had watched Lloyd's video.

Although I was sure I'd be wasting my time, I needed an excuse to

let Robin know that I had done everything I could and that it was not meant to be.

I could use the expression "falling out of my chair" to describe the moment I saw Lloyd in a video interview conducted by the dating service. Here was a completely different man from the character I'd seen in his photos. He didn't have that Halloween-pumpkin grin. This man had thick, curly, and untamed beautiful gray hair. He must have missed his last appointment to get his hair gelled, or he had decided not to bother grooming himself for the videotaping. If he had been an animal, the video caught him in his natural state. Instead of the dark-blue suit, he was in an off-white T-shirt and blue jeans. Behind the glasses his deep-set eyes showed intelligence, honesty, and kindness. He had a long, narrow—what he would later describe critically as "English"—nose and a mouth that smiled affectionately.

Unlike the man in the photos, the man in the video was at ease and self-assured. He was articulate and soft-spoken. In less than five minutes, he accomplished a thoughtful and thorough self-introduction. He was born in Pasadena, California, and served in Vietnam as a US Marine. With the GI Bill, he earned a degree in journalism, and he had been a classroom English teacher ever since. He said he loved teaching, then paused to add, "for the most part, though it can be a challenge from time to time. It's a consuming job, or I wouldn't be sitting here talking to a camera..." He lowered his chin as he smiled.

In the future, I'd learn that Lloyd's family ancestry led to England and Ireland on his father's side and Scandinavia on his mother's side. What impressed me about the man in the video was that he was completely comfortable in his own skin. He sought nobody's approval. As a teen, he had sold door-to-door for the Fuller Brush Company. He'd worked as a grocery boy and a dishwasher. After returning from war, while going to college, he worked part-time as a JCPenney stock man, Sears janitor, a McDonald's three A.M. cleaner, a landscaping trench digger, and a maintenance clerk at a truck company. "I do my best, although I don't think of myself as particularly special." He smiled in the video. In years to come, I would think of Lloyd Lofthouse as a well-trimmed

tree who enjoyed the sun, rain, and all the seasons, and who shared his canopy. I valued the fact that Lloyd was a man who lived an existence equal to mine. I was also pleased that he had strong and broad shoulders, a good-looking head on a fine neck.

Lloyd Lofthouse called and said, "I've just returned from a hiking trip and am thrilled that you called. May I invite you out for dinner? When would be a good time for you? Do you have time tonight?"

"I can't," I responded. "I need time to arrange a babysitter for Lauryann, my daughter."

"Why don't you bring her along?" Lloyd said.

"Are you sure you don't mind? She's seven years old."

"No, I don't mind at all."

"But..." I hesitated. I did not want Lauryann to be with me on my first date. I was at a disadvantage as a single mother and didn't want to emphasize that. I imagined Lauryann becoming bored and disrupting our conversation. I didn't want to be seen disciplining her.

"I'd rather arrange a babysitter," I said.

"Please, I really would like you to bring Lauryann," Lloyd insisted. "I'd like to meet her, and I can assure you that it will not be a bother. I've taught kids her age in the past. I know what they're like."

Later on, Lloyd confessed that he was not just being nice. It was his dating tactic. He wanted to get as much information as possible about the woman on the first date: "It's easier to move on when you are barely involved." Lloyd had learned that the best way to find out about a woman's true character was through her children.

"Children reflect their mother," Lloyd said. He once fell for a seemingly perfect woman who had "rotten children." "They had no manners, because the mother didn't demand any. She let them raise themselves. They jumped all over me like monkeys in the wild."

I wasn't prepared for Lauryann to be on her worst behavior that evening. I had taught her manners. But it turned out to be her worst night.

At 5:30 P.M., the doorbell rang. Lauryann was excited. She rushed to open the door and greet Lloyd. "Hi, I am Lauryann!" she said, offering a handshake.

The towering figure under the eaves pronounced my name in a hesitatant tone. "Anchee, I am Lloyd."

"Pleased to meet you!" I shook his hand and was a little disappointed. Lloyd was back to his photo look, with his hair pasted to his skull. He was dressed in the same blue suit he wore in the photos.

We got in his car. Although Lauryann sat in the back, she started to take over the conversation. She had a habit of doing this to me in front of strangers. She believed that I needed her help. Often, Lauryann corrected my English in front of others. For example, she would say, "Mom, it's Chinese *accent*, not accident! Don't say your bone is brutal, Mom, it's *brittle*! Mom, our neighbor is a yoga teacher, not a yogurt teacher! Grandpa Ness teaches children astronomy, not astrology!"

As she grew, Lauryann became more confident. "Excuse me," she would say to a reporter who came to our door looking for an interview, "my mom's English is not good. Why don't you ask me questions because I know what she wants to say"

My awkwardness in asking for help irritated Lauryann. Once, I was lost on a Southern California freeway. It wasn't until I saw a sign that read "Las Vegas" that I knew I had gone too far. From then on, whenever Lauryann sensed that I was driving in circles, she would roll down her window and ask a driver at a traffic light, "Excuse me, sir, my mom is lost. Can you help?" She would then turn to me. "Mom, come on, talk to the man!"

Lauryann told Lloyd about her favorite subjects at school and her favorite music. Lloyd told Lauryann the places he had lived, about his car and his favorite things to do, like reading and wood carving. I was amazed how quickly and comfortably they connected.

Lloyd took us to a Mexican restaurant he had selected because it had an evening performance by an Elvis Presley impersonator. Lloyd had noted my interest in learning about American culture through my dating profile. I noticed that Lauryann was filling herself up with chips. I whispered to her, "Save some space in your tummy." But Lauryann got too carried away in her eating. She took advantage of the fact that I was chatting with Lloyd.

When the waiter came to take our order, Lloyd wanted a vegan plate. Lauryann ordered a burrito, and I had fish with vegetables. By the

time the dishes arrived, Lauryann was stuffed with chips. She declared that she was too full to eat anything else.

"You ordered the burrito, you can't waste it!" I said.

Lauryann shook her head as she pushed the plate away. I gave her a "Don't you dare rain on my parade" look and her eyes filled with tears. We ate and watched the impersonator's performance. Although I wasn't impressed by the fake Elvis Presley, I clapped to show Lloyd my appreciation. Lloyd told me that he grew up with such songs. As he hummed along, I noticed that he sang off-key.

In the middle of one song, Lauryann began to complain about a stomachache. By the look on her face, I knew that she wasn't faking it. Lauryann begged to go home. When I asked her to wait, she threw a tantrum. It was impossible to calm her. "My daughter is never like this," I said to Lloyd, embarrassed.

"Well, she seems to be in great discomfort," Lloyd replied. "Let's go." Lauryann was asleep in the backseat by the time we arrived at my house. I apologized again for her misbehavior.

"If that was her worst behavior, she is an angel," Lloyd said as he parked on the street.

"I am supposed to say good night," I said.

"Let your daughter sleep a bit longer," Lloyd suggested, and then added, "I'd love to just sit and talk."

It felt strange sitting in front of my home in a car with this man. A sense of peace came over me. I was grateful that Lloyd didn't seem a bit upset about the interrupted dinner. We sat in the shadows of the streetlight looking at each other, and we both smiled.

"This is better than the restaurant." Lloyd said what I was thinking.

{ CHAPTER 31 }

HEN I WAS a Mao's Little Red Guard in China, he was a US Marine fighting in Vietnam. My dream had been to "liberate the proletarians of the world" so that poor children in America could eat; his mission was to prevent Vietnam from falling into the hands of the Communists and so bring peace to Asia and end starvation in the region.

Inside the car, under the shadowy streetlight, with Lauryann sleeping soundly in the backseat, Lloyd Lofthouse and I talked into the night. I was fascinated and chilled at the same time as he described how the marines were trained to kill instead of trained to fight. In turn, I shared the meaning of "the glorious Communist Martyrdom": To achieve a meaningful death in the fight for Communism was the ultimate honor. I described how my generation was afraid of Americans, who had turned Vietnam into a killing field. We believed China would be next, and we had prepared for the American invasion. Our leader, Chairman Mao, described our relationship with Vietnam as "teeth to lips." He famously asked, "Can the teeth survive without the lips?" Mao also taught us, "A person of humanity will refuse to preserve his life for the benefit of that humanity."

Lloyd remembered a day when the Vietcong launched rockets at his camp and killed his fellow marines. He said death was on his mind every day.

I had always wondered what it must have been like to be on the "other side." At the age of eleven, I was trained to throw grenades. We practiced throwing fake grenades made of wood and iron. I earned high scores because I threw farther than any girl in my school. During class, we were shown documentary films featuring our Vietcong comrades and their children fighting and dying as they engaged the enemy.

"You have a high nose," I said to Lloyd. "An enemy nose to a Chinese child."

"I have an ugly nose."

I told Lloyd that my biggest wish as a teenager was to be drafted to Vietnam. "My misfortune was that I was a female. I was so envious of my male classmates who got to go. They came to say good-bye wearing brand-new green army uniforms with two mini red flags on their collars. I waited for my turn to serve my country, but the call never came."

I told Lloyd how I fell in love with a propaganda movie titled *The Heroes*, in which a soldier named Wang Cheng demonstrated martyrdom. "Fire in my direction, now!" he shouted through his radio to his command center before pulling the fuse to the explosive. From a high rock he jumped into a group of US soldiers, blowing himself up and taking the enemy with him.

"In reality, your hero would never have had a chance to strike a pose like the actor in the movie," Lloyd said quietly. "Our defensive fire would have turned his body into a pockmarked measles patient before he had a chance to climb onto a rock."

Lloyd recalled hearing a noise one dark night in the rice pnddy outside the concertina wire. "We didn't want to take any chances, so we fired hundreds of rounds into the darkness. Then in the morning we discovered that the noise had been a water buffalo." He paused before continuing, "We never knew who would be out there coming to hit us. We were unable to tell an ordinary peasant from a Vietcong sniper. One minute you saw individuals bent over planting rice, and the next moment someone was shooting and taking down our men. There was no one in sight but the peasants working in the rice paddies, and none of them seemed to have weapons."

"Soldiers disguised as peasants was the only way to fight the Americans," I said. "Ho Chi Minh learned guerrilla tactics from Mao."

"Our hands were tied," Lloyd went on. "We worried about accidentally harming the civilians. It was always too late by the time we identified the enemy."

"There was no such thing as 'civilians' in Vietnam, or in China, if you would have dared to set foot on our soil," I echoed. "No child didn't want to be part of the force defending the homeland. Mao once said that if China didn't have supplies, it had an endless supply of bodies."

"There is no way America could have won," Lloyd said.

"Are you six feet tall?" I asked.

"Six foot four."

I remembered being yelled at by a drill instructor. "This is no dancing lesson, Comrade Min!" I was taught to thrust with a wooden bayonet at a dummy made of straw wearing a US soldier's helmet. "The enemy will be six feet tall and strong like a lion! If you don't take him down in a split second, he will kill you!" the drill instructor threatened.

I said to Lloyd, "I don't think I'd be able to take you down the way I was taught."

He smiled. "We could have met in battle. We could have killed each other." $\ensuremath{\text{\textbf{w}}}$

I told Lloyd that I loved the Broadway musical *Miss Saigon* and asked his opinion. "Was it really like that?" I asked. "The last days in Saigon?"

"The truth is uglier" I loyd mid. "All we could afford to care about Was our own escape and survival. We had to push people off the helicopters, abandoning our friends, the locals who had risked their lives to help us. We left them behind, threw them away to be tortured and killed. It was war. We had no options. I understand. But being called a baby killer back home really hurt. I could never forget the burned smell of my own flesh in Vietnam after a bullet nicked my ear."

I looked at Lloyd. He paused and stared at the darkness outside the car.

"I was an innocent and naïve eighteen-year-old when I joined the marines," he said quietly. "Four years later, I returned a different man. I drank heavily and had an explosive temper. I slept with guns and knives. The war taught me to trust no one. Although I wasn't violent, I carried a knife with me to work. I didn't feel safe otherwise. I had to be ready to defend myself at all times."

Watching Lloyd's eyes glitter in the dark, I pictured myself throwing a grenade at his bunker.

"Lucky that you didn't get killed in Vietnam," I said.

"I prayed to God to let me come home in one piece," Lloyd said. "I promised the Lord that I'd do good with my life. I have kept that promise, earned a university degree and went into teaching."

We sat and let the silence absorb us. Lloyd reached over and held my hand. I let him.

I wanted to know the reason Lloyd divorced twice. I let him know that I was aware of the term "habitual walker."

"Well, I was a horny marine returned from Vietnam," Lloyd said. "My libido was in charge. When I was a virgin and faced war, I often thought, This could be my last day! I could die tomorrow. How sad it would be if I never knew what it was like to make love to a woman. I guess I read too many books compared to my fellow marines. I was romantic, but there were only prostitutes in Vietnam. My parents taught me nothing about females and sex. My father was a union man and worked in construction. He was an alcoholic and did not believe in God. My mother, on the other hand, was a devout Christian who switched religions three times. They were typical American parents, I guess they did their best to provide, but they paid no attention to my education. They fed and clothed me until I turned eighteen, and then they threw me to the wolves."

"Threw you to the wolves?"

"They told me to either pay rent or move out."

"That's hard to believe for a Chinese."

Lloyd nodded. "Well, that was exactly my case. Because I had no source of income and had not developed any skills for a better-paying job, I figured my best choice was to join the military."

"But why the marines? Why pick the toughest?"

"I had always wanted to prove myself. As a teen, I was sickly and a bookworm, you know. No girls would look at me."

Lloyd confessed that he lost his virginity to a prostitute in Okinawa. "It was in a bar. I was drunk, and she was cute. I followed her to her place. I was attracted to her until she removed her wig. I couldn't believe that her beautiful long hair was fake! But of course the whole situation was fake. I guess I was stupid for wanting to get to know her. She hurried

me and I felt awful. She wanted to get the business over with and move on to the next customer. She kept asking, 'You done yet?'... It was terrible. Absolutely not worth it. What about you?"

"I was sent to the labor camp when I was seventeen," I said. "In China, we didn't belong to ourselves. We belonged to Chairman Mao and his Communist Party. Dating was not allowed until one reached 'marriage age,' around twenty-nine. Couples caught making love in the wheat fields were convicted as criminals. My best friend and I comforted each other by playing each other's imaginary boyfriend. We kept our affair a secret. We dreamed of love while working like slaves. By the time I met Qigu, I was in my thirties and China had embraced capitalism and free love. I felt cheated—my youth was stolen."

Lloyd told me that he got married at the age of twenty-three after he returned from Vietnam. "Looking back, I don't fully understand how we became a couple. I was just back and still reeling from my experience. We staved together for yours, and it got so bad that I was seriously planning to shoot myself, because I was raised as a Catholic and divorce was not an option. I desperately wanted to escape. I was actually sitting on the couch with a loaded rifle. Then, suddenly, I thought, if I survived Vietnam, why would I now go and kill myself for an unworthy woman? I have legs. Why can't I just walk out? So I did."

Lloyd's tone was flat but not unemotional. "My son sided with his mother and doesn't want anything to do with me today."

Lloyd never imagined that he would divorce a second time. "My second wife was an animal lover. When we met, she had two cats. By the time I left, she had thirty cats, two dogs, three horses, one donkey, and several tortoises. Our debt grew and grew.

"I believe in living below my means. I couldn't afford my wite's passion. Teaching did not make me a rich man."

I asked Lloyd where he got the courage to pursue another relationship.

"I am an American male," he said with a laugh. "We are taught that it is our right to pursue happiness. Nobody victimizes me unless I allow myself to be victimized."

THE COOKED SEED

Half of Lloyd's face was hidden in the dark. His profile reminded me of the sculpture of Alexander the Great, with the same curly hair, deep-set eyes, well-defined nose, and firm lips. I thought about his grin in the photo and giggled.

Lloyd turned back to me. "A penny for your thoughts."

"The photos didn't do you justice."

"I am glad you didn't judge me by the photo."

"I did, in fact. It was the video that saved you. You didn't gel your hair in the video. Why did you do that for the photos?"

"First of all, I never gelled my hair. I just asked my barber to do something to control my curls. I don't like them sticking out in all directions. It makes me look like a madman."

"But you didn't prepare your hair the day you had the videotaping."

"Well, I planned to get a haircut in the afternoon. I rushed home after school, and there was an accident on the freeway. I missed my hair appointment, though I made it to the taping. The cameraman had been waiting. His next customer had already arrived. I had no choice but to go in front of the camera."

"Did you watch the video afterward?"

"No. I was offered a chance, but I was sure my hair made me look like a monster. Like I said, there was nothing I could do about it." $\,$

The air was chilly when I followed Lloyd as he carried the sleeping Lauryann from the car to the house. I felt my heart singing a happy tune. Watching Lauryann's legs dangling from Lloyd's arms, I tried to stop my imagination from leaping ahead and picturing the three of us as a family.

In time, Lloyd introduced me to his friends and colleagues—some were former marines and Vietnam veterans. I was glad to see that Lloyd was respected and adored. I detected no ill temper or signs of post-traumatic stress disorder. Later, Lloyd confessed that he worked hard to control his temper. He had studied psychology and took self-help classes.

I was overwhelmed as I received love letters from Lloyd. They

came daily. The pity was that I was unable to read his handwriting and was too embarrassed to tell him.

I turned to Lauryann for help, and she was happy to oblige. She interpreted the letters for me, but after a while concluded that Lloyd's letters were "boring" and skipped lines.

Lauryann loved the Broadway musical *Les Misérables*, adapted from the French novel by Victor Hugo. She imagined herself as the little girl Cosette, who was abandoned by her birth father and later became an orphan after her mother died of an illness. Lauryann called Lloyd "Jean Valjean," after the protagonist, an ex-convict, a good man forced into a bad situation. Lauryann assigned me the role of Fantine, Cosette's mother, who had been left by her first lover. The part of the musical Lauryann loved the most was when Fantine lay dying and entrusted Cosette to Jean Valjean's care. Lauryann felt that she had a special relationship with Lloyd, just as Cosette did with Jean Valjean. She started to call him Lloydee.

Lauryann and I made fun of Lloyd's tears at movie theaters. We called him a "tissue box" after discovering that Lloyd would weep at any story about loyalty and love. It could be a children's story—*Snow White*, for example. Lloyd wept as he watched the hunter, whom the evil queen employed to murder Snow White, let Snow White go at the last minute. "Such loyalty!" Lloyd cried as he blew his nose.

On one date, while sitting in the backseat of his car, Lauryann said, "Lloydee, I have read all of your love letters to Mommy. I know everything!"

It was too late for me to cover her mouth with my hand.

"Do you love my mommy, Lloydee?" Lauryann asked, leaning torward.

Lloyd's face turned red.

"Do you?" Lauryann pressed.

Lloyd hesitated for a second and then replied, "I do."

"Mom, what about you?" My daughter turned to me. "Do you love Lloydee?"

THE COOKED SEED

"Lauryann, I expect you to master the math tables tonight."

"Come on, Mom. Do you love Lloydee? I want to know. Yes or no?"

"Well..."

"I am waiting, Mom."

"I guess 'yes.'"

"Then Lloydee, it's time to propose! Don't forget, I want a ring too."

A Chinese saying goes, "Once bitten by a snake, for the next ten years one will be afraid of ropes." The pain of my divorce and fear of making another mistake held me back. I didn't feel that I could trust Lloyd until one day, a Friday, when Lloyd came to me from his school. He was glowing with excitement and kept saying, "He made my day! He really made my day!"

"He? Who?" I asked. "Who made your day?"

"A student in one of my classes."

"What happened?"

"He moved."

"Moved where?"

"He moved from an F to a C. The kid woke up!"

"Are you talking about his grades?"

"Yes!"

"From an F to a C?"

"Yes, from an F to a C!"

"Not an A? What's the big deal?"

"Oh, I wish you could understand! It's a huge deal to me! You have no idea how long I've been working on this kid. He has been a leader in a street gang and a troublemaker in my class since day one. He was every teacher's nightmare. Everybody had quit on him, including his family. He was so disruptive that I almost gave up on him too. He was the devil himself. I dared not turn my back to even write on the board when he was in the room. I kept my eyes on him and kept telling my stories. I told him that I could have led the same life as my

brother, who ran away from school and messed with the law. Instead of being a teacher, I could have been a prisoner. I made my choice, and my brother made his. This boy is not stupid, you know. He was intelligent enough to want to know his options. I ended up disarming him." Lloyd started laughing. "He didn't know who he was dealing with."

"How did you reach him?" I asked.

"It wasn't easy. I practically begged him to do the schoolwork. He didn't think it was possible for him. But I convinced him that it was. I convinced him that he could earn the grade step by step and point by point. It wasn't a gift, but there would be a reward in the end." A wicked grin creased Lloyd's face.

"So he earned a C?"

"Yeah, and it's the best grade he has ever achieved in his sixteen years of life! Excuse me, I feel like singing. It's worthy of a celebration. Would you and Lauryann like to go to dinner tonight? We'll go to your favorite Chinese restaurant. You can order your ten-ingredient fried noodles. I'll have the sesame tofu, and Lauryann can have the basil eggplant. We'll follow the dinner with dessert, of course...Oh, I am so pleased. One kid out of hundreds and thousands. One kid!"

It was then that I decided to marry Lloyd Lofthouse. I had no more questions or doubts regarding the character of this man. He had just proved to me that he was capable of great kindness and love. I admired him and felt fortunate to know him.

Over the years, Lauryann and I would grow tired of Lloyd's favorite stories about how those unlikely kids finally "woke up" to what made sense. "This Latino kid," Lloyd would begin, "wanted to earn an A for a book report in my freshman English class, but he hated reading. We fought tooth and nail. Two years later, we ran into each other in the school hallway. He was a junior, a big boy. He stopped me, and with both hands hidden behind his back, he yelled loud enough for everyone to hear, 'Mr. Lofthouse, I hate you!'

"I didn't know what he was up to. I slipped into a better position to defend myself. I thought I'd better get ready just in case. Then he pulled out a book and flashed it in his hand. It was a big, thick book, a science fiction novel. With this big smile on his face, he called

THE COOKED SEED

out, 'Mr. Lofthouse, I hate you because you've got me addicted to reading!' "

Lloyd laughed at this punch line every time.

As Lloyd and I began to spend more time together, I learned his routine. Most of his after-work time was spent correcting student papers. He would start right after he returned from school at around 4:30 p.m. He would take a break for dinner, then resume his work until his head drew closer and closer to the papers and he finally dozed off. Ten minutes later, he would wake with a sore neck and continue to work. He would work into the night. Five hours was all he could afford to sleep. His alarm clock went off at 4:30 a.m. He would rise, shower, breakfast, and dress to leave for work again.

Lloyd resisted the temptation to download or copy his favorite movies from the Internet. He would not click the "go" button. He would rather pay for those programs. This made me think of the night when my fellow students and I called China with a "free phone number." The number was stolen and given to us by a worker on strike from a telephone company. We gathered at a roadside pay-phone booth and took turns calling home. Lloyd would refuse to take advantage of such an opportunity, I found myself thinking.

"The Night at the Well of Purity" was the best short story Lloyd wrote, in my opinion. It was based on his own experience in Vietnam. I had never read anything like it. It was so dark and complex, yet so human. The story was about a soldier who was obsessed with the idea of killing his sergeant. The main character in the story wanted to stop his sergeant from buying sex from a nine-year-old Vietnamese girl who had been abandoned by her American-soldier father and Vietnamese mother.

"Witnessing a grown man doing it to a nine-year-old drove me crazy," Lloyd said. "Because she was too small to be fucked, she offered blow jobs only. She charged fifty cents per blow. But the sergeant wanted more. He wanted to fuck her. She was terrified. I saw him grab her, rip

her clothes off. He took her to the brush outside the bunker and raped her. She screamed and screamed . . ."

Lloyd drew deep breaths as if his lungs were failing him. "My finger wanted to pull the trigger . . . I was ready to shoot the man. I had to fight myself. It was useless to try to convince myself that the little girl was worthless and that we were at war with Vietnam . . ."

We sat face-to-face on his sofa. The moonlight was bright in the room. "Afterward... after he was done with her, he kicked her out. He didn't pay her. She climbed a hill near our bunker and we heard her crying and screaming for hours that night. The sergeant tried to shut her up. He took his weapon and shot at her but missed. It was too dark to see exactly where she was."

"What happened to her?" I asked.

"She disappeared, but then in the morning we saw her again. She was running toward our bunker with an entire village chasing her. The villagers were beating her with sticks and farming tools—chouting and cussing at her. It looked like they were going to kill her. We learned later that the little girl didn't have any money to buy food, so she stole from the villagers and got caught . . . The strangest thing was that she came to her rapist for protection. The sergeant took her in. He fired warning shots at the villagers and stopped them from killing her that day."

"What happened in the end?"

"There is no ending to this story." Lloyd sighed. "Real life leaves you with no satisfaction. My agent told me it was a good story, but he couldn't find a market for it. Readers pay for a good time. My characters are 'too dark and weak,' as they say."

Lloyd clammed up the moment I brought up the subject of his son, Did it still hurt not to be able to be there for his son? I wondered. Did he miss him? How did those weekend visits go years ago? When and how did the relationship begin to go bad? I was not interested in investigating what actually happened, but I was interested in Lloyd's feelings toward those events. I wanted to assure myself that Lloyd would be a sensible stepfather for Lauryann.

THE COOKED SEED

One day, by chance, I found a poem written by Lloyd titled "My Son." It was from a collection of poems he had typed.

MY SON

He peed on me
The infant, my joy, the love of my life
Diaper off
Poop in flight
A real gusher
Splat on the wall.

At two
"Stop!"
The cyclone kid
Tripped
Hit the table
Split a lip.

When the pool
Emptied
In need of repair
He dived into green slime
Looking like a
Creature from
A dinosaur time
"Daddy! Daddy!"

Divorced at three Weekend visitations Monthly payments made.

Tough Love
Was my route
I was the beast

The tyrant
With the paddle.

After he turned eighteen Going his own way I sent birthday cards With gifts Year after year But heard nothing in return My brush ran dry

Almost two decades later
With little or no contact
It has become a waiting game
A void for an aging man
To discover if he still has a son.

Lloyd had been trying to hide his broken arm inside his sleeve. Year after year, I would witness him making vain efforts trying to contact his son. He sent him birthday cards, Christmas greetings, and gift cards, but received nothing back. "He knows where I live," he said. "He knows my phone number and my address." Eventually, Lloyd stopped sending the cards.

There was no comfort I could provide to Lloyd but to share his sorrow. There was nothing sadder and crueler than being rejected by your own child.

On Lloyd's shelves I discovered dozens of self-help books on relationships and psychology. Lloyd believed that he had serious shortcomings when it came to communication skills. He wanted to learn from his failed marriages and his poor relationship with his son. He was committed to educating himself. "I'm not good at compromising when it comes to dealing with people," he concluded. "I have no redeeming qualities in my ex-wives' eyes. When it came to wooing women at the dating service, my lack of humor was also a problem. I don't understand why women today place 'sense of

humor' as a top quality when seeking a husband. *Oh, I love him because he makes me laugh!* They even vote for a presidential candidate based on whether or not the candidate can make them laugh. Women don't like stiff and boring men, men like me. I'm not funny. That's for sure."

I didn't think the self-portrait Lloyd painted was realistic. I didn't think he was stiff and boring. He was good company, attentive and fun. But more than that I appreciated his sincerity and seriousness. This was something I recognized in myself too. I could be funny—sure, sometimes accidentally, or by garbling the language, but this was a part of myself that most people didn't see because they only saw the Anchee Min who was serious, passionate, and focused. "Take time to smell the flowers," Qigu ceaselessly hurled at me.

It was strange to share a life with a man who outwardly couldn't be more different but who somehow seemed to breathe the same air. In fact, our similarities were greater than our differences. We had both chosen badly in the past, and our own inner insecurities and stubborn personalities had only made matters worse. For the first time in my life I didn't feel like I needed to translate or explain myself across a wide gulf. I felt more relaxed, and we often laughed together. I discovered that, by nature, Lloyd was a very funny man.

I hoped that Lloyd was as interested in me as I was in him. I wasn't sure if he wanted to marry me. Yet I was not interested in being a mistress, a lady on call, and I would not live with him as his "long-term partner." I had that with Qigu. I now had too much self-respect to put myself in a situation that didn't suit me.

Because I had no way of discovering Lloyd's intentions regarding marriage, I concocted a plan: I would pretend to be the Chinese princess Turandot in Puccini's opera and play him a riddle. I wouldn't tell him that it was a riddle. It would be a test that I hoped he would pass, or it would be the end of our relationship.

Lloyd and I met to discuss the direction of our relationship. I told Lloyd the opposite of what was on my mind. I proposed a long-term partnership without marriage. I asked if he would accept my proposal. After I dropped my words, I stared at him.

Lloyd's expression turned grave. I could tell that he was composing an answer in his head. I was afraid of what he might say. I would be doomed if he accepted my proposal.

Lloyd took a deep breath. He took his eyes away from me and turned to stare at the floor. After a long moment, he said with a steady voice, "Anchee, I am just going to be honest with you. My answer to your proposal is no. I will not accept carrying on our relationship without marriage. If I commit myself to this relationship one hundred percent, I'd expect the same from you. It is only fair. I'll be willing to work out any problems you have with me. I'll be willing to accommodate and compromise if necessary. I can change if you think I come on too strong. My bottom line is that we either get married or say good-bye. I love you, but I must be true to myself."

Joy filled me as my heart was flooded with the music of Puccini's "Nessun Dorma," the greatest love song. I broke down and wept because I remembered Olgu's proposali "Let's get married because I don't want the baby to follow your bad example." I remembered the judge asking Qigu, "Have you a ring for your bride?" I remembered the cold Chicago morning when I begged Qigu to pose for the camera so that I could have a wedding photo to send to my family in China. I remembered how unworthy I felt about myself. This was everything I had longed for and more.

Lloyd was puzzled by my response. He misinterpreted my reaction and said the strangest thing I had ever heard: "Don't worry, sex is not important."

What did he mean by "sex is not important"?

I became suspicious. Was something wrong with his...sun instrument? I wanted his passion. One of the biggest reasons I didn't regret leaving Qigu was that he was never passionate. He never desired me, and I was starving for affection. I hated to play the beggar in a relationship that left me with no dignity and integrity.

Of course sex is important, I thought. It is extremely important. Why was it not important to Lloyd? My imagination began to run wild: Is he a eunuch? Does he suffer a dysfunction? War damage? Prostate trouble? Premature ejaculation? Psychological impotency? Bad experience in Vietnam with prostitutes? Mental scars left by abusive ex-wives?

I decided to abandon my original plan, which was to delay having

THE COOKED SEED

sex until we were engaged. I wouldn't feel secure until I found out if Lloyd was fully functional. I wouldn't marry a eunuch. The more Lloyd elaborated on the theme that "sex is not important," the more suspicious I grew. Before we moved forward in our relationship, I was determined to get to the bottom of this. I told Lloyd that I was ready.

"Ready for what?" he asked.

"To have sex."

He was surprised. "But \dots you said yesterday that you'd prefer to wait."

"I have changed my mind."

"Are you sure? I don't mean to push you . . ."

"No, you didn't. It's my decision. I'd like to do it."

"You mean, you are ready-ready?"

"Yes, I am ready-ready."

"Wow!"

"Will tonight be convenient?" I asked, trying not to look embarrassed.

"Of course. Definitely. No problem. Wow, I mean, convenient. Uf course. Wow, wow, of course tonight will be convenient. Absolutely convenient!"

"I'll be at your place at ten tonight," I said.

The moonlight outlined the shapes of the distant hills. Outside the window under the sky below Lloyd's townhouse was a busy four-lane highway. The traffic lights formed a winding red-and-yellow dragon. I thought of dragons because the pleasure I felt was heavenly. Lloyd was more concerned with bringing joy to me than satisfying himself. I burst into laughter when I thought about my worry that he might be a eunuch. "Why did you say, 'Sex is not important'?"

Lloyd laughed. He said it was due to his limited knowledge of women. After marriage, his first wife accused him, "All you want from me is sex!" It shamed him.

I loved the way Lloyd wrapped his arms around me. I told him that I had dreamt of this moment all my life. "Do you know what 'forehead touches the ceiling' means in Chinese?" I asked, then answered, "It means that a miracle has taken place. I'd like to thank the Yellow Pages

ANCHEE MIN

in the phone book, Robin, her dating service, the stars above, the sun and the moon, the hills, the highway and the winding traffic dragons, and most of all America and what God has bestowed upon me."

Lloyd said that he was humbled by his good luck.

I kissed Lloyd and asked him to repeat one more time that "sex is not important."

HE THREE OF US made a special date. We decorated a chair and placed it in the center of the yard surrounded by blooming roses. Lauryann and I took turns sitting on the chair while Lloyd got on his knees and proposed with his engagement rings. I never expected that such pure happiness would ever be mine. My life had been lived defensively, consumed by figuring out how to suffer less by dodging pain. What was taking place in my backyard was a scene out of a romantic novel.

Lauryann couldn't wait for me to get off the chair. The moment I accepted Lloyd's engagement ring, Lauryann took my place. She was thrilled to receive her "friendship ring," although she lost it almost immediately—by accident. She took it off to wash her hands and the ring rolled into the sink drain. She was too devastated to report what had happened.

I was overwhelmed by my good luck. But at the same time, I suffered self-doubt. A few months of dating a man was not sufficient enough time to really know him. Was he who he painted himself to be? What about his two divorces? After all, it was a one-sided story that I had no way of verifying. In the back of my mind, I was cautious.

Lloyd was the adviser of the high school's student newspaper. He took his journalism students to national writing competitions and they won awards. He loved his job, but at the same time he resented it. On a bad day he would say, "I'd prefer being sent to Iraq to get shot at than try to keep teaching the walking dead. I'm sick of being mistreated by the morons in district administration."

I asked Lloyd if he had the support of the parents, and he replied, "I make phone calls and I leave messages. Dozens of messages. But most of the parents never return my calls. One parent who did return the call said, 'My son didn't do well in your class because you were boring!' I wanted to say, My job is not to entertain your kid. My job is to prepare him to survive in life. Her son didn't want to do homework or read the

assignment because it wasn't fun! Go and ask a plumber, a garbageman, a janitor, or a repairman if his job is fun!"

Lloyd had to visit a chiropractor because his neck was in constant pain from bending over correcting students' papers. Most of the time he simply had to carry on and live with the pain. Often in the middle of correcting his papers, I would hear Lloyd cuss, "Fucking idiots! No name again, and that's the first thing I tell them to do for every assignment—write your name, date, and period." Occasionally Lloyd would be so upset that he would jump up from where he had been sitting. He would grab anything he could reach and smash it. I saw him destroy a pencil jar and a wok lid. He would rip pages from his planning book, break his pen, or shatter a plastic ruler. He had to vent his anger. He became distraught when his open-book midterm exam's failing rate reached 50 percent.

I sat in the last row of Lloyd's classroom, against the back wall. My first thought was that these students were not children. They were adult-size boys and girls. Some were taller and weighed more than Lloyd did. I noticed that many students came into the classroom carrying neither a schoolbag nor books.

After taking attendance, Lloyd picked up a trash can. He went around the room asking the students, "Spit it out... Spit it out."

What kind of teaching style was this? I was startled. Spit out what? Then I saw students spit chewing gum into the trash can. One boy refused to cooperate. "I'm not chewing gum."

"Spit it out, please." Lloyd did not move. "I saw you chewing. Come on."

The boy stuck out his tongue. "I ain't got nothing in my mouth."

Lloyd gave him a don't-you-mess-with-me look. "I'll write a referral and send you to the office."

The boy spit the gum into the trash can.

Lloyd ran the class like a Broadway show without intermission. I sat through five of his classes that day. I witnessed Lloyd play at least four characters. He was a Mary Poppins, a comedian, a marine corps drill sergeant, and a teacher all at the same time. He was teaching a les-

son on Shakespeare's *Romeo and Juliet*. He asked the students to pay attention to the part he called "the switch."

"Shakespeare lets us know that Romeo was madly in love with a girl, but her name was not Juliet. Her name was Rosaline. In fact, Romeo crashes a costume party to see Rosaline but then he discovers Juliet. If you were paying attention, you would have seen his love switch from one girl to another in an instant. Shakespeare makes us see how a young man falls in love with his eyes. He shows us how fickle human love is. Did Romeo know Juliet's name? No. Did he know where she was from? No. Did he instantly decide that he was madly in love with Juliet? Yes. What happened to his love for Rosaline? Did he just forget her? What does this switch say about Romeo? Why did Shakespeare plant this detail? Why did he bother to show that Romeo was in love with Rosaline before Juliet? Shakespeare could have easily arranged for Romen to meet Juliet without even mentioning Rosaline, who we never most in the play anyway. The encounter and the love would have been perfect without Rosaline. Why add this disturbing detail? Why httpduce another girl that Romeo was passionate about? Why stain the romance? Why did the author put his leading characters on a suicide mission three days after their first meeting? What did Shakespeare really want us to understand?"

Lloyd drew a timeline on the board and then continued, "Both Romeo and Juliet were from incredibly wealthy families. When Juliet finds out who Romeo is from her nurse, after having just met him and not even knowing who he is or what his name is, Juliet says, 'My only love sprung from my only hate! Too early seen unknown, and known too late! Prodigious birth of love it is to me, that I must love a loathed enemy.' Notice that it was within an hour or so of meeting each other that Juliet says this. She, on the other hand, eventually threatens to kill herself if she cannot have him, and Romeo expresses a similar threat, as you will discover."

Although most of his students showed no interest, I was fascinated by the way Lloyd encouraged independent thinking. I felt bad for Lloyd when he was ignored. The students yawned, slept, idled, flirted, played video games under the tables, and a few stared into space with glassy eyes. One boy refused to participate when Lloyd called on him. "I don't need to study this shit," he said. "I'm gonna be a basketball player like Michael Jordan, and I'm gonna make a ton of money!"

Without missing a beat, Lloyd responded, "I have been teaching for twenty-five years, and I have worked with several thousand students. Every year I hear the same thing you just said. I haven't seen any of my students make it to Michael Jordan's level. You need to study 'this shit' for a backup plan, in case life doesn't work out your way."

A girl came to the boy's defense. "I hate Shakespeare. This is boring. I don't need this. I'm gonna be a model. I'll get to do what I want."

"That's what I thought when I first majored in architecture," Lloyd said. "But my professor at Cal Poly Pomona said, 'The guy who has the money will have the final word, not the architect.'"

"Doesn't the architect build?" The girl became interested.

"Most architects don't get to build their dream buildings. The man does what he's told to do not what he wants to do."

"Is that why you aren't an architect?" the boy asked.

"I changed my major to urban planning," Lloyd said. "But my professor told the class the same thing—the guy with the money rules."

"So you quit?" the girl asked.

"I went to my backup plan," Lloyd said.

"And that is?"

"I earned a teaching credential, which led to this job. I have taught Romeo and Juliet more than fifty times. I have taught some of your mothers, fathers, uncles, and aunts. My point is that you cannot count on your dreams. A big part of life is about being able to pay the bills and put food on the table."

It was my wedding day. I drove with Lauryann to Lloyd's place at dawn. Lloyd was standing in front of his bathroom mirror, putting on his tie. I was the photographer. Lloyd said that he hadn't slept well the night before. He'd had nightmares about his two failed marriages. I told him that I shared a similar fear. Neither of us wanted this to be another mistake.

For good luck, I wore a deep-red Chinese jacket. I dressed Laury-

ann in the same color. She would be our witness and sign our marriage certificate. She was excited about the ceremony.

Lloyd couldn't get his tie straight. He tied it either too long, too short, too loose, or too tight. He stood in front of the mirror pulling at the tie and choking himself.

I tried not to laugh. It was 5:30 in the morning. We had decided to leave early to beat the traffic. We wanted to make sure that we were not late to our own wedding ceremony. We were going to the county offices to register and be married. Lloyd had a ring for me.

Finally, Lloyd was ready. He was wearing a deep-ocean-blue suit with a red tie. I looked at him and thought, What a lucky woman I am!

Lauryann asked, "Lloydee, why don't you look happy? You are the groom. Today is your wedding day. You should smile."

"Nothing is real until it happens," Lloyd said. "Things can go wrong."

At the last minute, I changed my mind about my hairstyle. I didn't want it to look like the Egyptian Sphinx. I had used up a whole bottle of mousse to tame my hair. I heard Lloyd tell Lauryann, "Your mother has a photogenic face. She looks good no matter what hairstyle she wears. She is the sexiest lady alive!"

When we got into Lloyd's car, I turned on the radio. The voice of Pavarotti sent my blood stirring. He was singing "Nessun Dorma" from *Turandot*. There couldn't be a better omen, I thought.

The picture showed the three of us as a new family. Lloyd and I were now officially "man and his wife." I liked the term "man and his wife" better than "man and woman" or "husband and wife." I liked the feeling of being protected as "his wife." Lloyd looked relaxed and comfortable. I loved his silver-gray curly hair. I had tears in my eyes when Lloyd said, "I do." We both wept. It was hard not to. This was too good to be true. Lloyd whispered in my ear that he would die a happy man if he would have "a good twenty to twenty-five years" with me.

Lauryann looked like a china doll in the photo. She stood between us, beaming. The top of her head just reached Lloyd's elbow. She had just finished placing her signature on our marriage certificate. For weeks she had practiced her cursive. Lauryann insisted that she had missed the kiss. She demanded that we "do it again" in front of her. "I signed as a *witness*, and I must witness the act."

Lloyd turned to me. His expression read, "I don't think it's proper."

"Lauryann has been getting her way since she was two," I said. "Once she was mad at my interviewers and she threw my phone in the toilet. She's a spoiled American brat."

"I am an expert in dealing with spoiled American brats," Lloyd said. "You want to be a witness? Here you have it!" Striking a Rhett Butler pose, he pulled me toward him and pressed his mouth to mine and wouldn't let go.

We heard Lauryann screaming, "Eeeew!"

"You're grossed out!" Lloyd laughed. "You asked for it! You insisted! Yes, you did! Don't you say it's disgusting. That's how I kiss!"

To punish Lloyd, Lauryann offered to teach him some "useful" Chinese phrases such as "good morning," "apple," and "please" Lauryann picked these words knowing that he was tone-deaf. Lloyd ended up saying "Zao!" (good morning) in the fourth tone instead of the third, which turned the meaning into "Screw you!" His "Ping-guo" (apple) turned into "ass," and his "Qing, Qing!" (please) became "Let's kiss!" Imagine Lloyd doing this to a Chinese officer at the embassy:

Officer: Would you like a Chinese visa? Lloyd: Let's kiss.

The third photo was taken in China a few days later. There were four people in the frame: my father, my mother, Lloyd, and me. We had flown to China to see my parents, family, and relatives. We held a reception dinner at the old Jinjiang Hotel, where Nixon stayed in 1972. The place held a special meaning to me. As a teen I had stood a few hundred yards from the hotel with thousands of others and welcomed the American president. If anyone had told me that I would one day be married to an American, I would have never believed it.

My mother was so weak that she could barely walk, but she looked happy in the photo. She stood by her American son-in-law looking proud.

Her left hand held on to Lloyd's arm. She had been distressed over my divorcing Qigu. She knew the fate of a divorced woman in China. She was afraid that I had ruined my life as well as Lauryann's. Joy overwhelmed her when she saw me come home with Lloyd.

My father was glad that I divorced Qigu. It had always troubled him that Qigu did not have a real job. I had to tell my father that Qigu worked as an artist. I warned Qigu about my father's discontent and asked him to behave himself in front of my father. But Qigu could not stop being himself.

To smooth things over, Qigu offered my father a haircut during his first visit to America. The old man was to visit Chicago's Adler Planetarium. My father regarded the opportunity as a great honor, the highlight in his career as an expert in the field of China's astronomical education.

My father told Qigu exactly what he wanted done. "Just trim lightly." He wanted to keep the foot-long strand of hair that covered his balding top.

Humming a happy tune, Qigu picked up the scissors. While his scissors danced, the old man waited excitedly.

It was too late when I tried to stop Qigu from playing with the footlong strand. Qigu lifted its end up and murmured to himself, "To be or not to be? To cut or not to cut?"

Before I could say anything, Qigu's scissors snipped.

I sucked in my breath as the foot-long strand fell to the floor.

When Qigu finished and I gave my father a mirror, his face froze. He tried hard to hold on to his composure. His eyes shut as if to wipe out what was happening.

After my father came out of the shower, he was beyond rage. "You have ruined my look!" he yelled hysterically at Qigu. "You failed to deliver what you promised! I look silly, ugly, and bald! How can I go out and face people? You know tomorrow is my big day! I want my old hair back!"

It was no use comforting the old man. "You did this on purpose!" he yelled at Qigu.

"What's the big deal?" Qigu shrugged. "It's a great cut. Many people shave their heads. It's cool to look bald. If you don't like it, that's fine too. Hair grows back. There is no point acting like it is the end of the world."

"It is the end of the world for my father," I said to Qigu later. "He only gets one chance to meet with his fellow American planetarium people. You really shouldn't have done this to him. He told you what he wanted. I warned you. You deliberately did this. Why?"

"Life is about being spontaneous," Qigu said. "I was inspired by the moment. I felt creative. It was an experiment. That stupid strand looked silly on him. The more he tried to hide his baldness, the more it stood out. That strand of hair fooled nobody but himself."

"I agree with you. However, it is important that my father feels good about his appearance. You should have let it be. It was his hair."

"Too bad," Qigu said. "There is nothing I can do if your old man has fixed his mind on making me his enemy."

My father loved Lloyd the moment he learned that he had served in the US Marine Corpo. "My favorite movie is Midway," was the first thing my father said to Lloyd.

Lloyd responded, "That was the turning point in World War II—"

My father interrupted him. "The US beat the Japs!" He stuck up a thumb. "US Marines good . . . Japanese killed Chinese, my family . . . in 1937 . . . I was a child. Japanese soldier beheaded my cousin. They tied him on a post. I saw with my own eyes. They chopped his head, like this, off . . . That's why I watch *Midway*."

My family welcomed Lloyd, although there were inconveniences. For example, nobody could pronounce Lloyd's name. I was asked to translate his name and make it pronounceable in Chinese. "Lloyd, Llo-y-d, like *Lao-yet*, which sounds in Chinese like *Lao-ye*, which means 'Old Master.'"

"There is no way we are going to call him Old Master," my uncles protested. "We must respect our status."

"How are you going to address him, then?" I asked.

"Anything but Old Master," my father said.

My family wanted to verify Lloyd's mental state. My grandaunt worried that he might "apply force" and murder me and Lauryann by accident.

"He must have taken lives in Vietnam," my granduncle said. "He

THE COOKED SEED

couldn't have avoided it, could he? He might have killed Chinese as well."

"He might flip. Heaven forbid!" my uncle said. "He doesn't understand Chinese, does he?"

"No, not at all," I replied.

"Be very careful, Anchee. This man has blood on his hands! He is a trained killer. We want to see no tragedy. Think twice, Anchee."

"It's too late," I said. "I already married him. You know why I am not afraid? Because I was trained to kill American soldiers too. We all were. According to your logic, he should be afraid of me too. "

"Nonsense! Our guerrilla-style training does not count. Compared to American marines, we were apes living in caves. Anyway, we want you to pay attention to his unusual habits."

"Like what?"

"Like eating meat cooked rare. It's a sign of blood thirst."

"Don't worry, he is a vegan."

"What's a vegan?"

"He eats no meat."

My granduncle screwed up his eyes, then nodded. "This makes sense to me."

"Makes what sense?"

"He stopped eating meat because he is seeking redemption. Too much blood on his hands."

Lloyd said on our wedding night, "I hope I don't have flashbacks."

I looked at him and replied, "I hope I don't have flashbacks."

The second night, I woke to the sound of Lloyd's heavy breathing. He was kicking his feet with his eyes shut tight. His head jerked from side to side as if he were dodging blows. Because of the bright moonlight, I didn't bother turning on the light.

"Lloyd! Lloyd, are you having a bad dream?"

The expression on his face terrified me. Lloyd opened his eyes and stared at me as if he didn't know who I was. I could see him struggling to recognize me, but he could not. His eyes showed fear and horror.

"I am Anchee, your wife!"

The thought that Lloyd might be experiencing a flashback scared me. After all, I looked like a Vietcong.

"I am Anchee. I am your wife," I repeated. "We are at home. Wake up, Lloyd!"

Instead of coming out of his trance, he rolled over to his side of the bed and reached under the mattress for the knife he had concealed there.

I had less than a second to react. I reached for the light. The sudden brightness jolted Lloyd from his spell. He recognized me. He was breathing heavily and was sweating.

"Were you fighting the Vietcong in your dreams?" I asked.

Lloyd didn't reply. He got up and went into the bathroom. He was in the shower for a long time. The next day he moved the pistol he kept in a drawer to a high shelf in the closet. Later in the day, he apologized for disturbing my sleep.

I didn't tell him that there were moments his high nose scared me.

Over the next ten years of our marriage, Lloyd experienced the occasional flashback. For example, he would tell me that someone was in our yard trying to harm us.

"It's two ${\tt A.M.!"}$ I said. "What makes you think that someone is in our yard?"

"The crickets!"

"Crickets? What about the crickets?"

"They've stopped singing."

Lloyd got up and picked up his .38 caliber Smith & Wesson. "Someone could be hiding in the bushes. I have to check."

So began my husband's two-in-the-morning house-patrol pattern. There was no way I could convince him that it was just his imagination.

We moved several times as Lloyd approached his retirement from teaching. We tried to find a home that fulfilled his security requirements. He preferred a dead-end street, with the property high up and fortress-like. Lloyd wanted to be able to set up a one-man defense. We eventually located a property in northern California near Mount Diablo with the features he had been looking for.

"Now there really is somebody in our yard every night." I drew Lloyd's attention to a family of deer presided over by a five-hundredpound buck with antlers as tall as small trees. The deer ate everything I planted and anything green in sight. I didn't need exercise because I had to go up and down the slope to chase them off. They uprooted my tomato plants and stripped the lawn. They sat next to my kitchen window, sunbathing. I was awestruck by their beauty, but I didn't like them killing the trees when they chewed off the bark. The only thing they couldn't destroy were the three-hundred-year-old oaks, the roosting place for a flock of wild turkeys. Thirty or forty of them flew in every day at dusk like soundless black helicopters. They alighted in the canopy of the oak trees and settled in for the night. Each dawn, the turkeys silently glided off from their high perch into the surrounding forest. It was an incredible sight. Wild turkeys were my natural alarm clock. Precisely at daybreak, both the males and the females started their courting songs. It was a magnificent orchestra, though unwelcome if one had gone to bed late.

Sometimes in the middle of the night we would wake up to the sounds of a battle, of someone thrashing around in the bushes. The male deer would be fighting each other in the yard. The engagement was intense and brutal. The loud slashing sound came from the deer as they crashed through the woods, the colliding sound from their antlers hitting. It was not unusual the next day to see a young buck strolling by with an antler missing.

I hired a fence company to build a six-foot-high fence around the property so that we could sleep. The deer now lived outside the fence, but the wild turkeys took their place almost immediately. They moved inside the fence and combed the slope, looking for worms. Squirrels dug for nuts along the side while the deer observed enviously from across the fence.

Lloyd built himself a bunkerlike basement office that faced the driveway and the street and from which he could see anyone coming onto the property through a small one-way window. He also built secret drawers where he hid his weapons. Locks were Lloyd's favorite things, and he installed them everywhere. Each of our doors had three different types of locks. As time went by, Lloyd upgraded the locks. He got rid of doors and windows when he thought the locks were worn-out, too old-fashioned, or poorly designed. He replaced doors and windows with

ANCHEE MIN

stronger lock designs. He followed the newest technology on locking devices. He would not hesitate to spend the money. He convinced himself that it was absolutely necessary for our security. I grew sick of getting locked out of the house all the time. The moment I stepped out to the yard or went to pick up the mail or simply went to get a breath of fresh air, Lloyd would lock the door behind me. He didn't mind running up the stairs to reopen the door for me with an apologetic grin on his face. Eventually I started to carry a key when I left the house for any reason.

{ CHAPTER 33 }

T's A MAN's world," I had been telling Lauryann since she was in the cradle. "Being a girl is a disadvantage, but it doesn't mean you're destined for a sad life. Being an American girl means that you are entitled to reverse your ill fate."

While we were visiting China, I could not prevent Lauryann from hearing the negative remarks about her "bad looks." Her relatives, especially her grandma, Nai Nai, didn't like her sun-kissed dark skin. "Why does Nai Nai wish that my skin was milky white?" Lauryann asked. She also told me that neighbors gathered around her and sang "The Sorry Kid from a Divorced Family," which upset her. I had to tell her that people in China believed that a kid from a divorced family was "cracked porcelain."

It made me feel fortunate that Lauryann did not live in China. A divorced family was not an issue in American society. Lauryann was proud of her natural olive-colored dark skin. It was considered attractive in America—some of her schoolmates even paid tanning salons to darken their fair skin.

When Lauryann was in Shanghai one summer, Nai Nai took Lauryann to be measured by the "height predictor." The machine predicted that Lauryann would grow up to be a dwarf. Nai Nai was crushed. Lauryann's height had always been her concern, because Nai Nai was less than four feet. Nai Nai feared that she had passed her "short gene" to Lauryann. She begged me to "beef up" Lauryann's diet to help break the "curse."

Believing that America was number one in the world in every aspect of life, I decided to change Lauryann's diet to a high-protein one:

Monday – McDonald's Tuesday – Burger King Wednesday – Kentucky Fried Chicken Thursday – Domino's Pizza Friday – Jack in the Box Saturday – Wendy's or Fatburger Sunday – Bagels, cheese, and ice cream

Lauryann developed plump cheeks and a double chin. It made Nai Nai happy. But I noticed that Lauryann was frequently tired and had to lie down. Her colds wouldn't go away. Every time she had a fever, she had to be put on antibiotics or the fever wouldn't come down. The intervals began to shorten between illnesses. Every two months she got sick enough to need antibiotics. What frightened me was that Lauryann seemed to fall ill again right after she had recovered.

Lauryann was a bag of antibiotics, and the drugs were losing their effect. Her doctor warned me that the antibiotics had reached their limit. The next time Lauryann became sick, there would be no effective medicine for her.

It it hadn't been for Lloyd, I would never have linked the "superdiet" to Lauryann's poor health. Lloyd asked me to stop feeding Lauryann American junk food. He pleaded, "Trust me, there is nothing nutritious about this superdiet!"

I could see Lloyd's point. I grew up playing with Chinese peasant children who were too poor to afford meat, yet they were never sick. They ate yams, soybeans, and vegetables, and they were extremely healthy and full of energy.

I went back to Chinese home cooking. Lloyd became our in-house food policeman. "We'd better fill Lauryann up before the school soda machine gets her!" Every morning, Lloyd made smoothies with fruit and nuts, which he called "sunshine for the brain."

Before Lloyd came into my life, I had been fond of the way Americans cared for their children. I never doubted that the children's movies broadcast through public TV promoted goodness. It wasn't until I saw Beavis and Butt-Head that I realized that Americans didn't always protect their children. The government turned a blind eye to TV commercials that targeted the young. The sponsors and producers seemed to have only ratings on their minds. Like food with additives, the movies

were designed to prey on the vulnerable. Beavis and Butt-Head became new role models for the young. Children loved to watch the characters challenge authority. They insulted the president, showing that he was a fool.

I witnessed the powerful effect on Lauryann. The show led her into a wonderland where children lived to defy adults. Lauryann began to show signs of disrespect. She adopted the cartoon characters' language and started to speak to me in sentences such as "My life is my life, and my life is not your life."

Like the fast-food industry, American popular culture grabbed its children by their aesthetic taste buds before they developed a taste for real food. It was simply "so much fun," in Lauryann's words. If I let these shows raise my daughter, I saw myself that I would lose her in no time.

I made Lauryann watch what I believed were quality shows. *People's Court, Judge Judy, 60 Minutes, 20/20,* and *The Magic School Bus.* Only on Lauryann's birthday did I allow her to choose whatever she wanted to watch.

Just as I believed that I had taught Lauryann right from wrong, I received a call from her school one day informing me that my six-year-old daughter was sick with stomach pains. I put down my writing for the day and went to pick her up.

Lauryann's "pain" magically disappeared the moment we walked out of the school gate. For the rest of the day, Lauryann played around the house and did whatever she liked. The next morning, soon after I dropped Lauryann off at school, I received the same call from the same nurse telling me that my daughter was having stomach pains again.

"May I come in the afternoon?" I asked.

"No. We are not responsible for keeping a sick child. You have to pick her up."

I had a feeling that Lauryann was lying. She had seen how I suffered from stomach pains. I decided to test her.

"Lauryann, honey, what happened? Stomach pain again? Oh, you poor thing! Let's go home and you have a good rest." Holding Lauryann's hand, we headed home.

It didn't take long for Lauryann to expose herself. She forgot that

she was supposed to be in pain and started to sing "Zip-a-Dee-Doo-Dah." I sang along with her until we crossed the street.

I dropped my happy mask, and locked both of my hands on Lauryann's shoulders. Looking straight in her eyes, I said, "You don't have stomach pain, do you?"

Like a deer caught in headlights, Lauryann froze. She then admitted her guilt.

After we arrived home, I told her that I must perform a mother's duty. "This is not the first time you lied." The first time was when she didn't like the lunch I made for her. She threw her peanut butter sandwich in the trash and stood in line for the school lunch. Lauryann told her teacher that her mother didn't pack a lunch for her.

Ten days later, I received a call from her teacher. "Are you having financial difficulties? You should apply for the free lunch program so that your daughter can eat."

"I pack a lunch sandwich for I auryann every day," I replied

When Lauryann returned from school, I conducted an interrogation. She promised never to lie again.

"A spanking will help you remember," I said. "My mother spanked me when I lied as a child. I stole three pennies from her to buy a pancake because I was starving. Unlike you who had a sandwich, I had nothing to eat. I got up at four every morning, rain or shine, to go to the market. By the time I carried the food basket home, I was starving. My mother said to me, 'Hunger shouldn't be a reason to steal. Honor is what differentiates humans from animals.' My mother had to beat me with a rubber tube that she pulled off the faucet."

I told Lauryann that I passed out in the middle of my mother's discipline. I remembered waking up surprised to see a cup of milk placed next to my pillow. When my mother told me to drink the milk, I cried. I knew the milk was not something my mother could afford.

Lauryann let me know that she was ready for the spanking. I closed the curtains while Lauryann leaned over on my bed on her stomach. The moment I hit Lauryann's behind, a handprint appeared. I broke into tears.

Lauryann felt sorry for me. She said, "Mom, why don't you get a towel and lay it over me so that your fingerprints won't show?"

I laid a towel over her butt. My heart ached.

Lauryann didn't move as she waited quietly for me to continue.

I forced myself to go on. With each stroke, Lauryann let out a muted cry. I told myself that I had to go through with it and accomplish my mission.

After I was done with the spanking, I hugged her. We both cried. I understood at that moment how my mother must have felt and how much she had to overcome in order to set me right.

When Lauryann became a young woman, she would remember the spanking. She would tell me what I had told my mother, that she was grateful that I had performed my duty.

"It was harder on you than on me," Lauryann would say. "I knew you loved me so much that you couldn't bear not to do the right thing."

Lauryann had no interest in discussing my divorce from Qigu, but she wanted to know what I remembered the most about my life with him.

"I remember our visit to the dental office in Chicago's Bridgeport," I began. "It was the first time we had anything leftover after paying all the bills, sixty dollars. We decided to take care of our teeth and see a dentist for the first time in our lives. We didn't want to end up like our parents, who lost all their teeth, and thirty dollars each would pay for a dental cleaning."

"Who went in first?" Lauryann asked.

"Qigu went in first. Ten minutes later, I saw him run out of the office as one would from a fire. Wiping his bloody mouth, he told me that he slipped down in the chair inch by inch as the dentist drilled. Finally he was on the floor. He said that the pain was absolutely unbearable. He wondered how Americans could go through this every six months.

"I didn't want to go through the same pain. But leaving would mean wasting the money. Perhaps my teeth were better than Qigu's, I thought. Perhaps the dentist would go easier on me since I was a female."

"Were you right?" Lauryann asked.

"I was wrong. I endured the pain but just couldn't stick to it. I came running after Qigu. He was in the waiting area holding his mouth.

'You've got a bloody mouth too!' he said. 'I told you not to go in!' 'It's for the thirty dollars!' I mumbled back. 'We'll never come again!' Qigu vowed. 'What did the dentist say about your teeth anyway?' 'He said that I had thirty-four years of scum built like a fortress along my gum line. He said that I'd be toothless in my old age!'"

Although cultural differences and language barriers still caused misunderstandings, Lloyd and I tried to sing harmonious tunes to each other.

A typical conversation would go like this: Lloyd would be heading for Home Depot, and I would ask, "Would you get me the swap killers?"

"Oh, right, wasp killer." He no longer bothered to correct me because he understood exactly what I wanted.

I miscarried twice after we were married. My body had not recovered from the trauma of giving birth to Lauryann. Considering my health, Lloyd suggested that we give up. I felt sad that I muldn't give Lloyd a child.

"We have Lauryann," he said.

Lloyd had a different parenting philosophy from Qigu. Lloyd described himself as "not a typical American parent" just as Qigu considered himself "not a typical Chinese parent."

Qigu, who is now a professor at the School of the Art Institute of Chicago, told Lauryann that the meaning of life was to "discover, explore, and understand the self." Lloyd, on the other hand, believed that Americans had become carried away with the self. Lloyd said, "In the US, life is about nothing else but pleasing the self!"

"Lauryann is entitled to express herself!" Qigu insisted over the phone. "She must be given the freedom and the opportunity!"

Lloyd refused to yield. "Parasites shouldn't be given the right to express themselves or to live the way they want at the cost of the tax-payers' money!"

It might have been California's dry air that caused the skin on my feet to crack along the old labor-camp scars. When I looked at my feet at night and saw the crooked nails and cracked skin, I remembered the days in the labor camp when my feet had been soaked in manure-, fun-

gicide-, and pesticide-saturated mud for months at a time during riceplanting season.

Lloyd said that my old life was haunting me. I said I didn't feel bothered. I now took pleasure in recalling my past. In my mind's eye, I could see the rain, misty, penetrating to the bone. I remembered when my comrades and I took off our dirty, mud-caked work clothes at the end of each day. We hung them on strings across the room to dry. Then we stopped bothering. The clothes wouldn't dry, and we had no energy left to wash them. There was little point, because in a few hours we had to be wearing them again. So we stayed wet the entire planting season. I felt so blessed that such a life was behind me.

Lloyd bought me vitamins and skin lotion and insisted that I use the lotion every night to rub on my feet. "We were taught to take care of our feet as marines," he said. "Before anything else, you have to be able to walk and run."

I mended Lloyd's jeans while he slept soundly beside me. Under the lamplight, I sewed cloth patches on the knees. I was entertained by a thought: How stupid that in the labor camp I hadn't thought to sew a thick cloth patch under my work clothes to protect my shoulder? Instead the blisters on my shoulder from the bamboo pole were constant and at times became infected. "If I knew then what I know now," I said to myself.

"Sorry," Lloyd muttered in his sleep, "the translation didn't go through."

Lloyd witnessed the struggles I had with my writing. I knew what I wanted, but I had a hard time coming up with words that matched what I saw in my mind's eye and felt in my heart. "Dead writing" was what I called what I produced when it had no poetry, no magic, no life. I had to produce a lot of those passages to get something I felt I could use. Sometimes it could take weeks or even months before I could find the right flow of words. Lloyd believed that a better writing environment would help. "Why don't you convert the tool shed on the slope into a writing shack?" he suggested. "That way you can have your solitude." Lloyd spent the entire summer building a meandering staircase and paved

path leading to the shack. It reminded me of the winding stairs in the hills behind China's Imperial Forbidden City. I now had a view of the Northern California mountains. I was surrounded by oak trees, camellias, magnolias, and the deer, birds, turkeys, and squirrels. In the morning and evenings geese flew by from a nearby lake. My writing blossomed.

I found myself listening to more Chinese music and operas. I began to allow myself to miss China, although I couldn't pinpoint what I missed the most. It was an internal ache. I didn't miss the old me. I suspected that it must be the trick of distance. Time heals all wounds. Plus the way memory preserved, reinvented, and represented itself. Over the years China had become my Shakespeare. My China was beautiful, tragic, and dramatic.

It was Lloyd's daily anecdotes that made my life real. Through him I experienced the America I would never otherwise experience. We were in the yard fixing my broken garden tools, a rate and a pitchfork. Lloyd opened a package of JB Weld and watched me apply the paste to the tools. He said, "The fact that your garden tools repeatedly fall off their handles demonstrates how capitalism works. America has the ability to build spaceships that make trips around the Earth, to the moon and Mars. The manufacturers can fix the flawed designs of these simple tools. They just don't want to. They want us to spend money and buy new tools every time one breaks. I'm glad that we have JB Weld. Its quick-setting cold weld bonds almost anything!"

I told Lloyd that this moment reminded me of a famous American painting.

"What painting? What's the title?" Lloyd asked. "I'll check it out for you." He was good at checking information and digging up material for me, however difficult to find. I once needed information on the name of the cave where the Chinese emperor Qianlong (who reigned from 1735 to 1796) of the Qing dynasty was entombed. Lloyd found it for me.

"I don't know the title," I said. "Gardener and Her Husband? Anyway, it is a very famous painting."

The painting Lloyd located for me was American Gothic by Grant Wood, painted in 1930. "Yes, it's you and me," I said. "Except we'd change the expression. We should take a picture posing just like that

THE COOKED SEED

after we fix the pitchfork. I want a big smile with your teeth showing. How about we dress up like the couple in the painting next Halloween?"

Lloyd's PTSD was getting worse. We had fights. Lloyd insisted that he heard someone walking up the stairway in the middle of the night. He was no longer able to sleep peacefully. When I insisted that he was hallucinating, he lost his temper. He cursed and said he would find out who was sneaking up the outside staircase at night and shoot the person. I became fearful for him. I walked out and stopped talking to him for two days. On the third day, Lloyd went to the nearest VA clinic to see a counselor. After several appointments with doctors and evaluations conducted with three different counselors, the verdict was that Lloyd had a 30 percent disability due to PTSD. He came home with instructions to lock up his weapons and take medication.

"I don't think you are that sick," I said, taking the medicine away. "The side effects of these drugs are going to make you sick. Every Chinese has PTSD for surviving the Cultural Revolution. If you are thirty percent disabled, I'm sixty percent."

"But you were mad at me," Lloyd said. "I don't want you mad at me."

"You can cheer me up by buying me a bag of fertilizer."

"Fertilizer? Why not flowers? I'd love to buy you flowers."

"I need fertilizer for the garden."

"Flowers are better."

"A bag of fertilizer is better. I'll think of it as your flowers."

From then on, every time we fought, Lloyd drove off and returned with a bag of fertilizer. He would carry the bag up and place it on the deck against the rail facing the kitchen, where he was sure I would see it.

Lloyd would often start his advice in the middle of exercising, while he was either on a floor mat or on his exercise bike reading a magazine or looking through advertisements.

"Start out strict," he said, offering Lauryann a tip on her future parenting. "Be as tough as possible even if you don't enjoy being mean. Offer

tough love, as I do. Don't let your kids choose what to eat, what to wear, or hand them money or gifts. Include house chores and yard work in their daily routine. Be fair but strict. Always follow through. Always. Never punish the child and then back down when they argue with you. When that happens, you will lose your authority—gee, look at that price! It's only forty dollars! I've got to check the weather!"

A moment later, Lloyd continued, "One parent called last night asking when the party would finish. I heard the girl in the background say, 'Soon!' The mother goes, 'When?' The girl goes, 'Soon!' If she were mine, I would explode! Party animals! . . . Look, there's forty percent off clearance at Target! . . . I mean you can raise a child, love him, but not let him go wild. Parents create monsters! For those spoiled brats, you need a marine corps drill instructor . . . Wait a minute, I still have to check the weather. Oh, my God, a guy lives alone on a ranch, is divorced, and has sixty-four dogs!"

We called those moments "Lloyd's monologues." Lauryann and I were his ardent fans. Lloyd fascinated me not only for his particular American mind, but also for his impact on Lauryann. He would influence the person she was to become. She would have a decade of training with Lloyd along with his explosions. I was a grateful wife who sang harmony to my husband's out-of-tune song. I enjoyed every note.

"I feel so good that I get to wear real sunglasses," Lloyd said after laser eye surgery corrected his nearsightedness. "I always wanted to wear sunglasses like General Douglas MacArthur's—that asshole. Maybe I should put a couple of stars on my baseball cap. People will ask me if I am an officer. I'll say yes, since so many people lie these days, although I'll say no if they ask me to tell the truth."

Lloyd made me laugh when he said something a Chinese man would never say. For example, "Look outside, your bamboo is having a hard-on!"

In Lloyd I saw what I would describe to Chinese as a "confident American style." At ease with oneself. "I am truly brain-dead. No doubt

about it!" Lloyd said when he misplaced the TV remote control for the fifth time that day.

When Lauryann wanted to do something I disapproved of, she'd say, "Mom, you don't understand. It's the American way." For example, one day Lauryann returned from her middle school excited about getting a facial. She had received a gift coupon from her best friend, whose mother owned a salon specializing in facial treatments. After I learned that the treatment would include the removal of Lauryann's body hair, I was horrified. I had seen electronic shavers advertised on TV, and the female models made shaving seem sexy. No one warned the children that once you shaved, you could never stop shaving, because the hair grew back thicker and darker.

"Why do you need a facial?" I asked. "You are only eleven years old!" "It's the American way!" Lauryann replied.

I was so glad to be able to turn to Lloyd. He was an American and he could tell exactly what was on Lauryann's mind. He beat her to the punch before she opened her mouth. He attacked the so-called "American way," ending with the sentence, "Don't worry about me going crazy, because I am already there!"

I wasn't prepared to learn that Lauryann had scored below average on the national standardized test for middle school. When the report arrived in the mail, I stared at it in disbelief. Trying to puzzle it out, it occurred to me that my daughter might be too right-brained. She excelled at many things; I knew she was not dumb. She learned ballet moves effortlessly and was able to memorize the entire *Swan Lake* after watching one performance. She could sing pop songs after hearing them just a few times on the radio. She spoke Chinese fluently without ever attending a single Chinese class. My Chinese friends were amazed when she sang Chinese folk songs and peasant operas. She didn't read music, but she taught herself to play piano by watching videos on You-Tube. She could do fantastic accents—the queen's English, a cowboy accent, an Indian accent. She was good at drawing, painting, and even embroidery.

I would have encouraged my daughter to pursue the arts if she hadn't had flatfeet, or if she had a greater vocal capacity, the ability to climb at least three octaves. I bought music tapes by Whitney Houston, Mariah Carey, and other accomplished singers so that Lauryann and I could compare her range to theirs. Lauryann concluded that she was good, but she would never be truly good enough to conquer the world of music.

Lloyd, on the other hand, was impressed with Lauryann's flashy improvisations in the living room. He believed that she was a natural world-class entertainer.

Lauryann said to Lloyd, "You are no different than the mother character in your own stories."

"Which mother?" he asked.

"The one who buys self-published books written by her daughter."

I expressed my views and delivered my comments carefully, making sure that Laurvann didn't feel I was putting her down. I understood that this was a delicate matter and keeping a balance was the key. Nurturing Lauryann's self-confidence had always been my priority, but I refused to offer, or lead on, a false one. I believed that cultivating Lauryann's ability to see her strengths and accept her shortcomings was my duty. She must learn to redirect and reset the start button when she found herself in a situation in which she kept crashing into a wall.

My friends had been sensitive and protective toward Lauryann when she was younger. Many of them told their children to be nice to Lauryann during video games. Lauryann was not to be challenged. On the surface, Lauryann accepted her status and appeared comfortable. She played along as the dummy, but underneath she was determined to surpass herself. I assured her that I was in the fight with her.

When Lauryann was about five years old, I took her with me to a book signing at a bookstore in southern Los Angeles. I sat behind stacks of my books and waited for three hours. No customer came forward. Finally, a lady appeared. She asked for my autograph.

I didn't notice Lauryann following the lady afterward. When

Lauryann returned, she whispered in my ear, "Mommy, the lady is not a customer. She's the cashier at the bookstore."

I turned to look behind the counter. It was true—it was the woman I had signed an autograph for.

I said to Lauryann, "If I were as good as the author who wrote . . . what is your favorite book?"

"Dr. Seuss."

"Okay, Dr. Seuss, would people show up and buy my book?" Lauryann nodded as tears filled her eyes.

A few months into our marriage, Lloyd suffered a burst appendix. It began with a stomach cramp after dinner. Lloyd thought it had to do with stress from his job as a teacher. He took a pill to ease the pain and we went to bed early. About midnight, Lloyd woke up to an assault of pain. He did not want to disturb me, so he endured. The pain did not go away. Eventually he crawled out of bed and rolled linto a ball on the floor. He forced himself to stay still and keep quiet.

At about three in the morning, he woke me. "Call 911," he said.

Barely awake, I dialed the number.

When the ambulance arrived, a paramedic asked, "Sir, from one to ten, one being the least and ten being the worst, give me a number that describes your pain."

"Eleven!" Lloyd said.

I met with Lloyd's doctor in the hospital. I learned that his appendix had burst, and that the rupture had led to an infection. I felt terrible about not getting Lloyd to the hospital sooner. He had put himself through great pain to assure me a good night's sleep.

The doctor told me that he had to open Lloyd to "clean him up." The next day, after Lloyd's surgery, I took Lauryann to see him. Lloyd was wrapped with tubes, with one leading to an IV bottle on a stand. Hours earlier, he had been adminstered a barium enema in preparation for an X-ray of his large intestine. He was expected to poop it out.

When the urge came, Lloyd pushed himself out of bed and dragged the tubes and the IV bottle and the stand toward the bathroom. The electric cords and tubes got in his way. "Damn, I am not gonna make it!" he said. "I'm gonna shit all over the place!"

I quickly looked around and saw a bedpan by the window. I picked it up. As if he were an infant, I pulled and pushed Lloyd back to the bed. I threw his leg over my shoulder, rolled his body to one side, and slipped the bedpan under his butt in time to collect the gushing residue of the barium enema.

I went to the bathroom and emptied the pan in the toilet and then cleaned the pan and filled it with water. I called Lauryann for help. "Let's clean him."

"No!" Lloyd pulled up the sheet to cover his naked limbs.

I ignored him and turned to Lauryann. "Come on, let's get to work!" Lauryann shook her head like a Chinese merchant's drum.

"Hold the sheets for me," I instructed. "Come on."

"I can't," Lauryann said.

"Why mus?" I became upoot, "What's wrongs"

"I have never seen a man's penis before," Lauryann replied.

"That's no problem." I turned to Lloyd. "Excuse me, I've got to borrow your instrument for a second."

Before Lloyd could protest further, I dragged Lauryann over and pulled down Lloyd's sheet.

"Now you have seen one," I said. "It's not scary, right? You are in a hospital, and you are supposed to think only of helping."

Lauryann listened and stared at the penis.

It dawned on me that my action might shock Lauryann and damage her in some unforeseen way. To apply damage control, I said, "Tell me what you see, would you?"

Lauryann paused for a second, then replied, "A bird in a sack."

"A bird in a sack?" I tried not to laugh. "Well, that's about right!"

Poor Lloyd. I turned to my husband and said, "Sorry to violate you. I meant to help."

As Lauryann held the bedpan, I wiped away Lloyd's poop and cleaned his bottom.

Looking back, this was Lauryann's first real-life lesson on human physiology in a hospital setting. For Lloyd, it was his first taste of a Chinese woman's stubbornness and craziness. He had to admit that I was effective and efficient. "Otherwise you would have slept in your own poop," I said, "or you would have fallen in the bathroom. You would have torn open your stitches before reaching the toilet."

The dream began with an image. I saw myself once again stuck. I was back in China at the brick factory, where we made bricks from mud. First we made the mud cakes, then dried them under the sun before sending them to be baked in the kiln. My metal cart had fallen off its track, and I couldn't lift it back onto the track. The cart was loaded with mud cakes. It weighed over a thousand pounds. I was in a squatting position, with my lower back pressed against the metal frame. I applied all my strength, but the cart was not moving. Rain began to pour. I would be in big trouble if I failed to save this load. I would be held responsible for ruining the factory's production goal.

It was a strange dream because I was awake. I was aware of the bed I was on, and I knew I was not in China. I could see the moonlight reflected on the wall and the curtain. I was in my house in America. Yet I couldn't wake up from this "dream." My memory was trapped in the old time zone while my mind watched it struggle. With my eyes open, I shouted soundless shouts and I cried tearless cries. I watched in terror and helplessness as that rain began to dissolve my mud cakes.

Roaring like a lion, I pushed the cart. It moved, slid, but it didn't land on the track. By now the track was covered by a running river of mud.

It was then that I heard the sound of the telephone ringing. I snapped out of the dream, sat up, and reached for the phone.

It was my father on the other end. Calling from China this early in the morning cent chills down my spine.

"Anchee," my father's voice was grave. Immediately I sensed that something terrible had taken place.

As if reciting an ancient poem, my father said, "Your mother has fallen into a permanent sleep. She left us last night at ten o'clock."

"Where is she?" My voice was cold and unrecognizable.

"She is sleeping." My father broke into choking sobs. "Sleeping permanently."

I wanted to yell at him to stop using the words "sleeping permanently"! Why couldn't he just say she was dead?

"Where is her body?" I asked, finding it difficult to pronounce the word *body*. I wanted to reach out to her, to put my arms around her, to lie next to her. But I knew that it was too late. I did not get to say goodbye. I had missed my chance.

"The neighbors helped me. The crematorium people came, and I signed the papers. Your mother is ready for her departure from the earth. I don't know what to do. Are you coming? Your brother and sister are coming."

"How did she die?" I asked. "Did she know that she was going? Did she get a chance to say anything? Seventy years old is too young. Was she in pain? Was there a sign? Any struggle?"

My mother had told me that her biggest fear was to die in pain. She had witnessed both her parents die in extreme pain. She had asked me about assisted suicide in the event that her illness worsened. I had promised to help her when her time came. I would make sure that she did not suffer as her parents had. I had been gathering information and was following the work of Dr. Jack Kevorkian in the news. I had also listed Denmark and Oregon in my notebook as places to visit and investigate.

"I don't think your mother died in pain," my father said. "In fact, we were waiting to take her to the hospital on Monday, which is today. She had been weak, but there was no clear sign that she was ready to go."

I found myself afraid to go to my dead mother. I was not ready to accept her death and didn't want to face it. I wanted her alive, to be waiting for me as she always had. I had taken my mother for granted. I had always counted on the next time. All these years struggling to survive in America, I had been unable to visit her. While seeking a happier life, I had missed what really mattered. The sudden realization struck me right after my father uttered the words "permanent sleep."

I had spent too many Thanksgivings and Christmases alone in America, working. This was the price I paid. I couldn't take a chance on being denied a return visa. I couldn't afford the airfare. I could only dream of our reunion. A delightful scene of happiness played over and over in my head. I always rewound and replayed my favorite part at will, the scene in which my mother is leaning over the windowsill wait-

ing for me. Then, one day, I magically appear. I wave at her. She doesn't wave back, because she isn't sure if she isn't hallucinating it all. It is her life, and she never expected something so wonderful.

I saw myself running toward her in my American jeans, sweater, and sneakers. I run through the narrow lane, past the public yard, up the slanting staircase, through the pitch-dark hallway, and into my mother's open arms. Again and again.

This was my Thanksgiving. This was my Christmas. The gift I gave to myself, the promise that one day I would get to see my mother anytime I liked. I would spend as much time with her as I wanted. Lauryann would give her a show. Lauryann would dance and sing American songs to her. I knew my mother would enjoy that tremendously. My singing and dancing was once her gift to her guests and friends. She used to say, "One can be poor, but one can still offer great gifts."

Now everything ceased in "permanent sleep."

I did not want to see my mother's dead face. I was afraid of my own regret and remorse. It was overwhelming. I liad planned to visit China and see my mother before the summer, but I had been having blackouts. I became nervous because I didn't know their cause. I had to stop driving because the blackouts could occur at any time. I knew I was sleep deprived. To rule out the possibility of a brain tumor, my doctor insisted that I get an MRI. I had been waiting for the results.

The doctor's office called. The MRI I had taken the week before was still being analyzed. "The results can arrive anytime," the doctor said. "It's important that you stay where you are so that we can take care of the problem promptly, be it a blockage or a brain tumor."

I did not attend my mother's burial. I saw the photos my father took. The dead person in the photo did not look like my mother. Not the way I remembered her. I tried not to count the days I did spend with my mother since I'd arrived in America. It was pitiful.

Being an immigrant meant to leave loved ones behind—part of yourself in *permanent sleep*.

{ CHAPTER 34 }

LOVED WATCHING LAURYANN and Lloyd play chess. I got a kick out of Lauryann's little tactics that she'd picked up from Lloyd himself. To distract Lloyd, Lauryann asked him about topics that she knew would blow his short fuse.

"I love candy," Lauryann said. "Everybody loves candy."

Lloyd took the bait and fumed. "Candy destroys your ability to taste and enjoy the natural flavors in food. Candy causes diabetes and cancer..." Before he was finished with his diatribe, he found his horses and bishops snatched by Lauryann.

"What about skateboard brains, Lloydee?" Lauryann asked. "Can you lell that story again? Mommy didn't get to hear it."

Lloyd was fooled again. "Well, I was waiting for the traffic light to change at the intersection, and I saw this young man cross the street against the red light. He was one of those typical teen assholes, you know, the type that's so impressed with himself. He had a shaved head, sunglasses, rings and stuff all over. He pissed me off, because I thought about how I risked my life in Vietnam defending bastards like him."

"Hey, your turn, Lloydee. By the way, what about Walmart's shrinking T-shirt?"

"Don't start me on that. The fabric is super thin to begin with. After I washed the only one I ever bought from Walmart, it shrank to the size of a handkerchief."

"Checkmate!" Lauryann announced.

I showed Lloyd a Chinese poem. "Rain" was its title. The poet's name was Du Fu, 712–770 AD, of the Tang dynasty.

Good rain knows about timing
It arrives only at Spring's invitation

Riding the wind, it moistens the night Nursing the soil in gentle silence

"Rain represents parental love," I interpreted. "'Spring's invitation' means the child's readiness, and 'gentle silence' means getting the work done in an artful way. In other words, be strategic."

Although I told Lauryann that her best effort was all I asked for, she knew I did not mean that she could get by with B's and C's. I would not forgive myself if I failed to bring out my child's true potential. I had witnessed the unhappy result of Lloyd's tough love with his only son.

I didn't want to travel the same path. Ever since Lauryann's birth, I had wanted to be the gentle rain that soaked and nurtured the earth. I wanted to be the spring itself. "Impulse control" were the words I posted on my bathroom mirror. Yet I often couldn't help but act on an impulse. For example, when Lauryann was about three years old, a bug bit her. One side of her lip was swollen. There was no point in applying a bandage, but Lauryann insisted. She wanted her whole mouth covered with bandages. Definitely she was not ready to listen to me.

I decided to let her have her wish. I bandaged her entire mouth. An hour later, frustrated that she could no longer talk, she asked me to remove the bandages. It was then that I rubbed her nose in her foolishness.

Another example took place in Arizona. I was a guest speaker at a literary festival. I took Lauryann with me. She was about seven years old. The hotel we stayed at had an outdoor swimming pool. When Lauryann was changing into her swimsuit, I went to test the water temperature of the pool. It was freezing. I went back to tell Lauryann that it was a bad idea to go swimming. Instead of listening to me, Lauryann ran toward the water. I followed her, yelling, "Please don't get into the water! It's cold!"

I could have easily caught and stopped Lauryann, but I purposely let her outrun me. Following in her joyful wake, I put on a dramatic act of pretending not to be able to catch her.

Lauryann got her way and jumped. The cold water shocked her. When she resurfaced from the water, she screamed. "Mommy!"

I let the moment sink in a bit before I helped her out of the water. I wrapped her with a towel and held her. When she stopped trembling, I asked, "What did you learn?"

"Lis...listen to Mommy."

In another instance, Lauryann went walking in a mosquito-infested area when we visited one of China's rural villages. She not only wore shorts but also refused to apply the mosquito spray. I had to force myself not to interfere in order to allow Lauryann a chance to learn. And she did. She would never again leave the motel without the mosquito spray. I must admit that it tortured me to think that Lauryann could be exposing herself to malaria.

I had to constantly remind myself not to clip Lauryann's wings. When Lauryann told me that she was sick of practicing ballet in the church parking lot, I allowed her to quit. As a result, she fumbled her steps at the American Dance Competition and missed the gold medal by a few points. Her hallet teacher, who was trained in China, rerused to believe that Lauryann had done her best.

"If you had practiced enough," the teacher said, "you wouldn't have messed up the steps. The movement would have become second nature, and you would have won."

Lauryann broke down in tears and admitted the teacher was right.

For my forty-sixth birthday, I asked Lauryann for a gift. I wanted her to learn to change a car tire. She was eleven years old. I got the idea from a news story about a mother dying of cancer who made videotapes preparing her children. I said to Lauryann, "In case I die in an accident tomorrow, I'd like to know that I did my best to prepare you."

I sat next to Lauryann as we removed the tire from my car. Lauryann wasn't happy, but she did it to please me. I let her know that it was the best birthday gift I received that year.

I have been learning from my American daughter ever since she started kindergarten. At a parent-teacher conference, the teacher said, "There is not one mean bone in Lauryann's little body." My daughter was praised for making friends with a handicapped boy named Wilson, whose head shape was severely deformed.

"Other kids stayed away, but Lauryann befriended him," the teacher reported. "She's been by his side, and they're doing everything together."

"It's very kind of you to befriend Wilson," I said to Lauryann. "I am proud of you."

"Mom, Wilson was the one," Lauryann replied.

"What do you mean, 'Wilson was the one'?"

"Wilson was the kind one, not me."

I was surprised to find out that no one played with Lauryann. Wilson was the one who offered his friendship.

It was an ordinary afternoon when Lauryann returned home from school. She announced that she was in love with biology. She was in fourth grade.

I wanted to kowtow to her teacher. I wanted to thank the teacher for helping my daughter believe in herself. Lauryann's shortcomings in math and science had worried me for years. There were no sweeter words to my ears than hearing Lauryann say, "I love biology!"

I understood that I could lead the cow to the river, but that I couldn't force it to drink. If there was anything I was passionate about and worked at the hardest, it was pushing Lauryann as much as I could without breaking her spirit.

"Try to see if you can make the p-trap work. I am afraid this is a job for a master plumber!" I repeated to Lauryann the line I had composed and rehearsed many times.

Another example: "What an improvement on climbing the math Everest! My test score on this would have been a big goose egg."

When Lauryann tried to decide her field of interest, I offered "advice" in an animated tone. "A salesgirl might suit you better. Biology? To be a doctor? That's too hard!"

I was thrilled when my daughter gave me the shut-up-and-goaway-Mom look. It was just the reaction I'd hoped for, and I was ecstatic when she defied me by signing up for all the classes I had "suggested" that she avoid, like math, computer science, and mechanical engineering. Although she didn't do well, the experience and exposure were invaluable.

I read Lauryann the Chinese story "The Marriage of the River God" around the time she was learning about Dr. Frankenstein. My story was about how an ancient Chinese judge fought against superstition. He stopped the practice of drowning children as offerings to the river god. As I read on, I imagined Lauryann on a mission as a medical worker. I imagined her walking through darkness and crossing the desert on a moonless night to reach a remote corner of the earth to save lives. I couldn't help entertaining the thought.

Lloyd, on the other hand, made up his mind to play the bad cop. When Lauryann asked him to pick her up at a sporting event and she was a few minutes late, Lloyd drove away even as Lauryann appeared jumping and waving in his rearrance mirror. Lloyd refused to go easy on her. "In real life, the train doesn't wait," he said to her. "You had a cell phone, and you could have notified me ahead of time that you'd be late."

Lloyd's method became ineffective when Lauryann became a teen. He installed a flip lock on the inside of the front door so Lauryann wouldn't be able to enter even with the key. Lloyd expected Lauryann to arrive home on time as promised. She was not allowed to stay out past 10:30 at night on weekends. A few times, Lauryann arrived late and did not call. She knocked on the door, but Lloyd refused to open it. For the sake of a united front I felt that I had no choice but to stay on Lloyd's side, although my heart went out to Lauryann.

Instead of begging, Lauryann called her friends. She ended up spending the night at a friend's house. There, with her friend's "normal" parents, she received sympathy and a bowl of popcorn.

When Lauryann was two years old I took her to China, hoping she would learn to appreciate her life in America. Lauryann had so much fun that she fell in love with China. She went back every year for the next sixteen years.

My motherland had been transformed in the decade since I had

left. In Shanghai, a magnificent skyline, fashionable boutiques, and fancy restaurants had replaced the old residential area where I grew up. The modern, high-tech subway system was more efficient than those in Europe. Every relative and friend we visited lived a prosperous life. Although they complained about job stress, the rising cost of food and utilities, the government bureaucracy, and not enough money saved in the bank, each of them had a roof over their head, a full belly, a private living space, and a toilet of their own.

Compared to the homeless population on the streets of Bombay, New York, and San Francisco, Shanghai's homeless population seemed nonexistent. I was fooled by a blind homeless person begging at a train station. I meant to teach Lauryann a lesson in compassion and asked her to hand out five yuan, but Lauryann discovered the blind person was a con artist. He not only wasn't blind—we later saw him counting the money—but he was also a thief who was busy the next day at the corner of a crowded intersection, picking people's purses.

The best part of Lauryann's experiences in China was that they gave her a more balanced view of China than was taught in American classrooms. The TV news and the school textbooks portrayed China as it used to be, a backward country. Lauryann's classmates even asked her, "Is it time for your arranged marriage?"

It was pointless when Lauryann explained, "Chinese people no longer wear Mao suits, work in labor camps, and have no freedom!" The class, including the teacher, refused to believe her.

Lauryann decided to make a point. Every day she put on a fashion show with clothes she bought in China. She became the envy of her fashion-minded high school girlfriends. The sexy outfits she wore were what they all dreamed of wearing. Getting a kick out of it, Lauryann kept on. She enjoyed telling the girls that she purchased all her clothes and accessories in "poverty-stricken Communist China" at a cost that was one tenth of America's prices. Finally, the teacher teased, "Goodness, Lauryann, when is this fashion parade going to end?"

Lloyd believed that Lauryann needed to "correct" and "sharpen" the lens through which she viewed her happiness. "Look at those TVs," Lloyd

said. "Products are designed to be immensely appealing, attractive, and addictive to children. Your generation grew up with the message that if you truly love someone, you buy him stuff! The TV commercial says, Love your baby? Buy her milk with calcium. Love your teen boy? Buy him a car. Love your girlfriend or wife? Buy her a diamond. Love your self? Buy a face-lift or liposuction surgery. Love your grandchildren? Buy life insurance. Love your family? Buy a vacation package! Then the kids feel *punished* if they don't get *stuff* from their parents!"

I was amazed watching Lloyd prepare Lauryann for reality. "You'll be lucky to end up doing what you don't hate," he said. "Only on TV do most people appear to love what they do. Look, the smiling delivery man, the smiling janitor, the smiling grocery man, the smiling night-shift security guard. Yeah, he's so happy not to be able to have dinner with his family . . . It's not that your mother is such an idiot that she doesn't know how to reward herself and spend money. Tell your daughter, Anther. what your theams are besides mining your hackyard into a thinnese flower garden."

"Well, I'd like to buy myself piano lessons," I began. "I'd like to build up a collection of art books, build a painting studio with a large easel on rollers and a matching paint tray, dress in fashionable designer clothes, learn to dance, join a gym and keep fit . . ."

"I know. Mom is saving for my college instead," Lauryann said.

"She's willing to let go of all her dreams for you," Lloyd said.

"I am her dream!" Lauryann said.

"That's correct. But my point is that don't ever think that all your mother knew and wanted was to be a bolt in a machine!"

I was grateful that Lloyd voiced my thoughts. Besides telling Lauryann endless stories about Alexander the Great, Socrates, Plato, and Aristotle, Lloyd helped me instill in Lauryann the ambition to become a scholar athlete.

"Life is yours to make," he said. "My mother was told that I would never be able to read or write because of my dyslexia. But she told me that she had lost my brother to illiteracy and was not about to give up on me. She beat me with a coat hanger and forced me to learn to read, and she succeeded."

"You're not going to use a coat hanger on me, are you, Lloydee?" Lauryann teased. "Hey, how about peaceful coexistence?"

"Never!"

In 2003, Lloyd came down with a series of severe sinus infections that continued for the next few years. He continued teaching while on anti-biotics. The virus invaded his lungs, and he was diagnosed with bronchitis. The air in the classroom bothered Lloyd so much that he had difficulty breathing. The doctor gave him an inhaler that contained steroids. At home, he had difficulty sleeping. He wheezed all night. I had little idea of the seriousness of Lloyd's condition. I encouraged him to keep working because he was only a couple years away from retirement. Then one day, I called Lloyd after his last class and I could barely hear him.

"Why are you whispering?" I asked.

Lloyd struggled to speak, but there was no voice. I realized that the classroom environment was destroying him. Every day he taught five classes one after another with a five-minute break between them. Lloyd was so exhausted that his body was unable to heal. The respiratory infection grew worse, but Lloyd kept returning to the classroom. He told me that he had no choice—the students took advantage of the substitute teachers. "They know the sub is not there to stay."

Extremely concerned, I went to see him at about six o'clock in the evening after the students had gone for the day. The campus was empty and quiet. I knocked on his classroom door and discovered that the door wasn't locked. I pushed it open, and to my horror I saw a person with the head of a beast sitting behind the front desk.

It was my husband, and he was wearing a gas mask that covered his face.

Removing the mask, Lloyd said it helped filter whatever was in the classroom air that made him sick. With the mask on, he could breathe without wheezing. He didn't want to scare the students so he wore the gas mask only when he was alone in the room. He had been correcting papers and working on the next day's lesson plan.

I begged Lloyd to quit. I insisted that he retire immediately. We

had witnessed two of Lloyd's best friends and fellow teachers die of cancer soon after they retired. I'd rather my husband lose some of his pension than die at his post. After he retired in 2005, his sinus and respiratory infections stopped.

"Pole? What? Vault? What's pole-vaulting?" I asked Lauryann. "Is it a legitimate sport? How come I have never heard of it?" The only thing I could relate to a pole was the one I used to carry manure in the labor camp.

"Mom, this is what I picked because you and Lloyd insisted that I participate in sports so that I could show that I am 'well-rounded' on college applications." Lauryann would later reveal that the only reason she picked pole-vaulting was because I had no idea what it was and so wouldn't be able to criticize her.

I was amazed that her coach, Randy, sincerely believed that Lauryann was worthy of his attention. He trained her as if she had Olympic potential. "This would never happen in China," I told Lloyd. "Kids who do not have an athlete's build, endurance, and stamina would never get any attention from a coach."

Under Randy, Lauryann, who was afraid of a fly, would now smile through tears and bruises. In less than three years, Lauryann became an athlete who competed at the state level. She won first place several times and broke the record at the North Coast Section Championships. She jumped higher than twelve feet, one inch. I learned the news from a neighbor who gave me the newspaper that featured a photo of Lauryann as she soared over the bar.

I watched the video Randy sent via YouTube. It captured the moment when Lauryann broke the record. The replay in slow motion detailed her airborne moment. The jump and the midair turn was dancelike. My tears welled up as I watched the clip. Once again I was reminded of what made America great—any ordinary individual stood a chance to fight and win.

I was distressed to discover that sixteen-year-old Lauryann viewed things differently. She described herself as sweet, cheerful, and obedi-

ent on the outside and miserable on the inside. Some of this she attributed to her never having gotten over my divorce. The separation from her birth father had left her with persistent feelings of abandonment. I had shared my perspective with Lauryann many times: that my marriage to her father had been ill-fated, that we were unsuited to one another, and that the best thing to come of it had been our daughter, herself. But this was not the story she seemed to need, and she continued to suffer.

To compensate for her loss and to help her build a bridge, I took her to China so that she could bond with Qigu's parents. For fifteen years, we made the trip across the Pacific Ocean religiously. Yet Lauryann didn't heal. As close as my relationship was with my daughter, I missed the signals that she was in great mental pain. Because she did not want to hurt my feelings, she always showed her pleasant side.

The explosion came when Lauryann returned from a leadership camp. She told me that she had shared with her fellow campers her deepest emotions, that she had broken down and cried out her pain for the first time.

I was surprised. "What pain?"

"The pain of being abandoned," she replied.

It was then that I realized that all the talks I'd had with her over the years had not worked. I saw her revelation as an accusation that I had been selfish and cruel to choose divorce. I couldn't help but feel that Qigu was the problem. He had quit paying child support, but he hadn't stopped influencing Lauryann. On the rare occasions when he actually made an effort to see his daughter, he tried to convince her that I was the irresponsible parent, He provoked in Lauryann "the grass is greener on the other side of the hill" syndrome. When I let Lauryann visit him in China during the summers, Qigu showered her with affection and gifts. He bought her an iPod when it was "cool." He put her up in a five-star hotel in Beijing that was paid for by one of his admirers. He invited her to exotic banquets and parties where she met with his students, fellow artists, collectors, and critics.

Lauryann realized that she had missed many good times with Qigu. Although she challenged him, criticizing his laziness and bad habits, she took comfort in him. She later admitted that she had fantasized living a different life with Qigu.

Lauryann's feelings of inadequacy disturbed me. I was upset when she told me that "Qigu's side of the story made sense." I had worked hard to control the damage caused by the divorce, but a few days with Qigu, and Lauryann was pushed into a pit of self-pity and self-loathing.

"Instead of feeling sorry for yourself, you ought to feel grateful that you escaped the mess of our marriage," I said, raising my voice. "Why can't you see the truth as I see it? Why can't you take life as it is and deal with it the way I do? When I came to America..."

"Don't start, Mom, please! I already know your next line. You didn't speak English, and you had no money and knew nobody . . . I am aware of what you've gone through, but Mom, what I'm experiencing is different—a pain of a different kind and nature. I don't think you understand. I don't think you want to understand. I am not supposed to feel this way, I know. I keep reminding myself that I have everything, that I am in good health, that I don't have leukemia, or HIV, that I am not deformed my looky doesn't have anything malfunctioning. I have been telling myself to snap out of this sad state, or whatever it is that causes this freaking mental pain. I have been telling myself that I am not broken. Yet I feel broken inside!"

I watched Lauryann and felt terrified.

"Mom, I wish I could understand why I am so needy, so insecure, and so dependent on validation from others. I've told myself that this is not who I am. I get sucked into this black hole, and it's driving me crazy. I am sick of pretending to be perfect. I just want to quit! I have been throwing myself into a steel wall repeatedly thinking that the wall will change into a wall of flowers. I don't know if you'd ever accept me as who I am. I looked at that YouTube video of a kid who committed suicide and thought, Well, at least he got to end his suffering."

If I had to pinpoint a moment when I felt that I rose to the challenge as a mother, I would say this was it. I could feel the leap taking place, transforming me from a Chinese mother with limited tools to an American mother blessed and empowered by love and the understanding of the art of loving. The information and the knowledge were there, from what I had learned in my own life and from others, but the transformation hadn't occurred until now. I could hear the grand sound of the imaginary click. I couldn't change the past or transform Qigu into a

more attentive father. But I could resist the urge to blame him and instead speak to my own role in my daughter's life. I would catch the chance my mother never had, a chance to truly connect with my child. There was no hesitation or fear. There was no *what if, perhaps,* or *maybe later,* but a sense of certainty.

"A mother's love can contaminate, poison, harm, and destroy as well as empower and protect," I began.

A little surprised, Lauryann pushed away the blankets that wrapped around her bare shoulders. She sat on the sofa and leaned forward toward me.

I told Lauryann that I had never been cruel in my life, but that I had done a cruel thing to my mother after I came to America. "In retrospect, I still wonder if the cost was not too great," I said. It was an act of liberation, a necessity on my part. Like pulling off the strips of cloth that bound the feet of so many Chinese women, I had to make the cut myself. "American education had changed my character. I felt strong enough to speak In my own voice, the voice of my honest self for the hirst time, to my mother, the person I loved most in the world, and the person who knew me the least."

I began writing letters to destroy my mother's perfect image of me. I had become disgusted with my own dishonesty. I was so sick of my mother pretending not to see my flaws. I wrote to tell her that I had never been perfect. Her model child, her flagship, had never existed. I had stolen from her. I had sold my father's books to buy a piece of candy. I had lied to my mother as an adult. I told her that everything was fine while I was in trouble and having an affair. I was depressed because I was unable to get out of my troubles. It didn't occur to me that I had altered my own reality.

"My mother didn't want to hear the news that Qigu and I were divorced," I continued. "But I kept reporting what I wanted her to hear. I was determined to penetrate her, to break her down, to force her to accept me as I was. I told my mother how I was not making it in America, that I was working as a maid and a cleaning hand at construction sites, that I was not able to get a normal job that would lead to US citizenship. I wanted her to like the me who was trying her best to achieve her full potential. I needed her support and approval.

"But she wouldn't give it to me. She refused to accept the flawed me. She was disgusted with the real me. She shut her eyes and turned her head. My father said that she used to wait for my letters. She looked forward to the sound of the postman's bell the moment she woke up. But now she was scared. She refused to open my letters. She said, 'No!' when my father offered to read them to her.

"When I visited China, I revealed the worst news. I showed my mother the scar, told her about the rape, and I described my failed suicide attempt in the past."

The image of my mother covering her ears with her hands stuck with me. Her eyes shut tightly. Her frame was shaking as she pleaded, "No more. Please. No more."

I remembered continuing, spilling the hurtful words, crying and sobbing at the same time.

"You are killing your mother," my father said. "She doesn't de-

Outside the widows, the sun began to set. Darkness descended and turned the trees into patterns of black paper cuts. "Not until I had you did I start to understand my mother," I said to Lauryann. "My mother lived to protect me even as she spoke the hurtful words, 'Shame on you.' Her philosophy that love can't hurt backfired. I did everything I could to defeat her purpose. It's not the rice but too little firewood that causes the rice to be half cooked, the Chinese saying goes. My mother didn't have sufficient firewood. She died not knowing the real me. If there is regret, this is it. I loved her so much. I wanted her to know me, but she never allowed me access. I appreciate the chance you are giving me now. I want to get to know you, the real you. It means everything to me."

Tears welled up in Lauryann's eyes. She reached out to hold my hands.

I continued, "The moment I smashed the mirror in which my mother saw the perfect me, she experienced an internal crash. I was sure. But she held her composure and sat straight-faced. That's the way she fought. She held on to her belief silently day after day, month after month, and year after year. She must have felt that she deserved to be punished, that she hadn't raised me right. She once told me that she considered

her life a failure because she never got to be the schoolteacher she wanted to be. She was a teacher who never got to hold a class. I was her only chance to show the world that she was not the 'Teacher Idiot.' I was her pride, her creation, her only work of art. I was her integrity and dignity. My success would be the proof that she hadn't wasted her life. I was the embodiment of her worth. Yet I couldn't let her have that.

"Now that she is dead, and now that I understand her love, I hate myself for making her suffer. I live with the misery that I let my mother down. I want you to be free of such dreadful remorse. I want you to know that I don't desire a perfect child. Because that wouldn't be the real you. It'd be impossible. It'd be fake. One can go to the trophy store and buy a wall of awards and banners. You'd fool everyone but yourself. I love the real you, the one who keeps hitting the steel wall and hoping that it will turn into a wall of flowers. I believe that you are perfect. Your bravery and courage to be the real you makes you the perfect child. You have been pleasing me, and you have my acceptance and approval."

"Of all my flaws, doubts, and confusion?" Lauryann said, wiping first her tears away and then mine.

"Of all your flaws, doubts, and confusion." I smiled, pulling her toward me, and hugged her the way I did when she was a little girl.

the first of the second of the

Commence of the second of the

The second secon

PART SIX

{ CHAPTER 35 }

AURYANN'S PSAT SCORES were considered low in comparison to other kids from Asian-American families. A few years before, I had researched the tests with the same zeal I had when applying for my US visa a quarter century before. What I discovered was that college admissions offices, especially at the elite colleges, would compare Lauryann's scores with other Asian-American applicants'. Although Lauryann was one of the best students at her public high school, her test scores might hold her back.

Brave as Lauryann masked herself to be, fear and nervousness crippled her ability to perform to the best of her ability during tests.

Lloyd encouraged Lauryann. "Fear is the best motivation," he said, "I stopped chewing my fingernails. See? I used to chew them until they bled. The marines set me straight. The drill instructor saw me and said, 'Stop it, you maggot!' And I stopped. You must learn to stare fear in the eye and say the same thing."

"Yeah, stop it, you maggot. Like that would work for me," Laury-ann replied. "It's not a magic wand."

An SAT score below 2200 meant that Lauryann would have less of a chance to be accepted to an elite college. Within the Asian-American community, the racial glass ceiling was an unspoken yet known reality. Chinese-American families accepted what they couldn't change and worked all the harder.

Like other Chinese parents, I kept repeating this to Lauryann: "America will grab you and offer you the best if you prove yourself to be gold-medal material. It's all about what you can do for America."

I suggested that Lauryann consider herself a second-class citizen. "It's better that you're taught the truth. If America honored race-blind competition, the nation's elite colleges would be filled with the hardworking Asians. Have you heard of the American saying 'You don't stand a Chinaman's chance'? Chinaman, that's who you are."

I asked Lloyd to work with me to help Lauryann improve her writing skills. Although Lauryann's reading and writing were considered excellent at her school, her scores for the PSAT test were low, especially in writing. Out of 800, Lauryann scored 620.

Lloyd was glad to help, but he had one condition. "I'll only use a red-colored pen," he said.

"What kind of condition is that?" I asked.

Lloyd explained that in America, in order to protect students' self-esteem, teachers (at least in the high school where he worked) were encouraged to stop using red pens when grading student papers. The students didn't like their teachers' remarks in red ink, a district administrator once told the teachers at a staff meeting. The parents had protected that their kids were uncomfortable with the red ink

"Well, in China, for thousands of years, teachers never used any other ink but red," I remarked.

"I was so mad that I bought two dozen red ink pens after I was told not to use them!" Lloyd said.

"Did you use them?" Lauryann asked.

"No. I didn't want to lose my job."

"I will welcome your red ink," Lauryann said.

Lloyd went online and found over forty SAT prompts for writing topics. It was enough for Lauryann to practice writing one essay a week for the entire school year.

Before practicing, Lauryann set her alarm clock for twenty-five minutes. It took time for her to get used to writing an essay in such a short time. Lauryann would then give the essay to Lloyd, who would correct it and give the essay a grade. We celebrated when Lauryann earned a rare six on a scale of six. We felt good when Lauryann earned a five, but if she earned a four or a three, we sat and discussed what the problem was. Lauryann and I would study Lloyd's red-colored criticisms. Lauryann would rewrite the entire essay, sometimes several times, until she achieved a six. Occasionally I disagreed with Lloyd's view. The three of us would then discuss the essay further and decide on the best approach for revisions.

After a year of these drills, Lauryann was able to achieve a five or a six on every essay. Lloyd and I felt confident that Lauryann was ready. She was able to come up with a unique and balanced point of view on any given topic and could compose the essay in twenty-five minutes—the time limit given for the SAT essay. Lauryann's command of the English language was efficient, and her grammar was sound. For nine years Lloyd had restricted his presents to Lauryann to books he thought she would enjoy and learn from, and it had had the desired effect. Lloyd loaned Lauryann his *Lord of the Rings*, and I loaned her my *Jane Eyre*. I had also been providing Lauryann with a wide range of quotations that had inspired me in my own life. I was not only surprised at the speed of Lauryann's improvement but with the maturity of her views. Lauryann also seemed confident that she would do well on the written part of the test.

We waited for the results of the SAT. To our great disappointment, Lauryann's score failed to improve significantly. She received 650 out of 800—only 30 points higher than her previous score. Based on Lauryann's account of how she had handled the prompt, Lloyd and I couldn't understand why her essay had been graded so low. What went wrong? Was it because we had taught her not to be afraid of trying creative ways of presenting her thesis? Lauryann said that she was comfortable during the test, that she was not nervous or scared.

I was more devastated than Lauryann. I felt that it was my defeat.

"A grader is supposed to be unbiased, and most of them are fair," Lloyd said, "but the human factor always plays a role in the scoring. The grader could have taken points off your essay because you failed to follow the expected formula. We just didn't believe in teaching you that way."

Lloyd and I were unable to convince Lauryann that nothing else mattered as long as she believed that she had done her best. Lauryann should be proud of the fact that both Lloyd and I had given her the highest score. But this did little to console her, and she remained doubtful of her writing abilities.

"Mommy's Boot Camp" was how Lauryann described our next trip to China. Lauryann may have been committed to a home-study plan, but she had difficulty sticking to it. She was constantly distracted by party invitations, phone calls from friends, text messages, Skype and Facebook chatting requests, and the latest YouTube video fad. Lauryann clung to the Internet. When I threatened to pull the plug, she yelled, "Mom, I am waiting for a reply from a friend who's helping me with my homework!"

I took Lauryann to China with me as soon as school was out for the summer. I didn't ask whether she was interested in coming with me, and I did not reveal my plan. Paying fifteen dollars a day for a motel on the outskirts of Shanghai, I created an environment where Lauryann could concentrate on her SAT practice books while I worked on my manuscript. "We will not leave this room until we achieve the day's goal," I announced.

Lauryann knew that her mother was in a "dictator mood," and she had no choice but to comply. Due to jet lag and the time difference, we rose at around three A.M. and immediately settled down to work. For breakfast and hunch, we are at Mr. He's Dishes across from the motel or the noodle shop down the street. To exercise, we walked to her grand-parents' flat. If Lauryann achieved a score of 720 after practicing her drills, she would earn my permission to go shopping in the center of Shanghai.

Math had always been Lauryann's weakness. Lloyd and I couldn't understand Lauryann's math textbooks. All we could do was purchase more practice books. Qigu, on the other hand, did not worry. "Why make Lauryann suffer over math?" he said over the phone. "As long as she knows how to count money, she'll do just fine."

I had drilled Lauryann before, and the result had been rewarding. This was long ago, when Lauryann was seven years old and I had worked with her on the times tables. Lauryann was too slow. To speed her up, I trimmed the words between the numbers—for example, the words *plus* and *equals* from "two plus two equals four." Lauryann would memorize the phrase as "two-two-four" to save time. Now, all these years later, we kept drilling until Lauryann achieved an average score of 720 on the practice units.

The drilling exercises exhausted and bored Lauryann. For breaks, I took her to a nearby hair salon for a five-dollar shampoo wash and a head massage. The girl who worked on Lauryann was her age, about

sixteen. She was from Anhui province. She was pretty and fair skinned. We learned that she had started working as a hairdresser at fifteen. We noticed that the girl was in pain. The skin between her fingers was cracked. I asked the girl about her hands. She replied that this was the result of soaking her hands in shampoo for fourteen hours a day. "My hands don't get a break," she said.

"You can wear protective gloves, can't you?" I asked.

"Yes, but customers don't like it," the girl said. "The customers like to feel the tips of my nails massaging their skulls."

"What if you insisted on wearing gloves?" I asked.

"The customer will go to someone else," the girl replied. "There are a lot of girls like me trying to find work."

After we returned to the motel, I thought about the girl and her damaged hands. "She is somebody's daughter," I said to Lauryann. "I couldn't bear to have you work like this. It'd kill me."

Lauryann was up early the next morning and dived into the math drills without a word.

Five months later, Lauryann achieved 790 out of 800 on the SAT math test.

Throughout her school years, Lauryann was desperate for acceptance from her peers. She would go so far as to pretend to be dumb. She had done the same when she was young. In order to remain friends with Fooh-Fann, she chose to diminish herself. Her sense of self-doubt and unworthiness hurt me. I felt guilty because I believed that it had to do with my divorce.

"You let your grades drop on purpose," Lloyd concluded after questioning Lauryann.

Lauryann confessed that it was true. "I don't want people to hate me!" She had been scolded and called a bitch and a whore by some of her schoolmates because she did her homework. She was accused of making everyone else look bad.

I had no idea of the extent of my daughter's battles. I simply couldn't understand it. Such a thing would never happen in China. Her classmates demanded that Lauryann stop raising her hand to answer teachers' questions. When she didn't stop, one boy took away her glasses and pushed her around between classes.

Lloyd decided to complain to the school district, but I stopped him. "You'll make Lauryann a public enemy!" I would have let Lloyd do it if it had been just one individual giving Lauryann a hard time. "But it's the entire school culture! It is a storm Lauryann can't weather!"

After repeated incidents, there was only one option left: move. Although Lauryann had to endure a newcomer's awkwardness once again, being bullied at the other school had toughened her. She adapted quickly.

Lloyd was proud when Lauryann was honored as a scholar athlete at graduation from her high school. The funny thing was that the multiple awards given to Lauryann didn't stop Lloyd from writing her a boldface letter, which read:

High School t-radiculon means that you are:

No longer protected by the law.

You are expected to pay your own rent.

You are expected to pay your own medical insurance.

You lose the freedom to talk back to your boss.

You either bag groceries, or wait tables, or earn a degree at a university that leads to a secure income.

You are responsible for your college loans and debts. THE FUN ENDS AT 18! GET READY TO SURVIVE LIFE! GOOD LUCK!

Words cannot describe my emotions when Lauryann was accepted to Stanford University. She had applied to major in biology. It wasn't until Lauryann printed out the acceptance letter and I read it word for word that I believed it was real. Lloyd's reaction was, "Gee, making her jump through all your hoops was worth it!"

The three of us celebrated. We reflected on how far we had come as a family. We shared laughter and tears. To Lloyd's astonishment, Lauryann and I revealed our "secrets." While Lauryann admitted that she

had once written "I hate my mom" in her diary, I admitted that I had plotted "a conspiracy" using Lloyd as my weapon. I often took advantage of Lloyd's short fuse and set him up. I added fuel to Lloyd's smoldering fire, sat back, and watched him explode.

"What do you say, Lloydee, now that I am a Stanford girl?" Lauryann held up her hands and the two of them gave each other a high five.

"Oh, you are going to be in hog heaven." Lloyd laughed. "You are going to have *sooooo* much fun, and your mother and I won't exist anymore. You will be a puppy wagging your tail when the tingling hits. I have paid attention to your body language. You get animated when you talk about boys. Yesterday our neighbor Betsy said to me, 'Oh, you are going to be missing Lauryann terribly, she is such a sweetheart!' I said, 'No, I won't.' And she said, 'Oh, you're just saying that. You'll miss her.' And I thought, What's wrong with this American woman? Kids have to leave. I went to Vietnam when I was her age. But she's going to Stanford—to party!"

"Don't get too carried away with your tough love, Lloydee." Lauryann laughed. "I don't talk back because I want to let you enjoy your senior moment. Just remember, you might one day need me to spoon-feed you when you turn a hundred and thirty years old. Be a good boy, Lloydee, behave and be reasonable."

I beamed at my child, now a five-foot-six, 110-pound young woman glowing with beauty and health. Her grandma was extremely pleased that she beat the height predictor. Lauryann was now ready to go out into the world. In a few months, she would call home to thank us for preparing her well—she received A's in her writing classes. "Apparently, professors here think that I can write," she said, although she cared more about bringing her math, physics, and chemistry grades up to "the Stanford level."

T'S BEEN TWENTY years since my first book, *Red Azalea*, my first publication. Sandra Dijkstra, my agent, is still the lady I met in Chicago. She is a zest of passion—beautiful, ageless, and superior in what she does. She is known as the Gate Tiger, someone who has so successfully put unknown authors on the literary map. She has created and re-created sensations and is a legend herself.

My longtime editor, Mr. Anton Mueller, is responsible for the success of my books since *Becoming Madame Mao*. My first editor was Miss Julie Grau, who edited *Red Azalea* and who is a phenomenal publisher herself today. I still remember the first time I met Julie. She flew to Chicago from Night York I wern my larler hotel room. When I knocked, a woman in her twenties opened the door. I looked past her because I assumed my editor would be an older woman with gray hair and perhaps smoking a cigarette. Julie Grau was too young and too stunningly beautiful to fit the picture.

It took years for Anton Mueller and me to develop a strong editorauthor relationship. We had our moments of cultural clashing. Anton learned to deal with my stubbornness, sensitivity, and will. He has been an excellent navigator and was the one who convinced his house to publish *Becoming Madame Mao* when everyone else in the business decided to let it go. Anton had no doubt that *Becoming Madame Mao* had the potential to become a bestseller, and he was proved right.

A psychiatrist once told me that the reason I wrote about China was that I missed China. She convinced me that writing offered me a way to cope with my homesickness. I denied the analysis at first, but after twenty-seven years I realized that the psychiatrist was not wrong.

I came to identify with Pearl S. Buck, the American novelist who won the Nobel Prize for her work *The Good Earth*. I understood Pearl's cry "My roots in China must die!" She was suffering from being unable to let go of China, her home of forty years. Pearl Buck carried her love for China to her grave. There were only three Chinese characters, her Chinese

name, carved on the stone tablet. There was nothing else. It moved me to tears when I visited her grave site at her home in Pennsylvania.

I had no need to talk about my homesickness, because China has never left my mind. I love China with all my heart and soul, although I feel fortunate to have escaped it. I considered it part of being an American that at times I felt uprooted, disoriented, and isolated. It makes me a better writer that I might understand the suffering of a permanent sense of loss and dislocation.

Writing about China has enabled me to stay in touch with my roots. After *Becoming Madame Mao*, I went on to write *Wild Ginger, Empress Orchid, The Last Empress*, and *Pearl of China*. My goal was to establish a "literary portrait gallery" featuring China's prominent historical women from ancient to modern times.

Although I labeled my historical novels as fiction, I take pride in being truthful. *Empress Orchid* was an original story about a village girl named Orchid from the poorest province in Anhui who became China's last empress and ruled for fifty years. I avoided altering my characters too much.

When I wrote *The Last Empress*, the sequel to *Empress Orchid*, I had a choice to make. I realized that the story line would be more attractive if I took some creative license with the characters and reinvented certain events. But I decided not to. It was important to me that my readers walk away with a solid knowledge of China. My focus was on Orchid's struggle to hold China together during the worst time in its history. Providing entertainment should not be my only goal. I feared misleading my readers. I have encountered numerous books and articles that have misrepresented China. If I manipulated history to make a more commercial story, I would do America a disfavor.

I couldn't be more grateful to Anton Mueller for supporting me and standing by me. Working with him and Sandra Dijkstra have been the highlights of my life. I was aware of Anton's pressure, but he demonstrated an unshakable commitment to and faith in me.

When Anton left Houghton Mifflin Company and moved on to Bloomsbury Publishing, I faced a choice to either follow him or change to another editor. Sandra Dijkstra discussed with me the pros and cons as she always did. It was a critical moment in my career. I decided to follow Anton. The relationship we developed over the years was irreplaceable. I joked with Sandra Dijkstra about my reason in following Anton Mueller to his new house: "Anton is the devil I know."

I have no complaints about the way my books were published except one detail that has been repeated in the author's biography. This said that I was "recruited" to play a leading role in Madame Mao's films. This oversimplified my story and gives the wrong impression. There was no such thing as being "recruited." China at the time was under the Maos' dictatorship. I was a laborer hoeing cotton when Madame Mao's Shanghai propaganda talent scouts noticed me. They had been searching for individuals who possessed the "proletarian beauty" to play a leading role in Madame Mao's films all over China. I was never asked whether or not I wanted to go to the Shanghai Film Studio and take part in Madame Mao's propaganda films, which were like unlay's campaign ado and which ultimately were introduced to pave the way for Madame Mao to become China's next president after her husband. I was simply given the order to follow. My will and talent was irrelevant—I was the bolt that fit the machine.

I was so focused on plowing my literary field that I didn't pay attention to how the reading world was changing. When I received the news that *Empress Orchid* had been nominated for the 2006 British Book Awards in the category of Best Read of the Year, I thought it would be just like other awards I had received, where I didn't have to do anything. I threw the stack of colorful announcement cards that came with the award notification letter into the trash bin.

Lauryann retrieved the letters and cards from the trash. She told me that my book was listed side by side with *Harry Potter*. And there was also a dinner invitation.

"Are you going to England to attend the award ceremony, Mom?" Lauryann asked.

"I don't think so," I replied. "You know I have motion sickness. I don't enjoy flying."

"Well, Mom, you are going this time."

"Why?"

"You are going to be with J.K. Rowling."

"Who is J.K. Rowling?"

"The Harry Potter author."

"Why would I bother her?"

"Because I want you to get her autograph for me."

I heard my name announced, followed by music. Looking up, I saw the cover for *Empress Orchid* projected on the giant screen. Next came a film clip that a British TV crew had shot a few weeks before. There were scenes set in my home, followed by a few in San Francisco with the Golden Gate Bridge behind me, and then some at the Japanese Tea Garden in Golden Gate Park. With their lens aimed at me, the camera crew ran in for a final close-up. The rest of the guests at the table turned toward me, including J.K. Rowling.

I thought, *This is the moment! Ask for the autograph!* Before I could open my mouth, J.K. Rowling nodded at the screen and asked, "Is that lovely girl your daughter?"

It was the image of Lauryann dressed up as the young Orchid. The producer thought it would be a good idea to have a "visual aid," and Lauryann was available that day. She was glad to help. The crew dressed her up and walked her around the Japanese Tea Garden carrying a pink Chinese umbrella. She was a natural princess.

"Yes, that's my daughter, Lauryann. And \dots she is the one who asked me to ask you \dots if she could have your autograph."

"Of course!" J.K. Rowling took the card I handed her and signed it. I let out a breath and thought, *Mission accomplished!*

I returned home and handed the autograph to Lauryann. She read it out loud in a British accent, "It was soooo wonderful to meet with your Mum! J.K. Rowling."

Instantly I felt that I had never risen so high in my daughter's estimation.

I returned to China in the summer of 2010. Lloyd and Lauryann joined me. "We are going to explore my motherland for Lloyd's ilookChina.net blog!" I announced. Since launching his blog, Lloyd has had several hundred thousand visitors. He wanted to spend more time learning about China. This time he planned to visit the southwestern part of the country and see the great Yangtze River and the Three Gorges. I wanted to vacation, relax, and celebrate. I had been to many places in China while working on film crews over twenty years earlier, but misery and despair was all that I remembered. I wanted to count my blessings by revisiting those places.

In the meantime, following the Chinese tradition, I came to "return" Lauryann to her Grandpa Old Frank and Grandma Nai Nai, Qigu's parents. It was to say that "I have completed my job as a daughter-in-law." Lauryann's acceptance to Stanford University had already made the old folks smile in their dreams. Grandpa Frank remarked that Luuryann had brought glory to the great Jiang ancestors. Americanized as I was, I still felt that I was in touch with my Chinese self. To be a decent daughter-in-law was important to me. I sought my parents-in-law's approval, and I was pleased that I was able to bring great joy to them.

After Qigu and I divorced, my in-laws forbade me from visiting them. They feared the neighbors gossiping. They preferred that I not go near the property when dropping off Lauryann. It took two years, after Qigu was happily remarried, until I was permitted to come to the house after dark. Although awkward, I understood their feelings. For the sake of Lauryann, we tried to get along.

Over the years I earned my parents-in-law's respect and trust. They finally lifted the ban. They not only told the neighbors that I was their adopted daughter but also welcomed me to visit their house anytime, day or night. I had achieved their affection by being an obedient daughter-in-law. The truth was: I couldn't have cared less what they thought of me. The motivation for my "good behavior" was that I believed that Lauryann had the right to know her grandparents. I was grateful for their love and affection—Lauryann had become everything to them.

Just as Old Frank Jiang was getting ready to receive us, he suffered

a heart attack. It was lucky that he was in a taxi. The driver took him right into the local hospital. Lauryann was beside him when Old Frank opened his eyes. He was in tears when Lauryann kissed and hugged him. Canceling all of our plans, we spent the next ten days at Old Frank's bedside.

Old Frank said to me, "Lloyd is here to travel and learn about China. He must be bored and feel that he's wasting his time!"

"Are you, honey? Bored? Wasting your time?" I asked Lloyd.

"Quite the opposite!" Lloyd replied. "I feel that I have been given a great opportunity to learn about Chinese people and the importance of family. I am proud of Lauryann because she seems to know the real value of life."

"She is a sensible girl," Old Frank agreed. "Divorce is difficult in China. It breaks down the entire family and hurts the child. It's a battle, a war, the terrible kind that brings out the worst in everybody. I am no fool. In the past, Lauryann insisted on meeting Qigu at my home. She wanted me to see that she has a good relationship with my son, her father. You and Anchee did a good job raising her, and I really appreciated it..."

This was how the dialogue started between Lloyd and Old Frank—between the former US Marine and Vietnam vet and current American blogger and a Chinese man who was also a sixty-year member of the Chinese Communist Party. By accident, Lloyd stumbled into a gold mine—he was able to get answers to all of the questions he had for his blog on China. From Mao to Chiang Kai-shek, from the Cultural Revolution to the Dalai Lama and the Falun Gong—whether it was a religion or a cult—from the Communist proletarian dictatorship to the transformation of a democratic Party, Old Frank made sure I translated his words exactly and correctly.

"My vote counts although I am only an ordinary member of the Party," Old Frank said. "You must know that during the Cultural Revolution the people who suffered the most, and who lost everything, were the members of the Communist Party. Today there are eighty million of us. Mao defied the Party. Mao didn't represent the Party. The Party has learned its lesson. It has since abolished-policies that would lead to

corruption and dictatorship. The high-ranking serving members of the Party are subjected to an annual audit. They are required to provide financial statements, to be subjected to independent and transparent investigation and discipline. The members of the People's Congress are limited to two five-year-terms. Mandatory retirement in China is fifty-five for women and sixty for men. Since the late 1990s, a semiofficial mandatory retirement age of sixty-eight has applied to all Politburo members. No exception. This way the Cultural Revolution will never happen again."

Old Frank refused to take a break. He was breathless, but he was enjoying himself.

"Don't you resent the fact that your houses in Hangzhou and on Mogan Mountain were confiscated by Mao and never returned to you?" Lloyd asked.

Old Frank laid back on his pillow and paused for a while before he replied. "I have made peace with myself There is a price in everything. I knew before I joined the Communist Party that my path would be bumpy. My head was tied on my belt, so to speak. I didn't fight to seek pleasure, I fought for the poor. I feel blessed to have survived. So what if the mansions my father built were gone? I still have my faith. I still voice my opinion. I will keep doing so as long as I live. Nai Nai, my wife, Lauryann's grandmother, is one of the great numbers of victims of the Cultural Revolution. She was denounced and imprisoned. She had a nervous breakdown. Her mind is still trapped at that meeting where she was denounced. She is spinning in the whirlpool of terrible memories."

"It's PTSD," Lloyd said, and asked me to translate.

Old Frank grew impatient and interrupted me. "Anyway, if you ask whether or not I regret ever joining the Communist Party, my answer is *no*. I am an idealist till I die."

I was tired of translating, but the two men wouldn't quit. I asked Lauryann to take over, but her Chinese was not sophisticated enough. Finally a doctor came. He told Old Frank that it was time to stop talking for the sake of his heart. Turning toward Lloyd, the doctor asked, "Who is this foreigner?"

Without a beat, Old Frank replied, "He's my son-in-law!"

THE COOKED SEED

"I love our conversation!" Lloyd said, as we bade good-bye to Old Frank.

"To be continued!" Old Frank waved, smiling.

I invited my father to live with me after my mother died. I knew it would be a challenge for Lloyd. Americans were not used to the idea of three generations living under one roof. "If you love me, you will put up with my old man," I said.

Before my father arrived, Lloyd replaced the old window in his room with a Milgard double-paned glass window and bought a digital flat-screen TV. After my old man moved in, Lloyd sprayed his room daily with air freshener. He also collected my father's bed covers, sheets, pillowcases, and clothes to wash, and made his bed for him. My father asked me if Lloyd wanted him to leave, because in Chinese tradition that's how you get rid of a guest. "More tea?" meant "Get out of my house!" in old China. I had to slow Lloyd down.

My real reason for inviting my father to come to America was to give him a set of teeth. He hadn't been able to eat solid food for years. Dr. Ronald Barbanell, my dentist, located in Downey, California, examined my father. He let me know my options. I was glad that my father's jawbones were strong enough to hold the implants. Afterward, I sat down with Dr. Barbanell. I let him know my ambition to restore a full set of teeth for my father. I asked him if he could make the price for implants affordable for me and he did. For that I was grateful because I knew Dr. Barbanell was the best I could find in America. He had performed a successful full-mouth periodontal surgery on me three years before and saved my teeth. I told Dr. Barbanell that I must not let my father learn the true cost, "or he will refuse to come." Dr. Barbanell said that he understood.

The night before his first implant surgery, my father sat on his bed. He said that he was uncomfortable with my spending so much money on him. My watered-down dollar amount was still an astronomical number to my father. I encouraged him to get some sleep. He asked if he could speak to Dr. Barbanell tomorrow. "See if he could do partial implants, not a full mouth."

"It has to be full mouth," I insisted. "It's like building a dike. A few rocks won't stand the pressure."

With Lloyd faithfully driving my father to his dental appointments and thanks to Dr. Barbanell and his partner Dr. Delacruze, my old man got his full set of new teeth. My father was a kid again. He couldn't believe that he was able to eat what he ate as a village boy, things like fried fava beans and dried pears. He loved to chew corn off the cob. He was happy and burdened at the same time. When he showed off his teeth to his friends in China, he would say, "What I have in my mouth is worth a house! I can't die now, because Anchee's investment will die with me."

With his revived health and energy, my father became restless. He started to miss his work in China. Although in his late seventies, Naishi Min was still considered China's leading scholar in astronomy education. Before he retired, he was director of the Planetarium of the Shanghai Children's Center. My father's work included organizing contests in astronomy. The biggest contest he held had sixty thousand participants. My father was the chief judge, and he enjoyed his status and influence tremendously. In the meantime, he became a columnist for the China Astronomy Magazine. While waiting for his gums to heal and his implants to set in America, he designed astronomy pop-up books that were published by China Science Publishing houses and the Beijing Planetarium. Lloyd understood my father's desire to go back to China. "The man's got to slay the dragon," Lloyd said. My father wanted to feel needed and useful.

Finally my father returned to China. He has been happy ever since. "No one took me for my real age," he reported. "Not with my full set of teeth! It helps me look young, not that it's necessarily good now that I'm having girl trouble."

At eighty, my father had been invited to lecture on astronomy in China's elementary and middle schools and universities. His new books were selling and the publishers were printing second editions.

"Have you gone to see a dentist for cleaning?" I asked when I phoned him.

My father went silent.

"You haven't been going, right?" I continued.

The silence continued.

"You've got to go!"

"I always brush my teeth after each meal," he said.

"But professional cleaning is a necessity. The dentist will go where your brush can't reach."

My father was quiet again.

"You still are afraid, aren't you?" I asked.

"Uh, Chinese dentists can ruin my implants. To them dentistry is about pulling teeth."

"The times have changed, Dad. China's dentists have gone through dental school and earned medical degrees."

"You are talking like an American, Anchee. Too trusting. Anyway, I think I am good for life."

"What do you mean, 'good for life'?"

"My teeth were made in America. Dr. Barbanell built a fortress inside my mouth. I can still chew if I was to lose half of my teeth."

"I don't think you know what you're talking about."

"I do. Believe me. I was the one who knew what it's like not being able to chew rice."

Looking at my father's recent photo, the one where he was standing next to a high-speed Maglev line, my heart was filled with joy. My old man's smile was so free—free of anxiety and gloom. I remembered how he was saddened when I couldn't get out of bed due to my spine injury. He could do nothing but watch when I coughed blood and my life was withering in front of his eyes. I also remembered his terror after learning that I was trying to go to America. "You will never make it! You will only be doomed and punished for trying to escape to an enemy country!"

Today, life means getting to know myself more, staying in touch with myself, making improvements upon myself, and, most of all, enjoying life. The cooked seed sprouted. My root regenerated, deepened, and spread. I blossomed, thrived, and grew into a big tree.

Every morning as I rise, I count my blessings:

I get to take a hot shower twice a day if I want I get to brush my real teeth

I get to wear a set of clean clothes, clean underwear, and a clean pair of socks

I don't have to wait in a line for someone to get off the pot—I have my own toilet, my own bathroom, bedroom, living room, and kitchen

I can say, "I quit!" and look for another job if I want to I have no worries over where my next meal will come from

I smile every Tuesday when Lloyd goes shopping to buy me what he thinks I need. He stocks the kitchen with fresh-picked vegetables and fruits from farmers' markets. He buys packs of dental floss and toilet paper, bags of potting soil, and boxes of rechargeable batteries. In case of an earthquake, there are water purifiers and canned and dry goods and an emergency medical kit.

The greatest reward came when I was least expecting it. Lauryann came home on Thanksgiving holiday. She is now a jumor at Granford University. I was surprised and impressed by the independent thinker she had become.

"Mom, it's your duty to write your memoir," she said. "Your editor is right—you need to dig deeper. You are not good at examining your own pain. You are good at killing the pain. Okay, you don't want to visit your past, but you owe it to so many women in the world who are trapped in a similar situation to the one you once were in, and who don't have a voice or a platform!"

Lauryann sat Lloyd and me down and briefed us with what she had been learning and doing at Stanford. She was passionate and focused, with great purpose and drive. "We want to make a difference," she said. Her tone was urgent. "And we think we can, because we care." She talked about a project she had been developing with her schoolmates. "Our billboard will read, productivity \neq \$." She told us that she had been taking classes that would prepare her. "I'm determined to be part of the change. The system needs to change. I'd like to find out, for example, why so many primary doctors have abandoned the patients who need them the most for specialty fields. I want to find out what's wrong and help fix it."

THE COOKED SEED

I told my daughter how pleased I was, and that she was fulfilling my dream. She was my repayment to America.

"Mom, remember the documentary *Doctors Without Borders* you dragged me to see when I was fifteen?" Lauryann continued, smiling. "I was not enthusiastic because it was not my choice. I wasn't sure that the health-care profession was something I wanted to get into. I didn't want to just do what my mom wanted. I wanted to do what *I* wanted. Thanks for respecting my space. But Mom, aren't you glad your wish is coming true? This is what I want to do with my life. I am committed. And I need your help through it. I want your input. Would you be my adviser? I'd like to test-drive my ideas and brainstorm with you. You're no-nonsense and tough. That's why I want you on board. Don't shoot me down too quickly. Go and fix your writing first. Dig deep. I know you can."

After I finish writing, I take long walks in the hills. As I climb the east side of a hill, I am bathed in the morning sun. I feel Iresh air in my lungs. My back is straight without pain. Happiness is in my every cell. Lines, my favorite from *Jane Eyre*, come to mind:

I have as much soul as you,—and full as much heart!...I am not talking to you now through the medium of custom, conventionalities, nor even of mortal flesh:—it is my spirit that addresses your spirit; just as if both had passed through the grave, and we stood at God's feet, equal,—as we are!

the continue of the party and any are

The region of the position of the second second